TRANS ⛊ FORMERS ™

TRANS ⛊ FORMERS ™

TRANS ⛊ FORMERS

½

2 3/16

TRANSFORMERS

A VISUAL HISTORY

Jim Sorenson

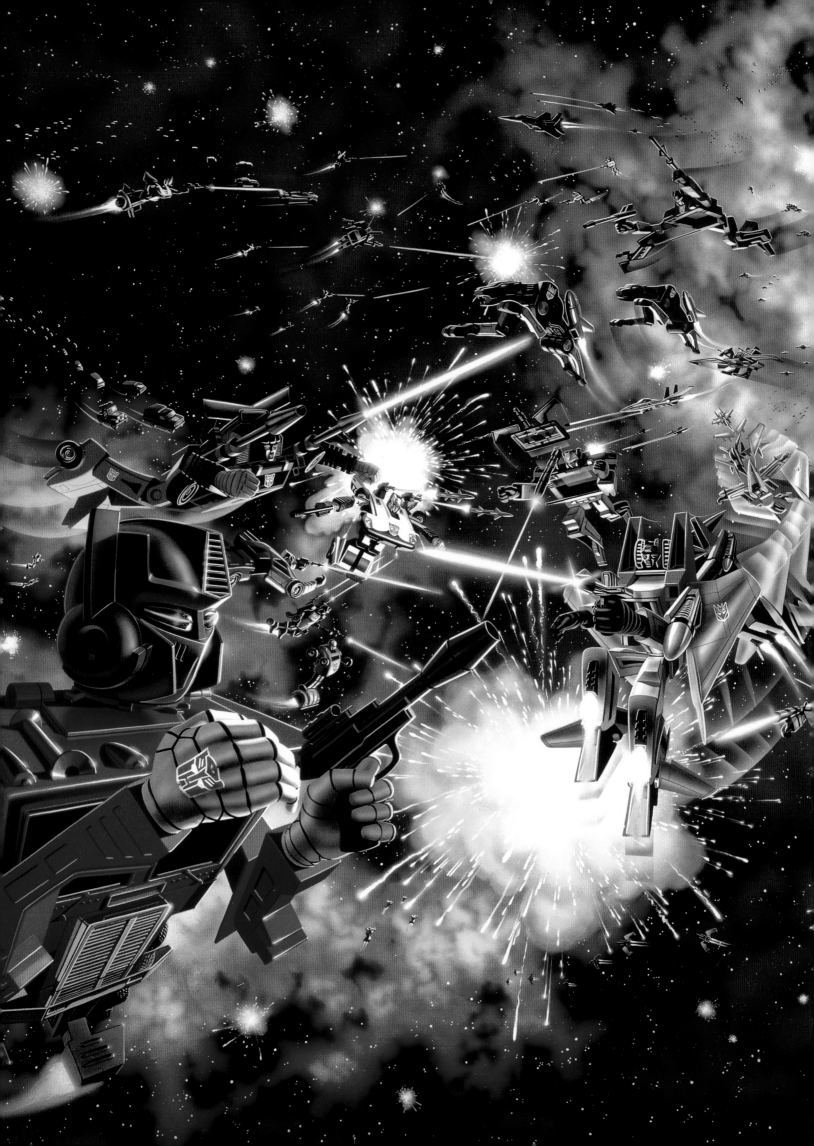

CONTENTS

7
Foreword

9
Introduction

10
PACKAGING

114
COMICS

212
ANIMATION

296
VIDEO GAMES

338
MOVIES

407
Acknowledgements

Opposite: Package art mural, 1984, Generation 1 | David Schleinkofer

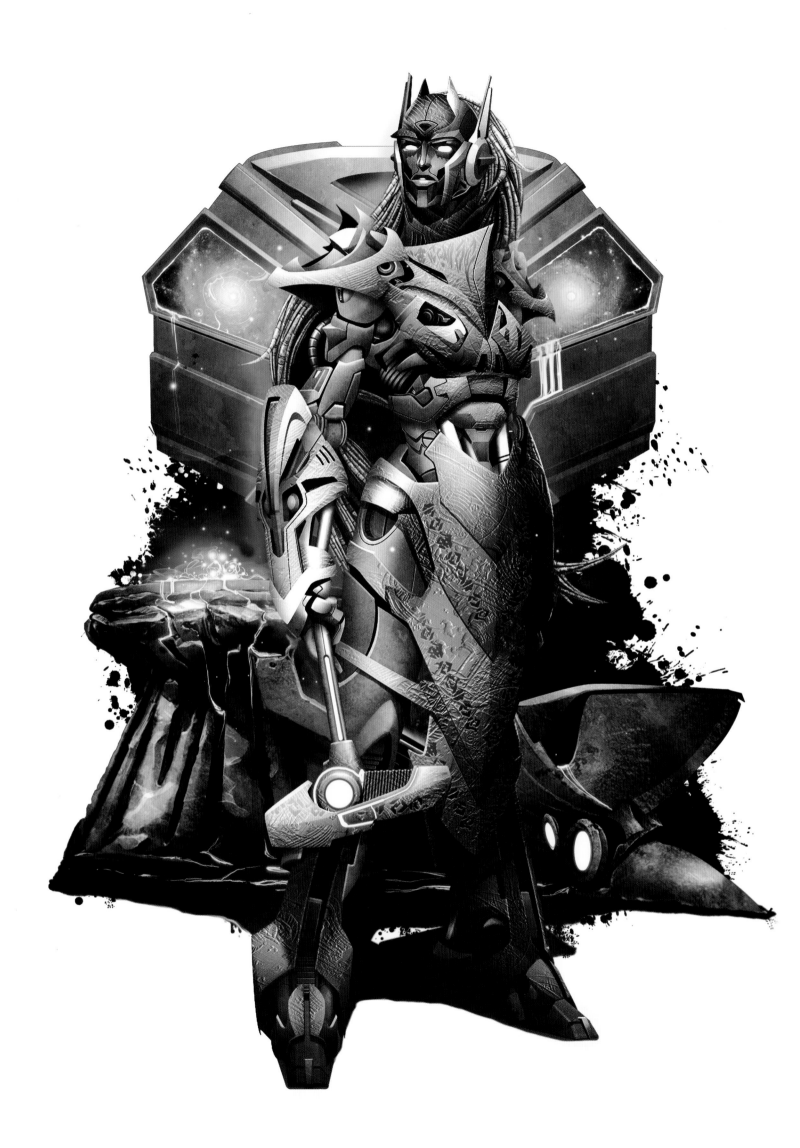

"HEY, ARE YOU INTO TRANSFORMERS AT ALL ... ?"

I had just finished doing a slate of pitch art for Activision in late 2005, and was ready to move on to the next project. "They're finally serious about doing a live-action Transformers movie, and we want to go for the game license. Are you interested?" My inner ten-year-old...the one from 1984...started doing cartwheels. I was ecstatic. At last, I'd get a chance to work on one of the franchises that meant the most to me.

It immediately took me back to hazy Saturday mornings, gazing endlessly at the original G1 catalog artwork so familiar to the fans—the epic battle of the Autobots waging their war to destroy the evil forces of the Decepticons! And that is where the appreciation of the artwork that defined the franchise started for me. The love of the TV show, admiring the hand-drawn versions of the beloved heroes and villains, animated on the small screen, and then on the big screen, and collecting the trading cards, comics, and whatever else I could afford come Allowance Day. I couldn't get enough and I couldn't stop drawing them. I traced the box art from every figure I had, came up with new scenes for the TV show, and created new characters to join the fray.

Years later, the opportunity to be a part of this phenomenon came along and I seized it, starting with the first two movie video game tie-ins. Then I began working directly with Hasbro Inc., being commissioned to create new versions of characters and scenes for their film and TV initiatives, developing toys, contributing to packaging art, and extending that relationship to working with IDW and other Hasbro licensees.

In all honesty, being even a small part of the visual history of the Transformers is an honor for me. I can't even begin to express my gratitude at being included in this worldwide phenomena, and the good fortune of being able to add to the wealth of incredible artwork that now spans decades. I'm humbled to be able to call these other artists colleagues, both the previous generations who inspired me as a kid and the current group working that inspires me today. And since this franchise shows no signs of slowing down, I hope that I, in turn, can inspire the next generation through my work.

As a fan, I cannot wait to flip through the pages of this book. What new treasures will turn up and what vintage images will stir the nostalgia? That inner ten-year-old is still doing cartwheels...

Ken Christiansen
March 2019

Opposite: Illustration, Solus Prime, Covenant of Primus | Ken Christiansen

INTRODUCTION

Transformers has been around for thirty-five years, an awfully long time in today's ephemeral pop-cultural landscape. It debuted in 1984, back when I was a wee lad of seven, and in the three and a half decades since it's been a consistent and welcome presence in my life.

That's not to say my relationship with Transformers hasn't changed. Far from it! As I grew up, Transformers grew with me. In 1984, there were twenty-eight Transformers toys, sixteen television episodes, and four comics. Last year, 2018, saw thirty-two television episodes spread out across four different series, dozens of comic issues and trade paperbacks, a video game, well over two-hundred toys, and even a rocking theatrical film in *Bumblebee*. There are numerous factors contributing to its longevity as a franchise, but one major aspect has to be its amazing and variegated designs. Each of the multitudinous incarnations of Transformers features its own artistic style: some only subtly different from what went before; some a radical departure. It's a testament to the strength of the brand that the visual cacophony of the live-action films can stand next to the whimsical simplicity of *Transformers Animated*, that the CGI canvas of *Beast Wars* can coexist with the stylized renderings found in the IDW comics, that the alien proportions of the airbrushed G1 package artwork exists side by side with the cartoony aesthetic of *Angry Birds Transformers*. It's an amazing, riotous visual offering; one that spans decades and every major mass-market form of media.

Over the decades—it feels strange to say decades, rather than years—Transformers has continued to grow and evolve. Incredibly, it has stayed relevant, even as kids like me aged into adults and then parents, and new generations discovered the wonder. It's a truly international phenomenon, with fans from all over the world converging on theaters and conventions, interacting online and in person, all brought together by their shared love of these giant transforming robots in all of their various guises. My own relationship with Transformers has taken me to three continents and helped forge friendships with people all over the globe.

Welcome to *Transformers: A Visual History*. Over the next five chapters, I'll do my best to sketch out some of the most iconic, representative, and just plain gorgeous pieces from the thirty-five-year history of the brand. We've broken the franchise into five distinct segments: packaging, animation, comics, video games, and film. Each chapter proceeds roughly chronologically and covers most of the major offerings of the franchise, separated by small breakout sections covering artwork that didn't quite fit neatly into the organizational scheme. Browsing through this book should give you some inkling of the sheer volume of artwork produced for the Transformers franchise over the decades and the staggering variety of artistic voices contributing to the tapestry.

If you're anything like me, you'll find yourself transported to alien worlds and reliving the ultimate battle of good versus evil in all its various iterations. Transformers is a franchise unlike any other, and the artwork exemplifies that uniqueness.

Buckle up, you're in for one heck of a ride!

Jim Sorenson
February 2019

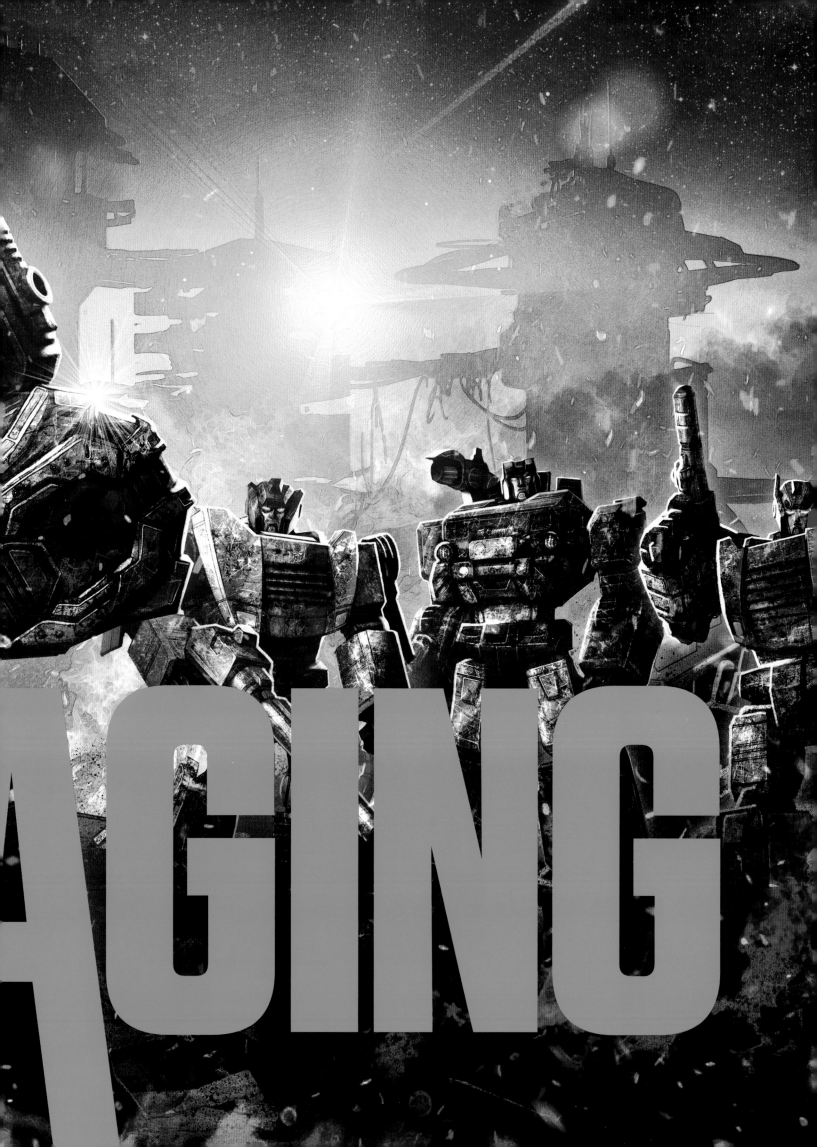

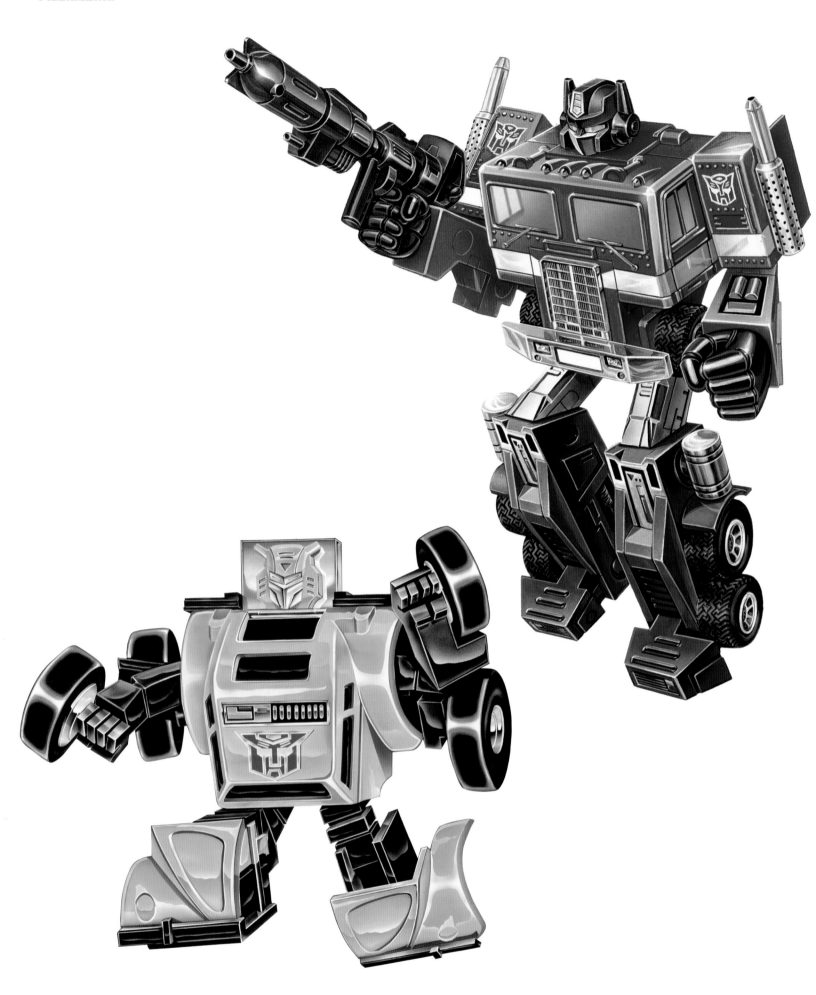

The year was 1983. American toy manufacturer Hasbro was doing quite well. They had avoided the video game implosion of the early '80s, and had recently achieved phenomenal success with their relaunch of the G.I. Joe toy line and their creation of My Little Pony, becoming the second-largest toy manufacturer in the world. Naturally, they were looking for the next big thing. Meanwhile, Takara, Japan's third biggest toy maker, had struggled to break into the US marketplace. They had attempted to interest American consumers in their novel transforming robots under the *Diakron* line to little effect. Together, these companies turned two existing Japanese toy lines (*Diaclone*, which featured transforming vehicles and animals, and *Micro Change,* a role-play toy line featuring robots who turned into guns, cassettes, a microscope, and other handheld items) into the global powerhouse known as Transformers.

Many elements went into the initial launch of the Transformers—the animated cartoon and the comic book series were key elements—but it should never be forgotten that Transformers is first a *toy* line. The toys needed to stand out on crowded shelves, and indeed everything a kid needed to know was right there on the box. Clear windows showcased the vehicle mode of the toy, with a stylized illustration of the character's robot form juxtaposed. Just in case anyone missed it, the gimmick was clearly spelled out right above the physical toy: "TRANSFORMS FROM RACE CAR TO ROBOT AND BACK!" Photo references of the step-by-step transformation process were also included.

But conveying the gimmick was only part of the job of the package. It also sold the fantasy. Two different versions of the Transformers logo were created, one for the heroic Autobots, one for the evil Decepticons. The back of the packages featured a gorgeous mural of Autobots and Decepticons locked in a fierce space battle, as well as individual biographies called Tech Specs. All of these aspects came together to create a play experience that was truly special. Transformers was *the* hot toy of 1984, with the *Washington Post* noting that "For Christmas 1984, the pitty-pat of little feet won't be reindeer but robots."

The packaging was a slickly designed masterpiece, and central to its success were the brilliant toy illustrations. The style itself owed much to the artwork from *Diaclone* and *Micro Change*. Indeed, many illustrations from that first year were lifted directly from their Japanese counterparts and only slightly modified, including Megatron, Soundwave, Starscream, Ravage, Prowl, Hound, Trailbreaker, and others. For characters without suitable Japanese art, new pieces were commissioned. Characters were posed to emphasize their slightly unearthly proportions, with extreme foreshortening to make them appear tall and imposing. Toy details, especially stickers, were emphasized. Each illustration was painstakingly airbrushed, a process that could take weeks. It was undoubtedly worth it, as to this day many longtime fans cite the beautiful classic illustrations as one of the key ways they engaged with the brand.

Transformers continued throughout the rest of the '80s. More toys were imported in 1985, and from a wider variety of companies. In 1986, the line continued to grow, supported by a feature-length animated film. By this time, Hasbro had just about run out of products to import and began to create their own original robots, though still in partnership with the team at Takara. Thus did the line continue for several more years.

But kids were fickle, always looking for the next big thing, and in 1990 the Transformers line released its last wave of products in the US. The line continued overseas, both in Europe and Japan, and was relaunched in the US in 1993 as Generation 2. (Thus did the original Transformers line retroactively come to be known as Generation 1.) G2 was a middling success, lasting three years. The 1984 art style persisted all the way through 1995, evolving somewhat but mostly continuing to hew to its roots even through the end of Generation 2.

But all that was about to change. In 1991, the first year without new Transformers toys on US shelves, Hasbro acquired rival toymaker Kenner. In 1995, they transferred their boys' toys division from Rhode Island to Kenner's Cincinnati offices. This new team thought that the time had come for new ideas, and Transformers received its biggest reinvention to date—*Beast Wars*! Cars and trucks were out, apes and dinosaurs were in.

Beast Wars, along with its sequel toy line *Beast Machines*, ran from 1996 through 2001, and was by any

metric a huge success. As befitted a line of organic transforming animals, the art style of the packaging undertook an equally radical evolution. Gone was the slightly surreal form of hulking machines; in was a harsher, raw style, painted in gouache. *Beast Machines* abandoned the concept of individual illustrations for each character, as did the next Transformers line, 2001's *Robots in Disguise*, a filler line consisting largely of imports from Japan's 2000 series, *Car Robots*.

Package illustration returned the next year with 2002's *Armada* line, the first of three connected toy lines that would retroactively become known as the *Unicron Trilogy*. However, instead of the laborious paintings that had characterized the first fifteen years of the brand, in their place were comic-style illustrations. This trend would continue through *Energon* and *Cybertron*, the *Armada* sequel series which ran through 2006 and beyond.

Around this time, Hasbro began to branch out, running multiple lines concurrently. A line of accurate licensed 1:24 scale vehicles, *Binaltech*, ran from 2003 through 2006. Meanwhile, a catchall line called *Universe* kicked off in 2003, consisting of recolored existing toys. These lines also used original comic-style illustrations on their packaging.

The next sea change took place in 2007, a huge year for the brand. The live-action film franchise launched and was, naturally, supported by toys. The films and their accompanying toy line continue to run to this day. Interestingly, movie toy packaging tends to use existing art assets rather than create new ones. The first two films tended to use close-up shots of the robots' heads, and the third, *Dark of the Moon*, a render of the vehicle

"TRANSFORMS FROM RACE CAR TO ROBOT AND BACK!"

mode. It was not until film four, *Age of Extinction,* that action shots of the robots returned.

The success of the films meant that Transformers was bigger than ever. It was now common for there to be as many as four concurrent lines, depending on how one chooses to count. From 2007 through the present, there is typically the ongoing film line, a line targeting G1 collectors, a line targeting preschool-age children, and the primary line, which is generally supported by a cartoon. The G1 lines (including *Classics*, a new *Universe* line, *Generations*, the *Prime Wars* trilogy, the *War for Cybertron* trilogy, and more) tend to feature new, comic-style art.

Most of the primary lines (*Transformers Animated*, *Transformers Prime*, *Robots in Disguise*, and *Cyberverse*) used style guide artwork to decorate their boxes and cards. A notable exception is *Transformers Animated* (2007–2009), which used a mix of existing style-guide imagery and newly commissioned artwork.

Not all of the toy art is printed on the package itself. Several G1 toys were packaged with flyers advertising mail-away toys or promotional posters, often featuring beautiful paintings. *Armada* introduced the idea of packing collector cards in with the toys, a practice that would be used off and on across multiple modern toy lines.

It's amazing, with thirty-five years of hindsight, to see just how varied and creative the art of Transformers toys has been. From pencil and ink to computer generated designs, from airbrushed paint to digital coloring, from cartoonish whimsy to grimdark devastation, Transformers toys have been adorned with fantastical imagery of a plethora of styles. One can only imagine what future decades will mean to the brand.

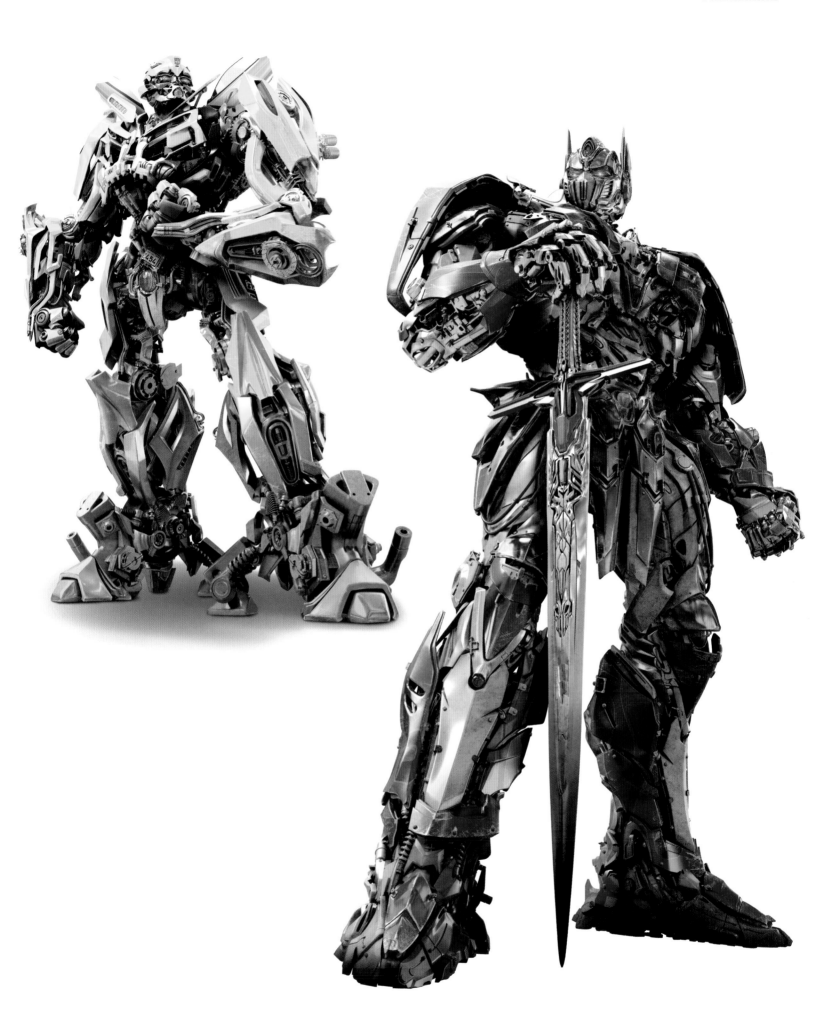

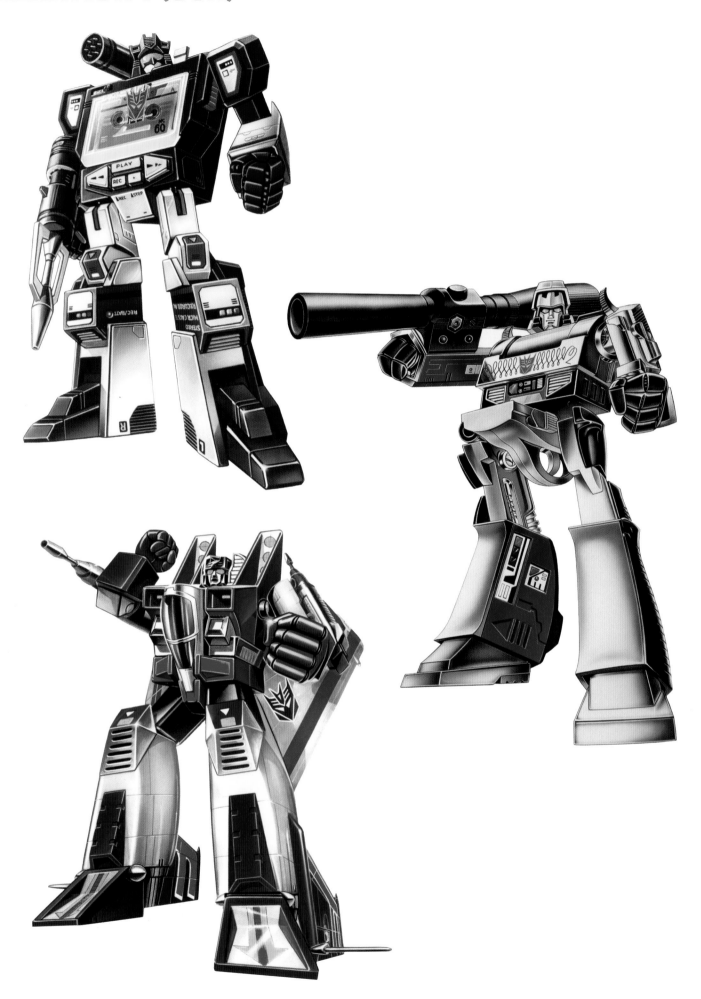

From top: Package art, Soundwave, Megatron, Starscream, Generation 1

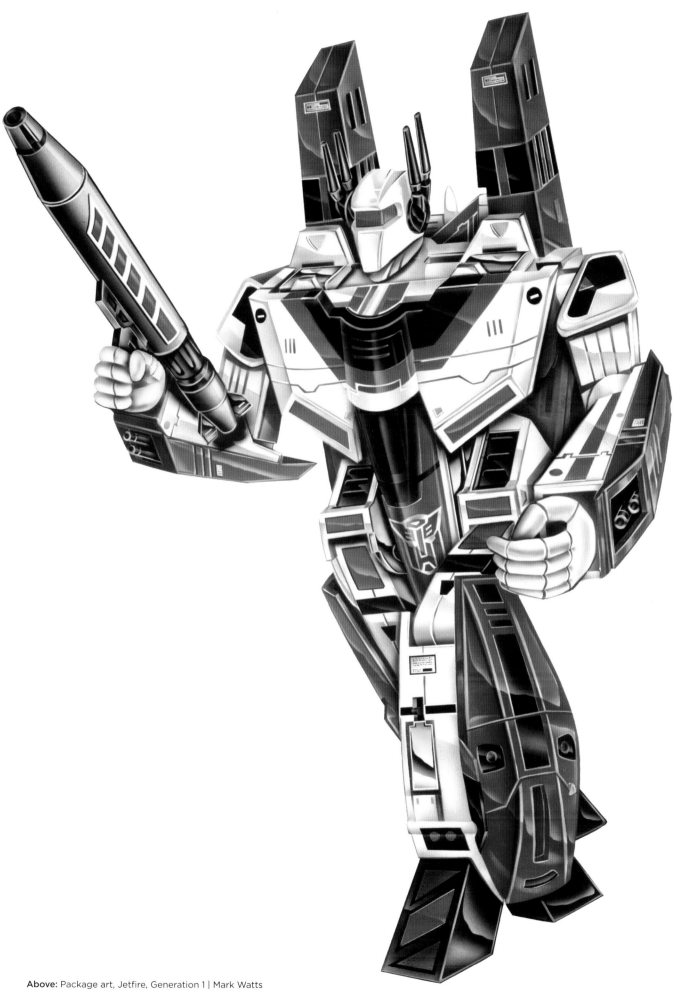

Above: Package art, Jetfire, Generation 1 | Mark Watts

"Jetfire was created after I had already done about fifteen Transformers boxes and blister packs. It was created entirely with an airbrush using acrylic paint, with cut frisket. Very little brush work. You never know when a line will take off, like Transformers did, and become such a sensation." — Mark Watts

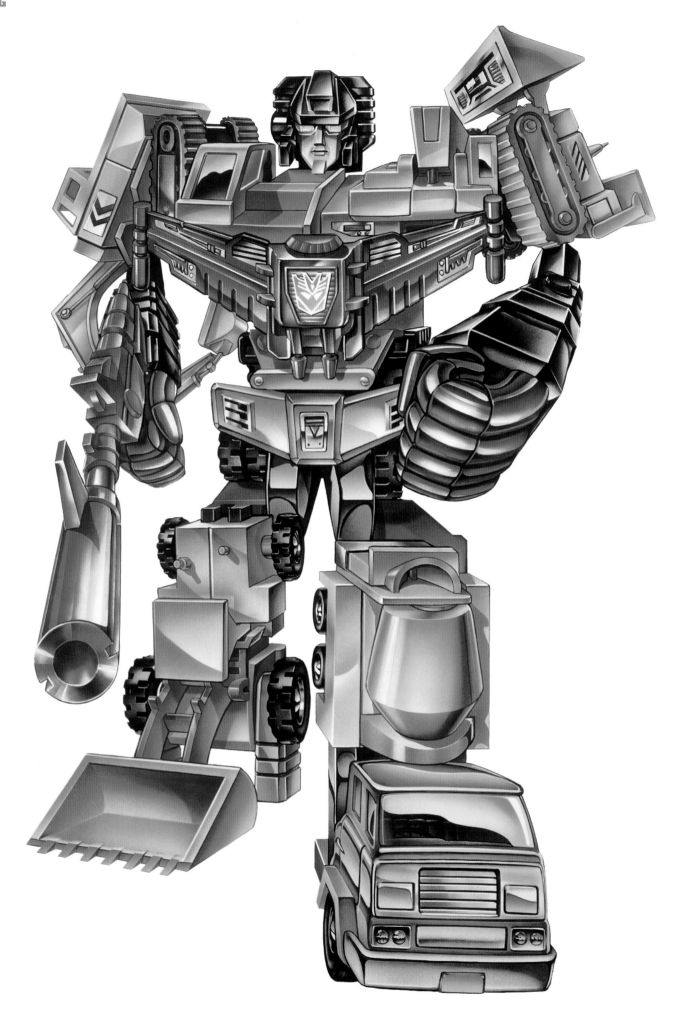

Above: Package art, Devastator, Generation 1

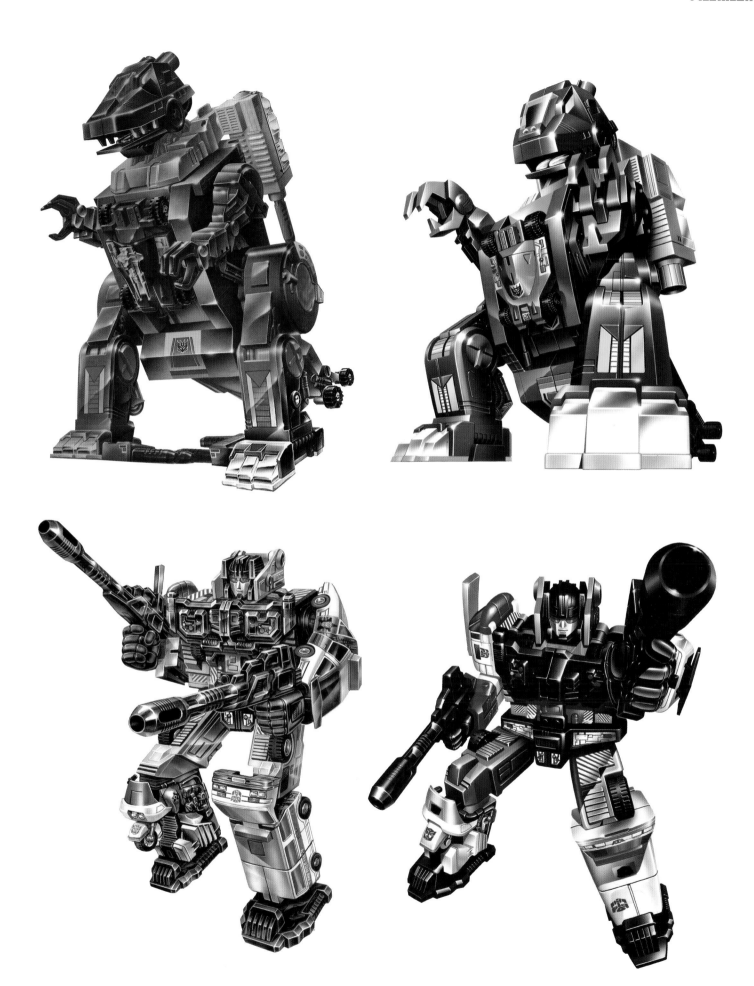

Top: Package art, Trypticon (United States), Trypticon (Japan), Generation 1

Above: Package art, Defensor (Japan), Defensor (United States), Generation 1

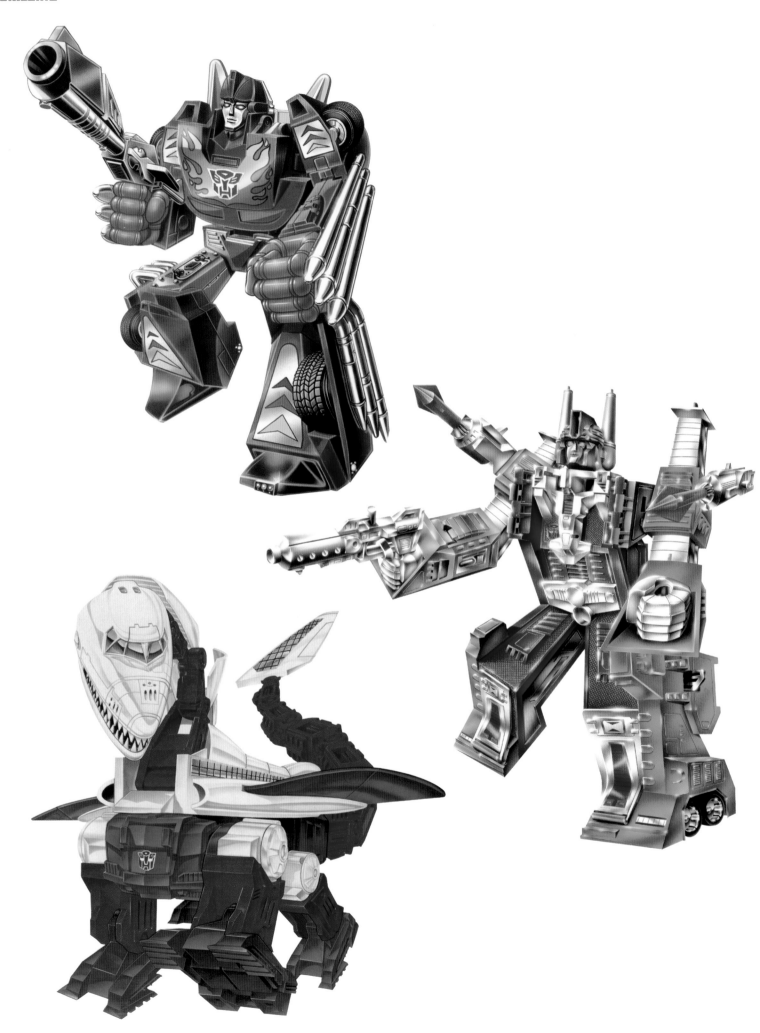

Clockwise from top: Package art, Hot Rod, Ultra Magnus, Skylinx, Generation 1

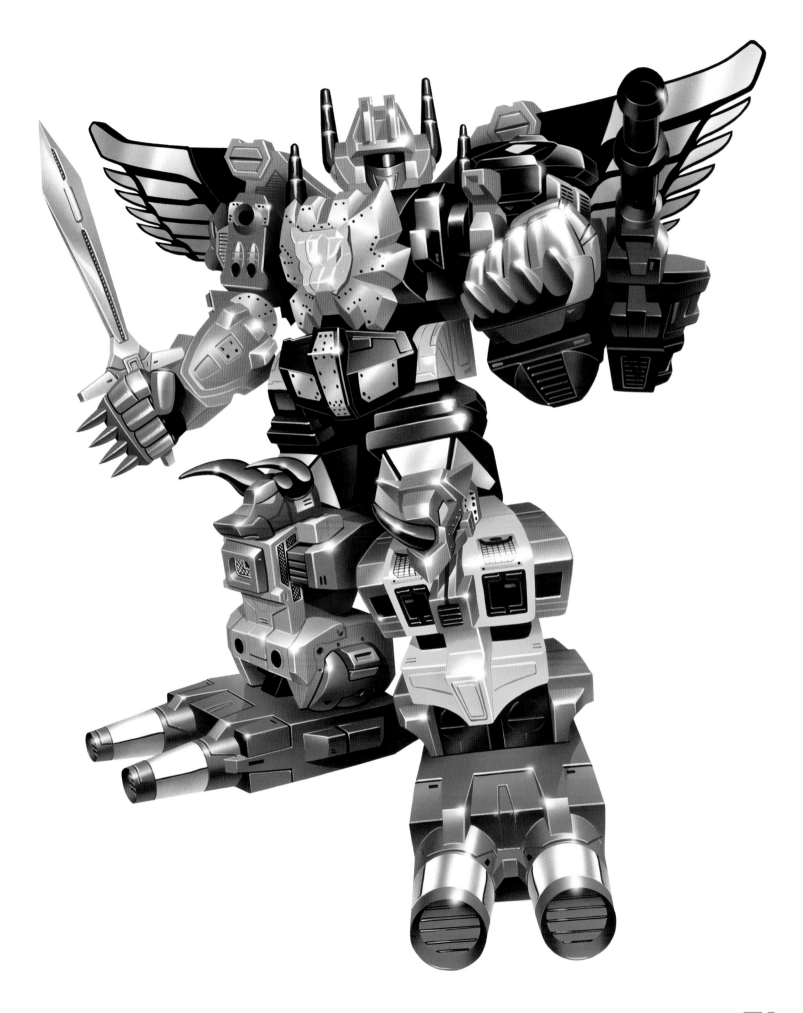

Above: Package art, Predaking, Generation 1

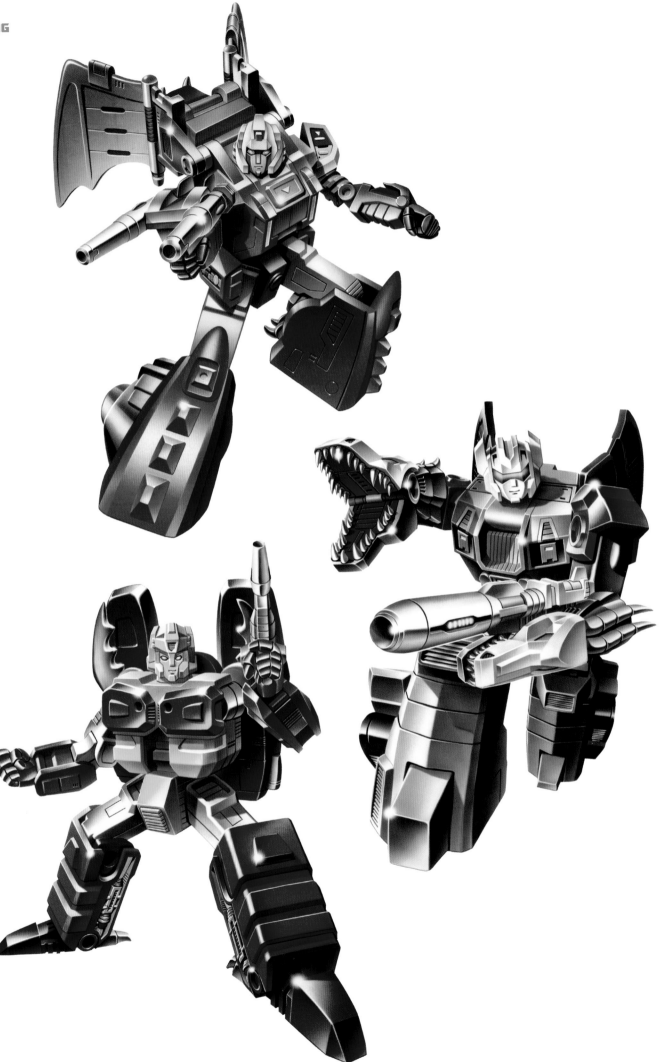

Clockwise from top: Package art, Grotusque, Doublecross, Repugnus, Generation 1

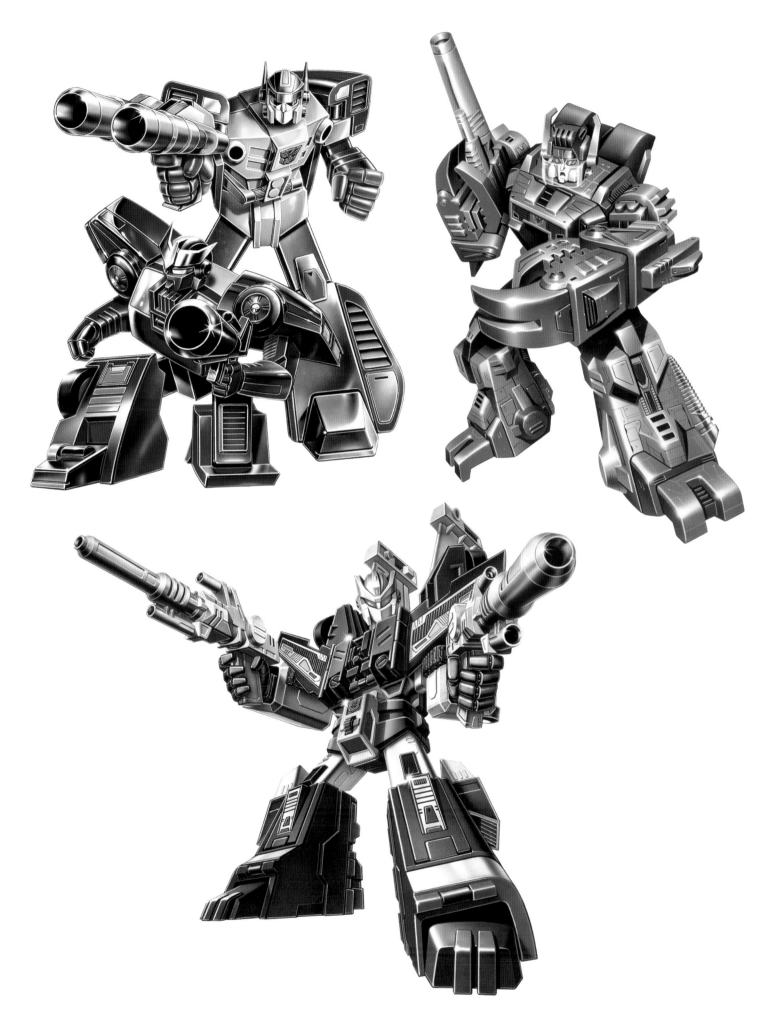

Clockwise from top: Package art, Punch/Counterpunch, Scorponok, Sixshot, Generation 1

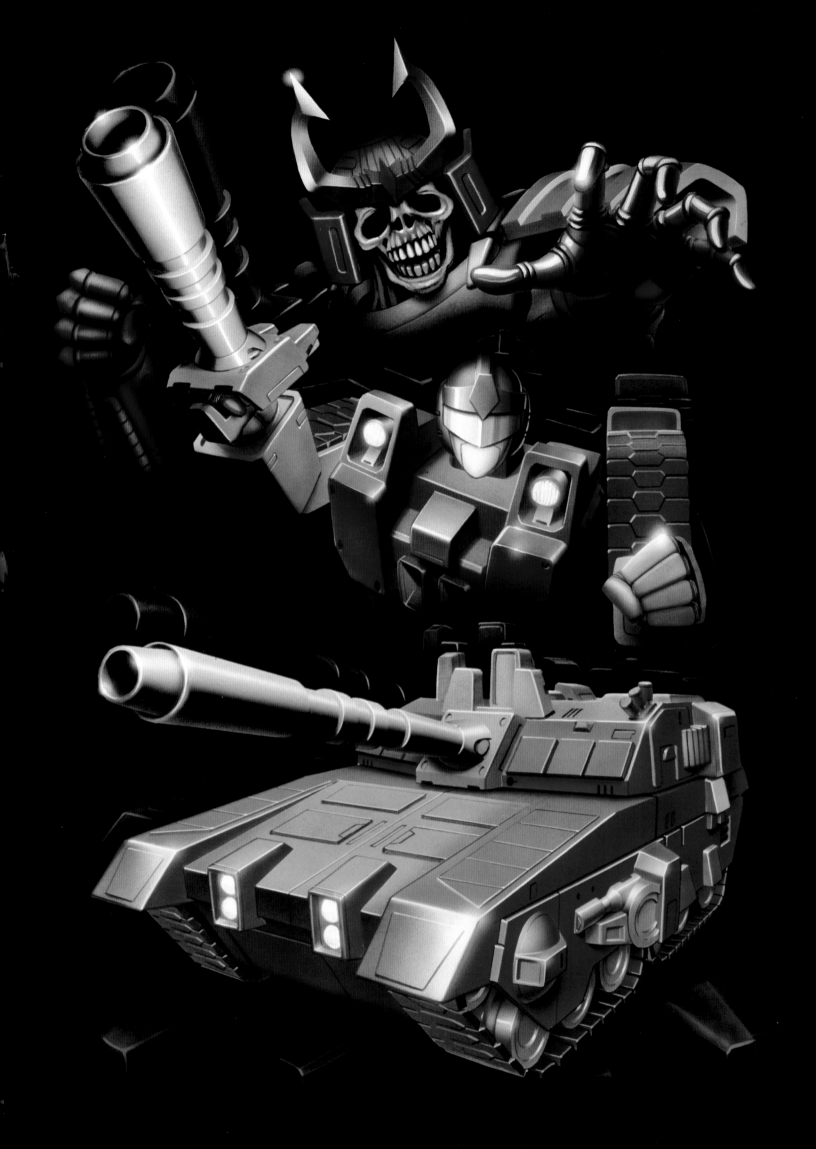

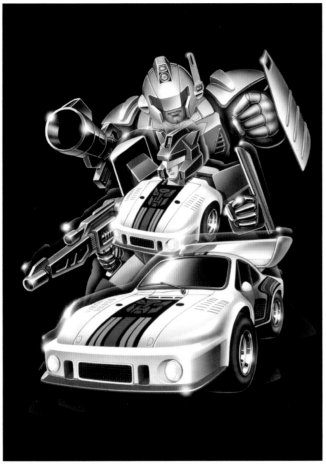

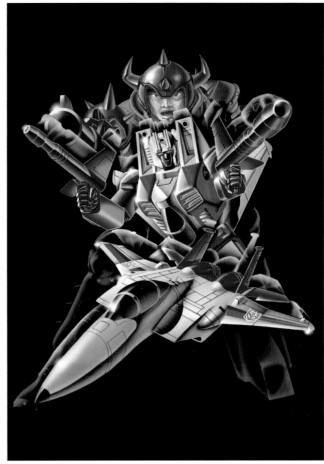

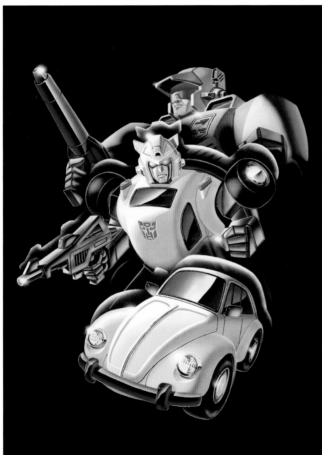

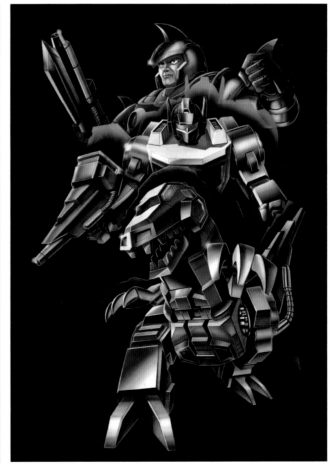

Opposite: Package art, Bludgeon, Generation 1

Clockwise from top left: Package art, Pretenders Jazz, Starscream, Grimlock, Bumblebee, Generation 1

Volkswagen trademarks, design patents, and copyrights are used with the approval of the owner Volkswagen AG.

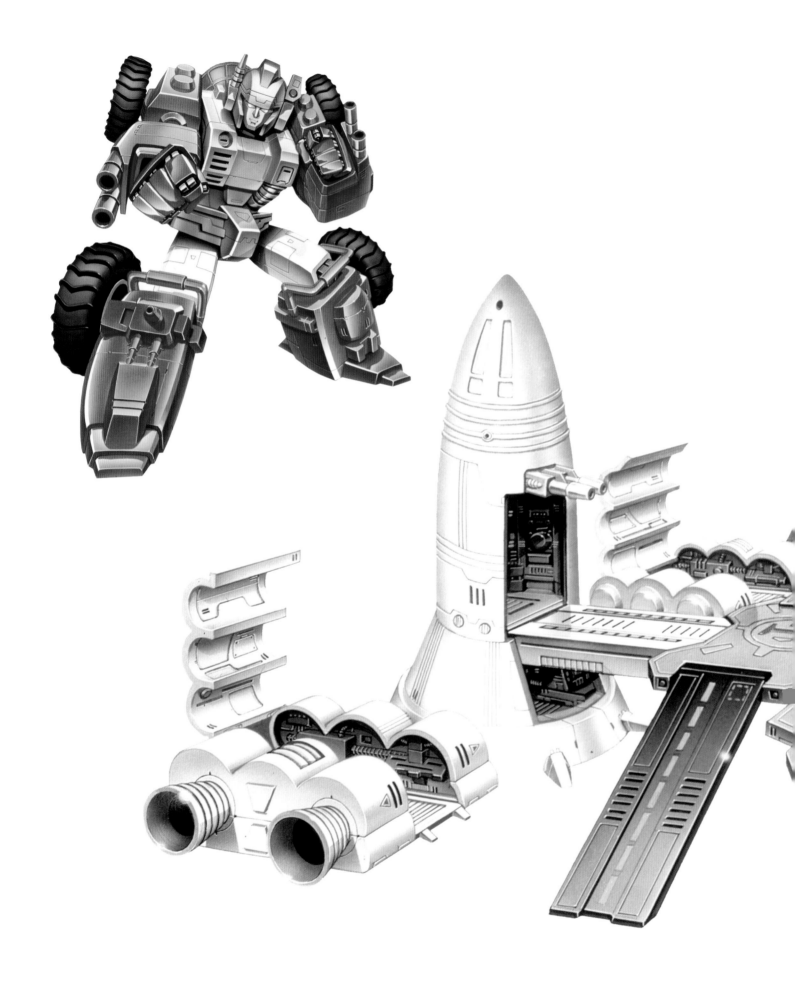

Above: Package art, Countdown (with base), Generation 1

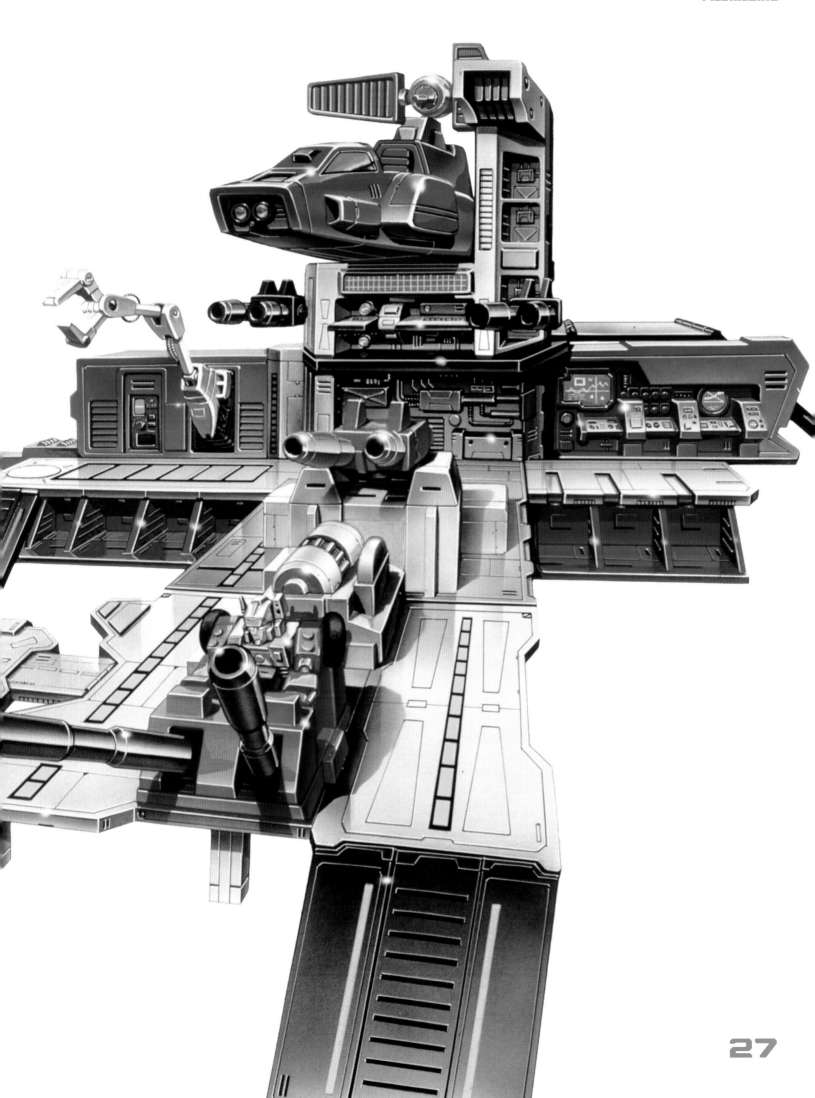

Above: Package art, Ultra Pretender mural featuring Skyhammer and Roadblock, Generation 1 | Richard Marcej

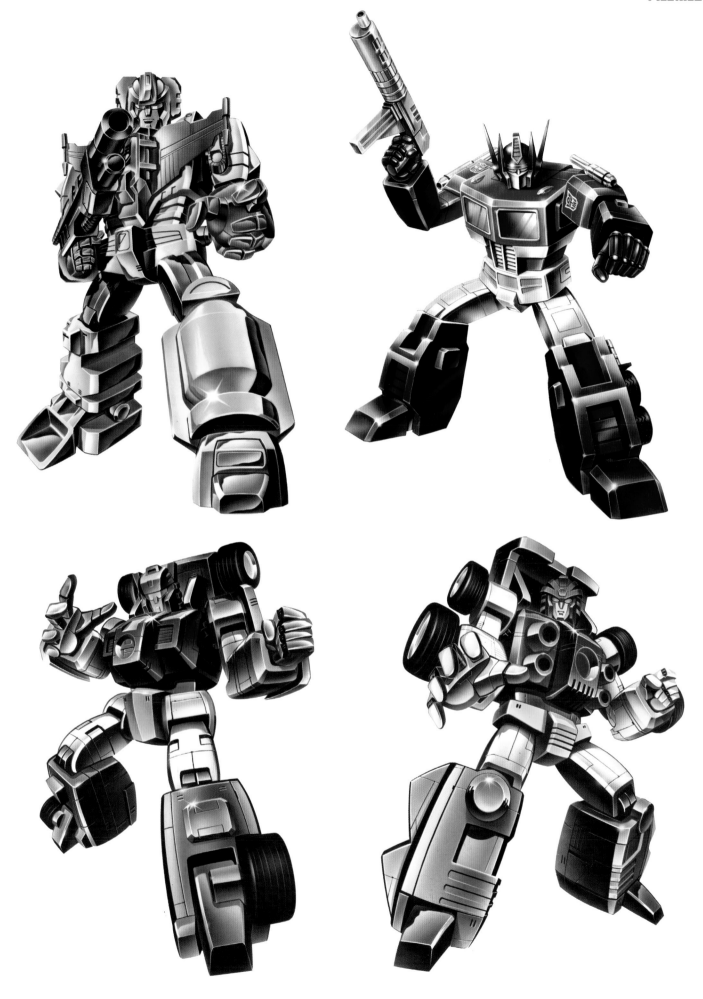

Clockwise from top left: Package art, Action Master Devastator, Action Master Optimus Prime, Full-Barrel (unused), Overflow (unused), Generation 1

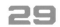

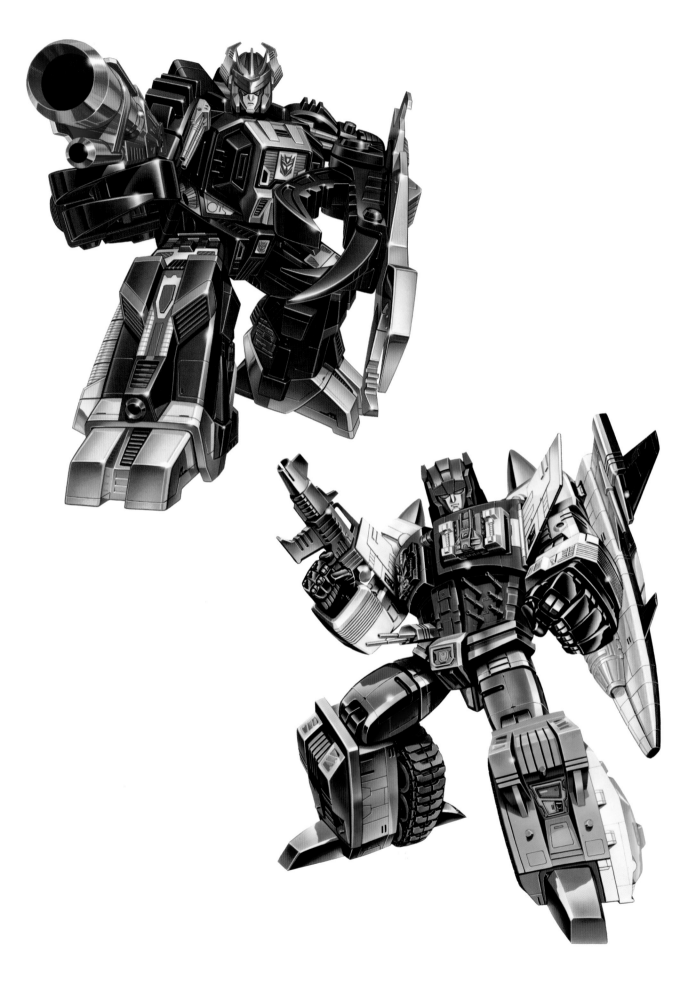

From top: Package art, Black Zarak, Overlord, Generation 1 (Japan)

Opposite: Package art, Metalhawk, Generation 1 (Japan)

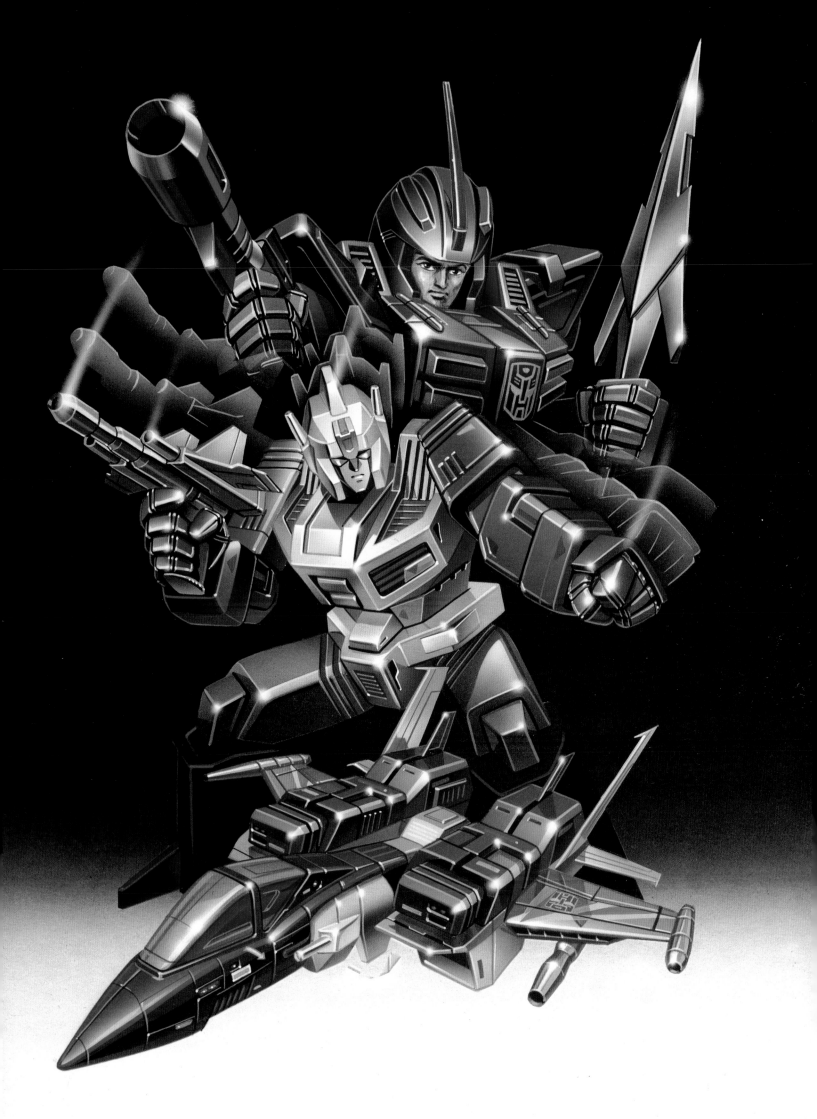

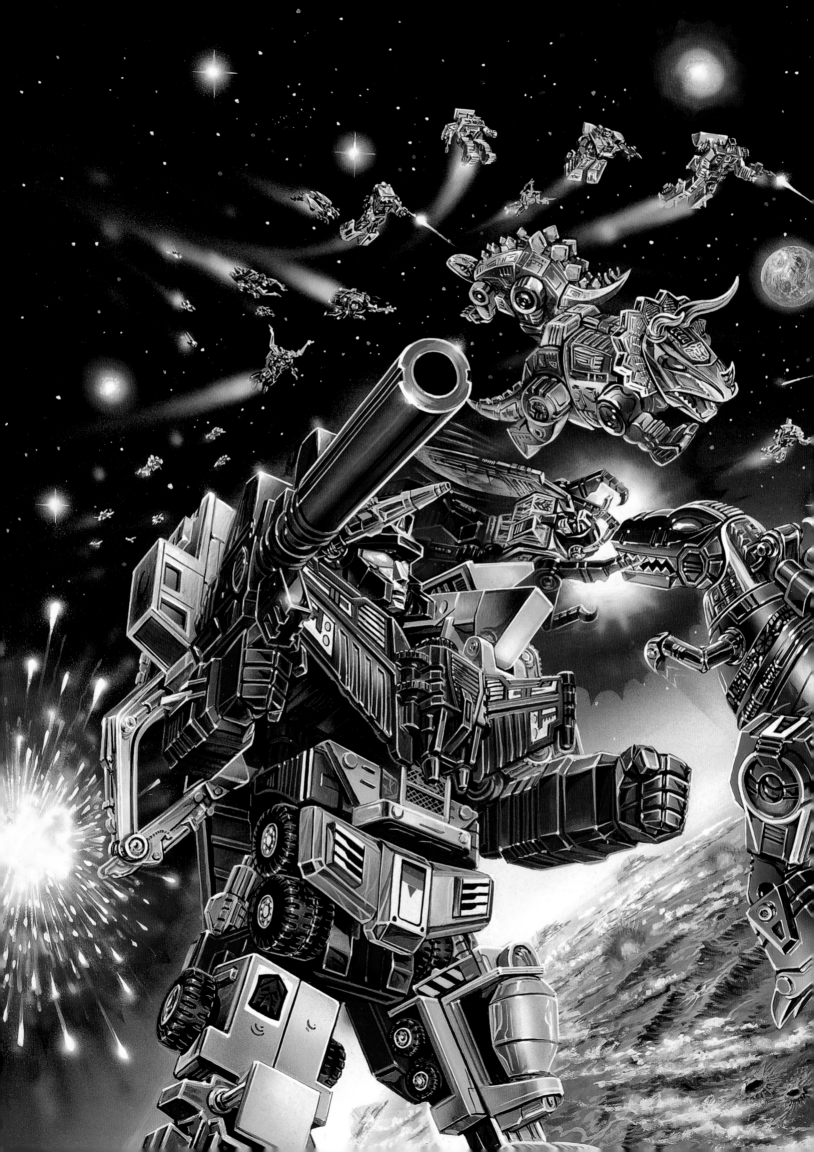

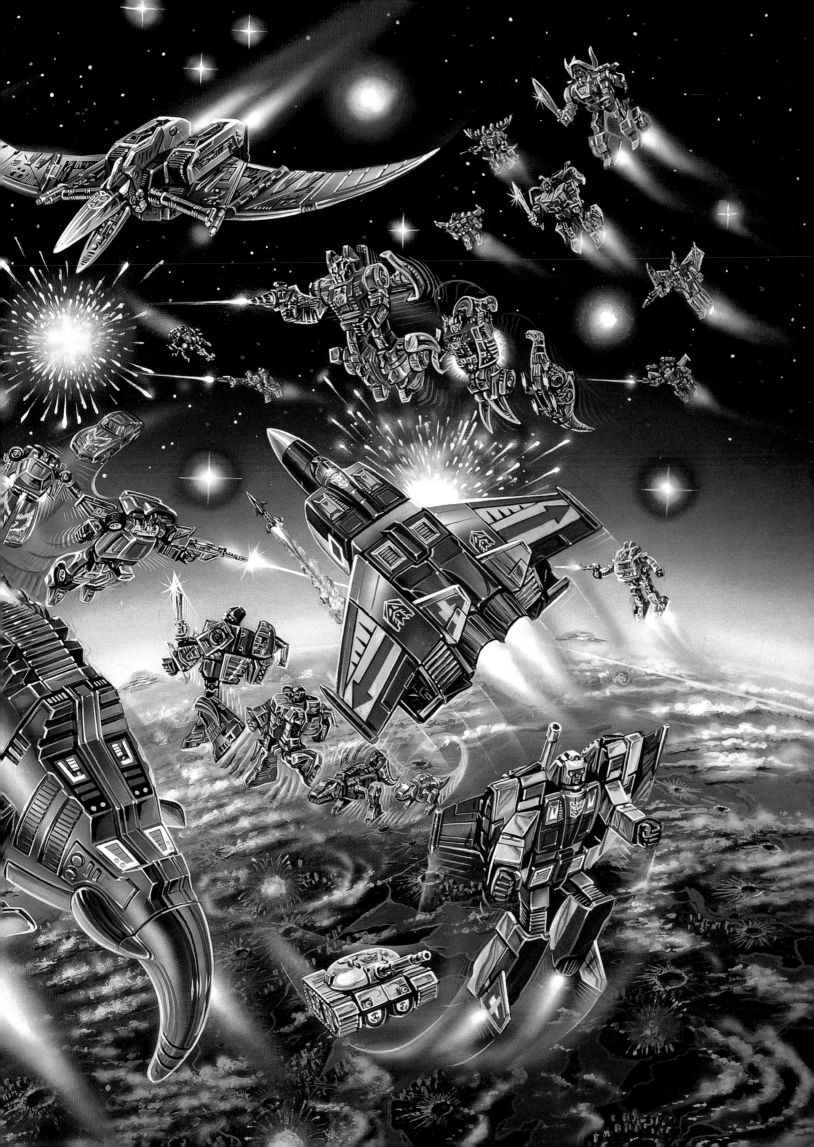

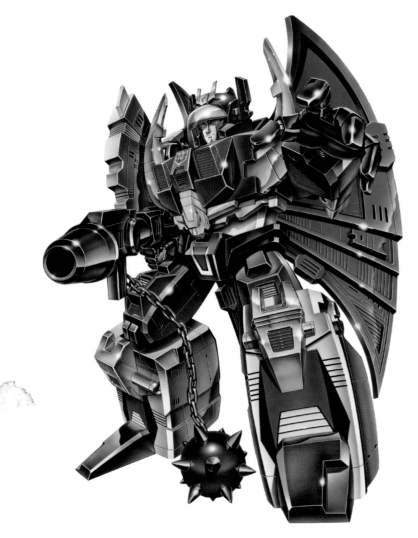

Previous: Package art, 1985 mural, Generation 1 (Japan)

From top: Package art, Deathsaurus, Liokaiser, Generation 1 (Japan)

Opposite: Package art, Star Convoy, Generation 1 (Japan)

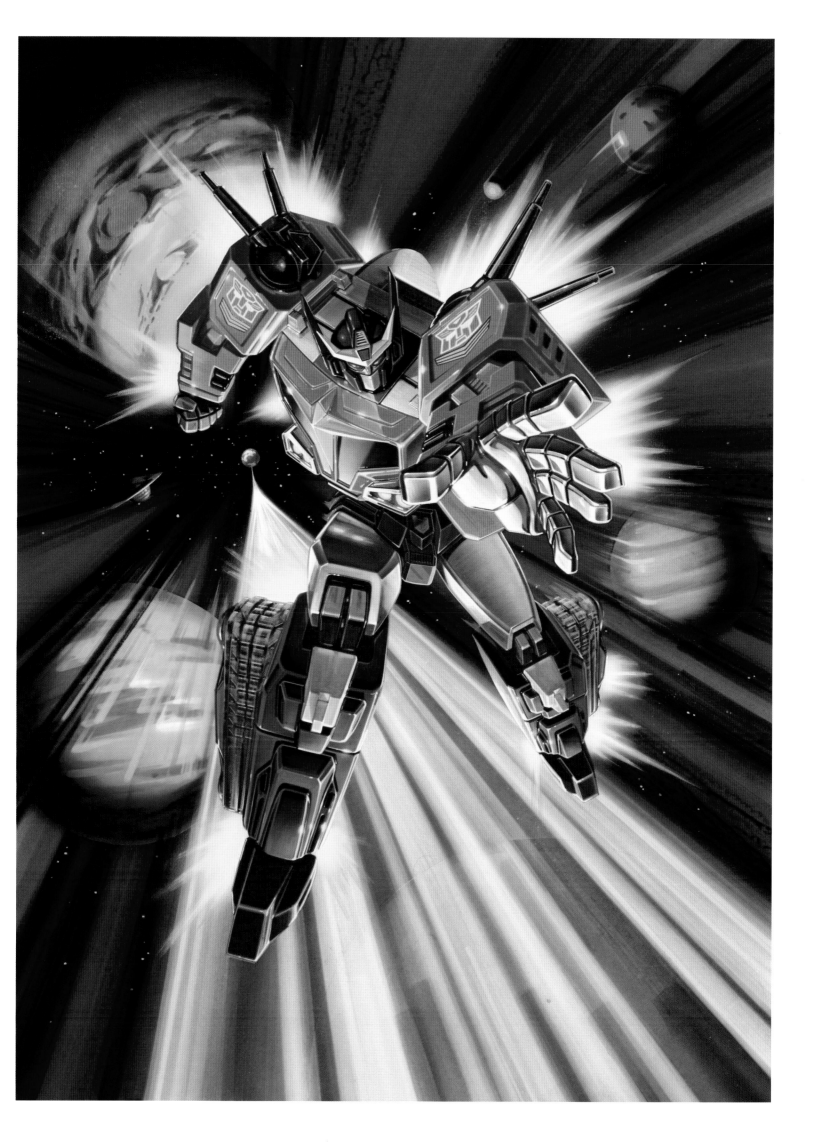

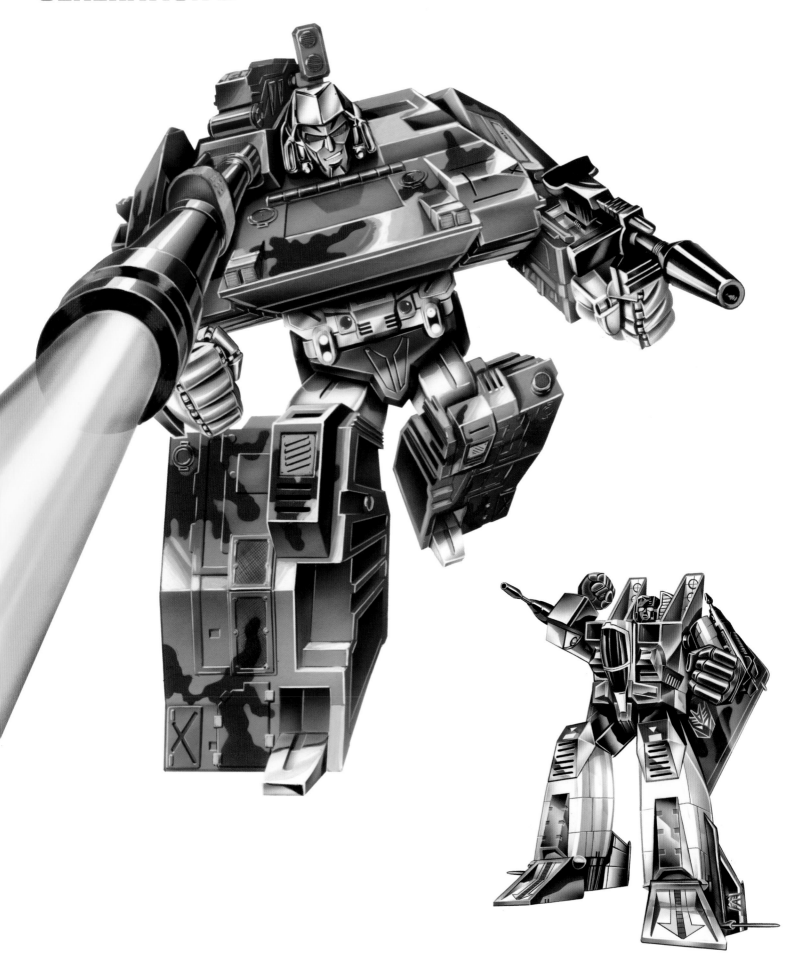

From top: Package art, Megatron, Starscream, Generation 2

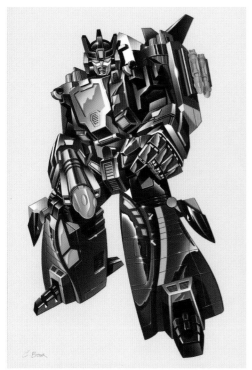

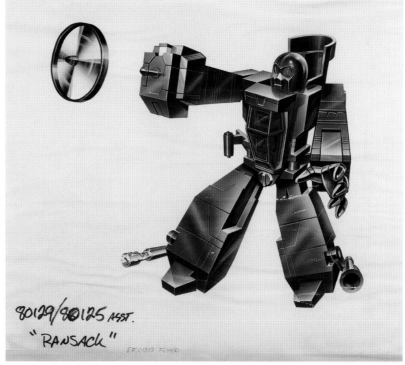

80129/80125 ASST.
"RANSACK"

EX0X01353 FC4/01

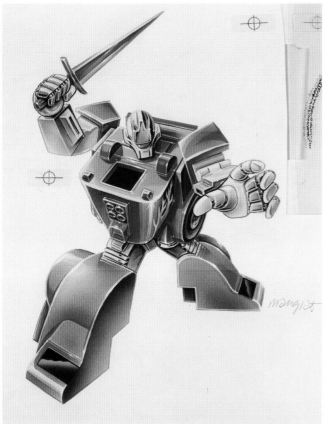

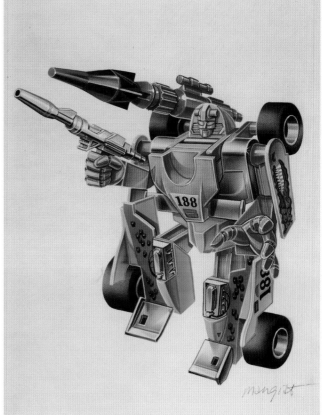

Clockwise from top left: Package art, Skyquake (Europe), Ransack, Mirage (unused), Volt, Generation 2

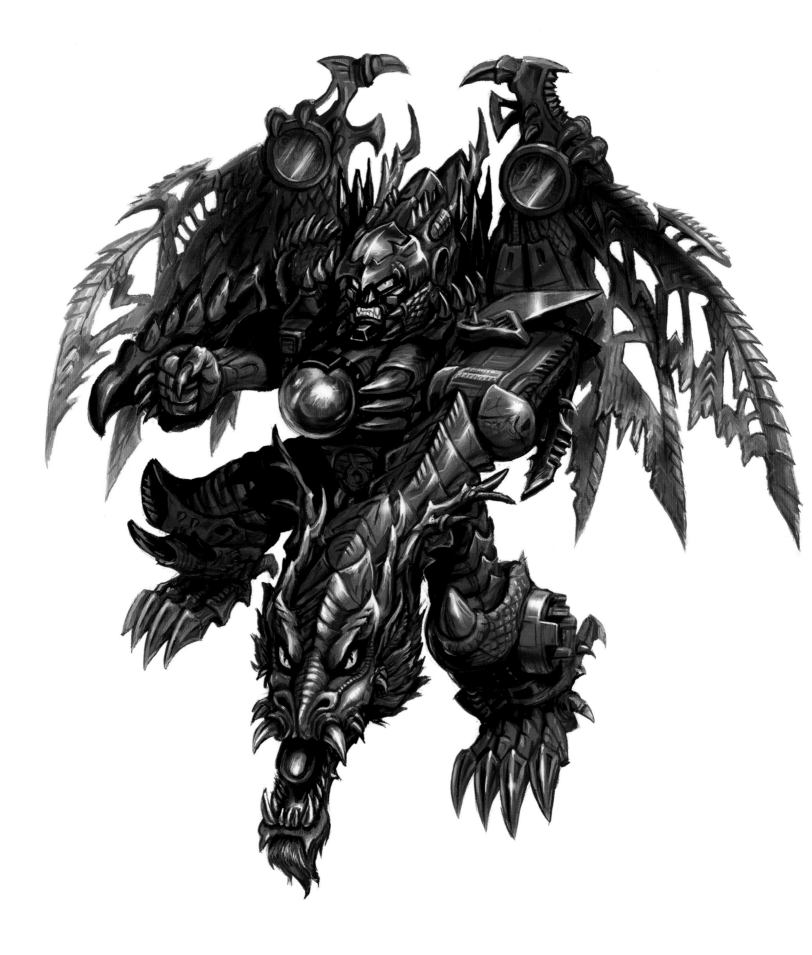

Above: Package art, Transmetals 2 Megatron, *Beast Wars* | Doug Hart

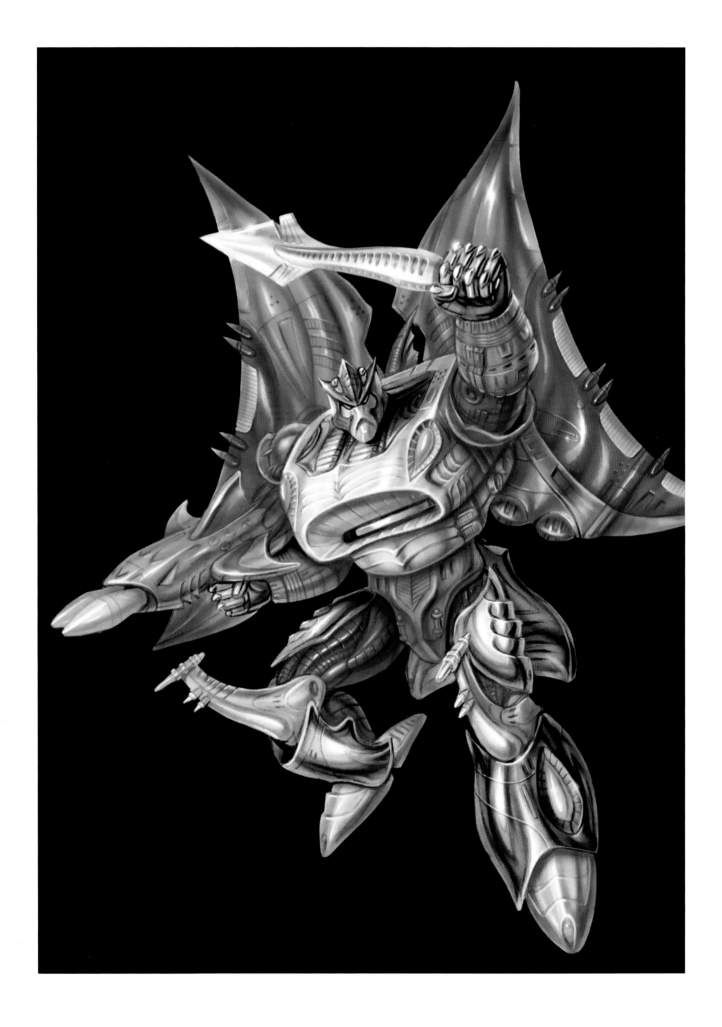

Above: Package art, Depth Charge, *Beast Wars* | Doug Hart

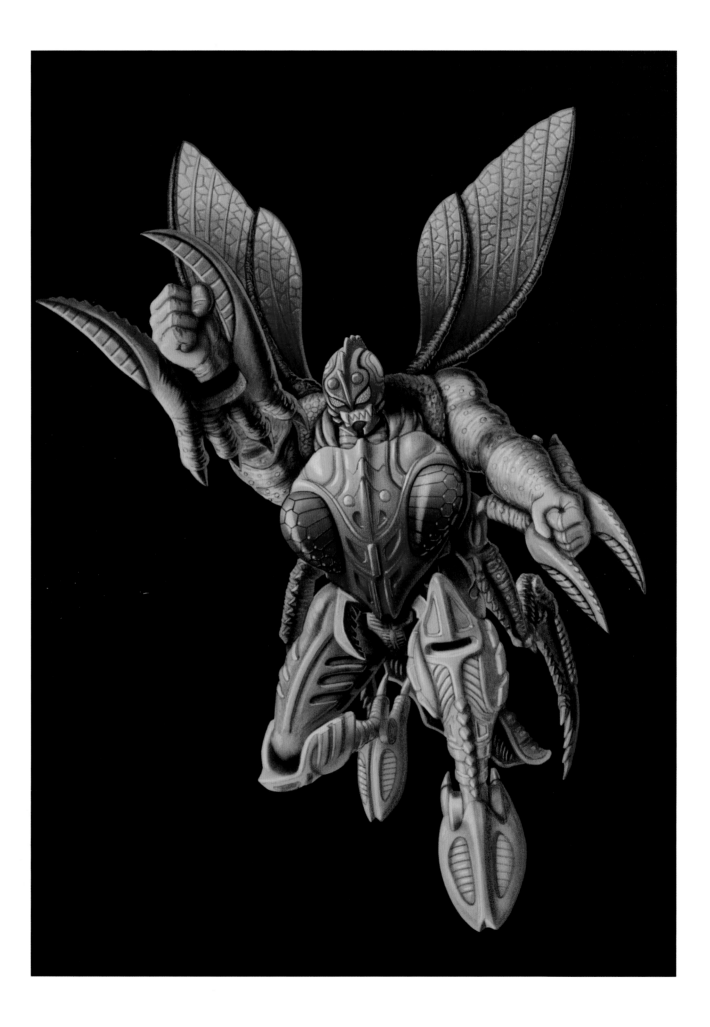

Above: Package art, Buzzclaw, *Beast Wars* | Doug Hart

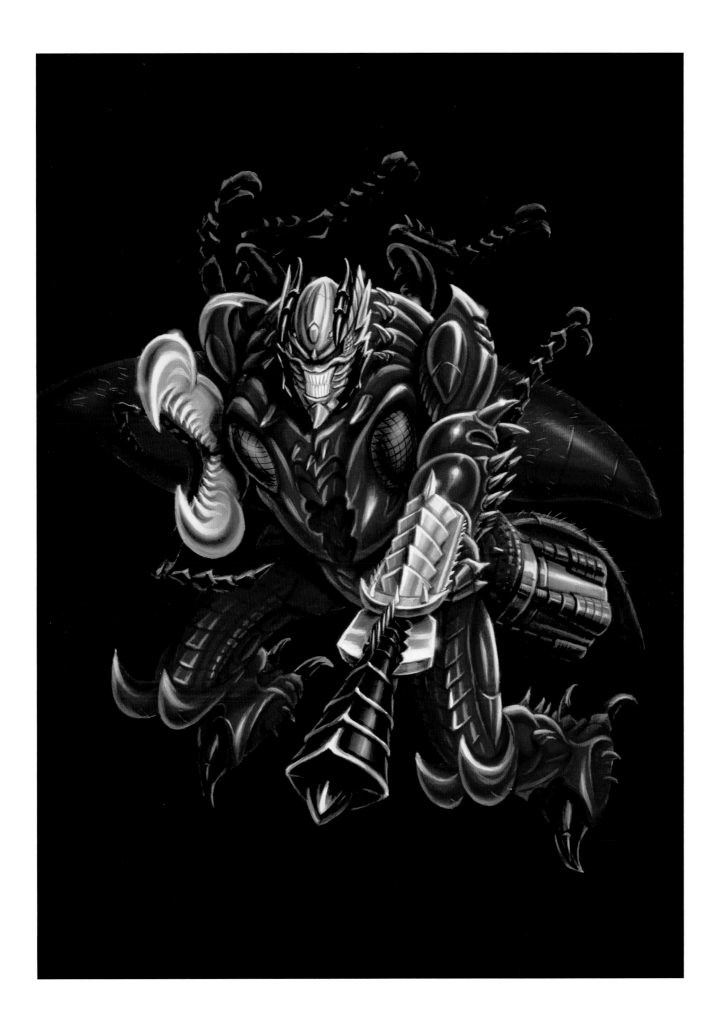

Above: Package art, Inferno, *Beast Wars* | Doug Hart

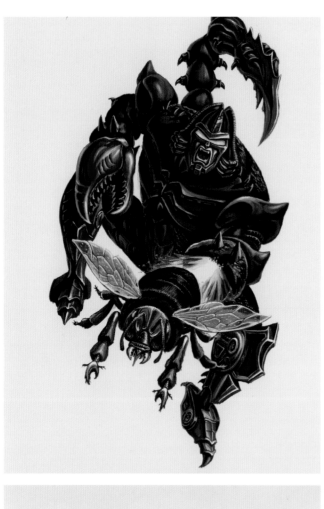

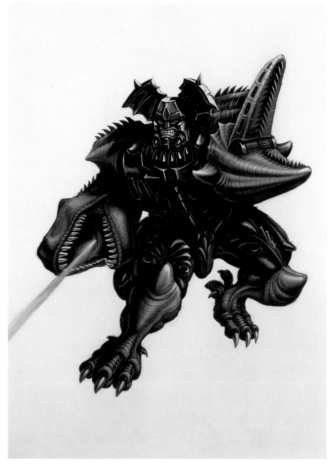

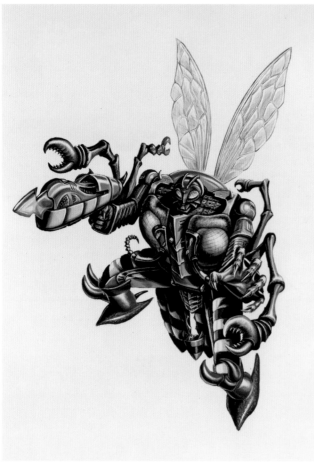

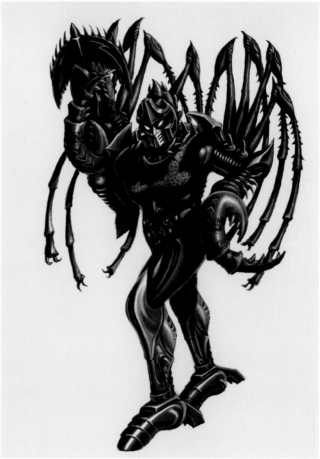

Clockwise from top left: Package art, Scorponok, Megatron, Blackarachnia, Waspinator, *Beast Wars* | Doug Hart

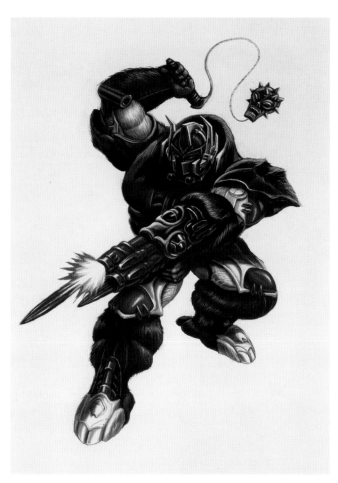
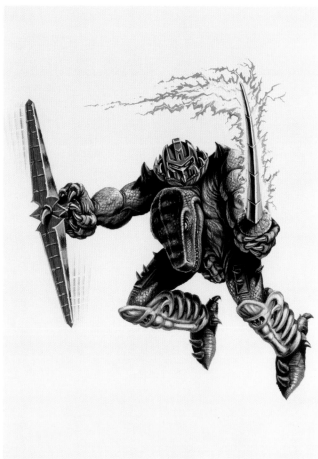
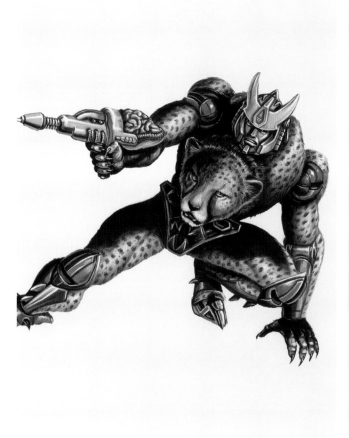

Clockwise from top left: Package art, Optimus Primal, Dinobot, Tigatron, Cheetor, *Beast Wars* | Doug Hart

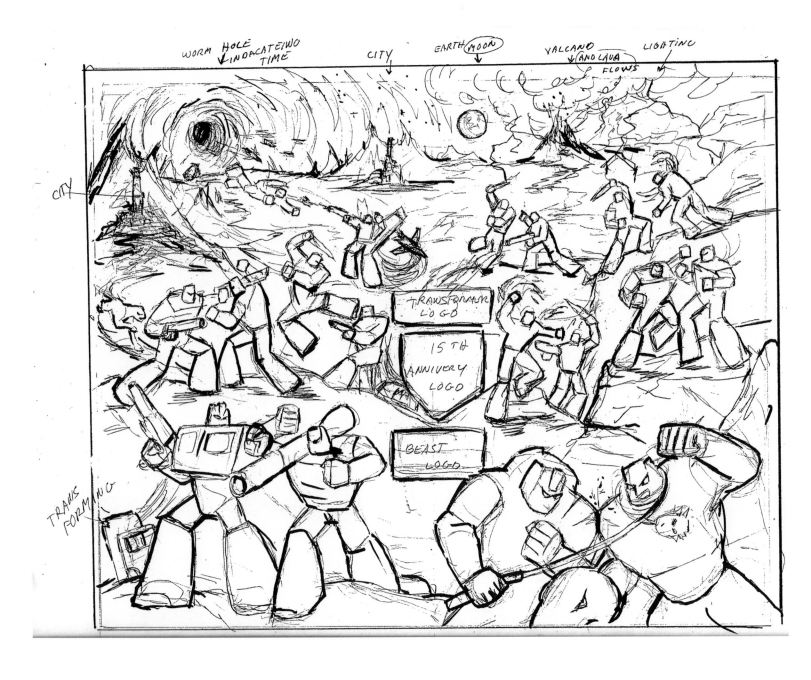

Above: Concept art, Transformers 15th Anniversary Box Set (unproduced) | Doug Hart

"I illustrated all the package art for *Beast Wars*. The art direction was different from Generation 1; not so much airbrush and more painterly, so I worked in gouache. To convey the beast aspect, I gave them more aggressive poses and a little fur and scales. Other than that, not so different. They were still metal robots. I loved working on *Beast Wars*!" — Doug Hart

Above: Package art, Spittor, *Beast Wars* | Doug Hart

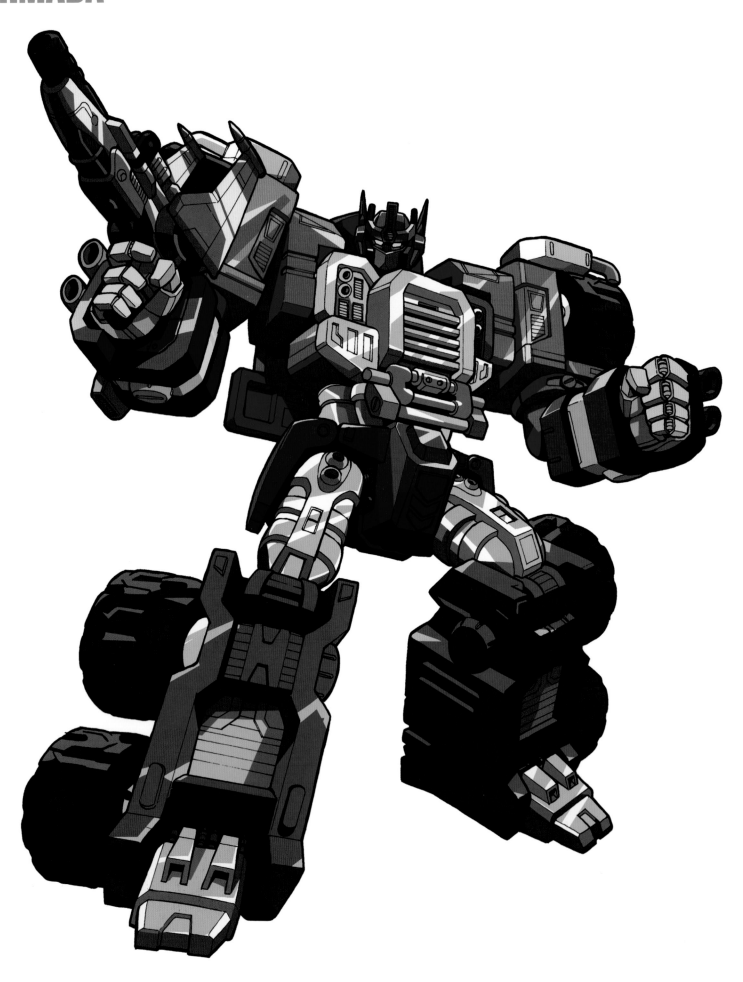

Above: Package art, Optimus Prime, *Transformers: Armada* | Guido Guidi

47

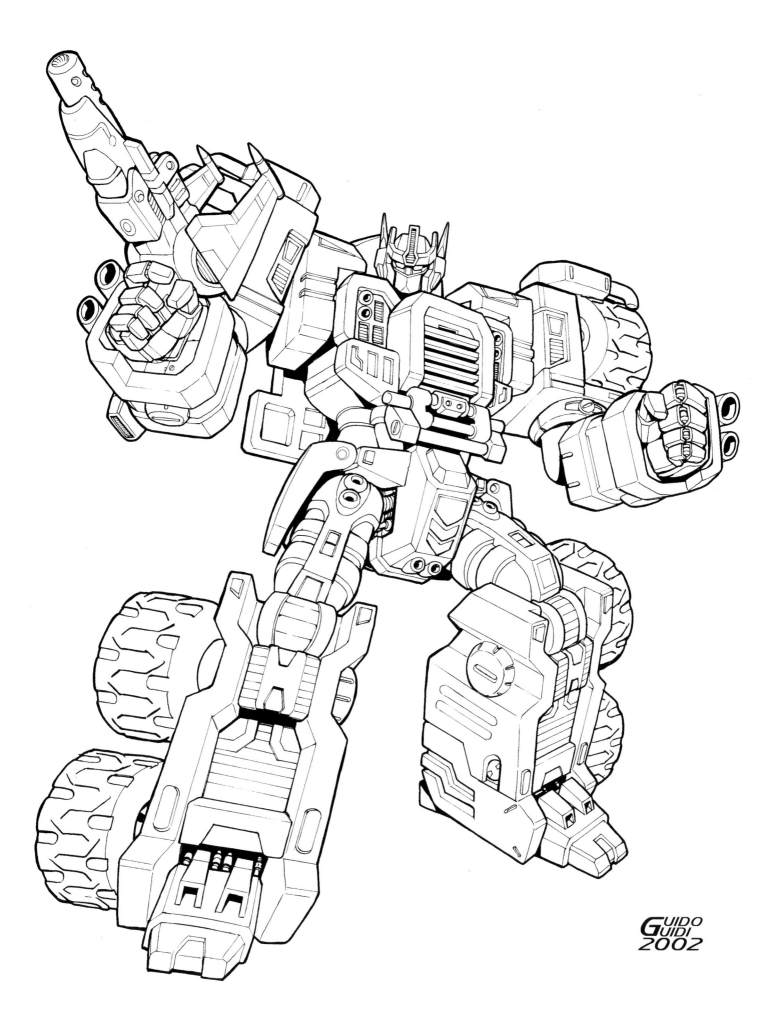

Above: Line art, Optimus Prime, *Transformers: Armada* | Guido Guidi

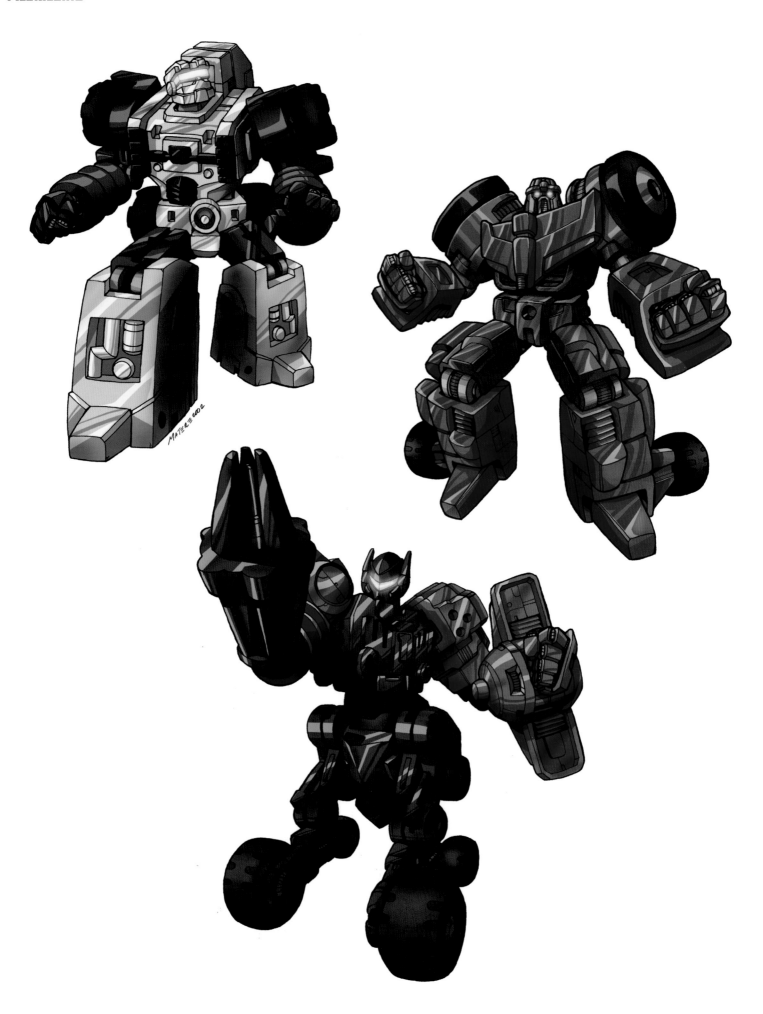

Clockwise from top: Package art, Leader-1, Swindle, Comettor, *Transformers: Armada* | Marcelo Matere

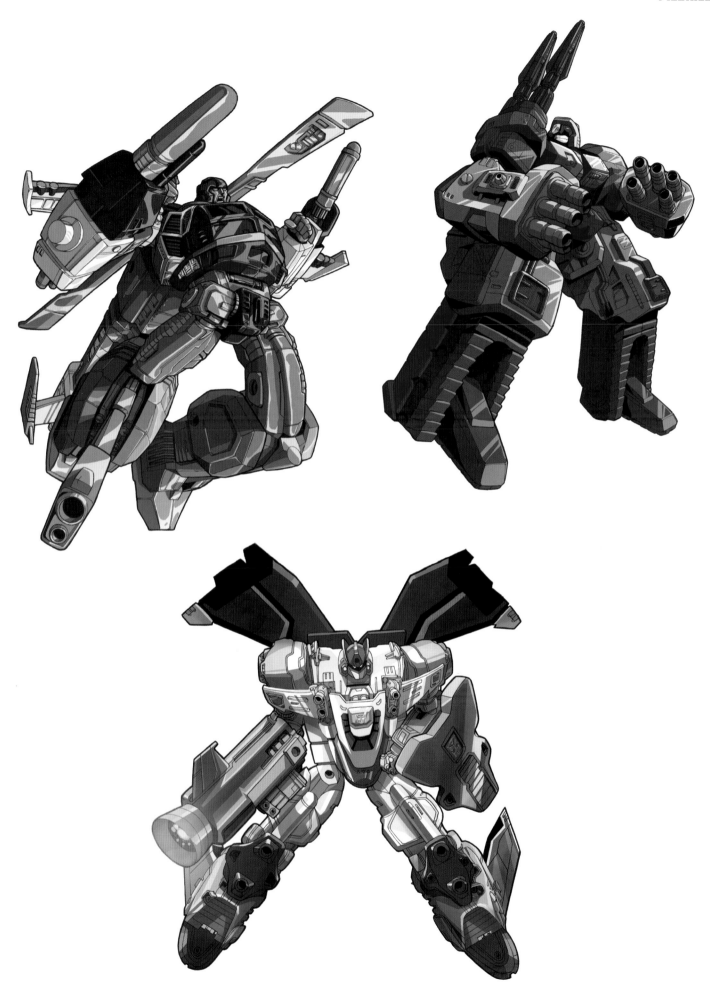

Clockwise from top: Package art, Cyclonus, Demolishor, Jetfire, *Transformers: Armada*

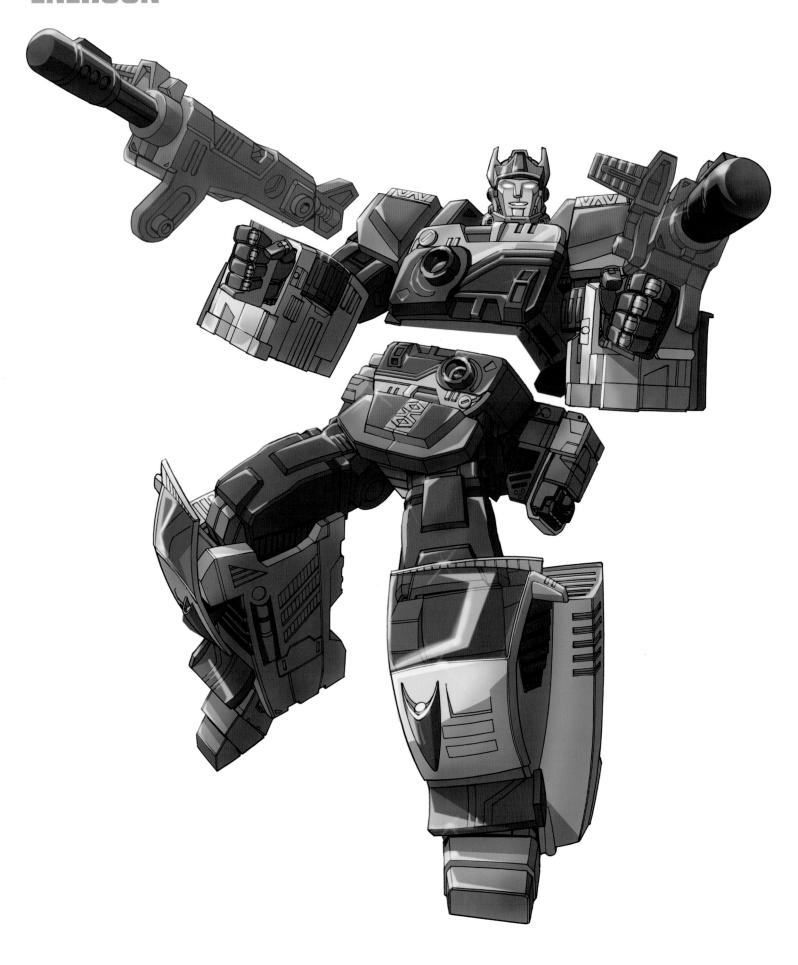

Above: Powerlinx "Spark of Combination" concept art, Hot Shot, *Transformers: Energon*

Note: Transformers: Energon figures were designed so that any toy could be the top half or the bottom half of any robot, hence the separation in their art.

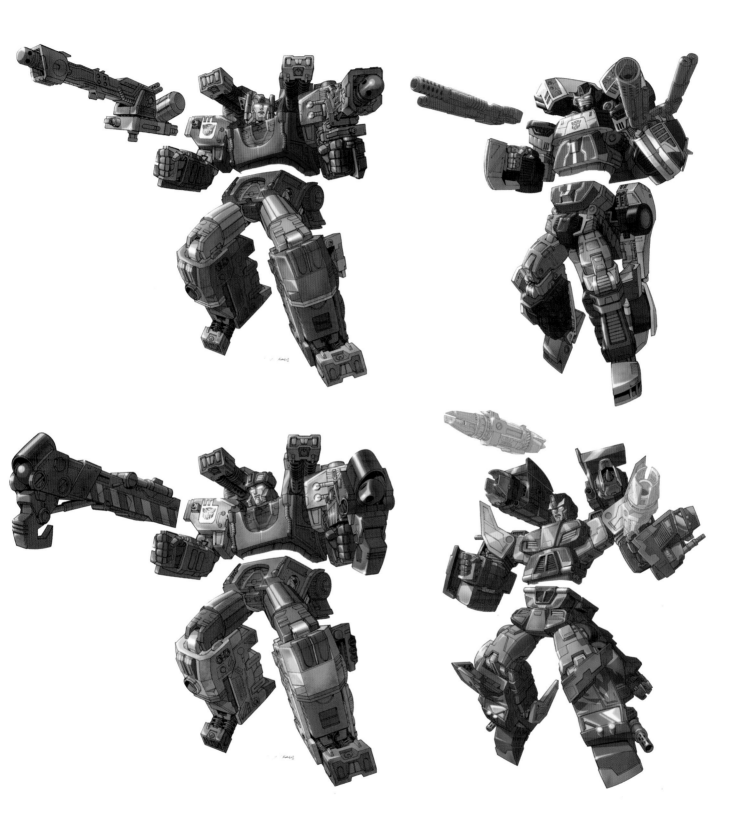

Clockwise from top left: Powerlinx "Spark of Combination" concept art, Inferno, Downshift, Rodimus, Roadblock, *Transformers: Energon*

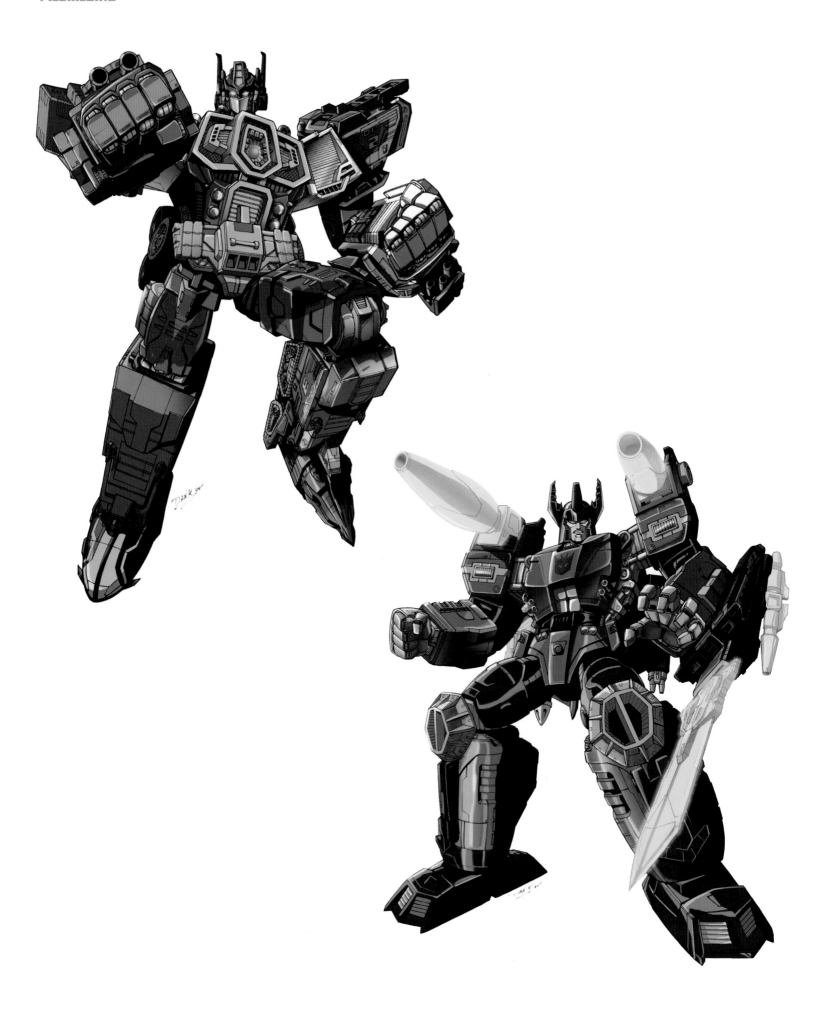

Clockwise from top: Package art (unused color variations), Optimus Prime, Megatron, *Transformers: Energon*

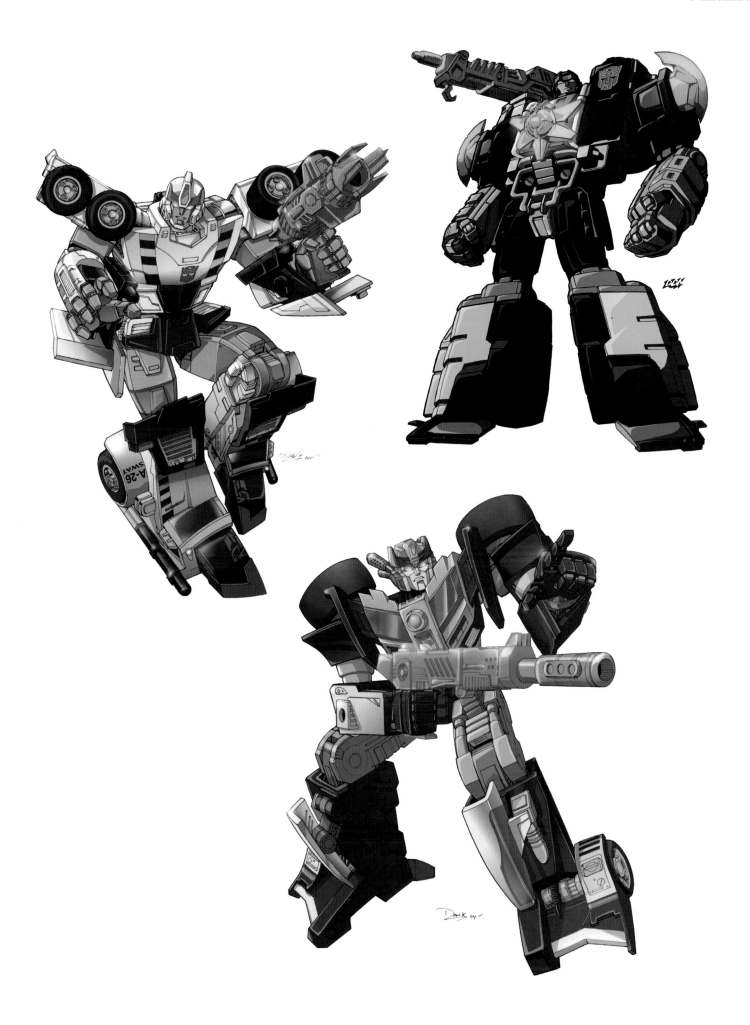

Clockwise from top: Package art, Strongarm, Prowl, Checkpoint, *Transformers: Energon*

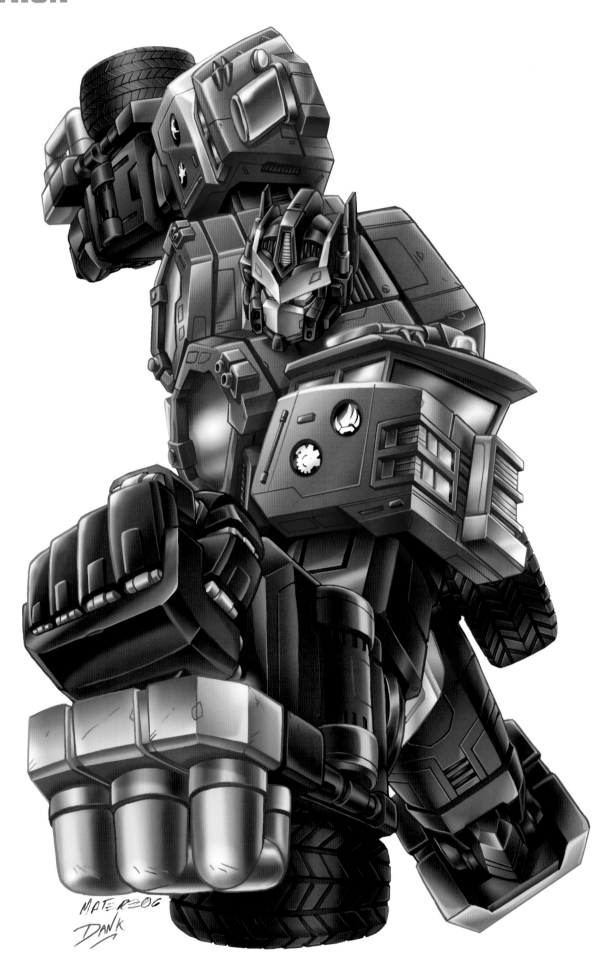

Above: Package art, Optimus Prime, *Transformers: Cybertron* | Marcelo Matere & Dan Khanna

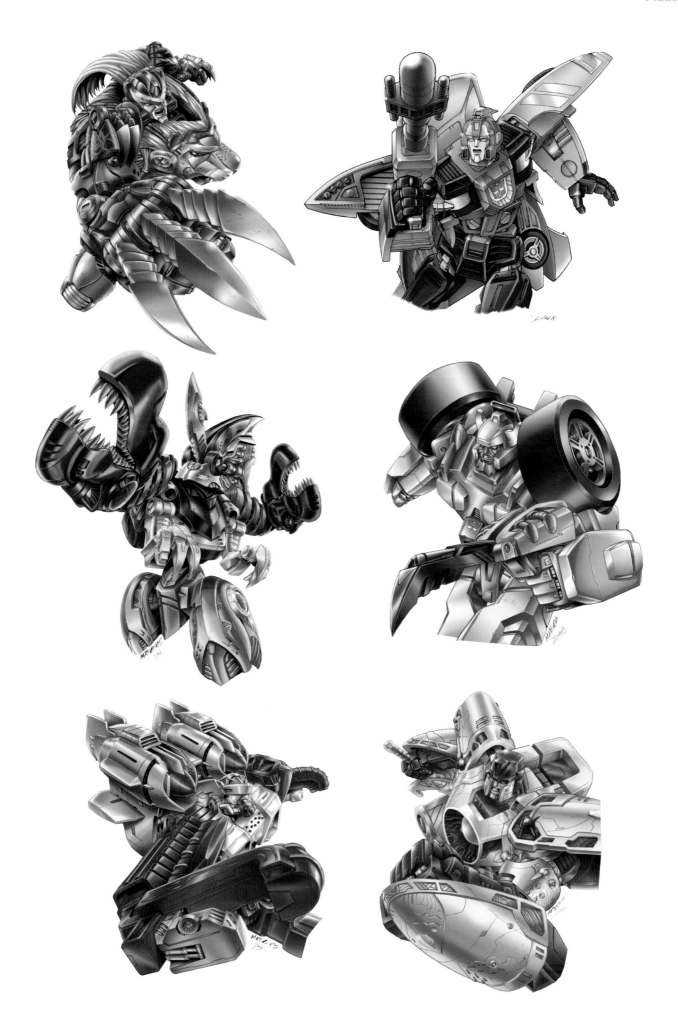

Clockwise from top left: Package art, Nemesis Breaker, Blurr, Brakedown, Vector Prime, Shortround, Repugnus, *Transformers: Cybertron*

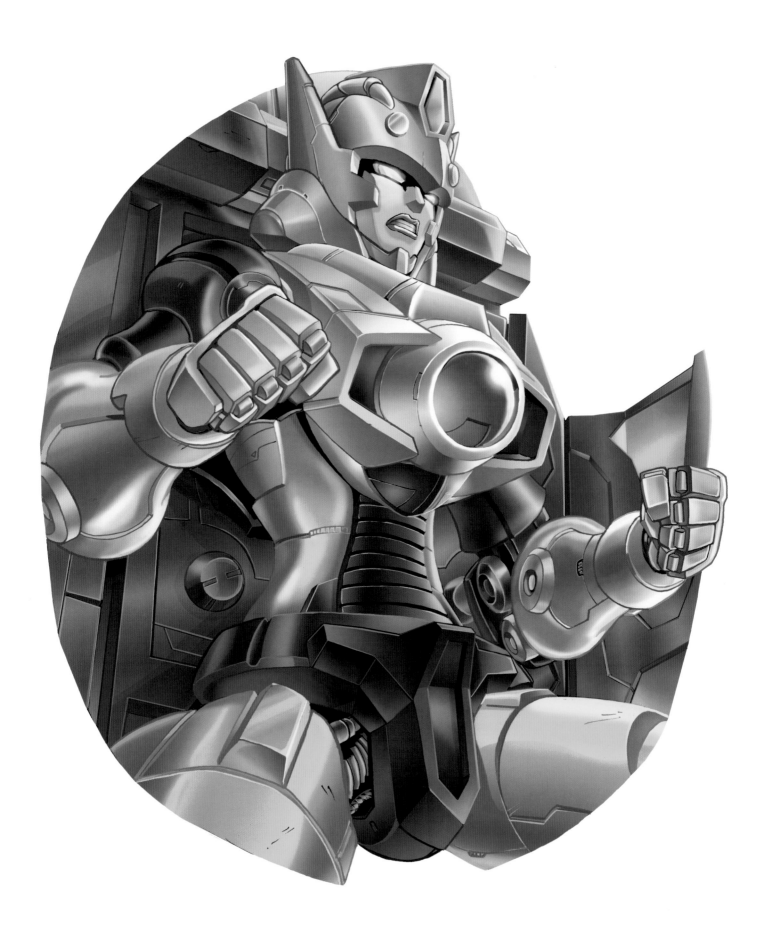

Above: Package art, Thunderblast, *Transformers: Cybertron* | Marcelo Matere

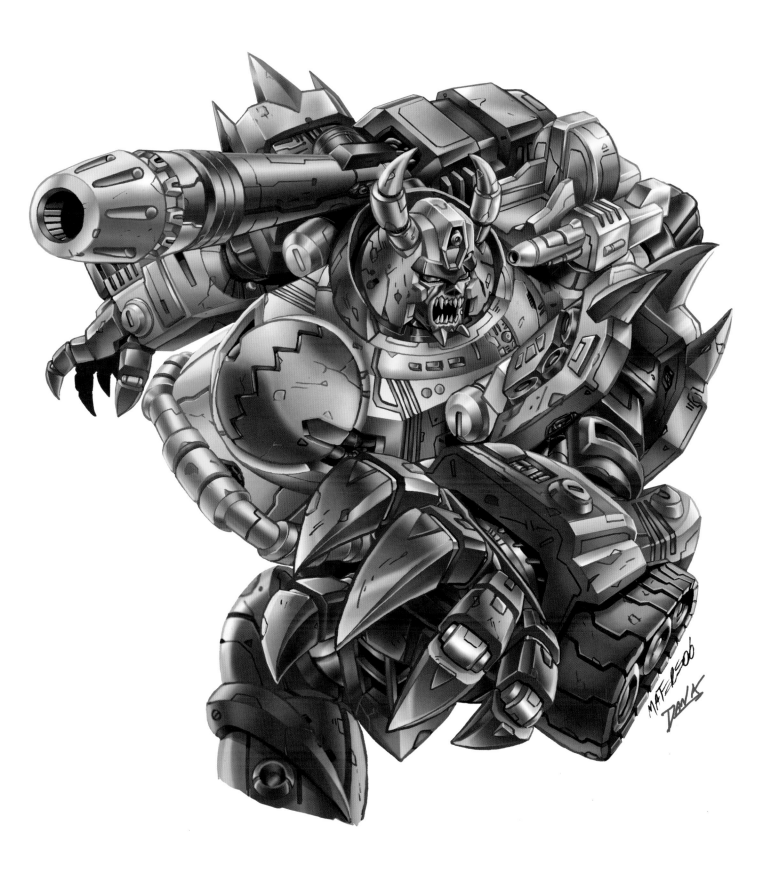

Above: Package art, Unicron, *Transformers: Cybertron* | Marcelo Matere & Dan Khanna

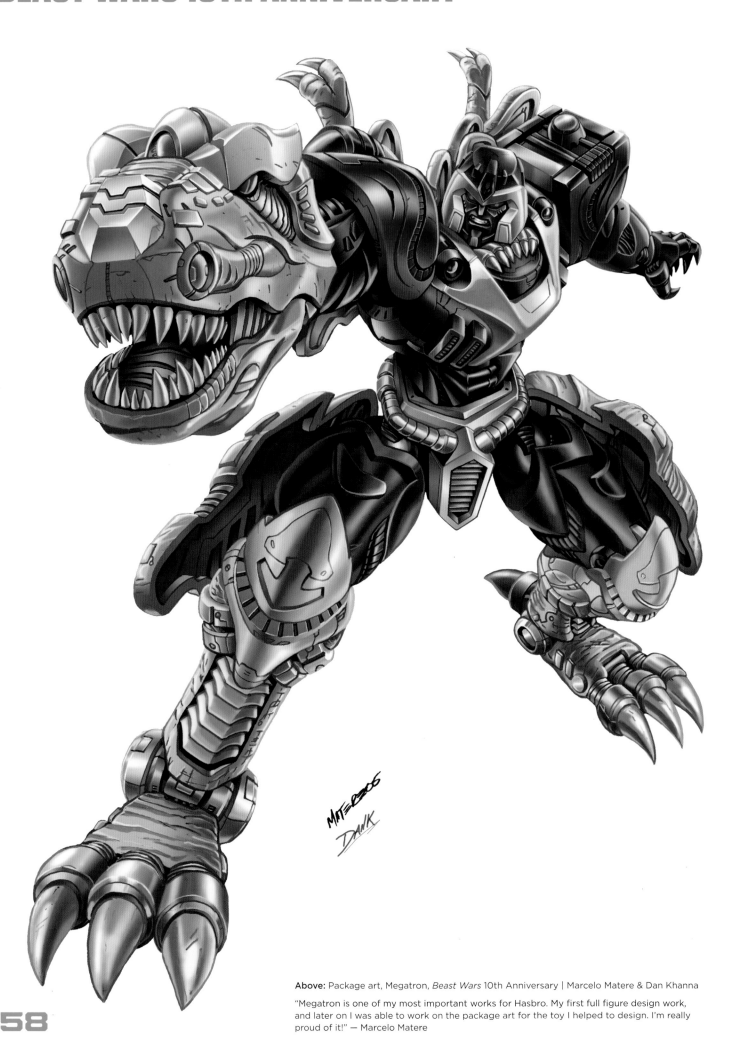

Above: Package art, Megatron, *Beast Wars* 10th Anniversary | Marcelo Matere & Dan Khanna

"Megatron is one of my most important works for Hasbro. My first full figure design work, and later on I was able to work on the package art for the toy I helped to design. I'm really proud of it!" — Marcelo Matere

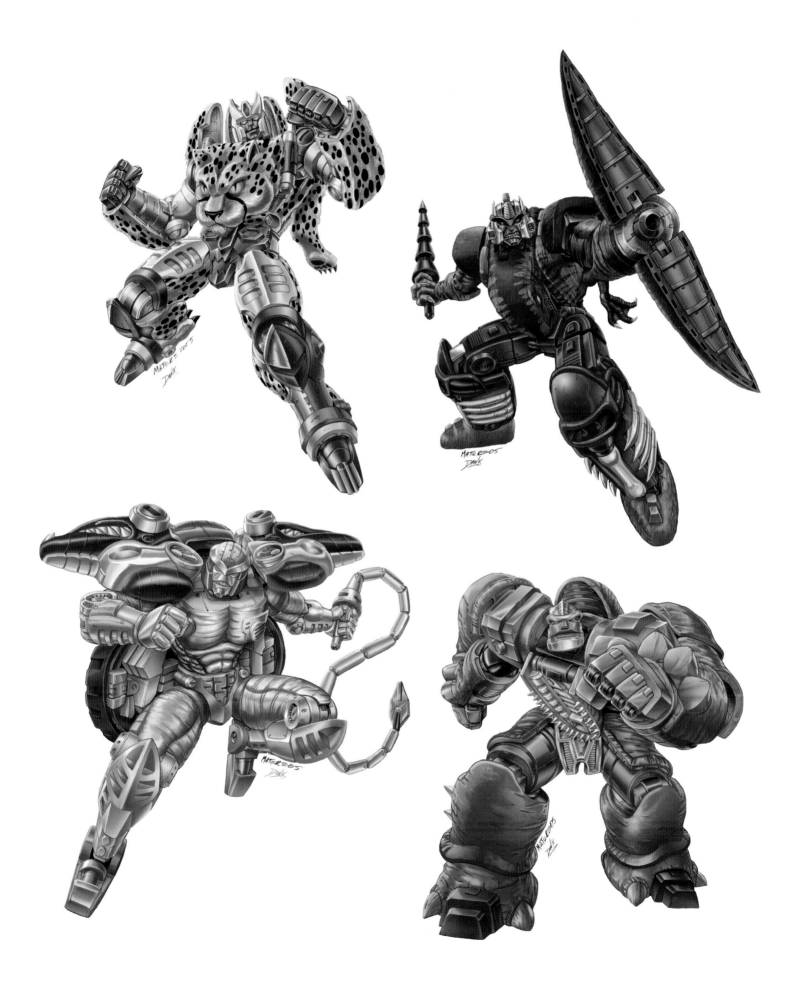

Clockwise from top left: Package art, Cheetor, Dinobot, Rhinox, Rattrap,
Beast Wars 10th Anniversary | Marcelo Matere & Dan Khanna

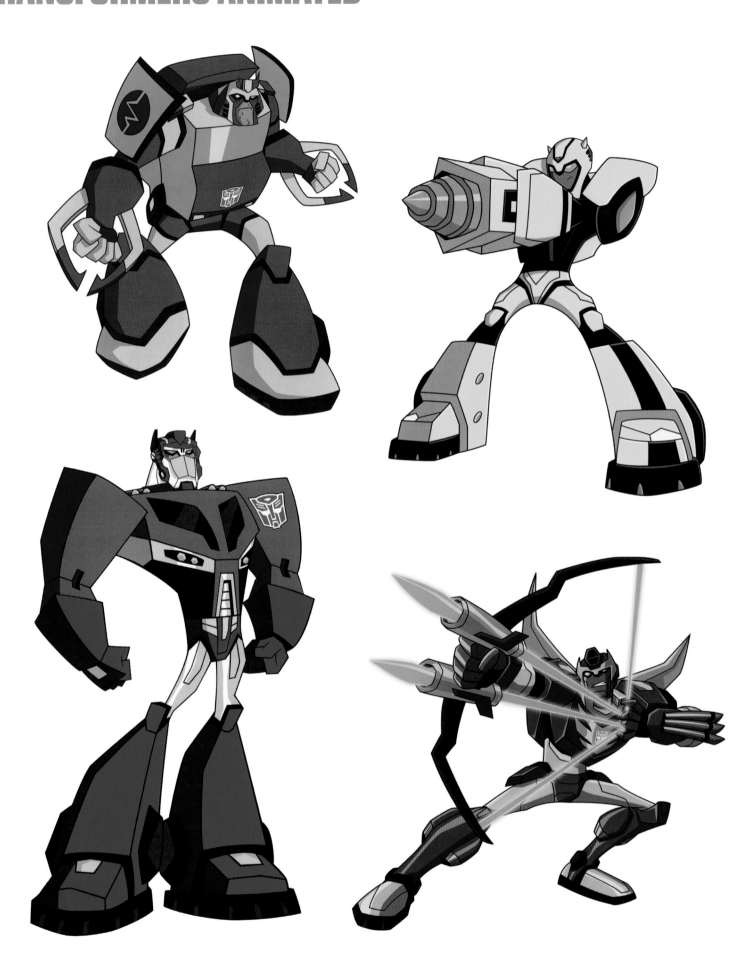

Clockwise from top left: Package art, Ratchet, Bumblebee, Rodimus Minor, Optimus Prime, *Transformers Animated*

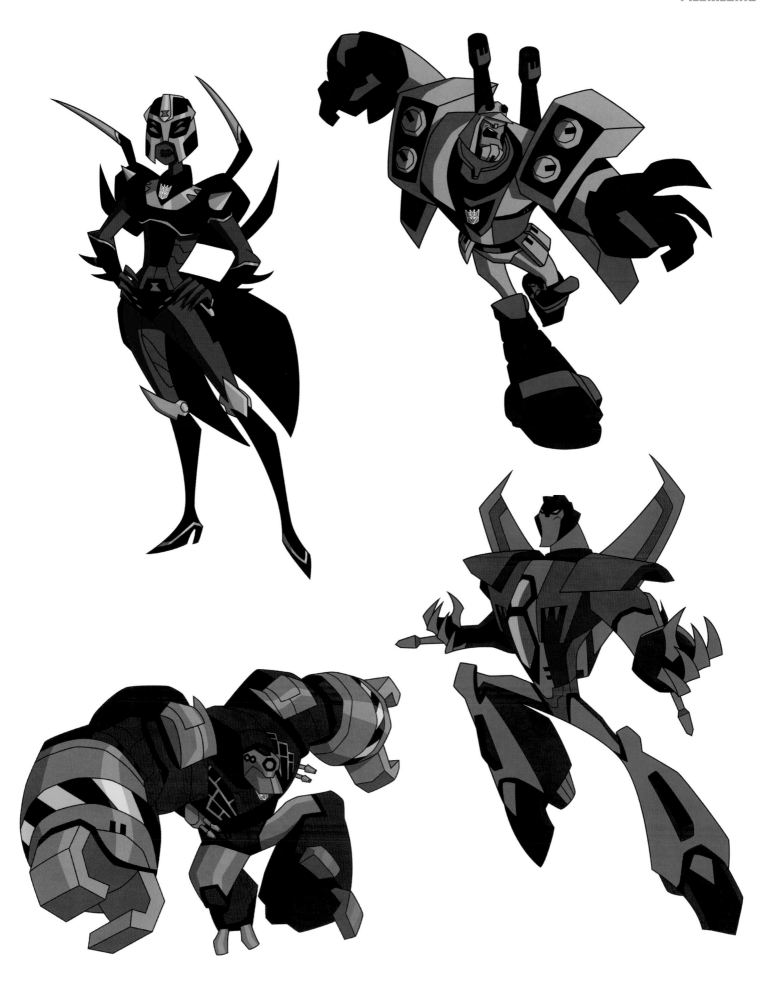

Clockwise from top left: Package art, Blackarachnia, Blitzwing, Starscream, Lugnut, *Transformers Animated*

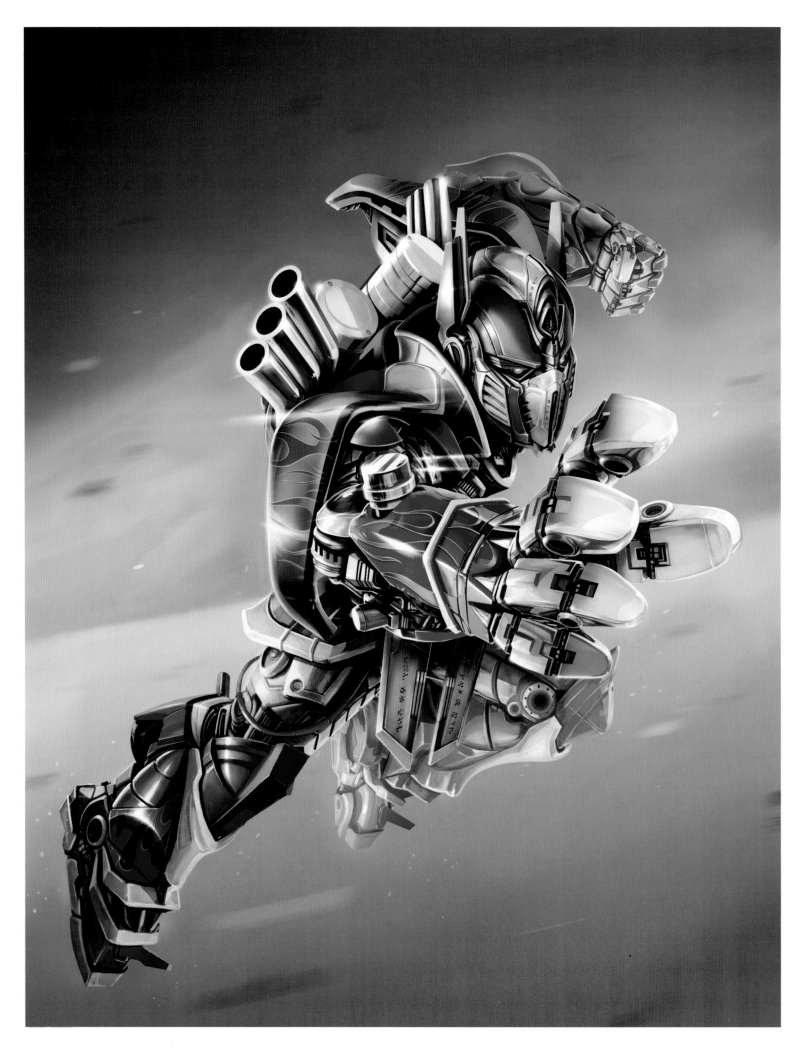

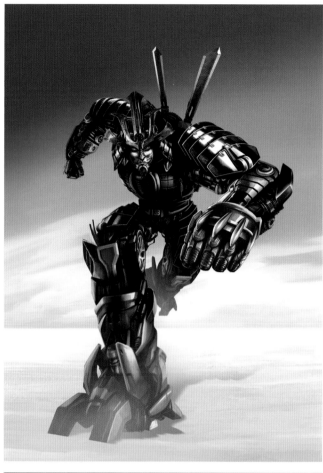

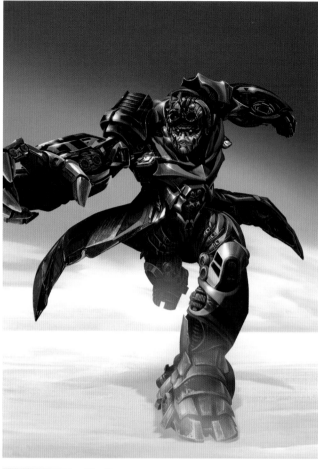

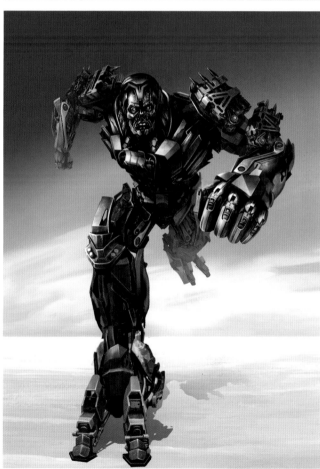

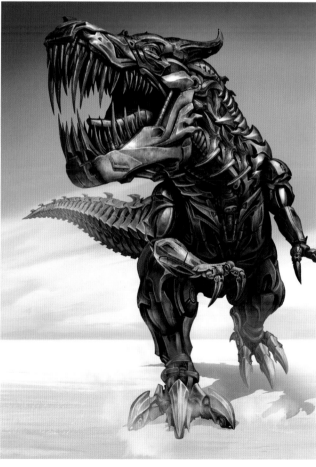

Opposite: Package art, Optimus Prime, *Transformers: Age of Extinction*

Clockwise from top left: Package art, Drift, Crosshairs, Grimlock, Lockdown, *Transformers: Age of Extinction*

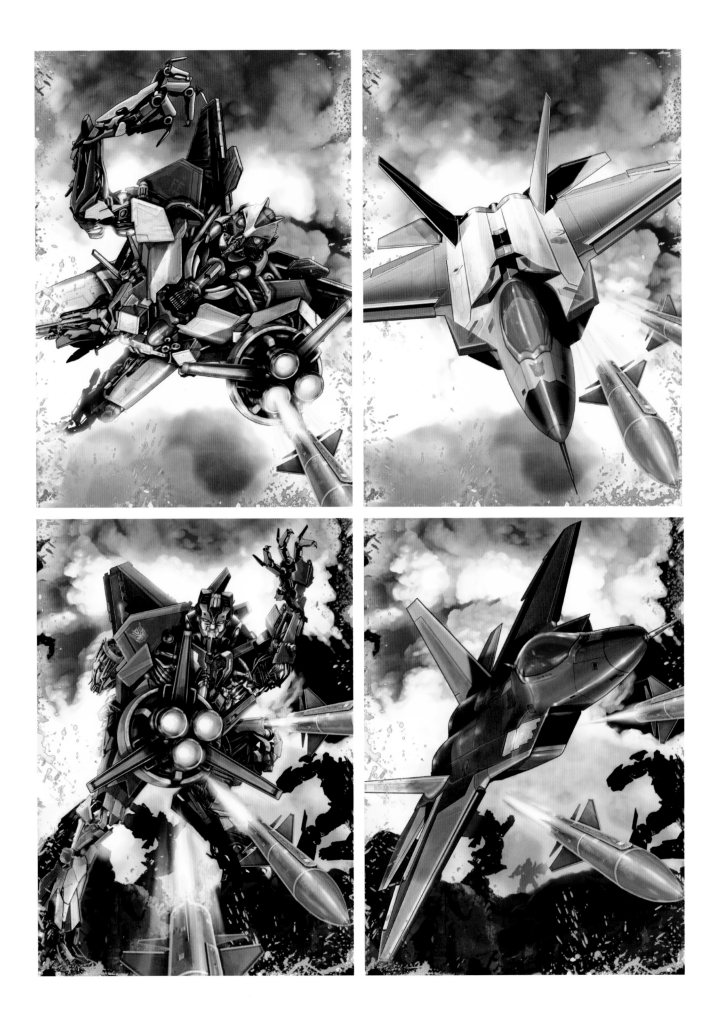

Top: Pack-in card art, Ramjet, *Transformers: Revenge of the Fallen*

Above: Pack-in card art, Skywarp, *Transformers: Revenge of the Fallen*

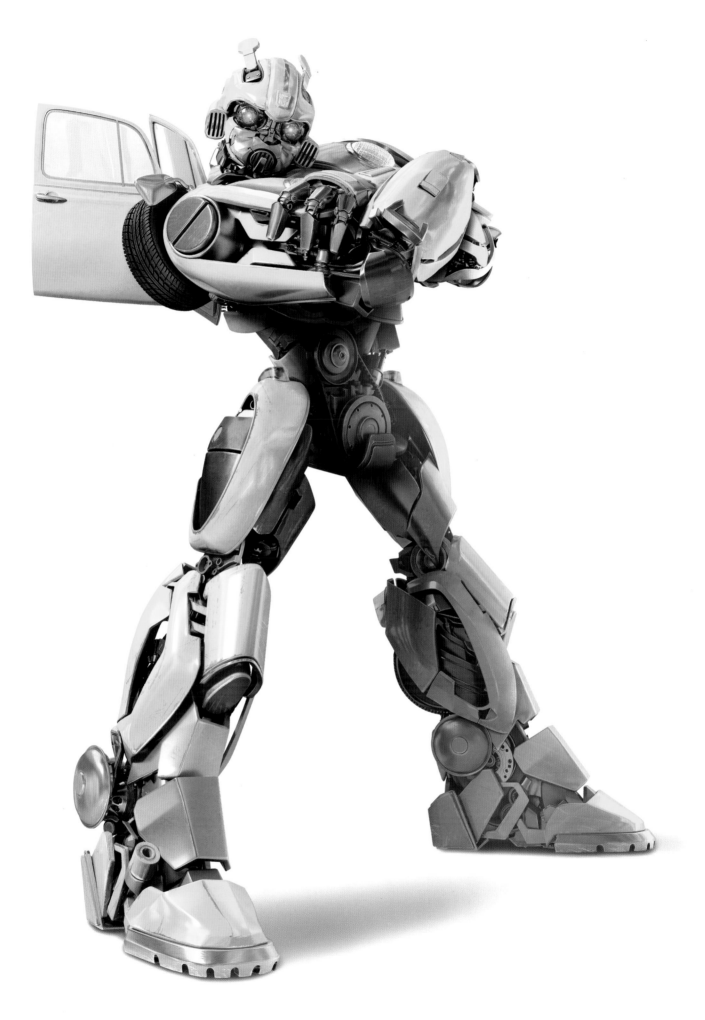

Above: Package art, Bumblebee, *Bumblebee*

Following: Package art, Megatron (unused variant), Optimus Prime, *Transformers*

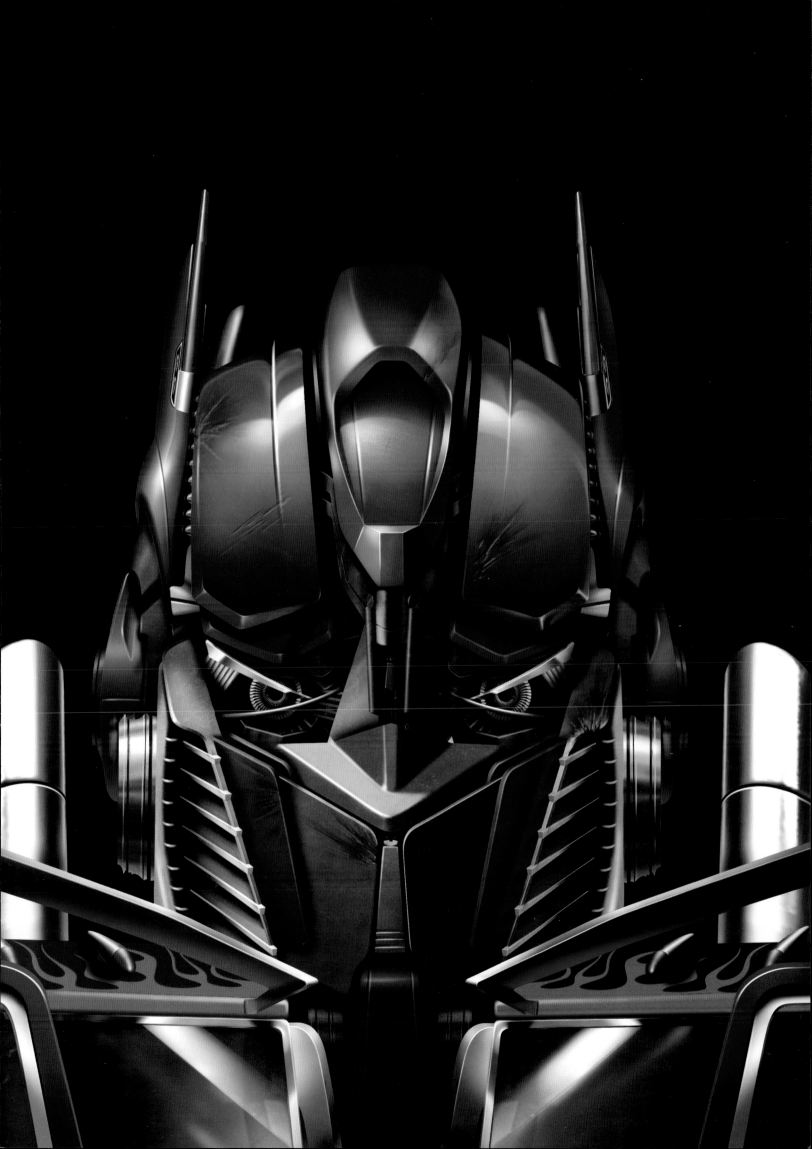

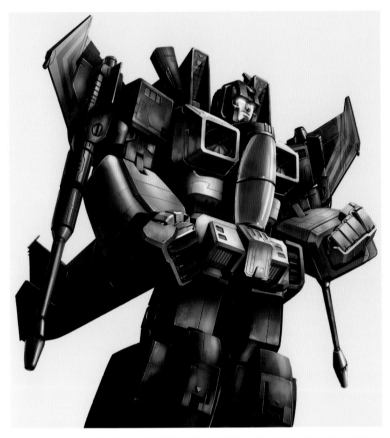

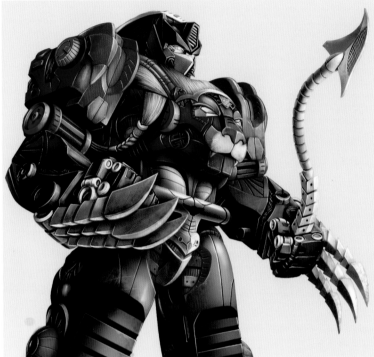

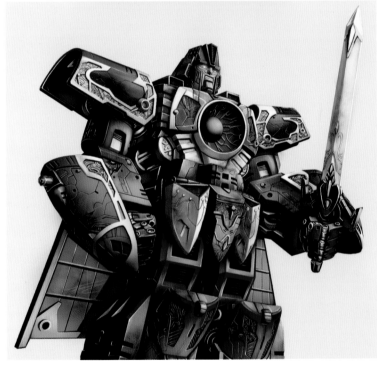

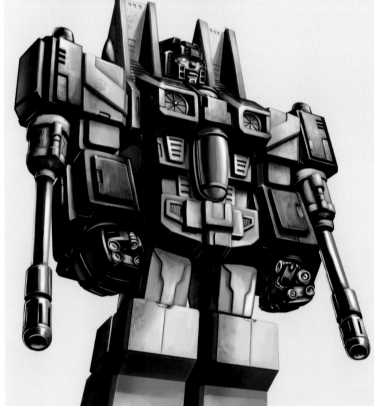

Clockwise from top left: Package art, Skywarp, Leo Prime, Acid Storm, Vector Prime, *Transformers Universe*

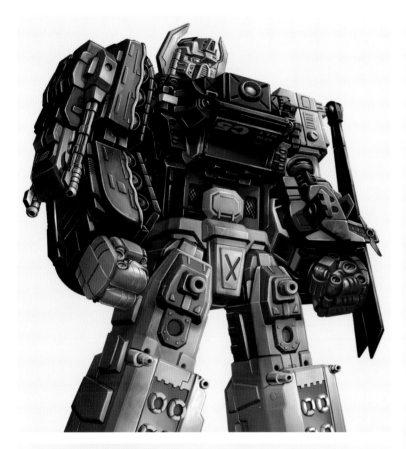

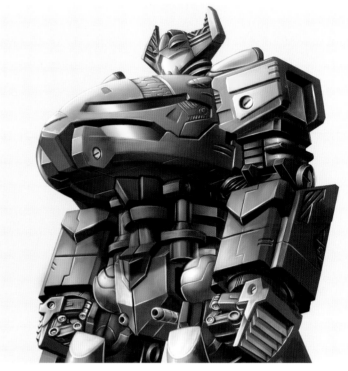

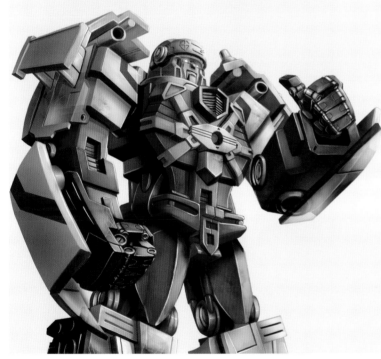

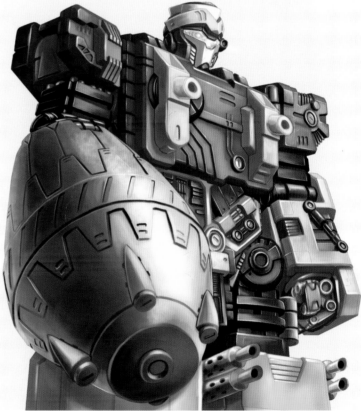

Clockwise from top left: Package art, Bruticus Maximus, Ratbat, Heavy Load, Hot Shot, *Transformers Universe*

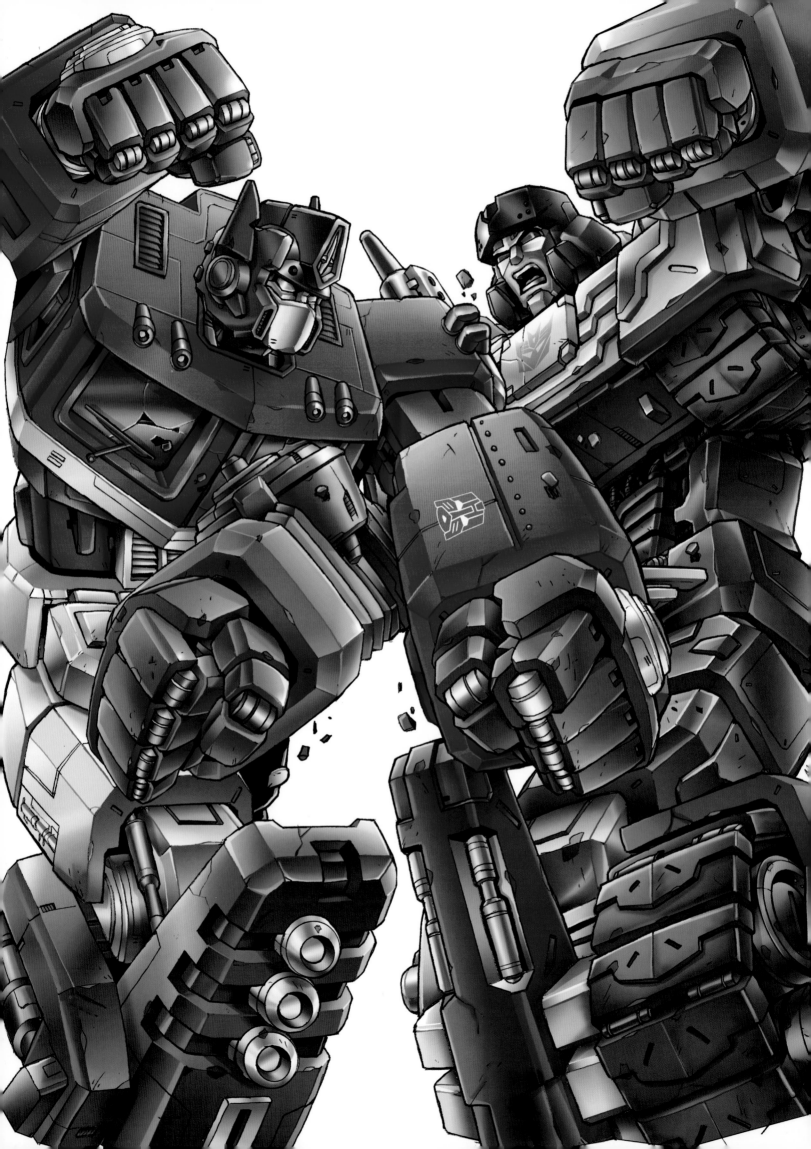

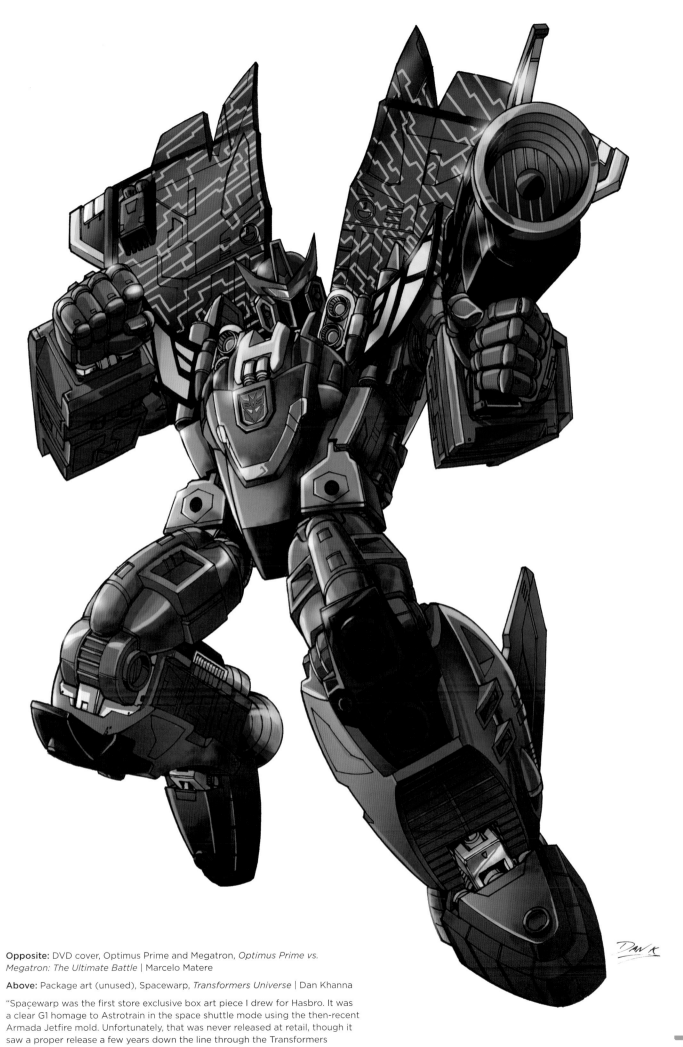

Opposite: DVD cover, Optimus Prime and Megatron, *Optimus Prime vs. Megatron: The Ultimate Battle* | Marcelo Matere

Above: Package art (unused), Spacewarp, *Transformers Universe* | Dan Khanna

"Spacewarp was the first store exclusive box art piece I drew for Hasbro. It was a clear G1 homage to Astrotrain in the space shuttle mode using the then-recent Armada Jetfire mold. Unfortunately, that was never released at retail, though it saw a proper release a few years down the line through the Transformers Collector's Club." — Dan Khanna

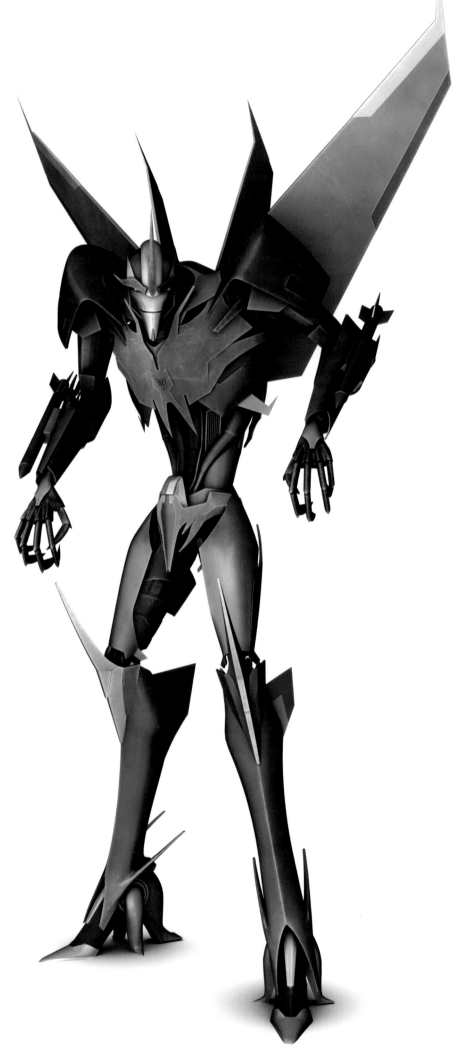

Above: Package art, Starscream, *Transformers Prime*

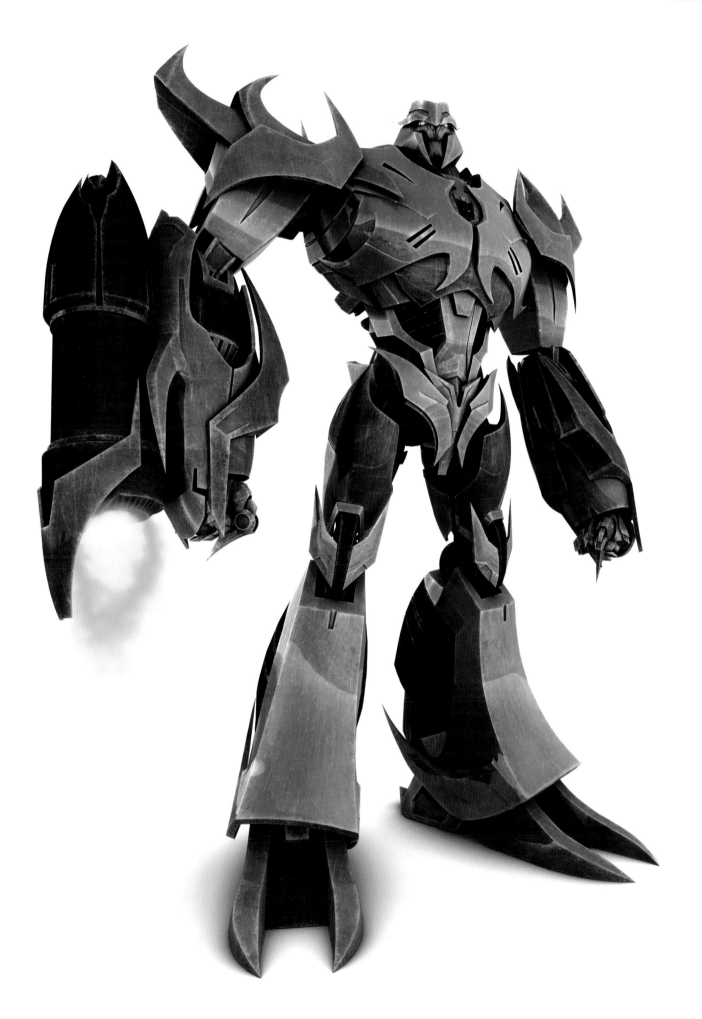

Above: Package art, Megatron, *Transformers Prime*

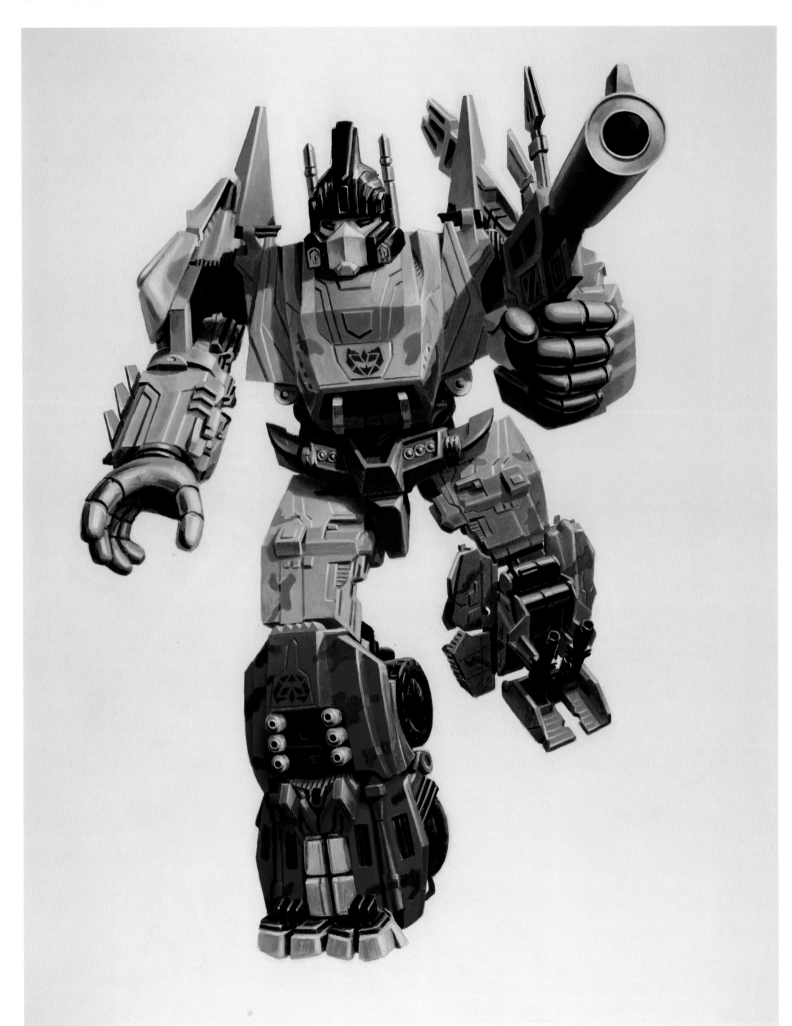

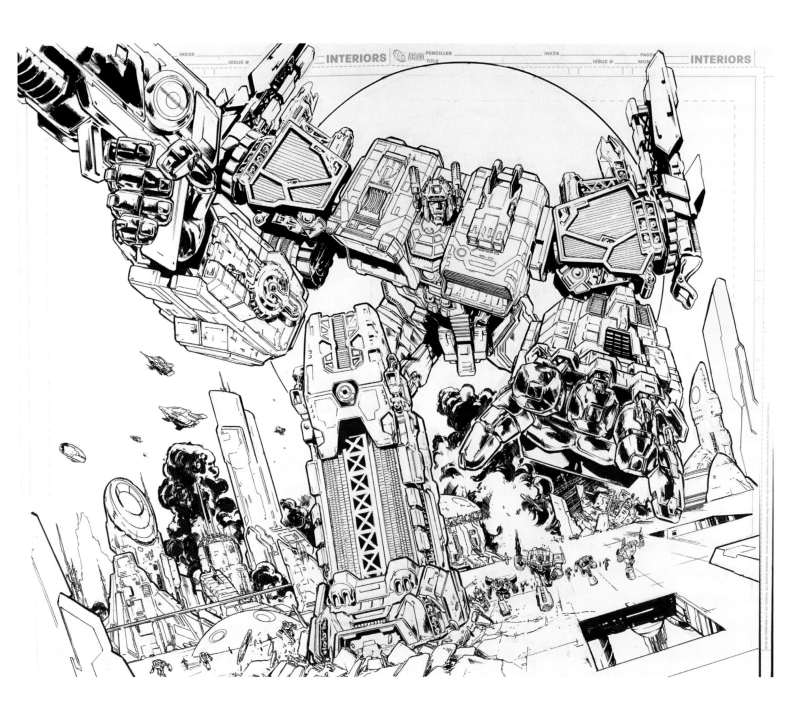

Opposite: Package art, Generation 2 Bruticus, *Generations*

Above: SDCC variant package art, Metroplex, *Generations* | Phil Jimenez

Following: Package art, Platinum Edition Trypticon, *Generations* | Ken Christiansen

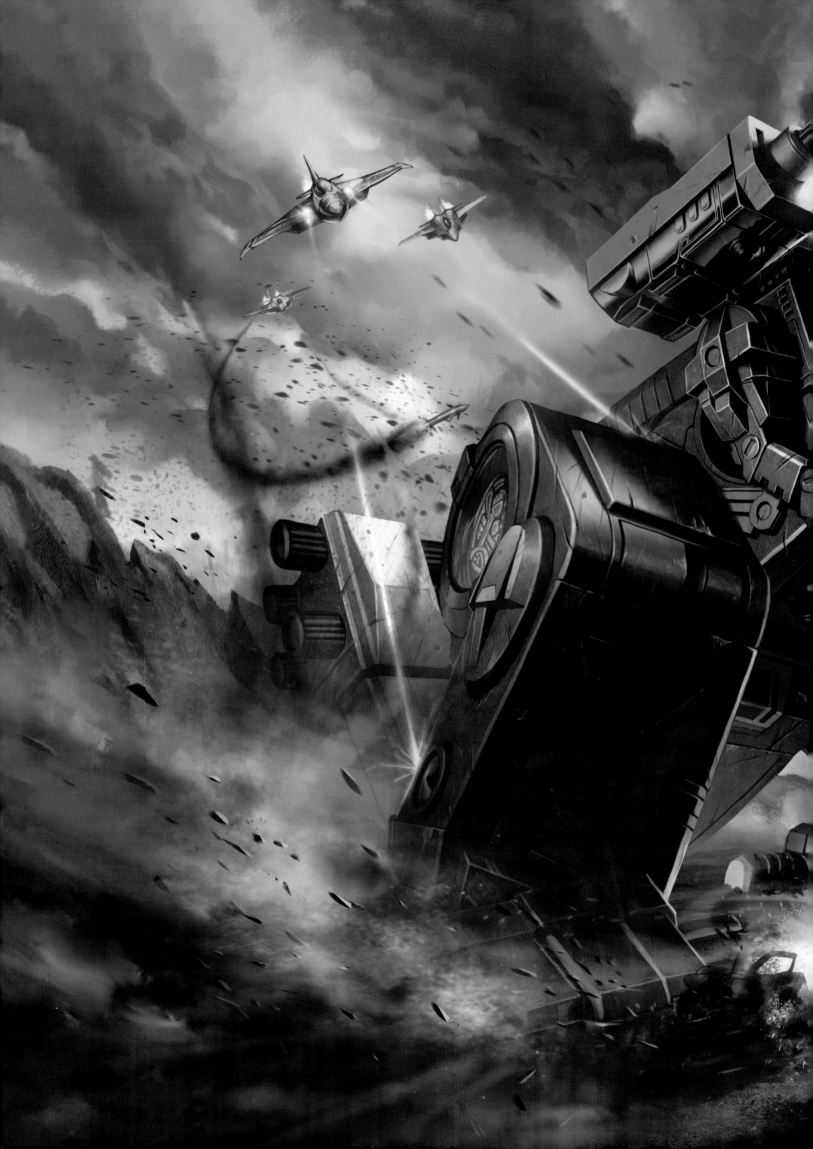

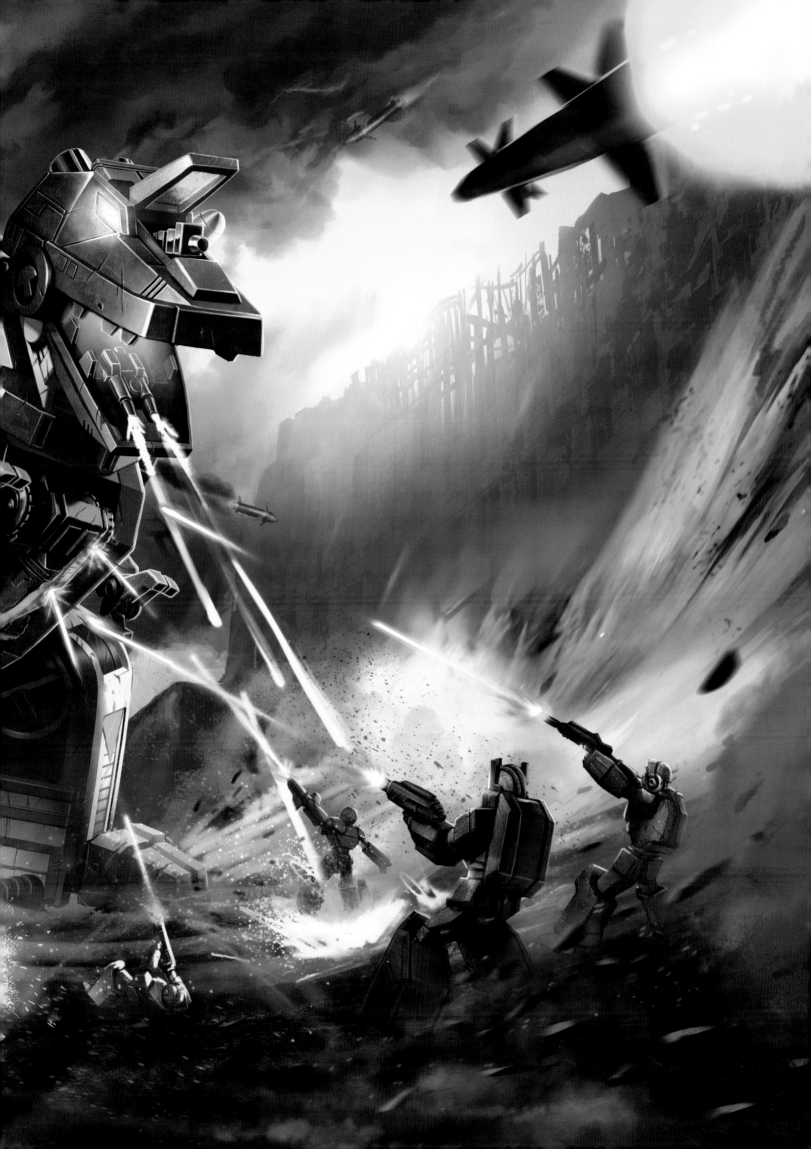

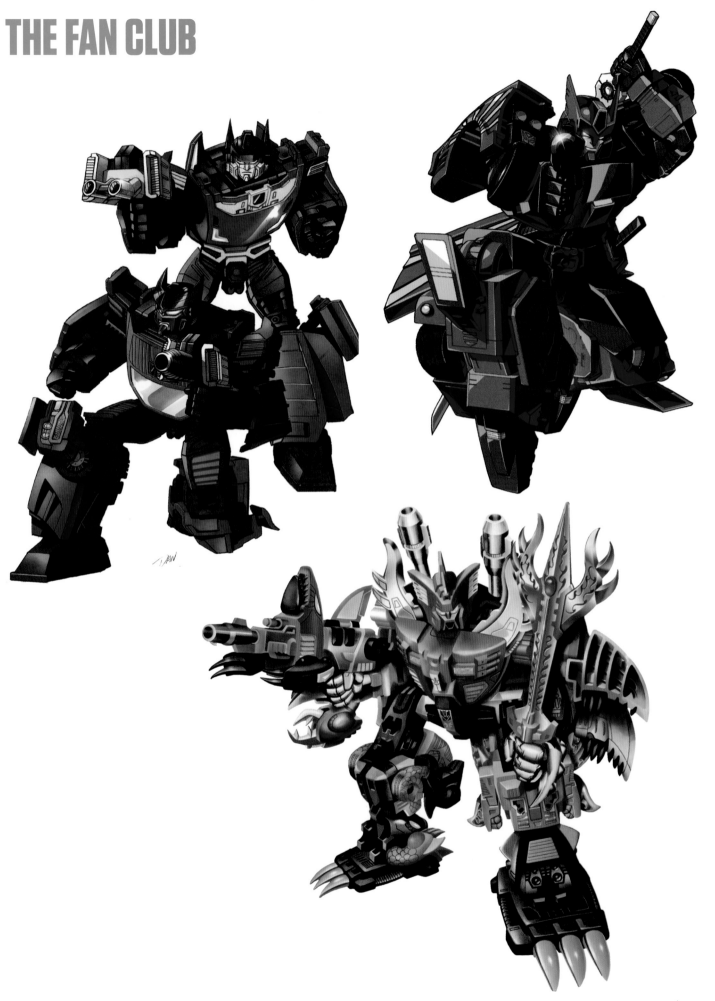

Clockwise from top left: *Package art, Punch/Counterpunch, Shattered Glass Drift, Piranacon, Transformers Fan Club | Dan Khanna, Casey Coller, Joe Moore*

Opposite: *Package art, Pretender Megatron, Transformers Fan Club | Dan Khanna*

"Pretender Megatron here is most notable to me for reusing the G1 Pretender Shell Grand, who originally came with the Japan-exclusive Grand Maximus. It's one of the rare times the Transformers Collector's Club got to actually use a G1 mold for an exclusive toy." — Dan Khanna

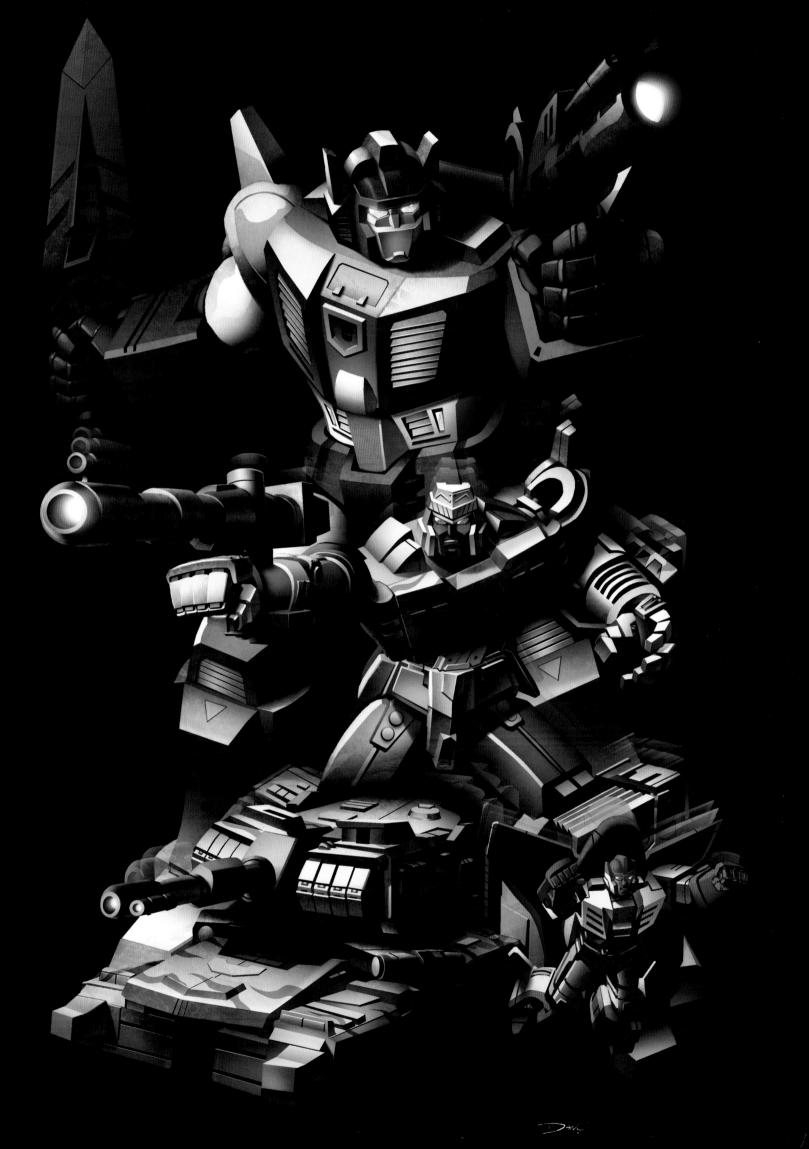

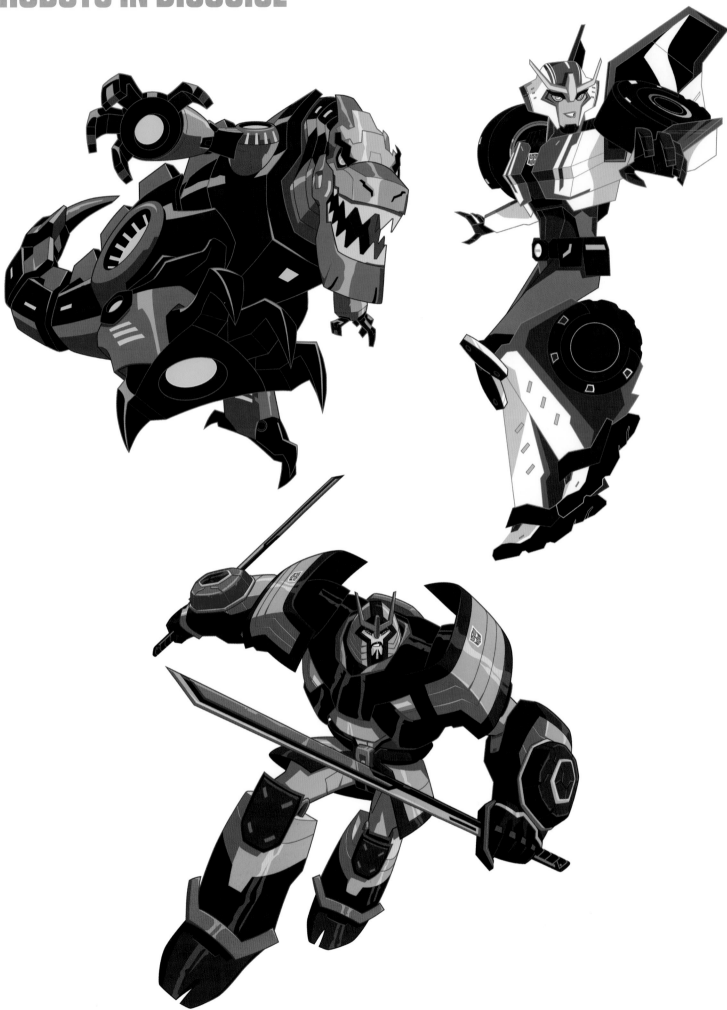

Clockwise from top left: Package art, Grimlock, Strongarm, Drift, *Transformers: Robots in Disguise*

Clockwise from top left: Package art, Thunderhoof, Bisk, Springload, *Transformers: Robots in Disguise*

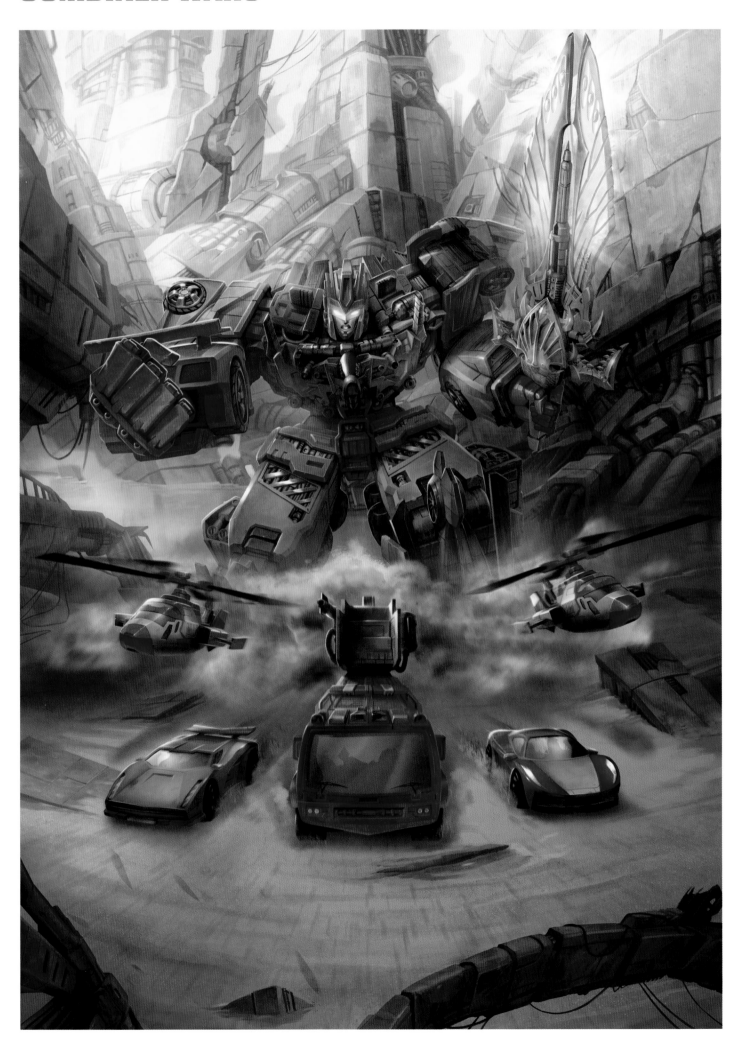

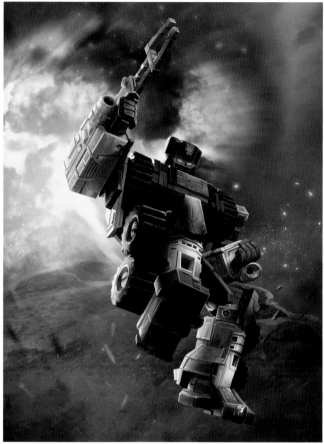

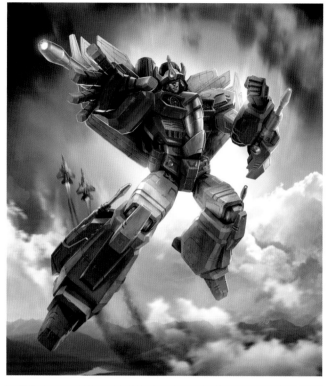

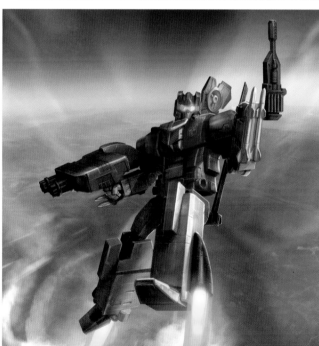

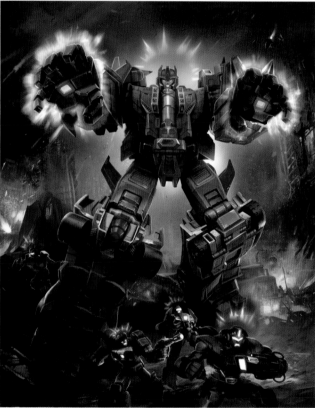

Opposite: Package art, Victorion, *Transformers: Combiner Wars* | Marcelo Matere & Volta

"I was fortunate enough to be able to work on the designs for the robot mode torso and some arms, and later on invited to work on the package art. This one in particular was really nice to work on. The illustration needed to work in a horizontal format for the package art and vertical format for poster and promotional pieces. So we ended up going for the full body for the combined mode and separated pencils for background, alt modes, and combiner mode. This way, the package art team would have more options to work on the design for the box and promotional pieces." — Marcelo Matere

Clockwise from top left: Package art, Rook, Starscream, Galvatronus, Alpha Bravo, *Transformers: Combiner Wars* | Volta (color)

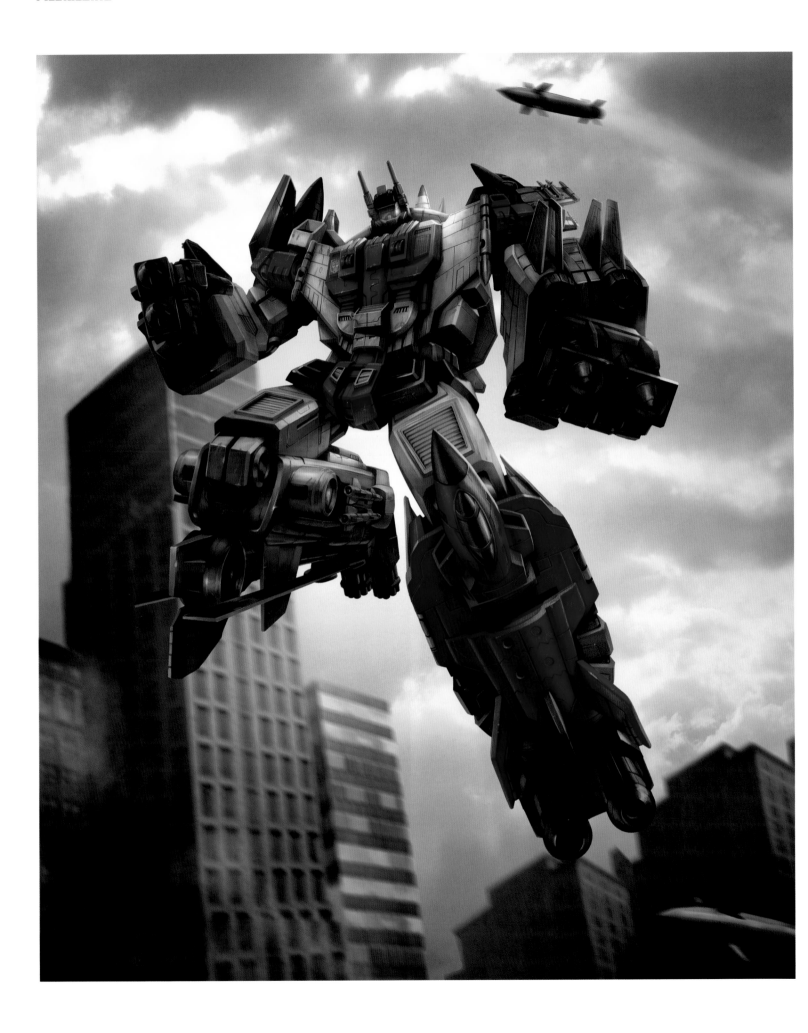

Above: Package art, Superion, *Transformers: Combiner Wars* | Volta (color)

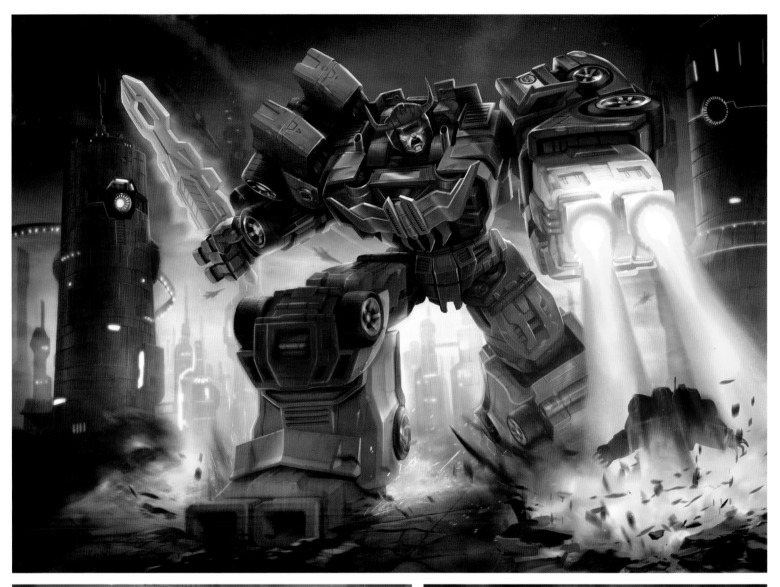

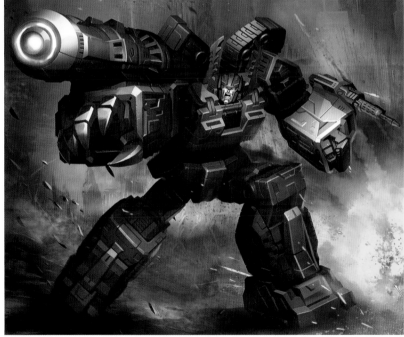

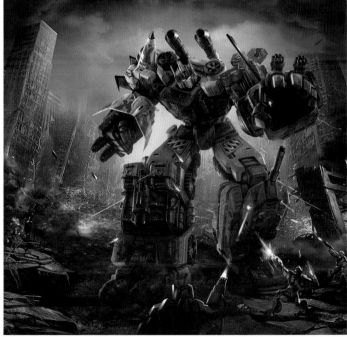

Clockwise from top: Package art, Generation 2 Menasor, Generation 2 Bruticus, Armada Megatron, *Transformers: Combiner Wars* | Volta (color)

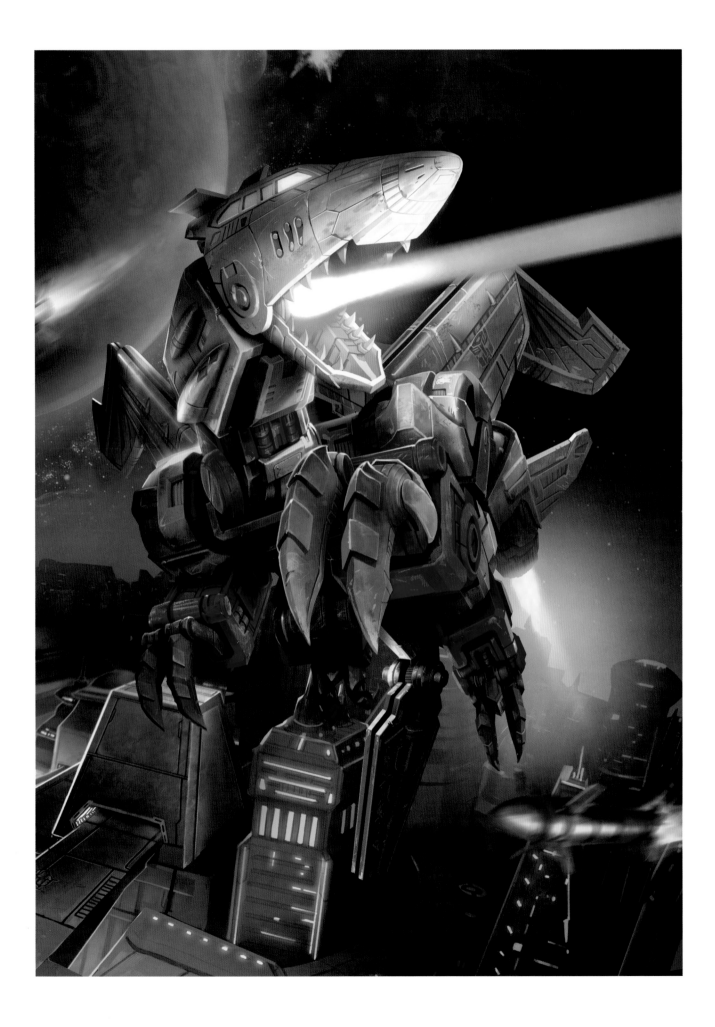

Above: Package art, Sky Lynx, *Transformers: Combiner Wars* | Marcelo Matere & Volta

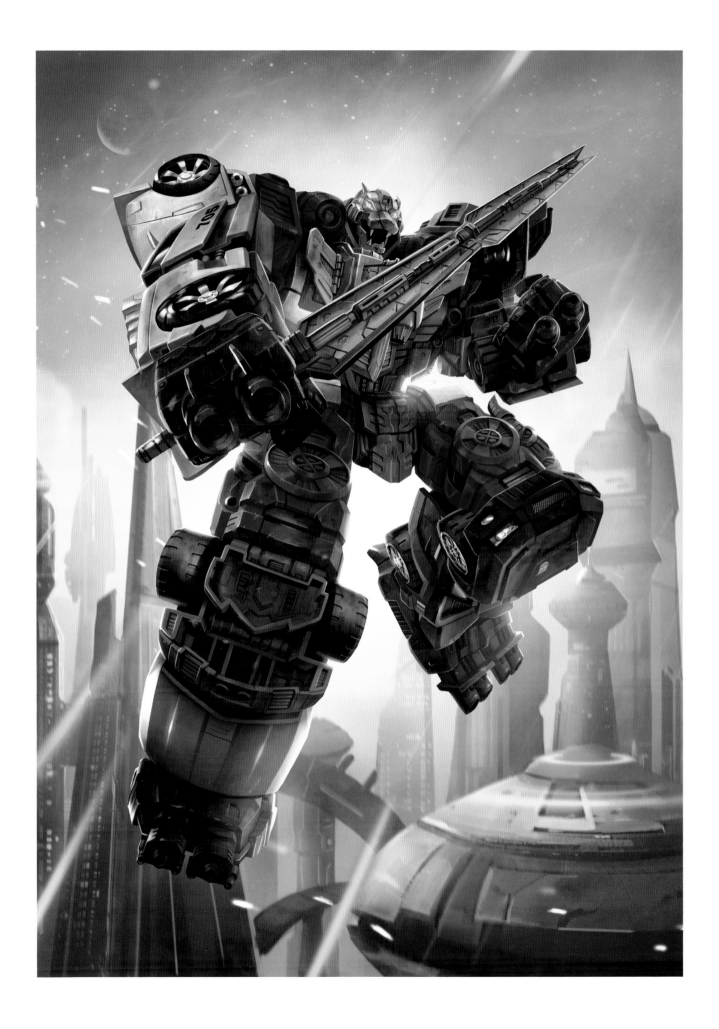

Above: Package art, Sky Reign, *Transformers: Combiner Wars* | Marcelo Matere & Volta

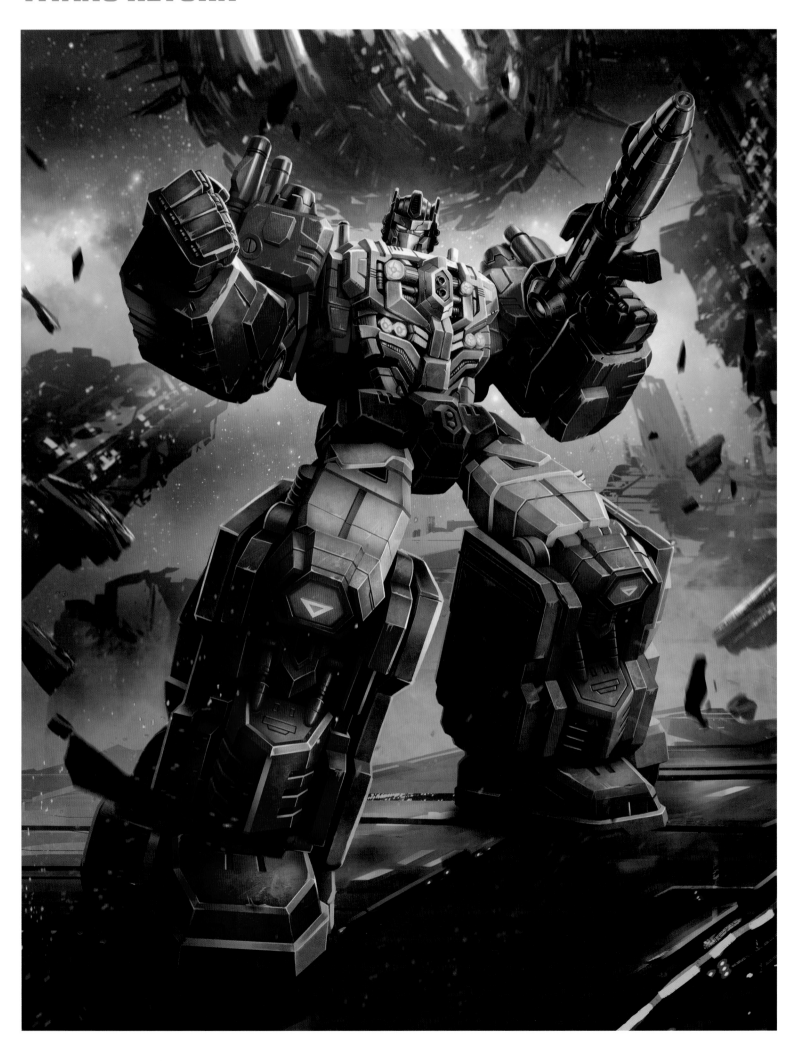

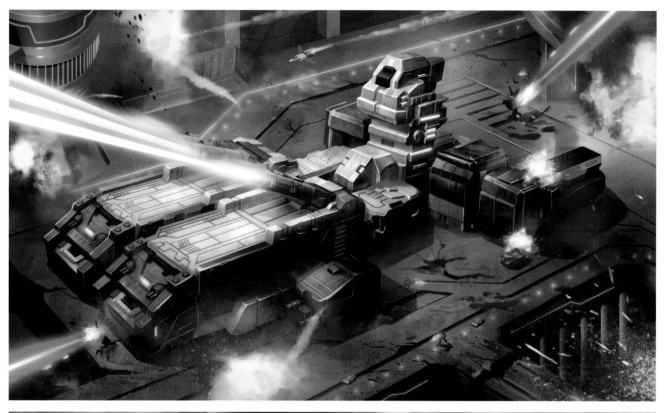

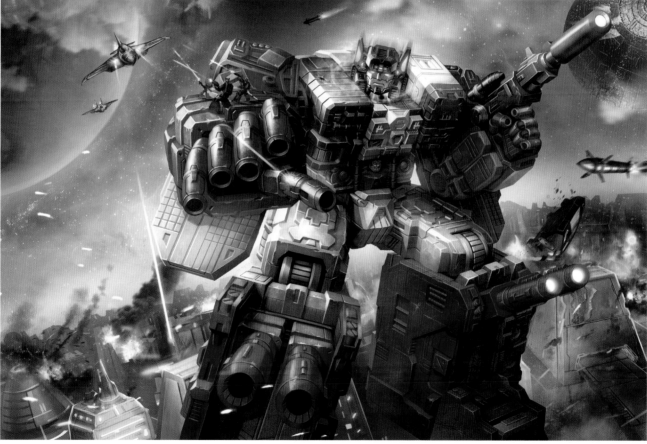

Opposite: Promo art, Powermaster Optimus Prime, *Transformers: Titans Return* | Marcelo Matere & Volta

From top: Promo art, Fortress Maximus Battlestation, *Transformers: Titans Return*; Package Art, Fortress Maximus, *Transformers: Titans Return* | Volta (color)

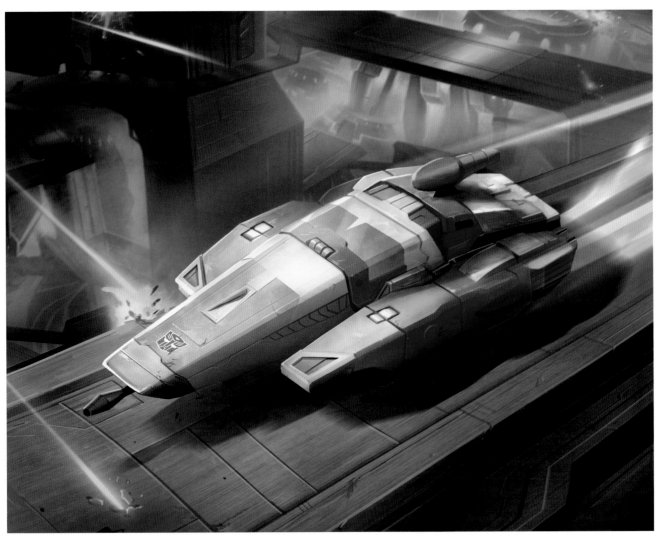

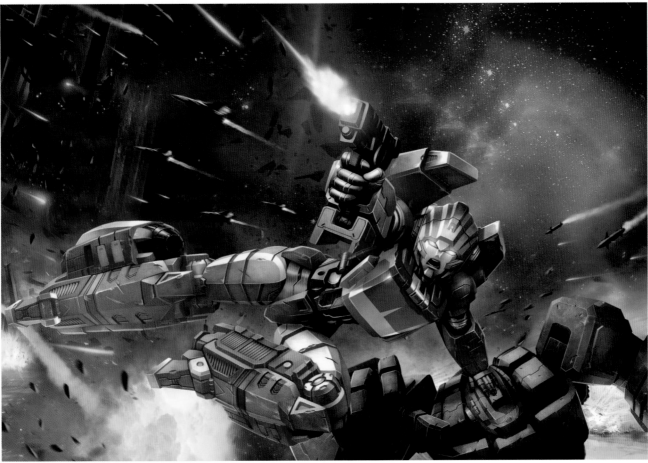

Above: Promo art, Arcee vehicle mode, *Transformers: Titans Return* | Volta (color)

Below: Package art, Arcee, *Transformers: Titans Return* | Volta (color)

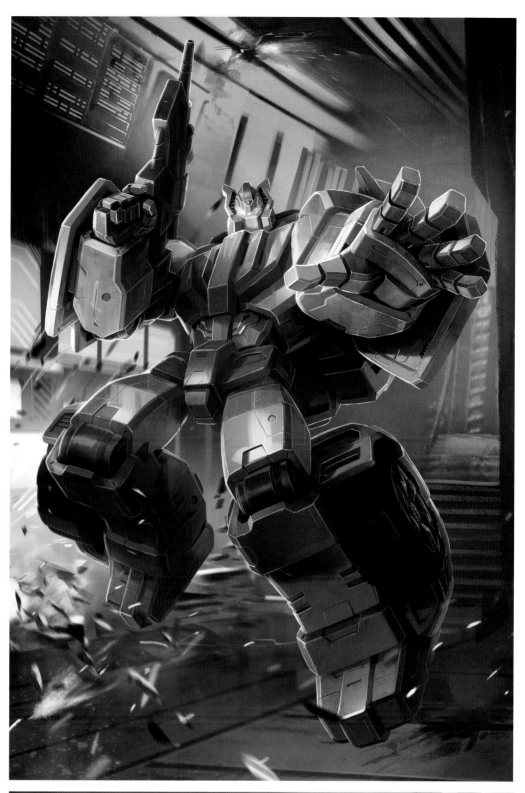

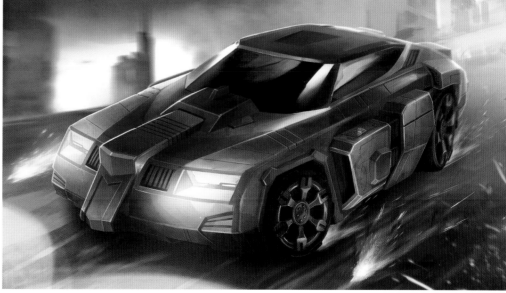

This page: Promo art, Chromedome,
Transformers: Titans Return | Volta (color)

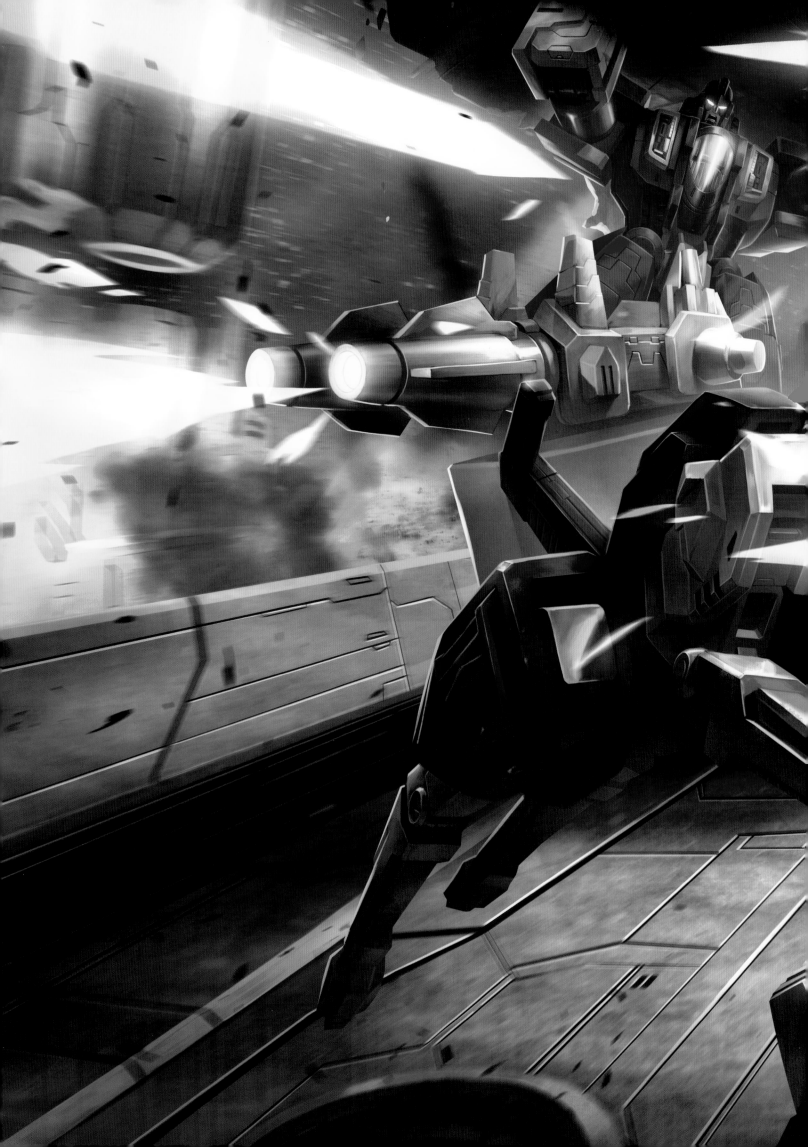

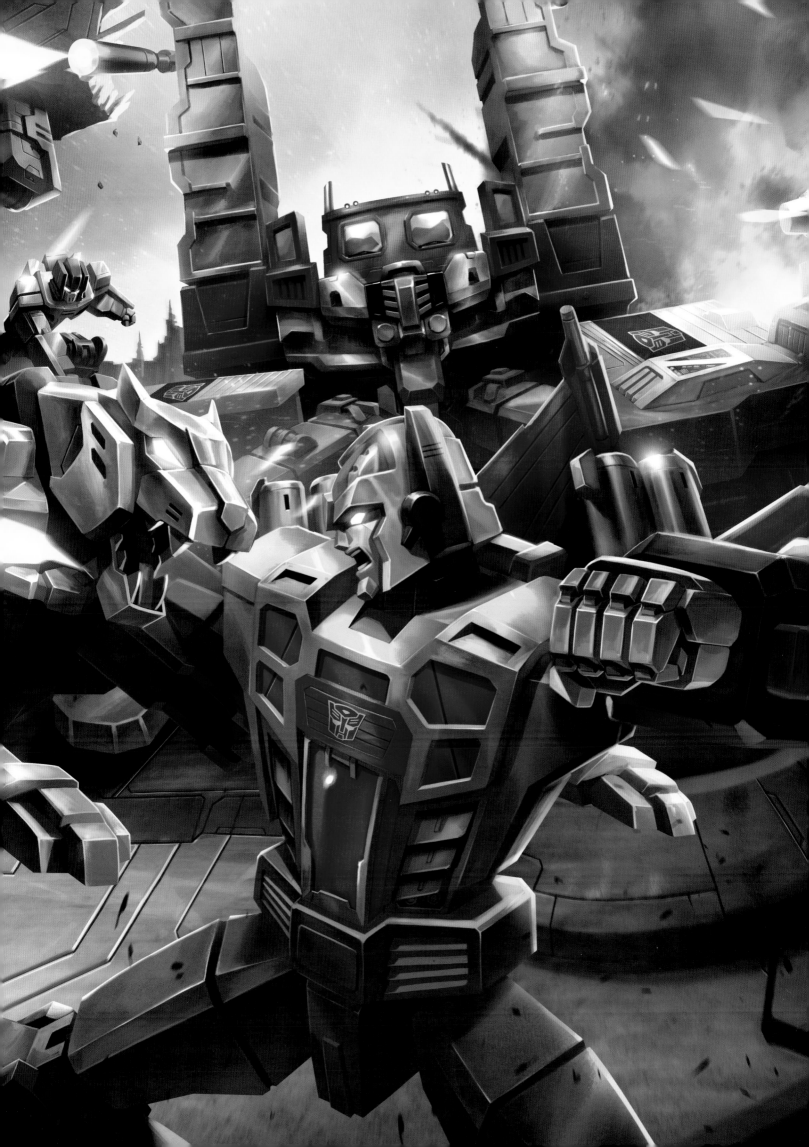

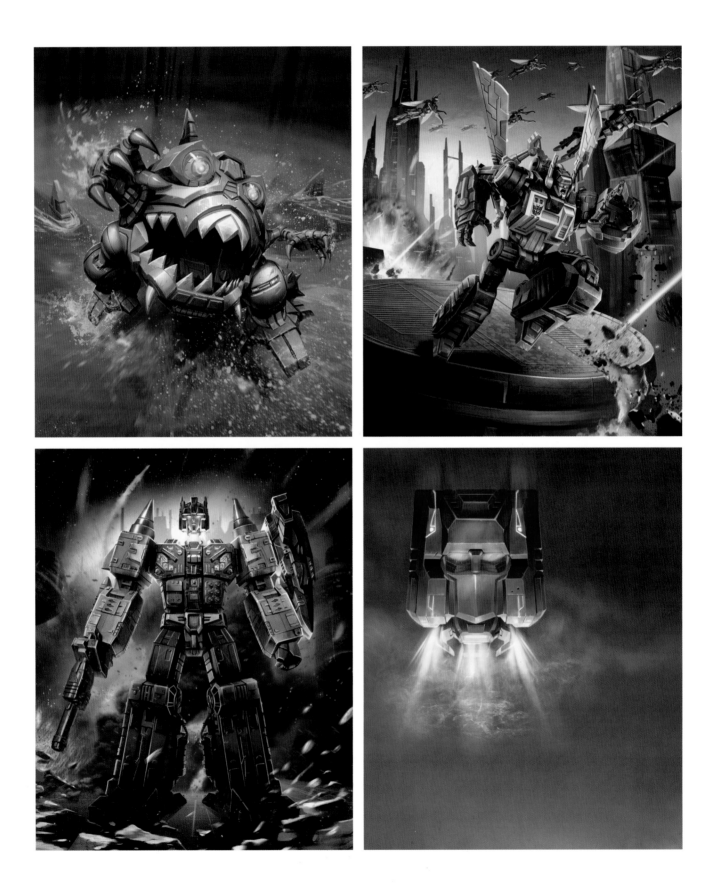

Previous: Package art, Siege on Cybertron box set, *Transformers: Titans Return* | Volta (color)

Clockwise from top left: Package art, Gnaw, Kickback, Terri-Bull (promotional art), Overlord, *Transformers: Titans Return* | Volta (color)

Opposite: Package art, Stripes, *Transformers: Titans Return* | Volta (color)

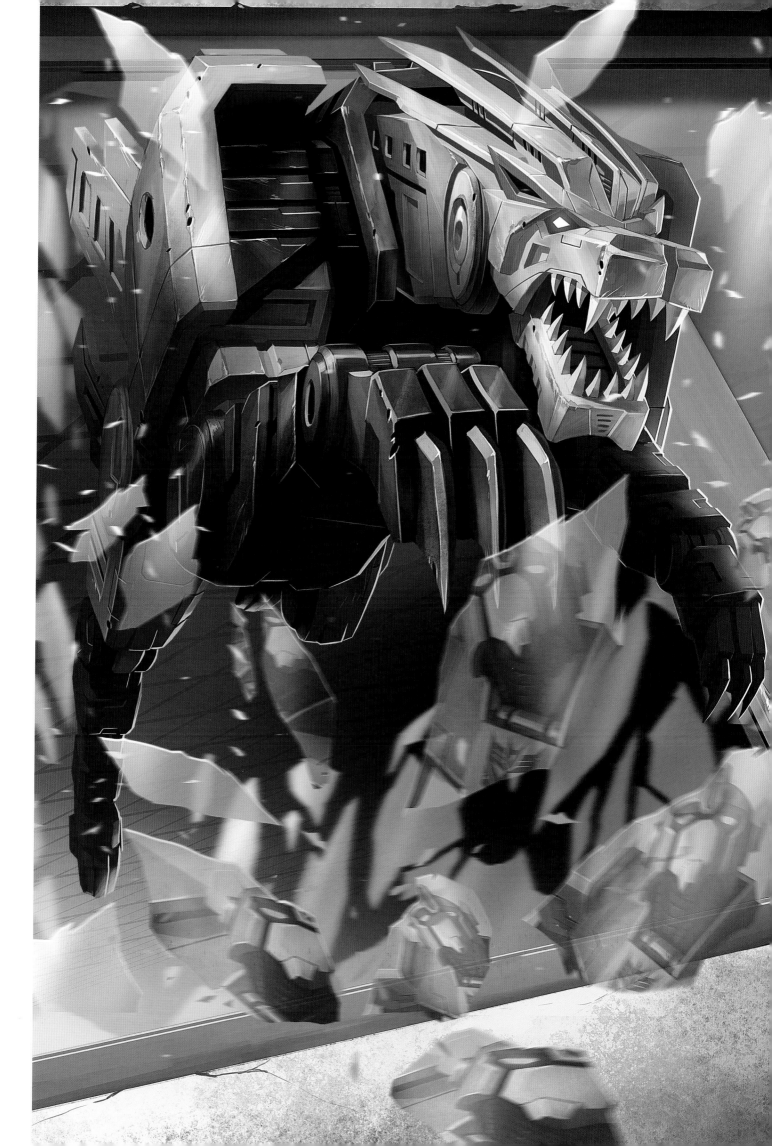

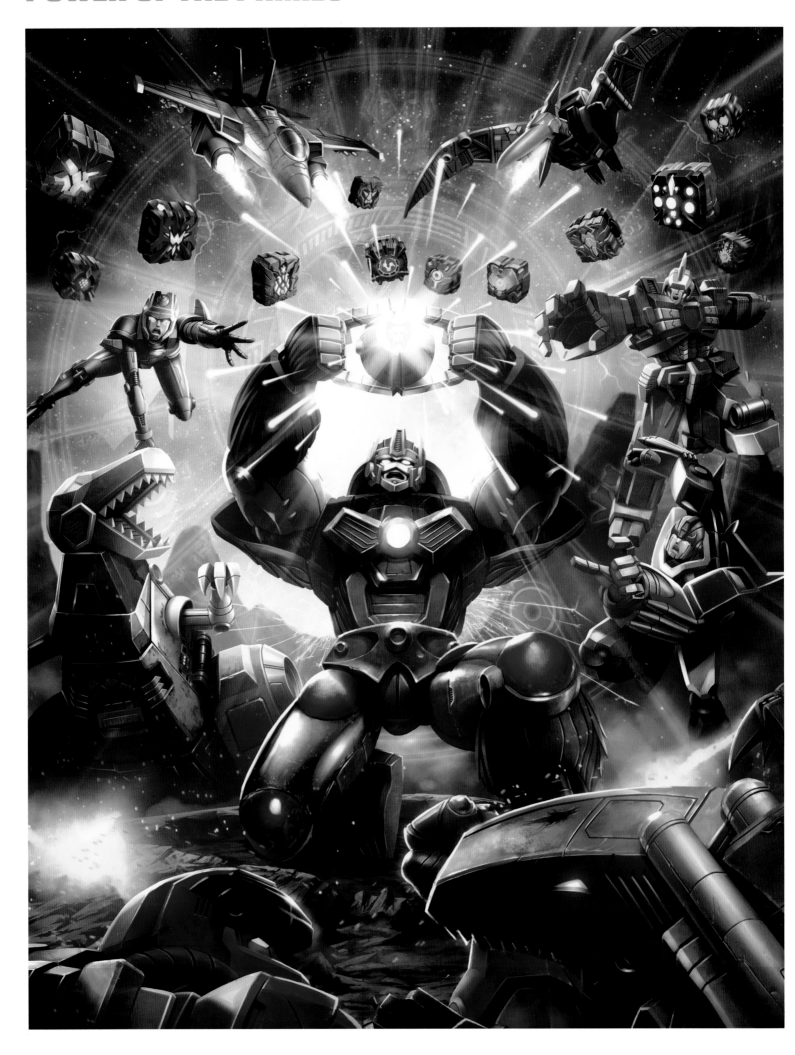

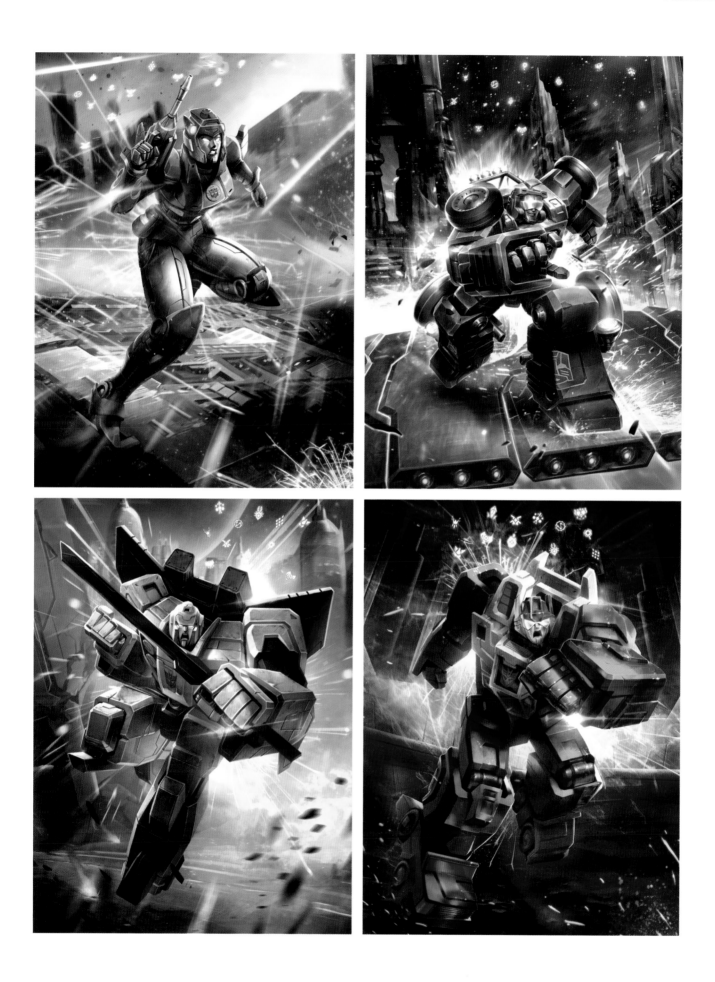

Opposite: Promo poster, *Transformers: Power of the Primes* | Volta (color)

Clockwise from top left: Package art, Moonracer, Beachcomber, Battletrap (promotional art), Battleslash, *Transformers: Power of the Primes* | Volta (color)

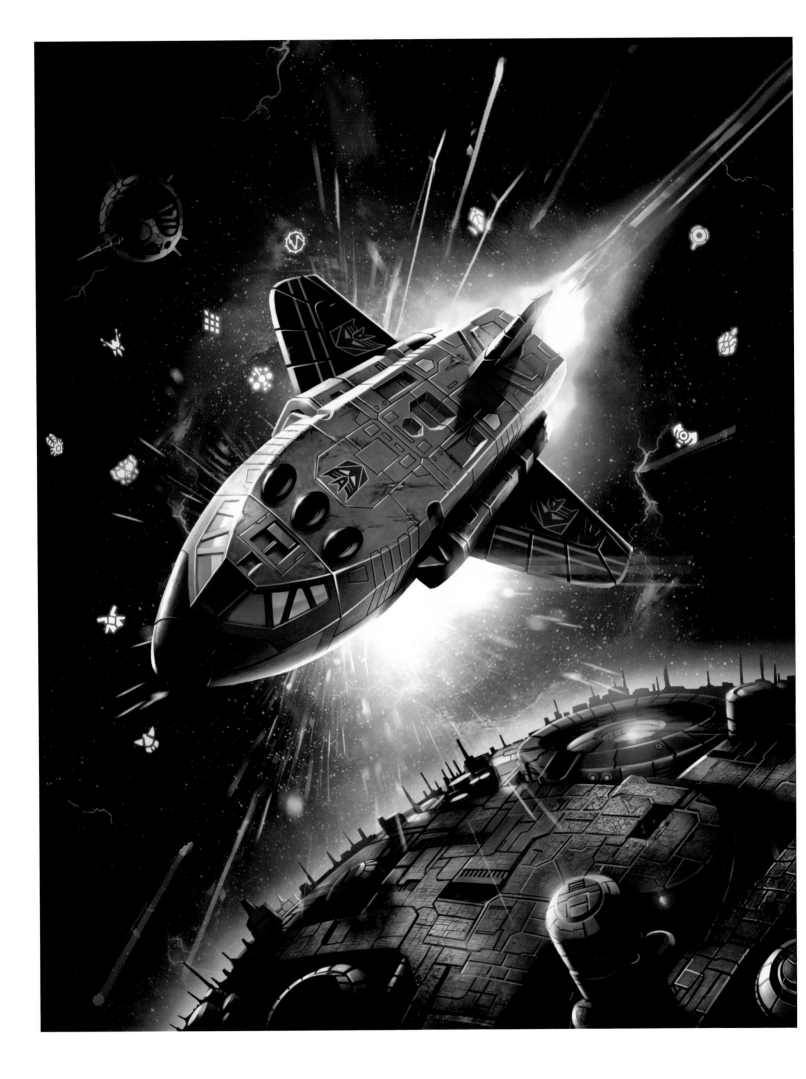

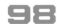

Above: Package art, Special Edition Blast Off, *Transformers: Prime Wars Trilogy* | Volta (color)

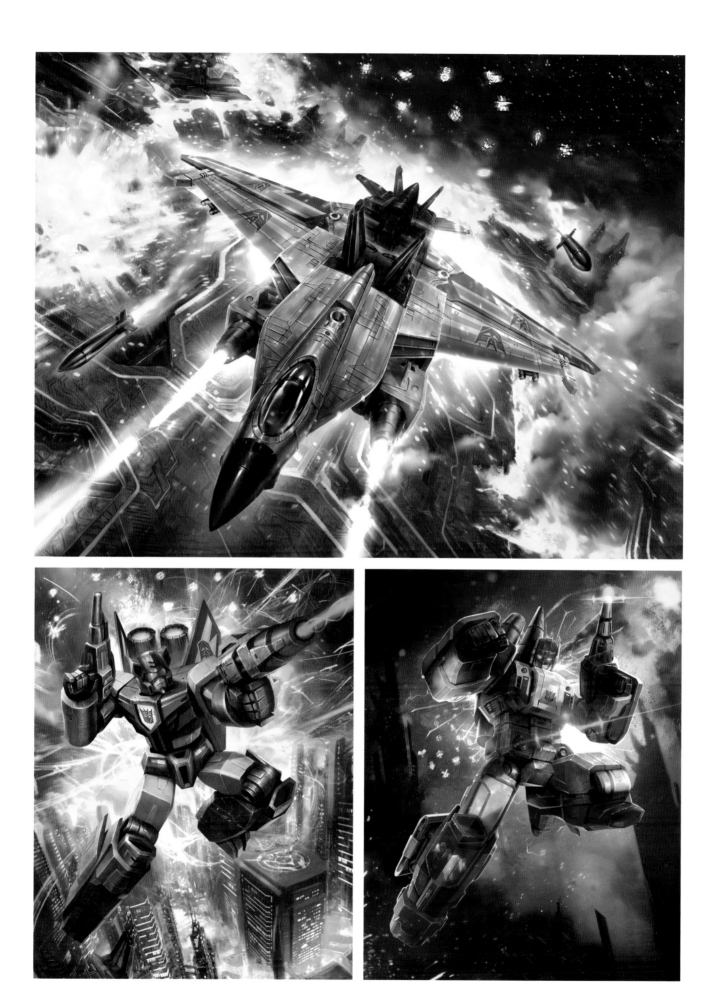

Top: Promo art, Dreadwing, *Transformers: Power of the Primes* | Volta (color)

Bottom: Package art, Dreadwind, Blackwing, *Transformers: Power of the Primes* | Volta (color)

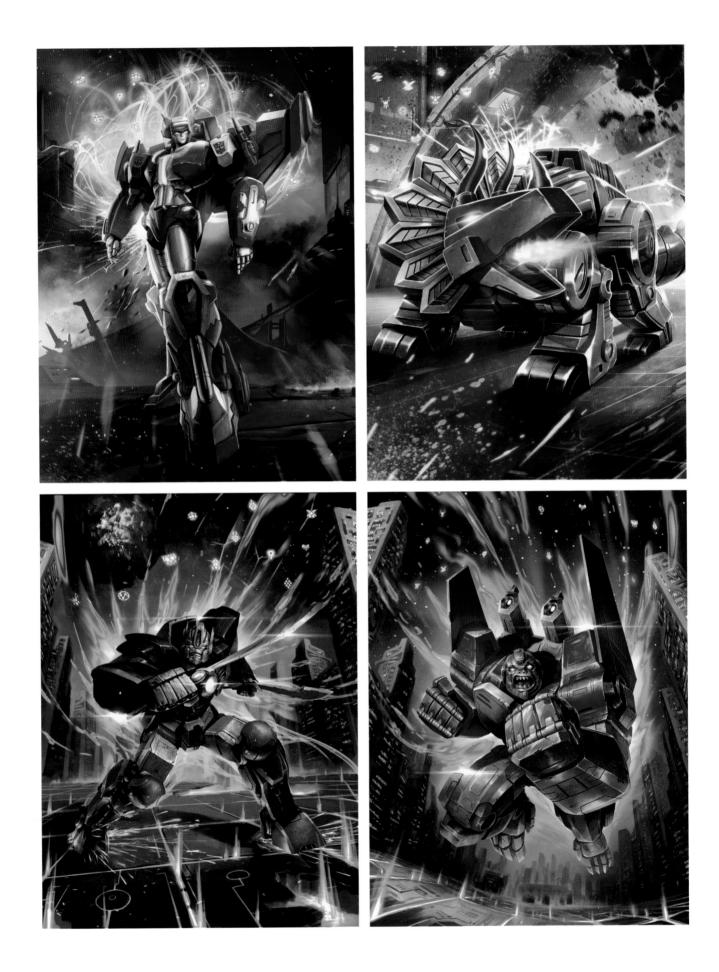

Clockwise from top left: Package art, Elita-1, Slug, Optimal Optimus (unused color scheme), Optimus Primal, *Transformers: Power of the Primes* | Volta (color)

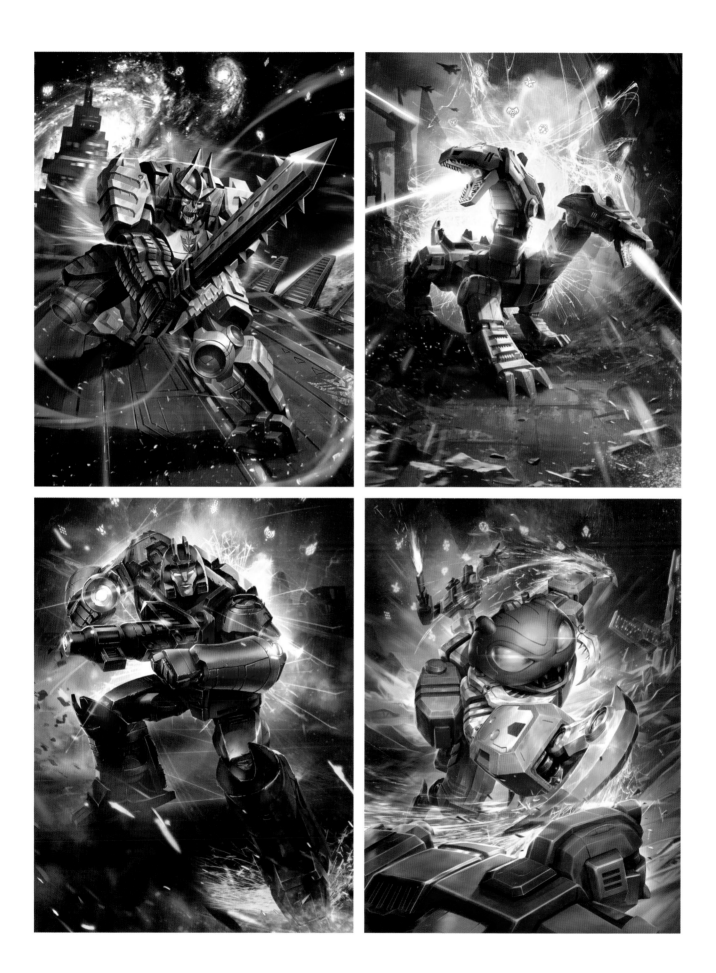

Clockwise from top left: Package art, Bludgeon, Hun-Gurrr, Special Edition Repugnus (Prime Wars Trilogy), Orion Pax, *Transformers: Power of the Primes* | Volta (color)

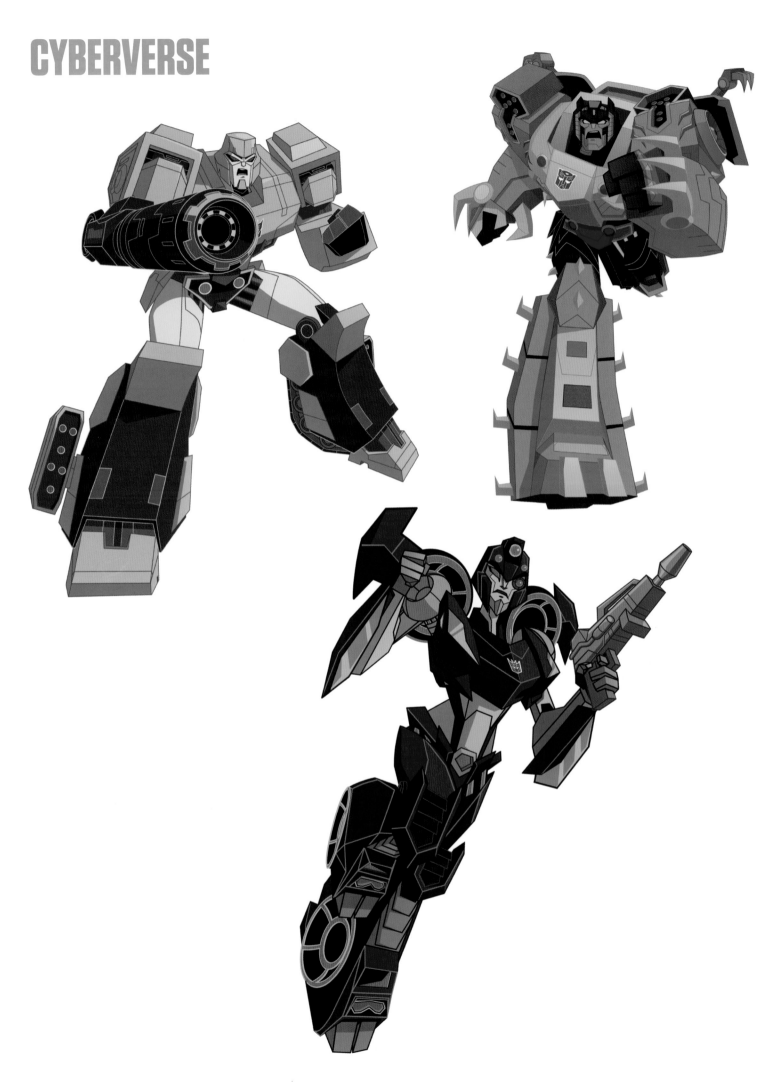

Clockwise from top left: Package art, Megatron, Grimlock, Shadow Striker, *Transformers: Cyberverse*

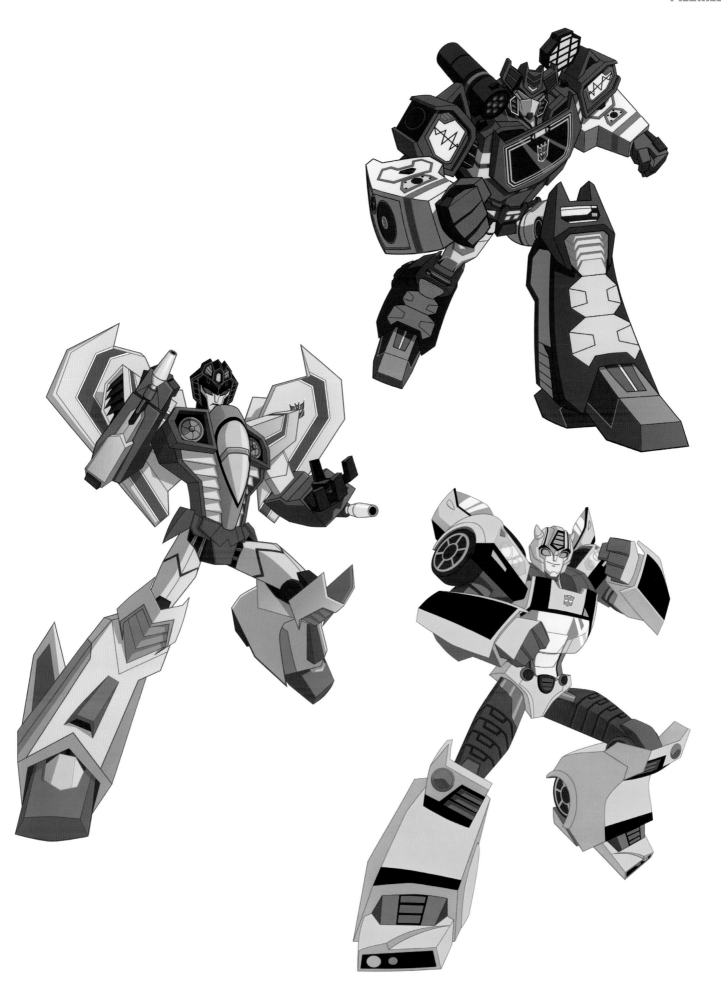

Clockwise from top right: Package art, Soundwave, Bumblebee, Starscream, *Transformers: Cyberverse*

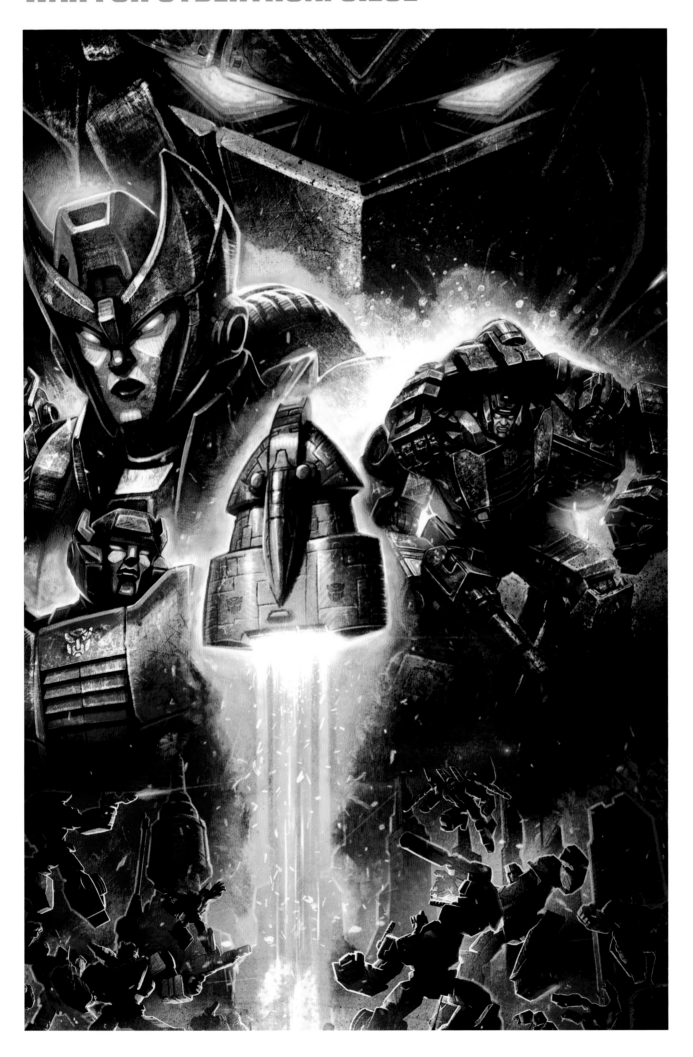

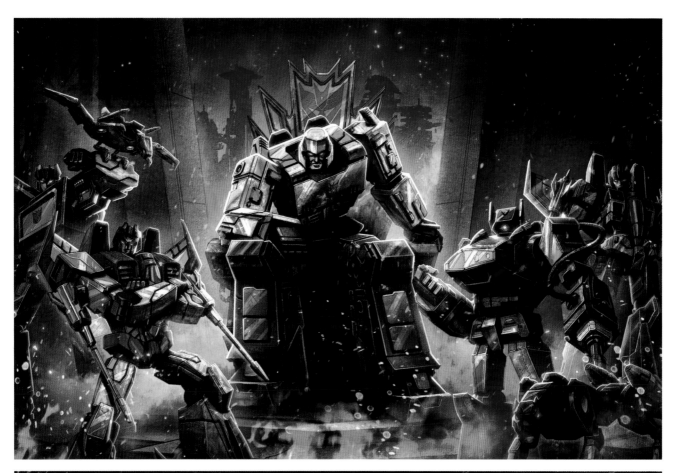

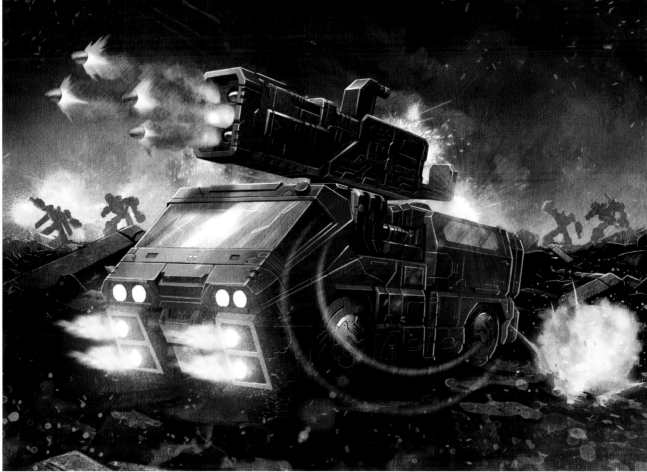

Opposite: Package mural, *War for Cybertron: Siege*

Top: Promo art, *War for Cybertron: Siege*

Above: Promo art, Ironhide, *War for Cybertron: Siege*

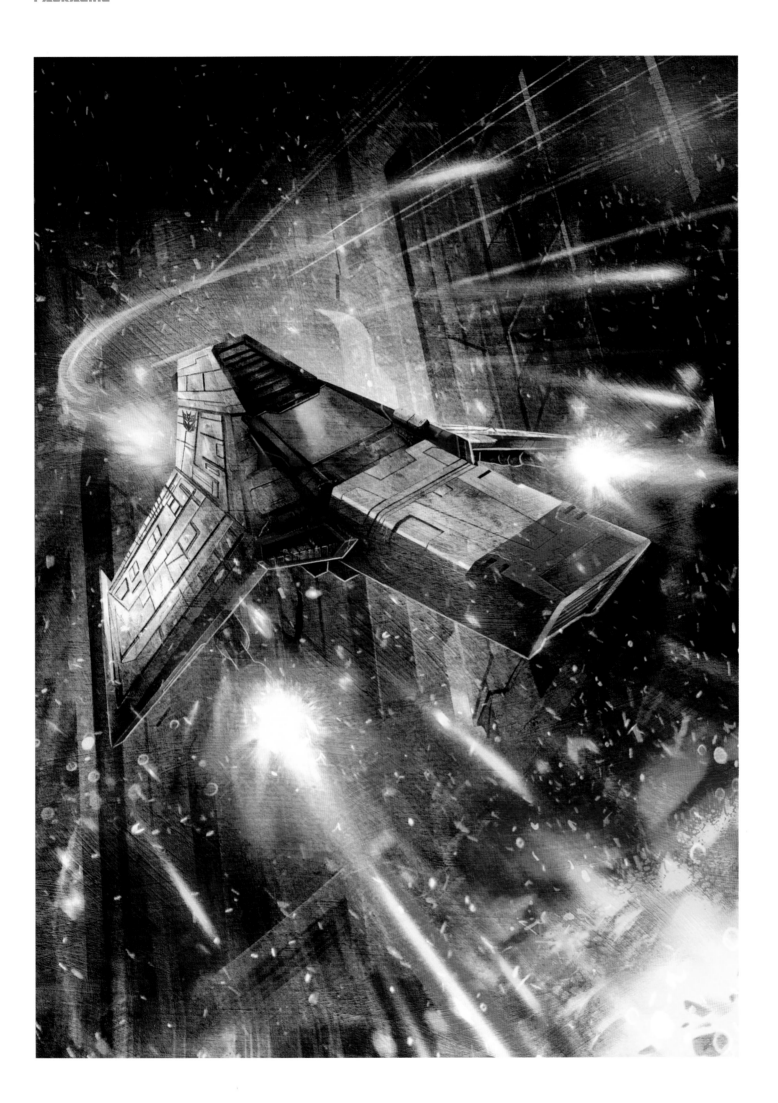

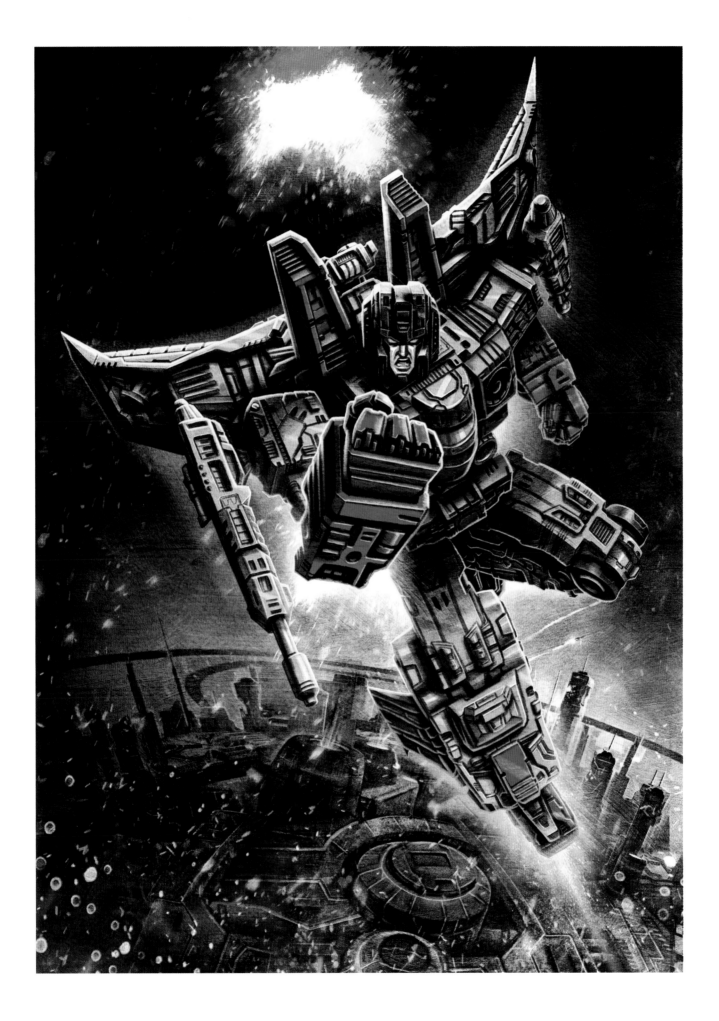

Opposite: Card art, Starscream, *War for Cybertron: Siege*
Above: Package art, Starscream, *War for Cybertron: Siege*

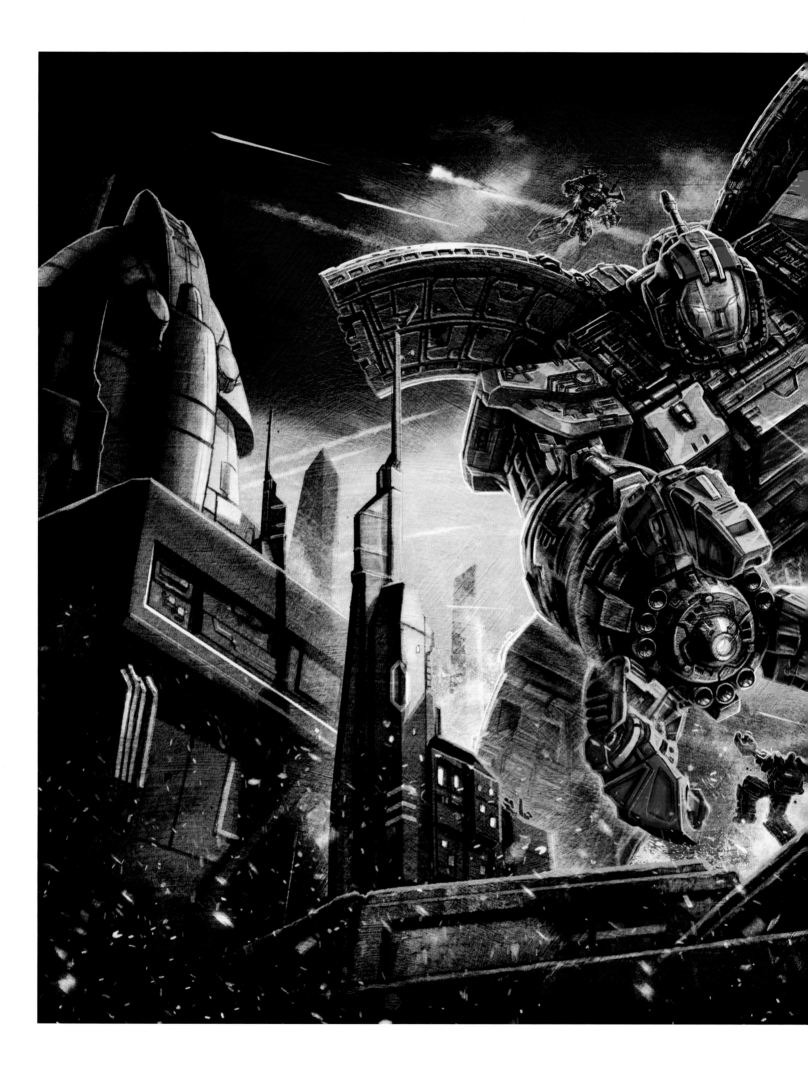

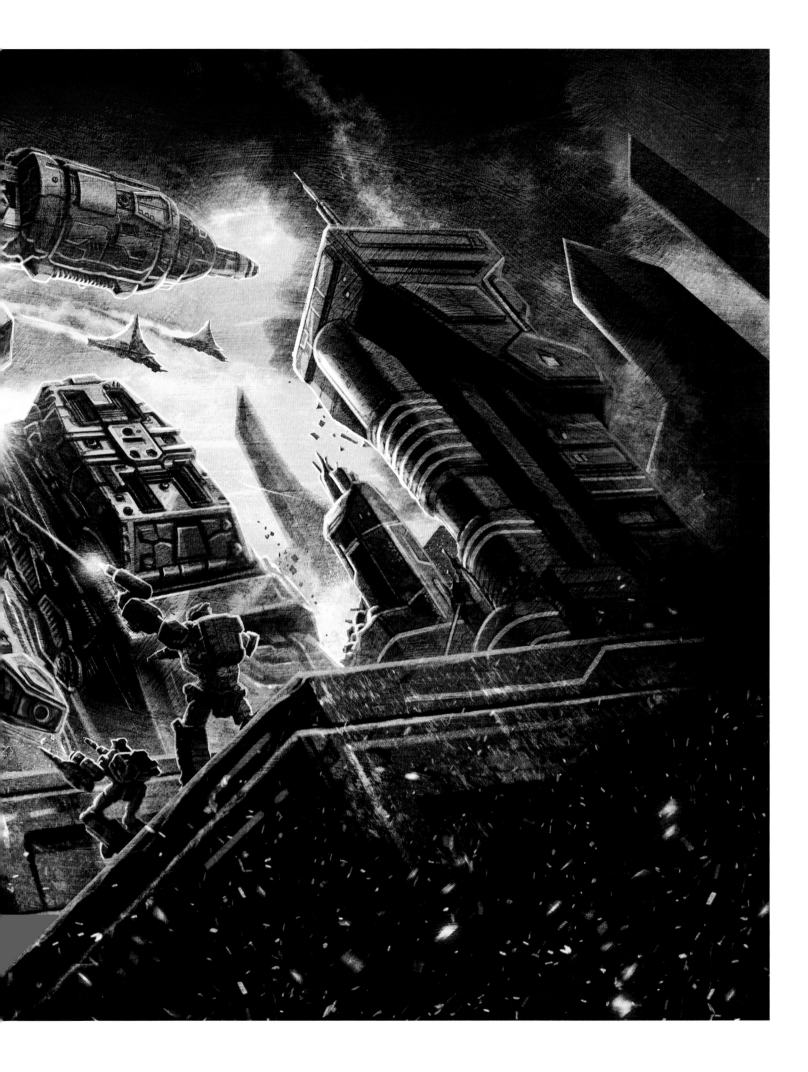

Above: Package art, Omega Supreme, *War for Cybertron: Siege*

Although they were created with little thought given to outside consumption, there is nevertheless a kind of stark beauty to these industrial drawings. These vintage technical documents were created to aid in the process of toy creation, specifically the 1987–1990 toy lines. Illustrations such as these are almost never seen outside of the context of toy production.

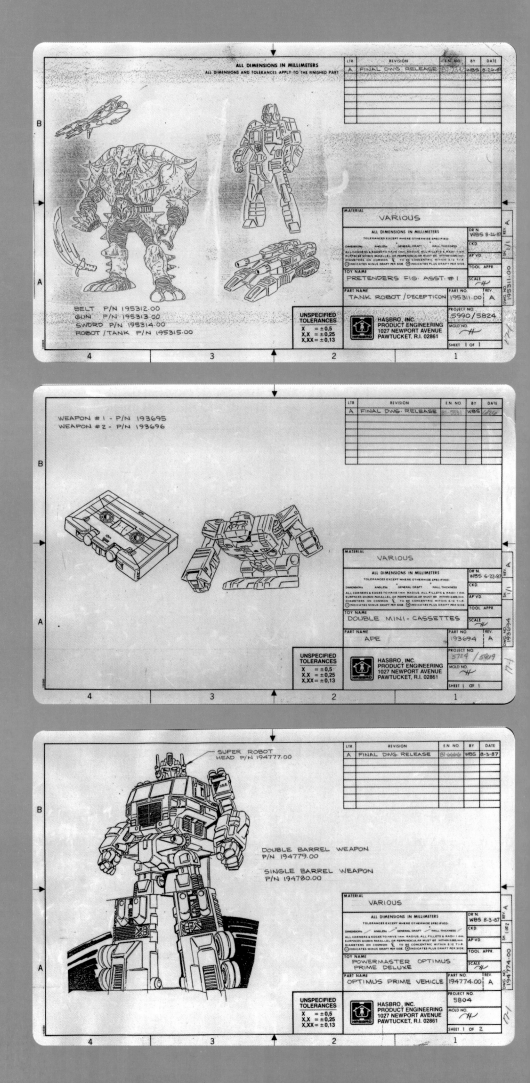

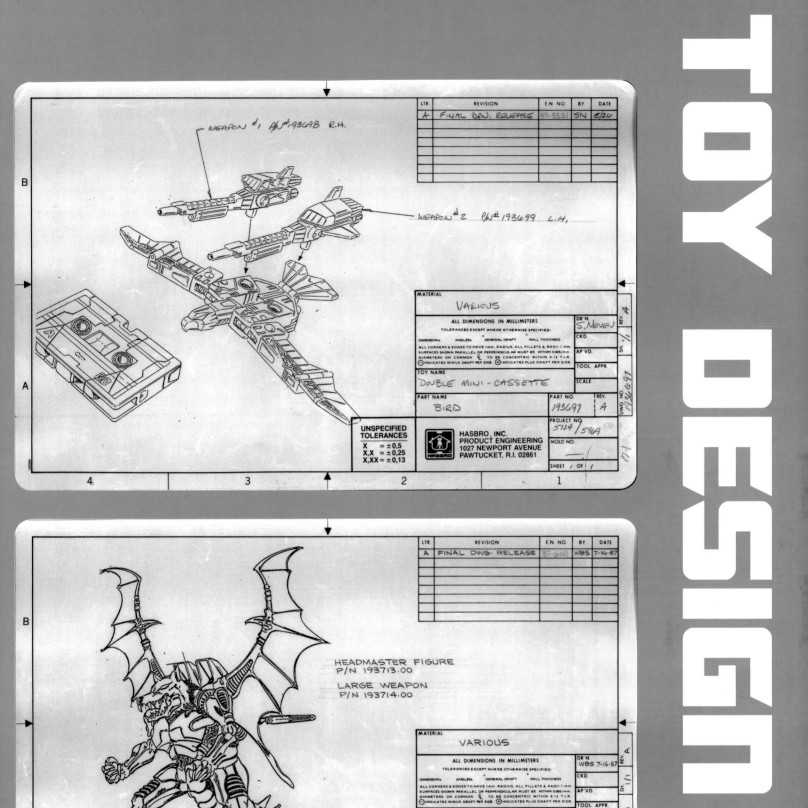

Opposite, from top: Technical drawings, Skullgrin, Beastbox, Powermaster Optimus Prime, Generation 1

From top: Technical drawing, Squawktalk, Fangry, Generation 1

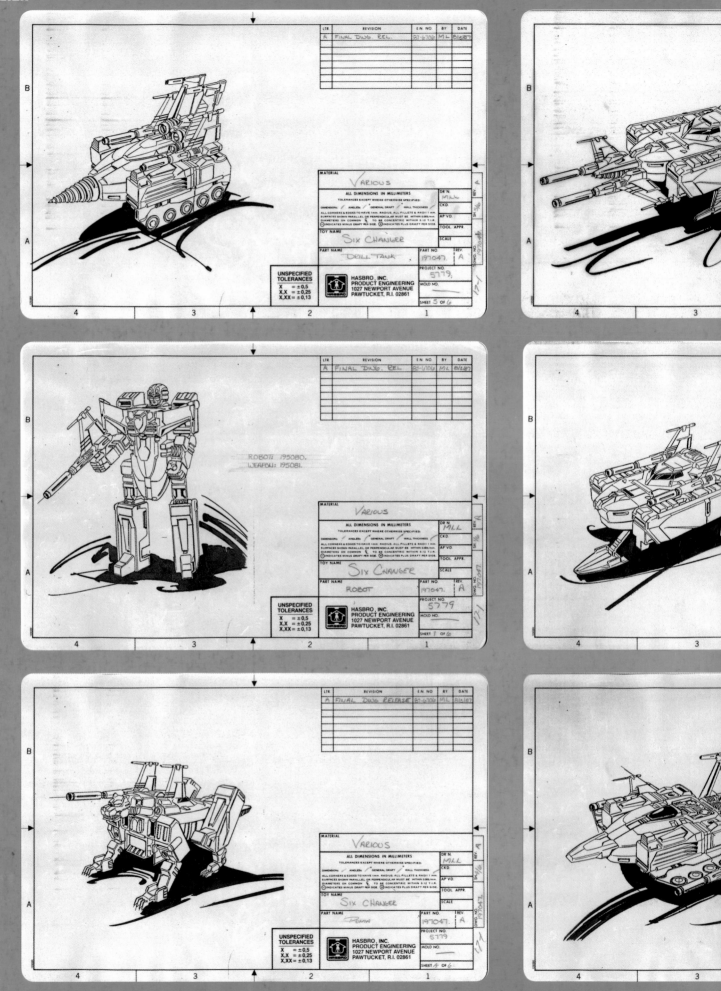

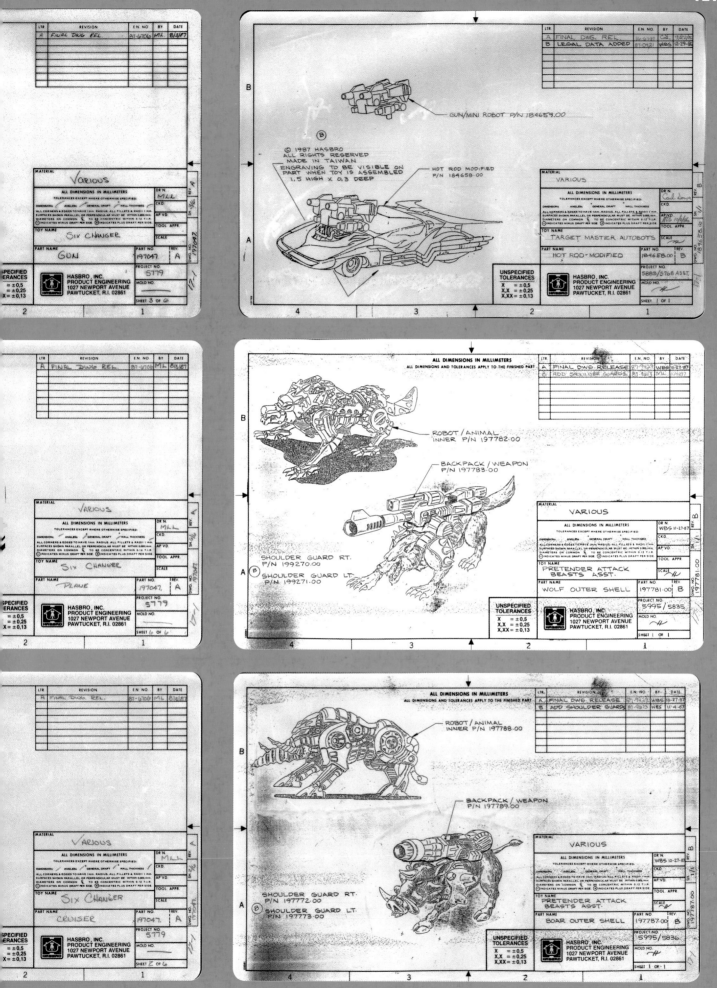

These pages, first two columns: Technical drawings, Quickswitch, Generation 1

These pages, righthand column: Technical drawings, Targetmaster Hot Rod, Carnivac, Snarler, Generation 1

THE TRANSFORMERS
Treatment

Civil War rages on the planet Cybertron. Destruction
is catastrophic and widespread, and yet no life is lost.
None, at least, in the sense that we know life--for the in-
habitants of Cybertron are all <u>machines</u>. There is no "life"
on Cybertron save for mechanical, electronic "creatures".
As mankind is first among the organic denizens of Earth, in-
telligent, sentient <u>robots</u> are the dominant species on Cyber-
tron. Even the planet <u>itself</u> is one vast mechanical con-
struct. Perhaps there was once a "real" world upon which
Cybertron was built on, into , under, and through until no
trace of the original planet can be found, but the origin of
the planet is unknown, lost in antiquity. Similarly, it is
unknown whether the robotic "life" of Cybertron was originally
created by some mysterious, advanced, alien race in the dim,
distant past, or whether these strange metallic beings some-
how evolved from bizarre, basic life forms beyond human com-
prehension.

What is certain is that the sentient, robotic beings
of Cybertron are destroying one another.

The Autobots have, for untold eons, devoted themselves
to peaceful pursuits--commerce, trade, and travel--wayfaring
endlessly upon the broad turnpikes, through the winding
transit tubes, and across the soaring skyhighways of Cyber-
tron.

The Decepticons have no use for peace. For untold eons
they have developed their technological capabilities, and
quietly prepared themselves for war, all the while dwelling

Transformers has inarguably flourished in many mediums, but comics has always been where the boundaries of the franchise have been pushed. With relatively low costs and production cycle times compared to other expressions of the brand, Transformers comics have proven to be something of a laboratory where different creators can experiment with new characters, themes, settings, and even cosmology.

Comics played an integral role in the initial launch of Transformers. In 1983, Hasbro was getting ready to import a funky line of Japanese robots who could change shape. They had the name of the brand, as well as the name of the two warring factions. They needed to develop everything else. Who were these robots? Why were they fighting? Why did they turn into cars and planes? Collaboration being the name of the game, Hasbro brought in Marvel Comics Editor-in-Chief Jim Shooter, who ultimately created an eight-page treatment, a foundational document from which every subsequent Transformers continuity has drawn. With the basic premise in place, Hasbro worked with Marvel editor Bob Budiansky to create names and personalities for the toys, a job he'd hold for the entirety of the Generation 1 run. Bob remembers fighting for the name Megatron, which was originally rejected as "too scary" due to its vague associations with the Cold War and the specter of nuclear war. However, the name stuck. The treatment and character bios ultimately went on to be used in every major prong of the initial Transformers release: the Transformers comic, the animated television series, and the toys. This cross pollination worked both ways, with the character designs produced by Floro Dery for the television show featuring in the comics.

With the backstory firmly in place, Hasbro got ready to roll out their new product line. They'd learned much from the action figure boom that was the 1982 G.I. Joe relaunch, and were ready to put that knowledge to good use. One key component was a comic book launch.

The comic itself was a smash hit. Originally marketed as a four-issue miniseries, its popularity expanded the run into an ongoing series, one which featured four spin-off books in the US and ultimately ran for 80 issues.

There were two main writers, the aforementioned Bob Budiansky, who helmed the series from issues 5 through 55 with just a few exceptions, and Simon Furman, from issue 56 through the end. A plethora of artists lent their talents to the series, with large stretches by Herb Trimpe, Frank Springer, Don Perlin, José Delbo, Geoff Senior, and Andy Wildman.

But the United States market was only half the story. So successful was the *Transformers* comic in the United Kingdom that Marvel UK ran the comics weekly, with most US stories split into two eleven-page segments. With the US getting twenty-two pages a month and the UK getting forty-four or more, Britain quickly ran out of material to import. Enter Simon Furman, who was brought on to pen new stories. At first they took place largely in and around the American stories, using characters who weren't getting much play in the US, like the Dinobots. Later, when *The Transformers: The Movie* introduced the idea of a time jump two decades into the future (the far-off year of 2006), Furman had a whole new cast of characters to play with. When Budiansky eventually left the US series, he recommended Furman for his old job, as probably the only working writer in the world who could hit the ground running on an incredibly convoluted toy comic with a cast of hundreds. Furman brought Senior and Wildman with him.

All good things come to an end, and Furman eventually presided over the end of the US series (dutifully reprinted shortly thereafter in the UK) with the eerily prophetic quote, "it never ends." The book would be briefly revived in the '90s as *The Transformers: Generation 2*. Featuring a radically new art style by Derek Yaniger and Manny Galan, with Furman again at the helm, it ran for twelve issues as a direct continuation of the Marvel series. But that soon came to an end, and so too did Marvel's ongoing relationship with Transformers.

For a time there was darkness. Oh, to be sure, there was some Transformers manga produced in Japan, a toy pack-in *Beast Wars* mini-comic—even the occasional convention book—but American comic book shops had nothing but back issues. Then, in the year 2000, newcomer Dreamwave Productions (at the time a studio within publisher Image Comics) made a big splash with a manga-inspired Transformers image published

Previous: Cover art, *The Transformers* #36 and *Transformers: More than Meets the Eye* #36, IDW Publishing | Alex Milne & Josh Perez

Opposite: Treatment letter for *The Transformers* comic by Marvel Comics Editor-in-Chief, Jim Shooter

in the pages of *Wizard* magazine. Suddenly everyone wanted to get the Transformers license. Ultimately, it was the now-independent Dreamwave that prevailed, and when the brand-new *Transformers* #1 hit in April 2002, it was the best-selling comic of the month. Indeed, a *Transformers* comic would top the charts for four out of the next five months as well.

Dreamwave's success would be short-lived. Financial troubles plagued the company, and by January 2005 they had declared bankruptcy. Despite this, Dreamwave managed to produce nearly one hundred issues of content in their scant three years, brought writer Simon Furman back into the fold, and introduced fan artists such as Don Figueroa, Guido Guidi, James Raiz, and Alex Milne to a wider audience. They also introduced the idea of multiple independent continuities, namely their thirty issues of *Energon* (née *Armada*) ongoing and their G.I. Joe crossover set during an alternate World War II history. This was something Marvel never attempted with Transformers. Finally, their *War Within* series, by Furman and Figueroa—considered by many the high-water mark of the Dreamwave days—even inspired a number of toys, a first for comics. Its focus on the pre-Earth conflict betwixt Autobot and Decepticon and detailed Don Figueroa designs made it ideal for this milestone.

Though Dreamwave was no more, Transformers had once again proven itself a viable property. Enter IDW Publishing. A small publisher, best known at the time for their *30 Days of Night* horror comic, they acquired the license shortly after the collapse of Dreamwave. By October of 2005, they had published their first book, a prelude to the six-issue miniseries titled *Infiltration*. Once again, Simon Furman was brought on board, and he crafted a series of miniseries and stand-alone issues telling a slow-burn story of a vast interstellar conflict. As in *The War Within*, much attention was paid to the design of the characters, with Autobots and Decepticons transforming into modern vehicles. Artist E.J. Su provided early designs, and was soon joined by veterans like Don Figueroa and newcomers like Nick Roche. The series debuted to solid numbers, and ran in this fashion for several years.

The second wave began with writer Shane McCarthy's *All Hail Megatron* maxi-series. *All Hail Megatron* was a twelve-issue event (plus five supporting Spotlight issues and eight coda stories spread out over an additional four issues) that functioned as a soft reboot. With designs owing more to the classic G1 cartoon and a penchant for ultraviolence, this series attempted to again harness the nostalgia beast. Guido Guidi returned to provide the bulk of the artwork, and distinctive propaganda-style covers were provided by Trevor Hutchison.

WHO WERE THESE ROBOTS? WHY WERE THEY FIGHTING?

It paved the way for the third wave of stories, an ongoing series penned by Mike Costa. Costa began with the fallout of *All Hail Megatron* and gradually expanded the scope of his stories, from national to international to interstellar. His run lasted for thirty-one issues and was again supported by multiple miniseries, ending with the event storyline *Chaos*. A variety of artists, new and returning, lent their talents to these issues, so no one visual style dominated. Of all the plotlines, it was probably *Chaos*, with the unique stylings of Livio Ramondelli, that had the most recognizable art direction.

But IDW was just getting started. All of the above, some 125 issues of content running from 2005-2011, merely represents Phase 1 of IDW's Generation 1 output. 2012 would see not one but two ongoing G1 series; *More Than Meets the Eye*, written by James Roberts, and *Robots in Disguise*, written by John Barber. Roberts had previously distinguished himself during the third wave of content with the 2010 miniseries *Last Stand of the Wreckers*, and he did not disappoint on *More Than Meets the Eye*, telling the tale of the crew of the *Lost Light* and their search for Cyberutopia. Fan favorite Alex Milne was the primary artist for the entirety of the book's run. Barber, meanwhile, who was known to Transformers fans for his work with the *Transformers* movie comics, shifted to focus on the political scene on Cybertron following the planet-shaking events of *Chaos*. Andrew Griffith served as the main artist. Both books saw regular retailer exclusive covers by artist Marcelo Matere. This wave of stories ended with the *Dark Cybertron* plotline in 2014, seeing the crew of *Lost Light* return to Cybertron and again synching up their casts.

The fifth wave of IDW stories was less of a shake-up than previous iterations. Roberts stayed on *MtMtE*, though the crew was changed, with the notable addition of Autobot Megatron as co-captain. Barber stayed on *Robots in Disguise* (eventually simply renamed *The Transformers* to avoid confusion with the new *Robots in Disguise* cartoon) but brought the cast to Earth. New writer Mairghread Scott, who had previously worked on the *Transformers: Prime* television series and various comic spin-offs, was given a third branch of stories featuring the fan-created character Windblade. This wave ended with the *Titans Return* event in 2016, ushering in the sixth and final wave of IDW G1 stories.

The sixth wave, running from 2016 through 2018, once again kept Roberts, Barber, and Scott on as the primary writers, but saw significant shake-ups nonetheless. *More Than Meets the Eye* came to an end after fifty-seven issues and was reborn as Lost Light, which ran for twenty-five issues. Jack Lawrence provided the bulk of the artwork for that series. The Transformers ongoing also ended at

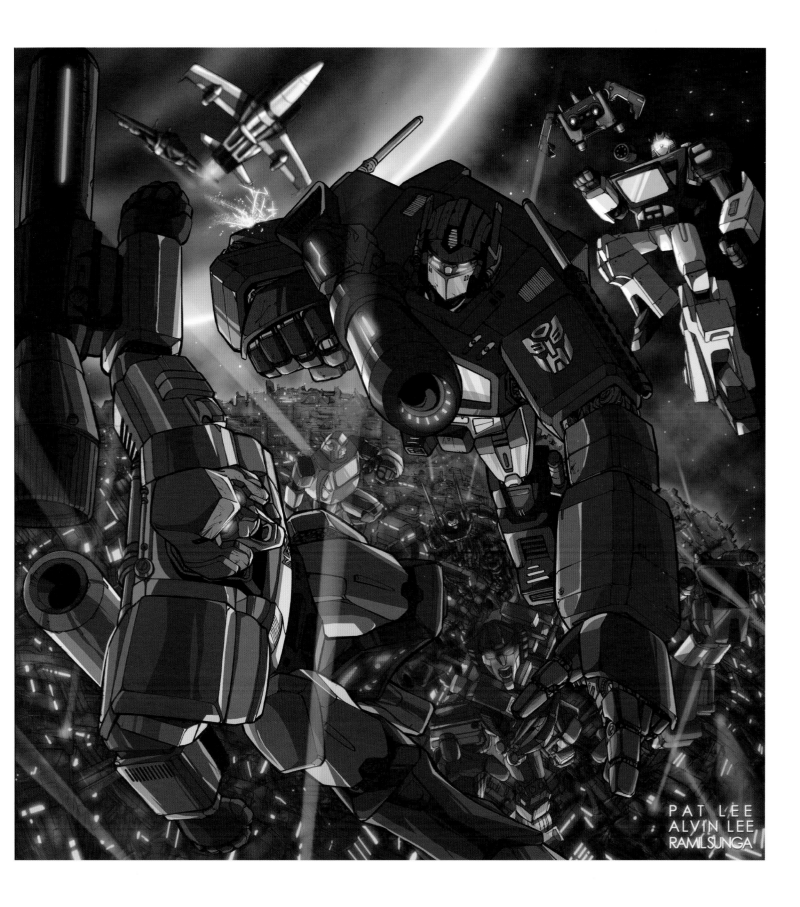

Above: Concept art, *Wizard Magazine* | Pat Lee, Alvin Lee, & Ramil Sunga

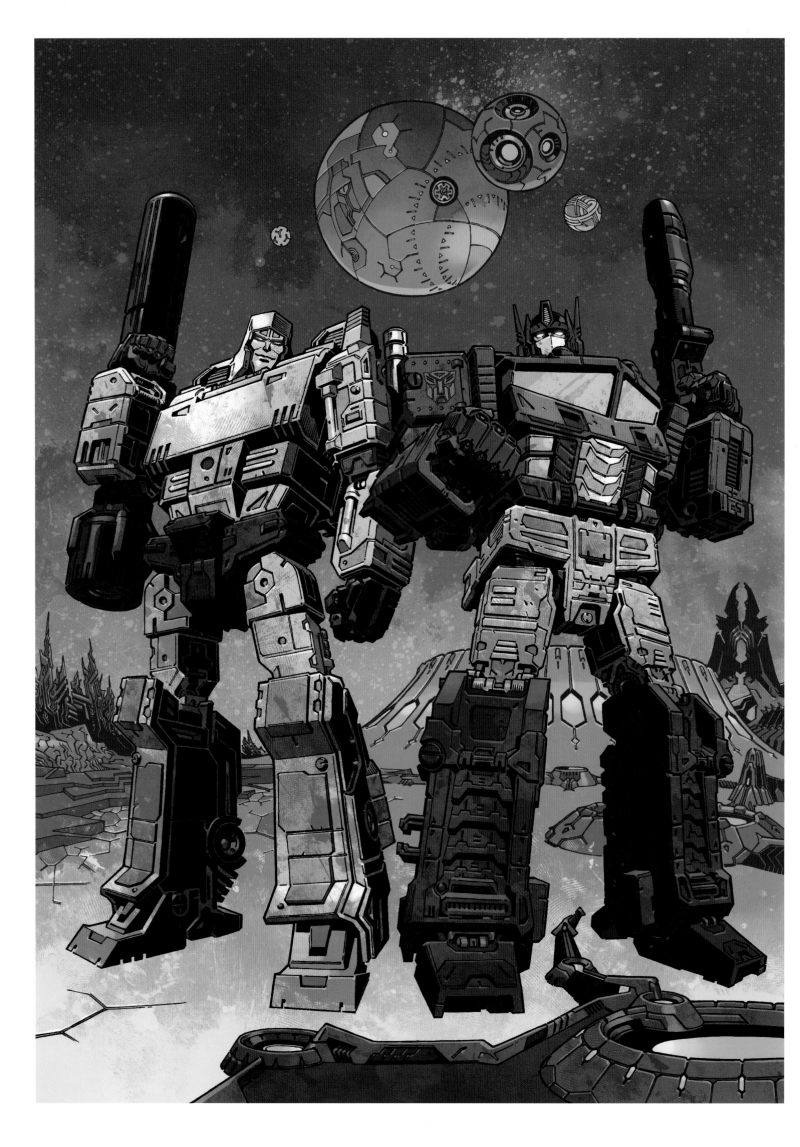

issue 57, with plot threads picked up in the Optimus Prime ongoing, which also ran for twenty-five issues. Artist Kei Zama was the lead artist on the book. Scott was given the twelve-issue series *Till All Are One*, with art by Sara Pitre-Durocher. But what really sets the sixth wave apart isn't Transformers at all—it's all the *other* Hasbro characters. Over the course of two crossover events, *Revolution* and *First Strike*, the Transformers universe was expanded to include G.I. Joe, M.A.S.K., ROM Spaceknight, Visionaries, Micronauts, and Action Man. These various heroes would intersect with the Transformers again and again, over numerous miniseries, until eventually the entire enterprise came to its universe-shattering conclusion with the six-issue *Unicron* miniseries (by Barber and Milne). When all was said and done, the IDW G1 continuity had spanned thirteen years and well over four hundred issues, by far the largest and most successful *Transformers* print continuity to date.

While Generation 1 undoubtedly represented the flagship of IDW's *Transformers* output, those were far from their only *Transformers* books. IDW also released a pair of *Beast Wars* miniseries and a series of *Beast Wars* profiles; a long-running series of adaptations and expansions of the Transformers film franchise running dozens of issues; a six-issue in-continuity miniseries for *Transformers Animated* written by the head writer of the show Marty Isenberg; a twenty-two-issue sequel to the original Marvel G1 *Transformers* series

that reunited the dream team from the final days of that book; an ongoing *Transformers vs. G.I. Joe* book by writer/artist Tom Scioli featuring one of the most way-out interpretations of the brand ever; and six miniseries tying directly into *Transformers: Prime* and its associated spin-offs and tie-ins.

Over the years, other, smaller publishers have tried their hands at Transformers. Notably, convention organizers Fun Publications produced a number of *Transformers* comics over their twelve-year association with the brand, spanning from 2005 through 2016. Each convention featured a full-length comic, and their bimonthly magazine featured six pages of comic stories every issue. They also released a series of online prose stories, all of which were illustrated. In Japan, a rich tradition of manga and ancillary publishing supported many of their various cartoon and toy releases, including some stunning artwork from Studio OX released in the pages of *Television Magazine*.

And what comes next for the *Transformers* comics? We'll just have to wait and see. Though IDW has ended their main continuity, they've recently rebooted the series, beginning appropriately enough in the days before the Great War between the Autobots and the Decepticons. If their new continuity is half as successful as their last, it'll be a storytelling juggernaut.

It never ends, indeed!

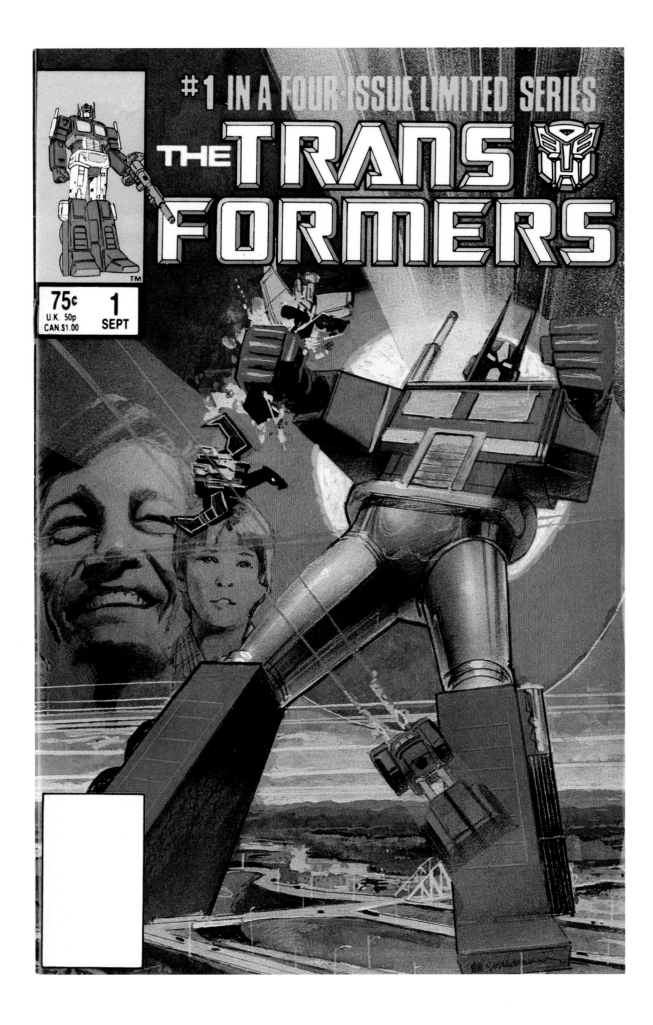

Above: Cover art, *The Transformers* #1, Marvel Comics | Bill Sienkiewicz

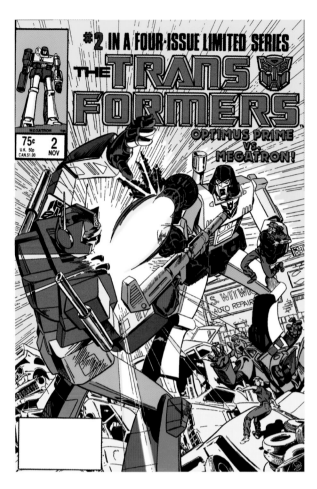

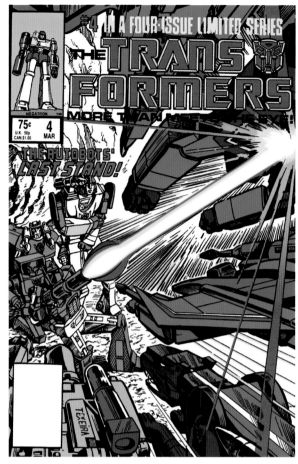

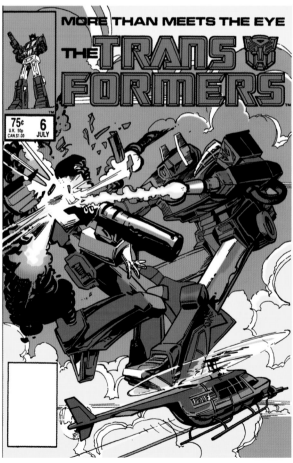

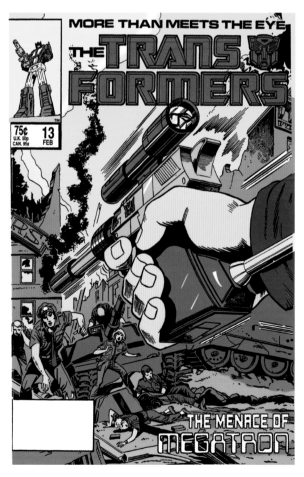

Clockwise from top left: Cover art, *The Transformers* #2, *The Transformers* #4, *The Transformers* #13, *The Transformers* #6, Marvel Comics | Michael Golden, Mark Texeira, Don Perlin, Alan Kupperberg

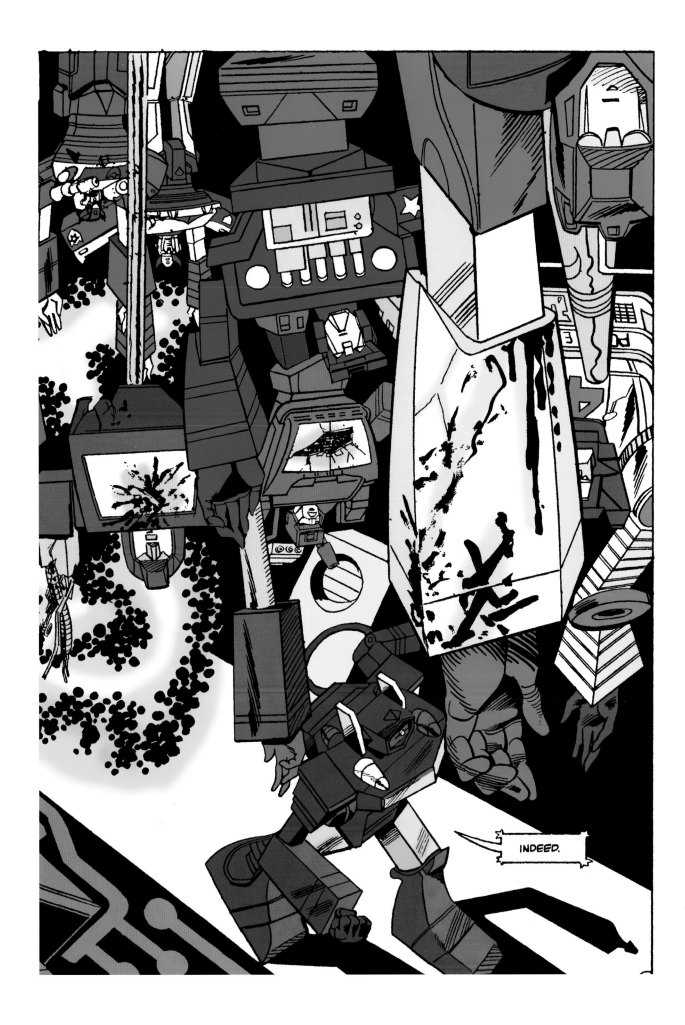

These pages: Interior art, *The Transformers* #5, Marvel Comics | Alan Kupperberg & Nel Yomtov

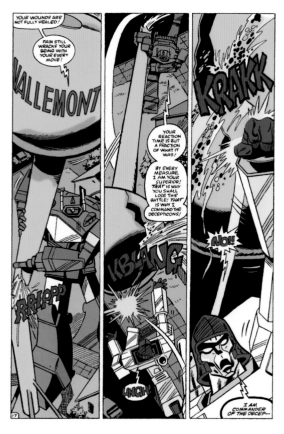

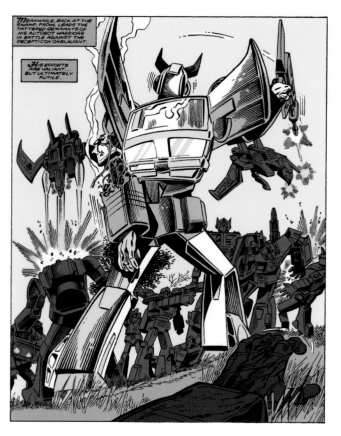

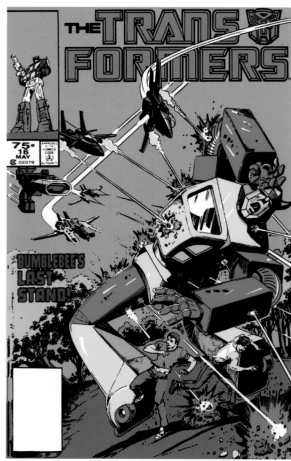

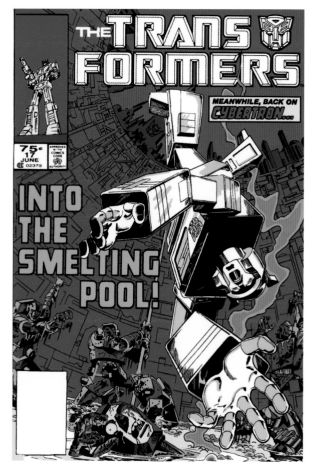

Top: Interior art, *The Transformers* #6, | Alan Kupperberg, Nel Yomtov;
The Transformers #12, Marvel Comics | Herb Trimpe, Al Gordon, Nel Yomtov

Below: Cover art, *The Transformers* #16, Marvel Comics | Herb Trimpe, Nel
Yomtov; *The Transformers* #17, Marvel Comics | Herb Trimpe, Nel Yomtov;

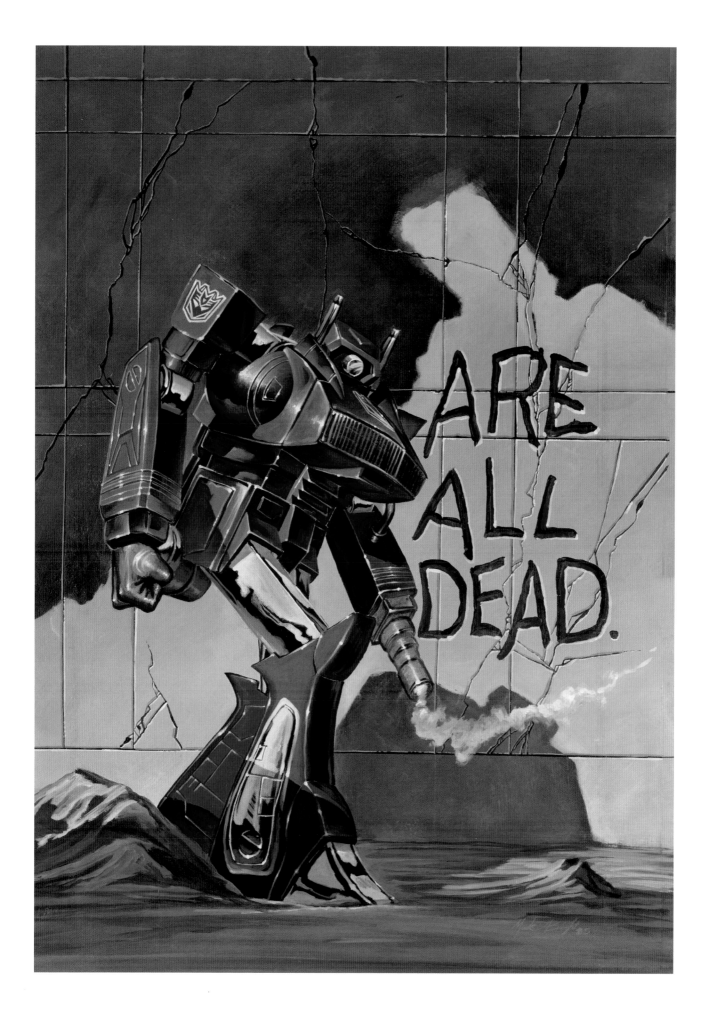

Above: Cover art, *The Transformers* #5, Marvel Comics | Mark D. Bright

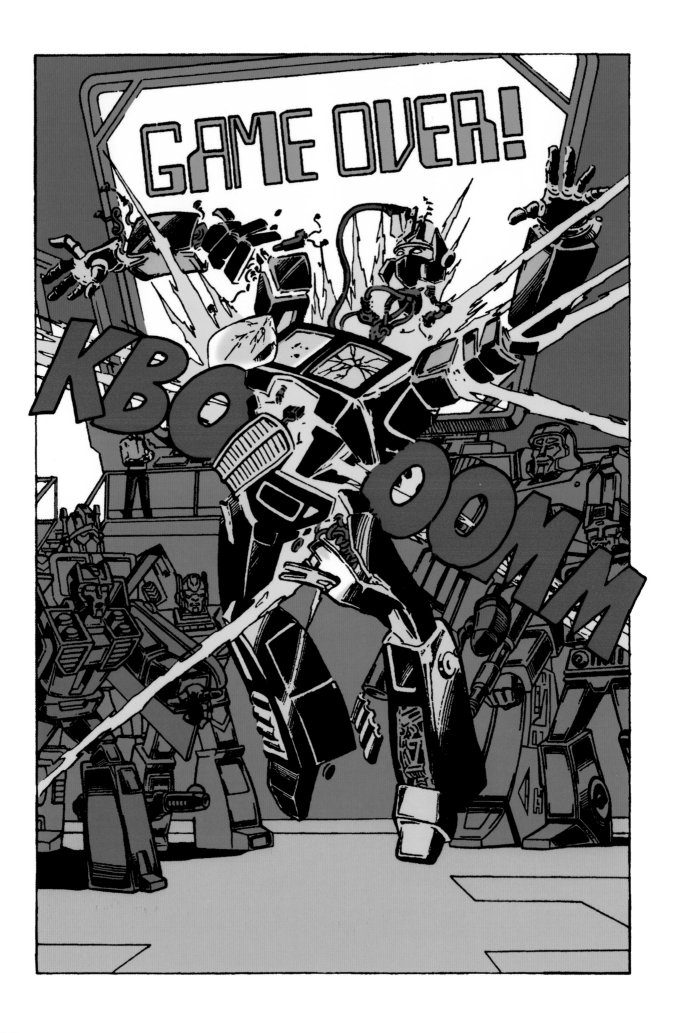

Above: Interior art, *The Transformers* #24, Marvel Comics | Don Perlin, Ian Akin & Brian Garbey, Nel Yomtov

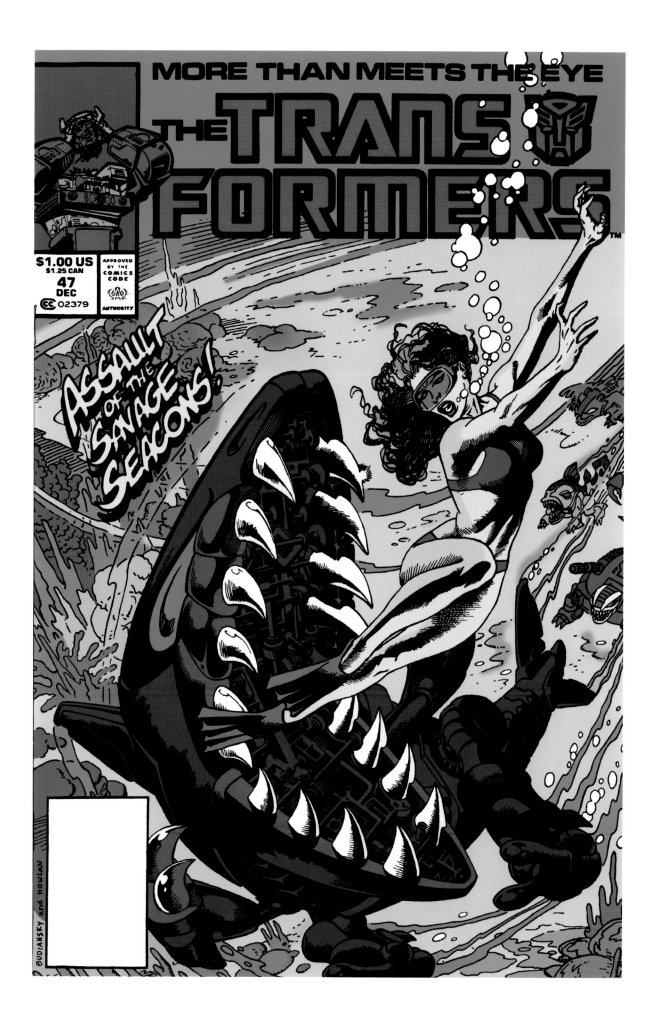

Above: Cover art, *The Transformers* #47, Marvel Comics | Bob Budiansky & Kevin Nowlan

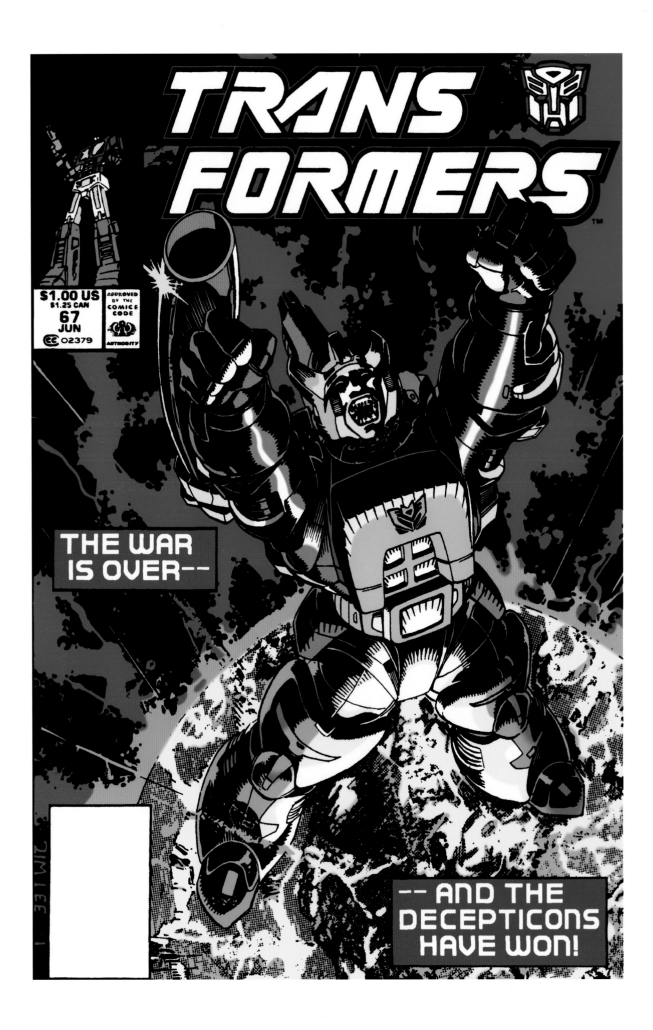

Above: Cover art, *The Transformers* #67, Marvel Comics | Jim Lee

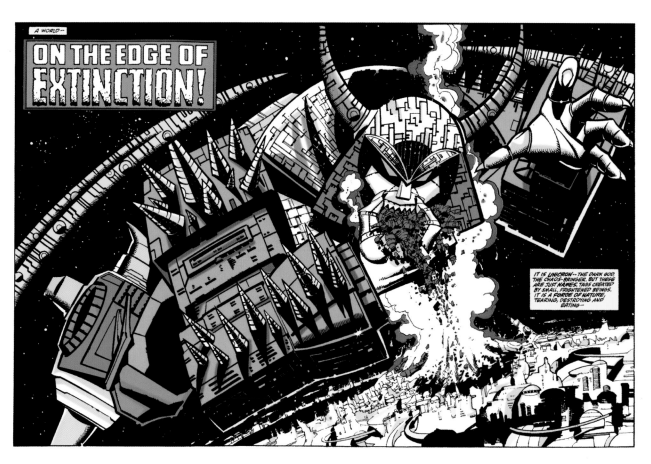

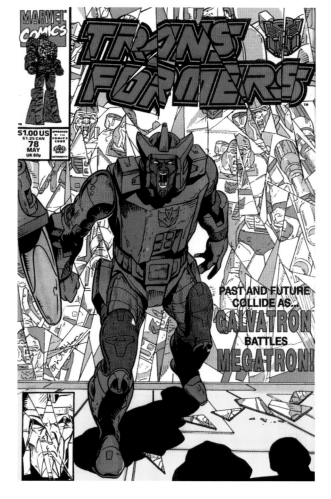

Top: Interior art, *The Transformers* #75, Marvel Comics | Geoff Senior & Nel Yomtov

Below, from left: Interior art, *The Transformers* #65, Marvel Comics | Geoff Senior & Nel Yomtov; cover art, *The Transformers* #78, Marvel Comics | Andrew Wildman

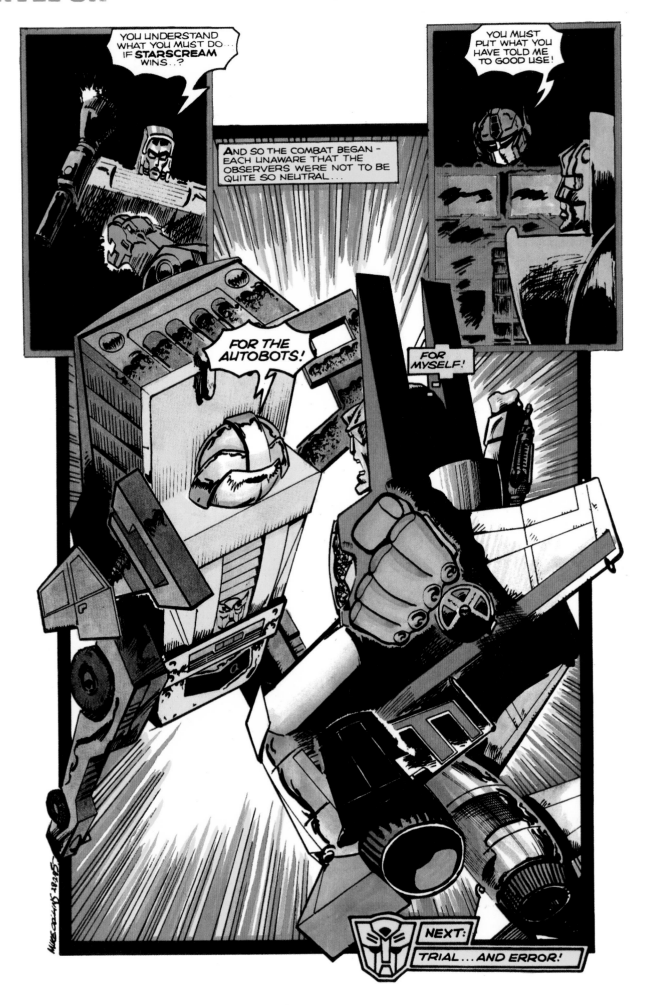

Above: Interior art, *The Transformers* #15, Marvel UK | Mike Collins, Gina Hart

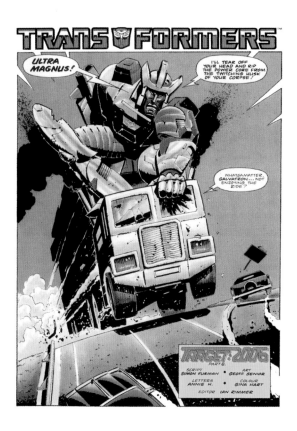

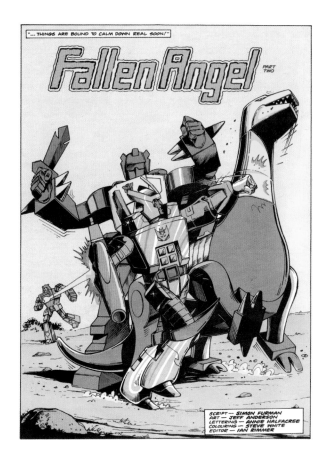

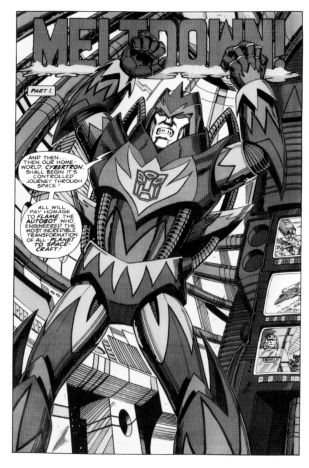

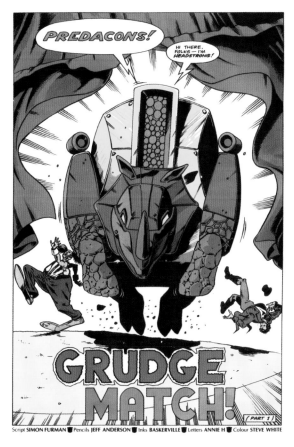

Clockwise from top left: Interior art, *The Transformers* #86, #102, #135, #168, Marvel UK | Geoff Senior
& Gina Hart, Jeff Anderson & Steve White, Jeff Anderson & Steve White, Robin Smith & Euan Peters

Following: Poster, *The Transformers Annual 1986*, Marvel UK | John Higgins

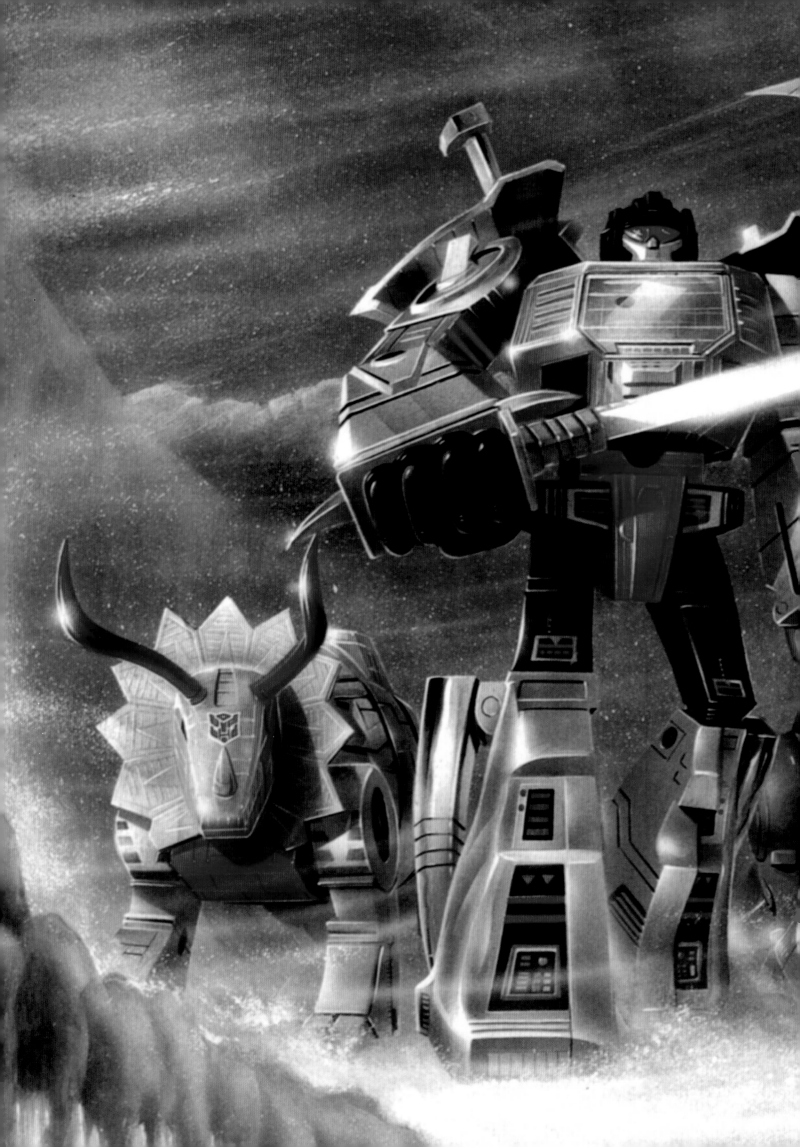

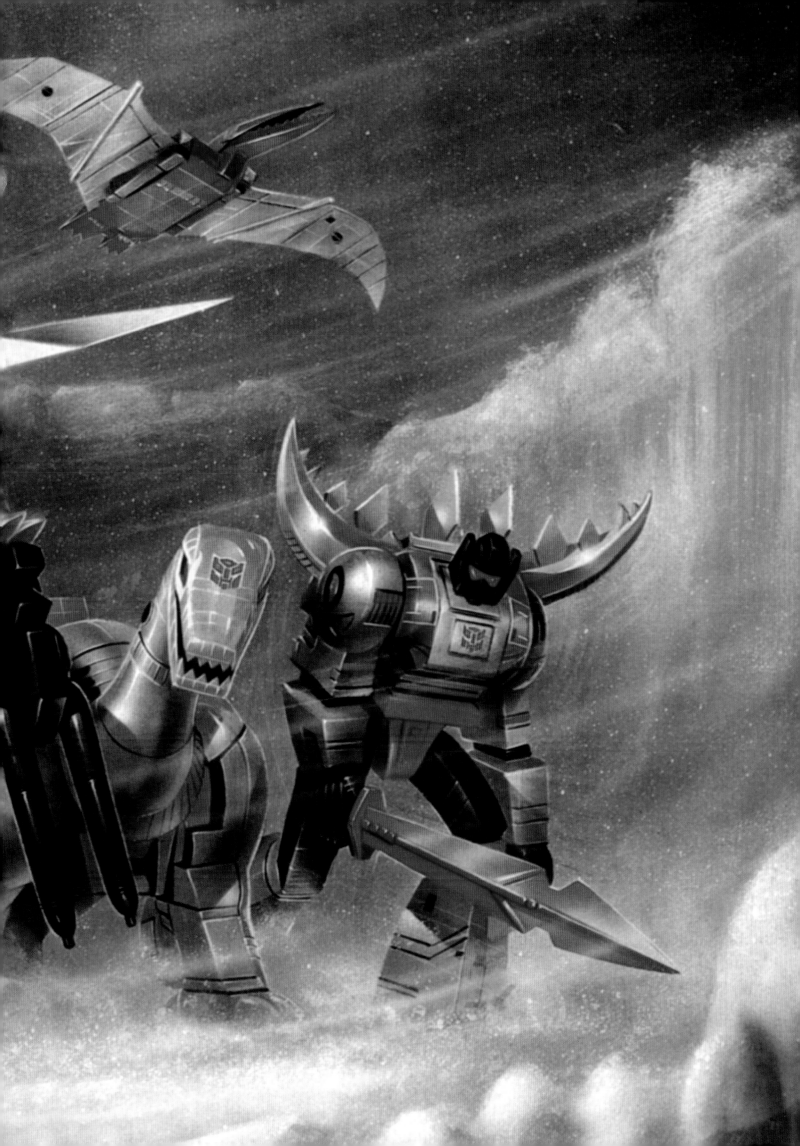

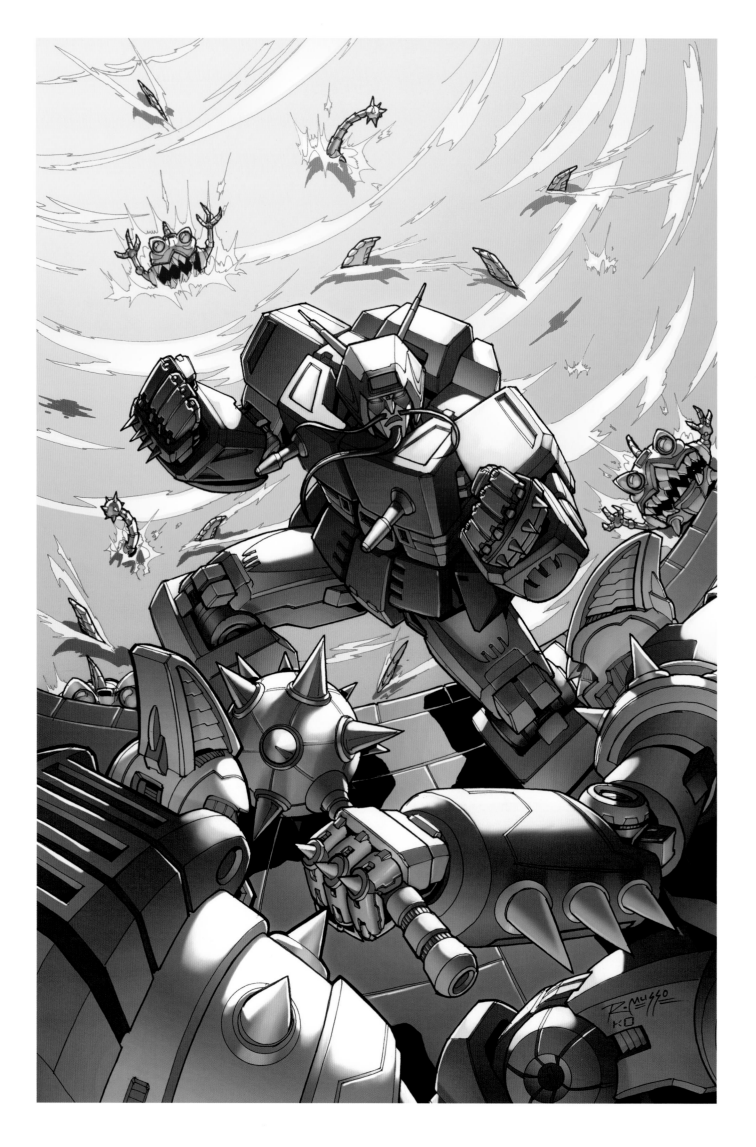

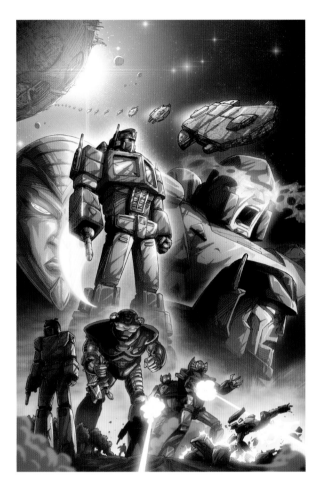

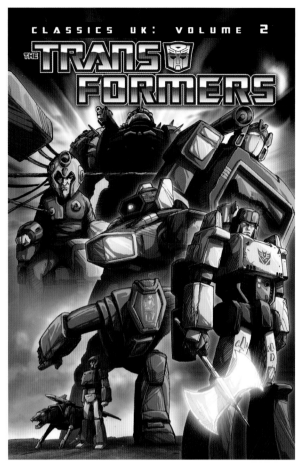

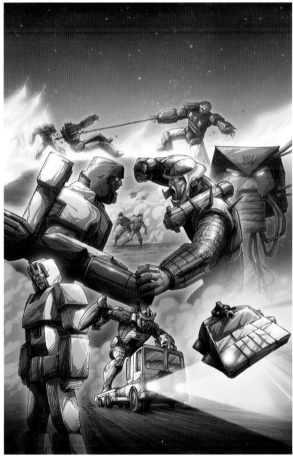

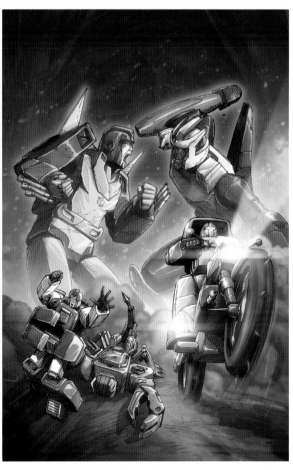

Opposite: Cover art, *The Transformers: Best of UK: Space Pirates* #1, IDW Publishing | Robby Musso & Kieran Oats

Clockwise from top left: Cover art, *The Transformers Classics UK*, IDW Publishing | Andrew Wildman

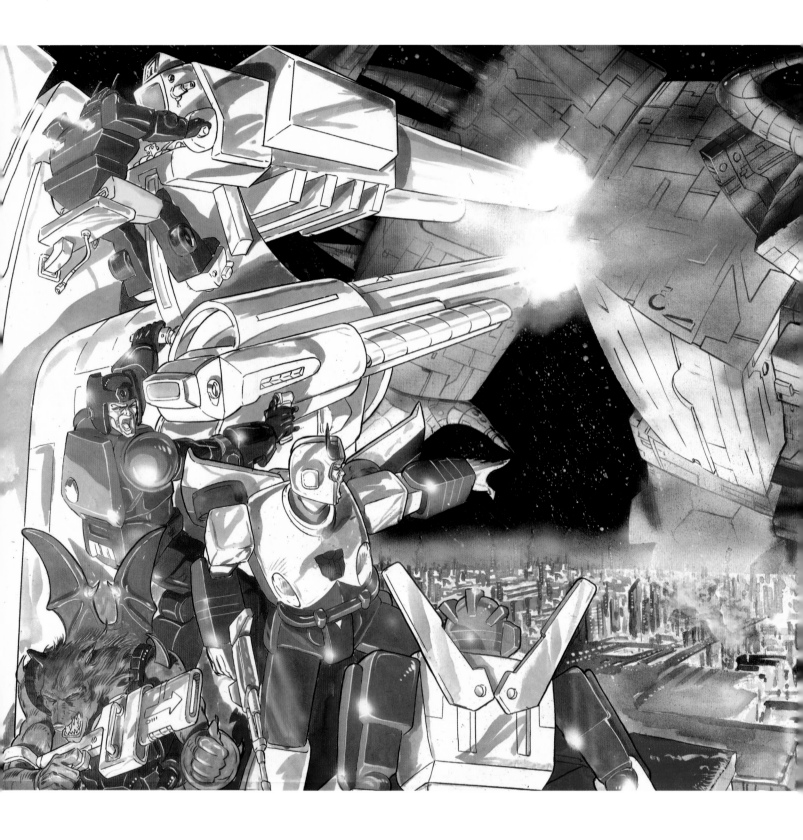

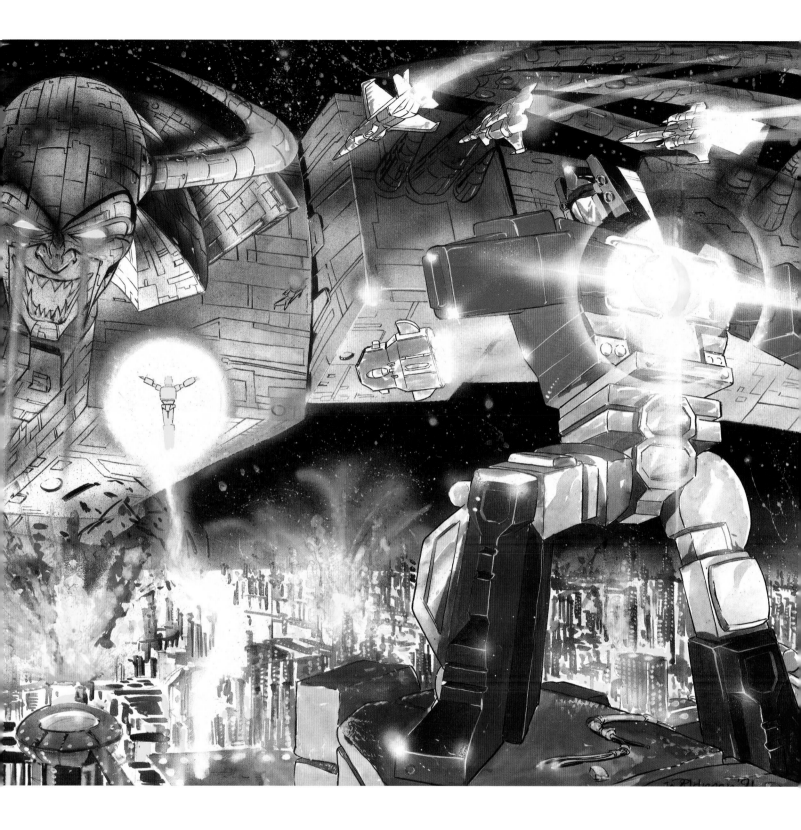

These pages: Poster art, *The Transformers* #320-322, Marvel UK | Andrew Wildman

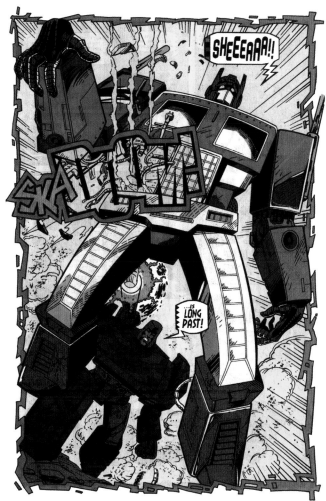

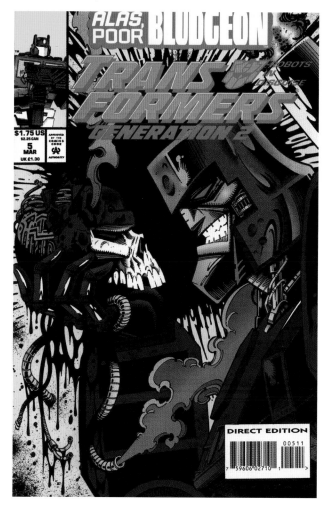

Opposite: Cover art, *Transformers: Generation 2* #6, Marvel Comics | Derek Yaniger

Clockwise from top: Poster, *Transformers: Generation 2* #1, Fleetway | Robin Smith & Gill Whelan;
Cover art, *Transformers: Generation 2* #5, Marvel Comics | Derek Yaniger;
Interior art, *Transformers: Generation 2* #6, Marvel Comics | Manny Galan & Sarra Mossoff

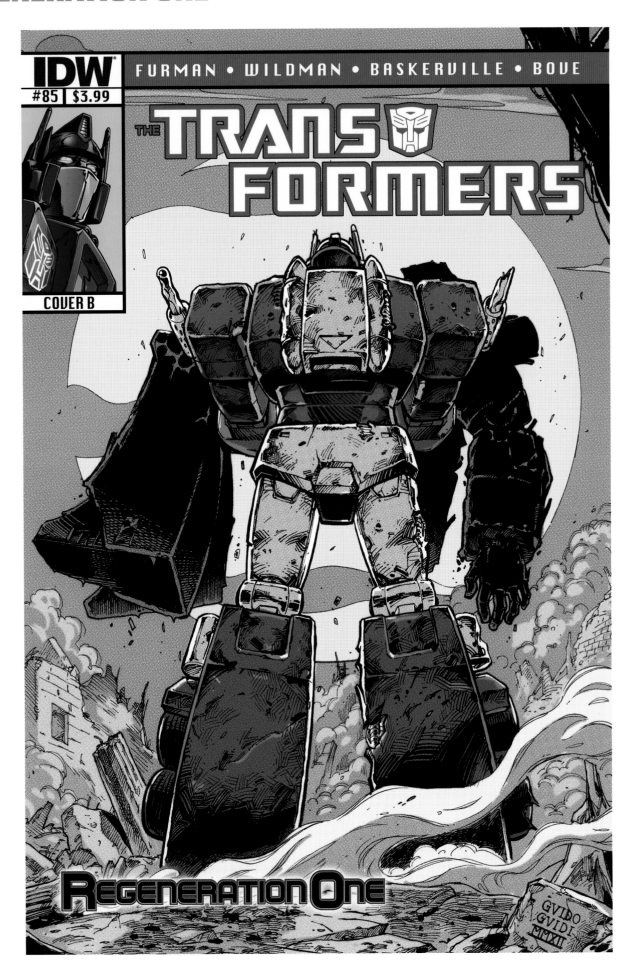

Above: Cover art, *The Transformers: Regeneration One* #85, IDW Publishing | Guido Guidi

Above: Cover art, *The Transformers: Regeneration One* #100, IDW Publishing | Geoff Senior & Josh Burcham

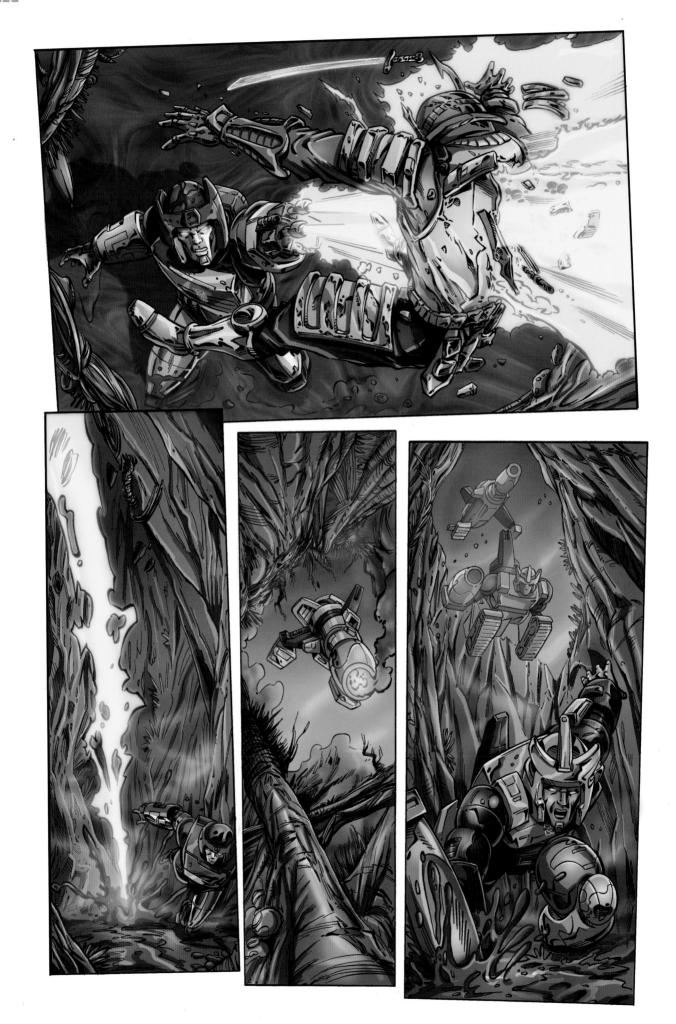

Above: Interior art, *The Transformers: Regeneration One* #81, IDW Publishing | Andrew Wildman & John-Paul Bove

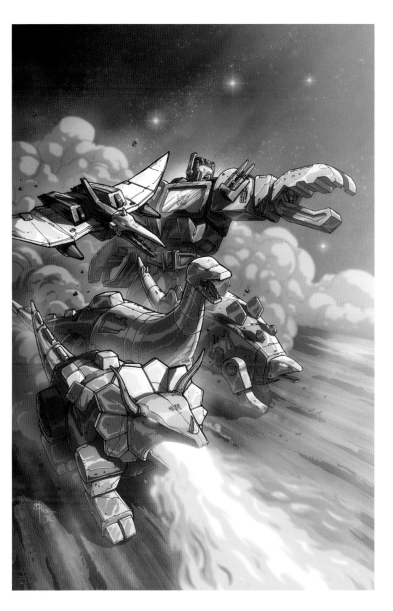

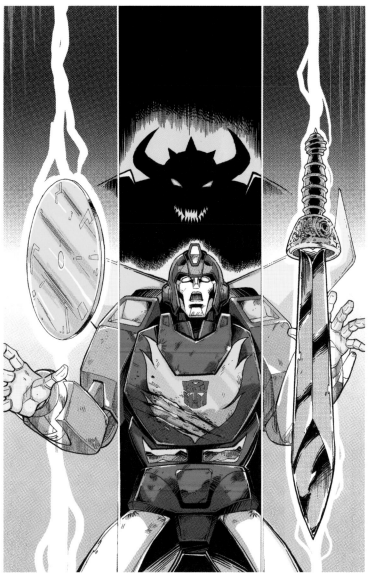

From left: Cover art, *The Transformers: Regeneration One* #86, *The Transformers: Regeneration One* #89, IDW Publishing | Andrew Wildman & Jason Cardy, Guido Guidi

"It was a privilege to have the opportunity to work with Simon again and to finally tell the story that we never got to tell back in the day. I was a storyboard artist for TV and film in the intervening years, so I was able to play with these *Regeneration One* scenes in a far more cinematic way. Very often you will notice that panels are a horizontal format as a storyboard would be. We held the torch for so long and now it has finally burned bright and been put to rest." — Andrew Wildman

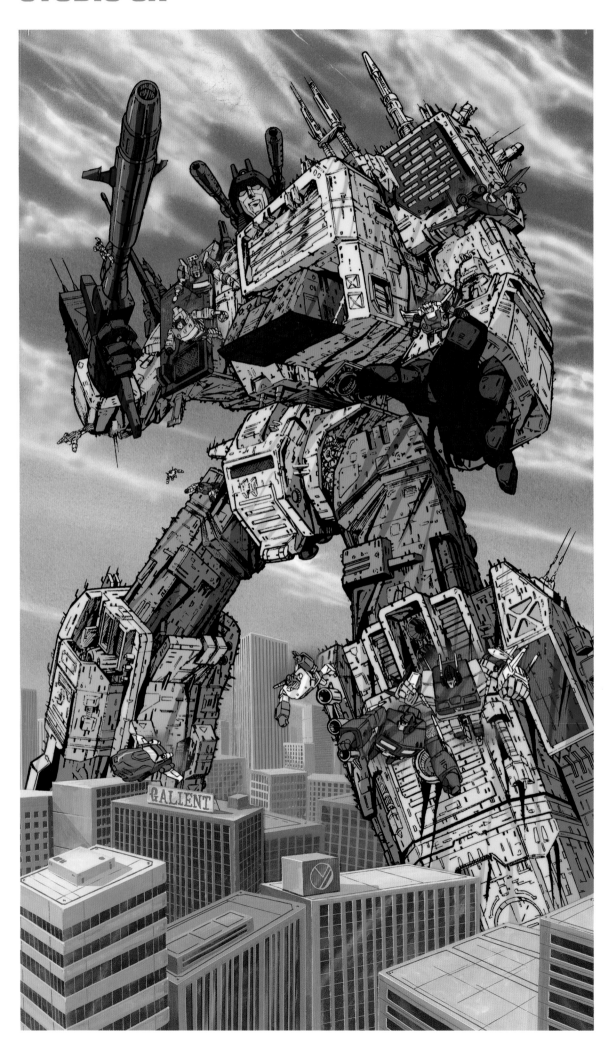

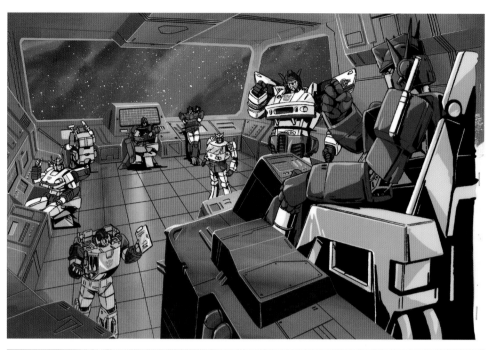

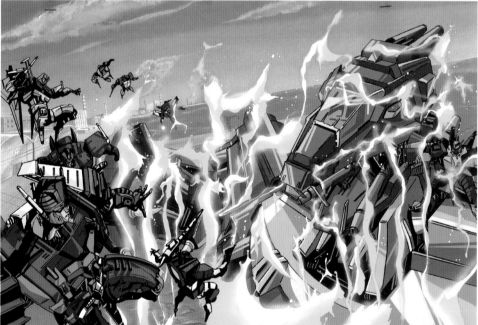

Opposite: Interior art, April 1986
Television Magazine, Studio OX,
Kodansha

From top: Interior art, *Transformers
Pocket Encyclopedia*; Interior art,
September 1986 *Television
Magazine*, August 1985 *Television
Magazine*, Studio OX, Kodansha

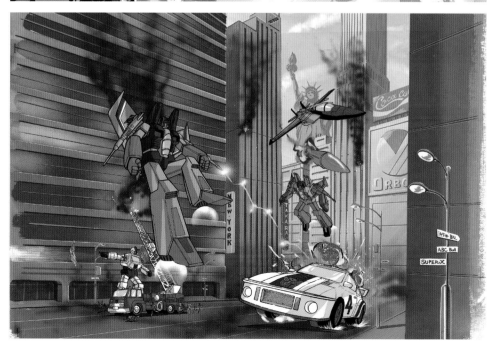

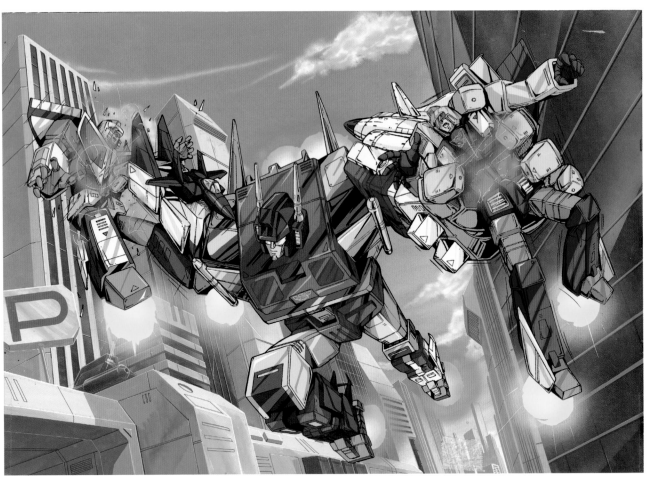

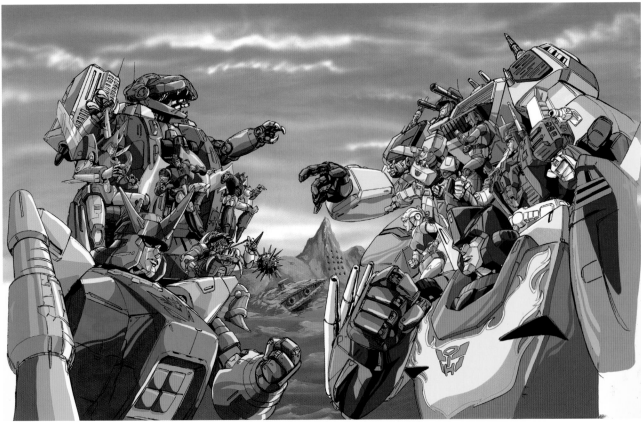

From top: Interior art, February 1986 *Television Magazine*; Cover art,
Television Magazine Color Special, Studio OX, Kodansha

Opposite: Interior art, June 1986 *Television Magazine*, Studio OX, Kodansha

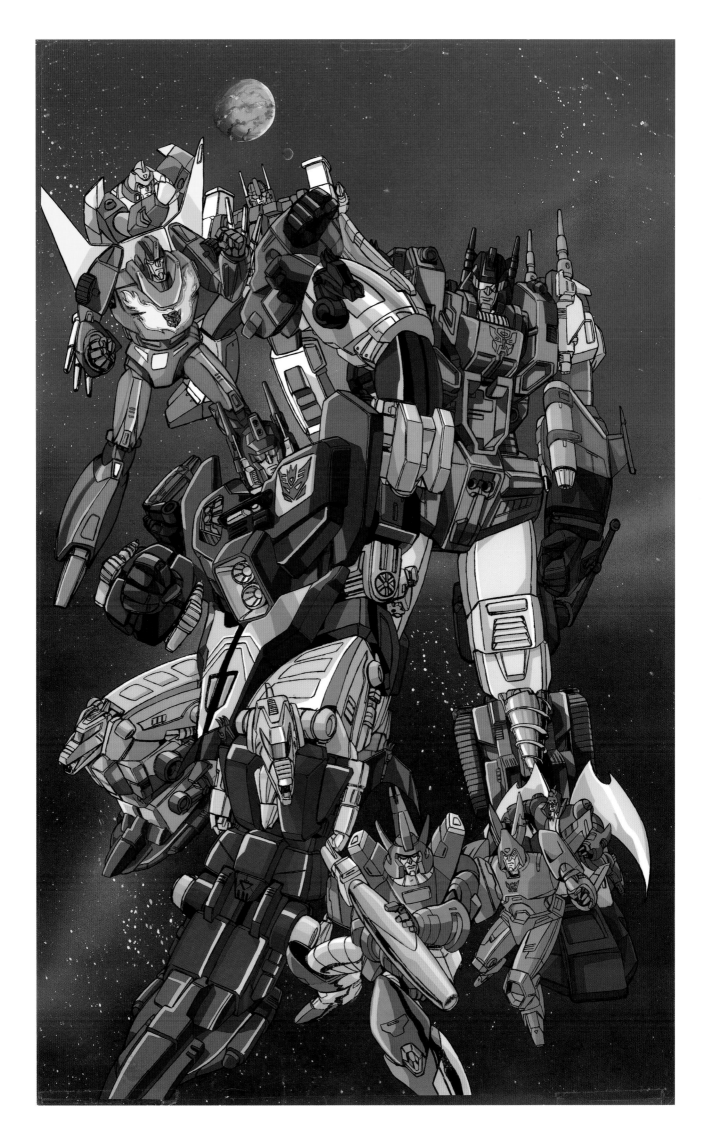

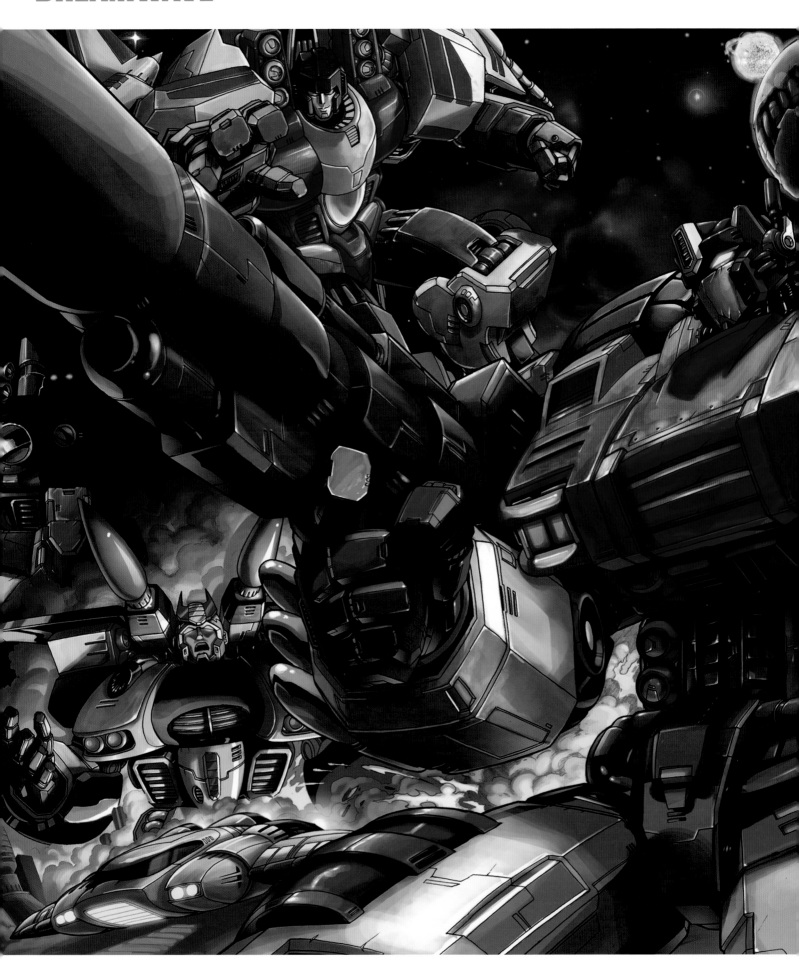

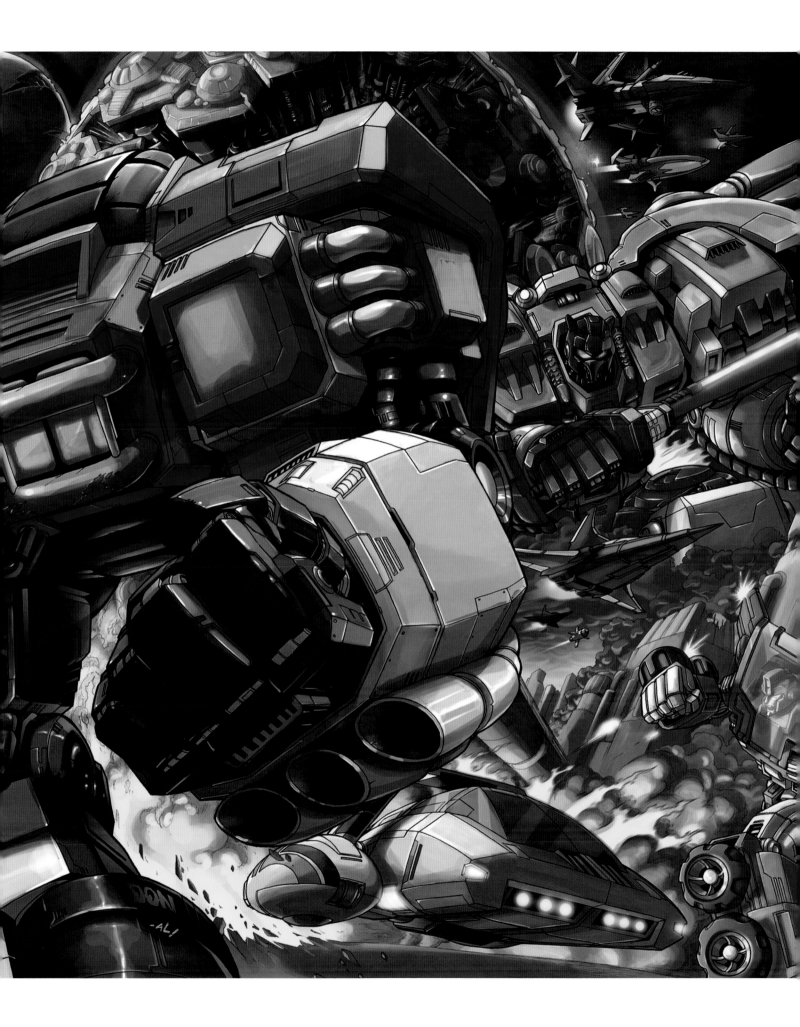

Above: Cover art, *Transformers: The War Within* #1, Dreamwave Productions | Don Figueroa & Alan Wang

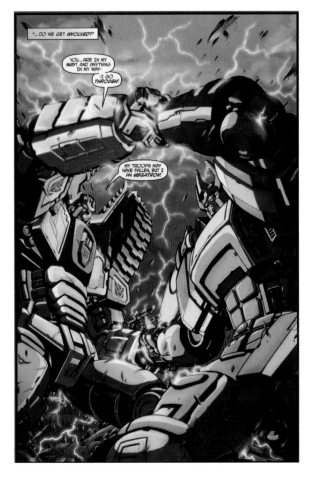

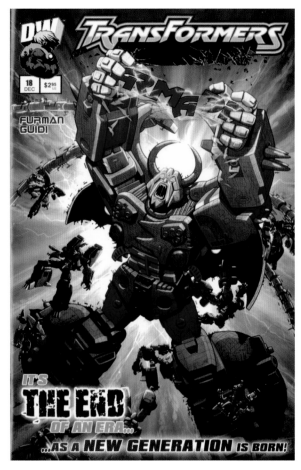

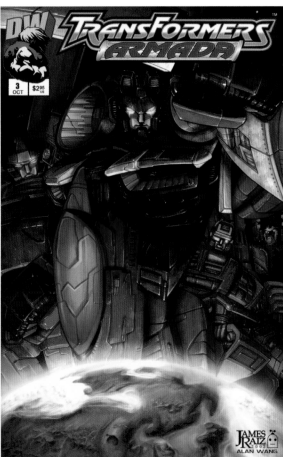

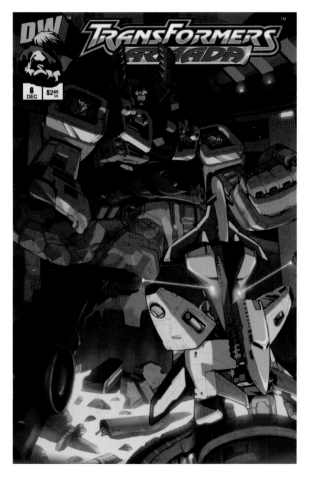

Top left: Interior art, *Transformers Armada* #16, Dreamwave Productions | Pat Lee

Clockwise from top right: Cover art, *Transformers Armada* #18, *Transformers Armada* #6, *Transformers Armada* #3, Dreamwave Productions | Guido Guidi; Pat Lee, Edwin Garcia, Rob Armstrong, & Gary Yeung; James Raiz, Rob Armstrong, & Alan Wang

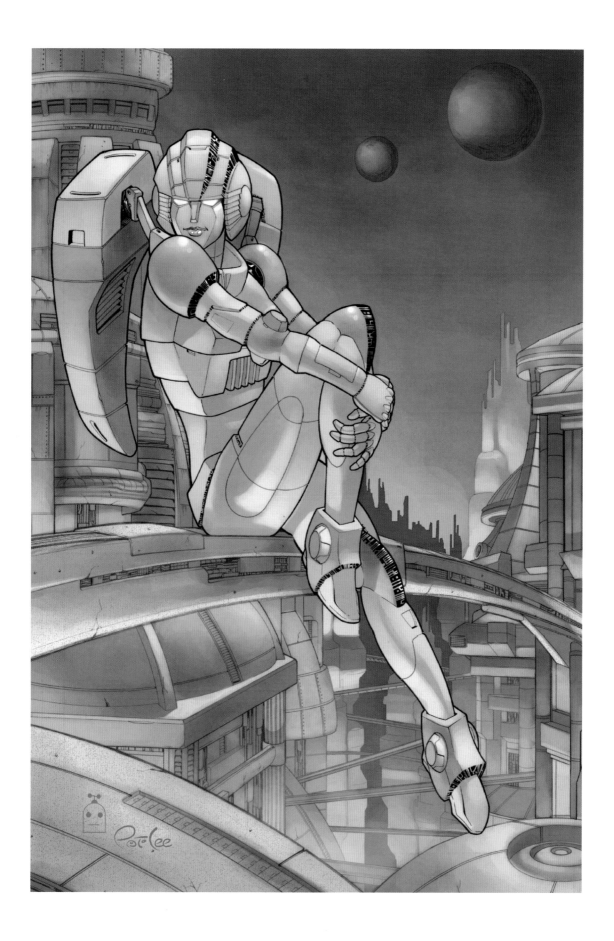

Above: Lithograph, Arcee, Dreamwave Productions | Robbie Armstrong & Pat Lee

"I was lucky enough to work for Dreamwave Productions while they had an exclusive contract with Hasbro for Transformers.
I worshipped classic pinup artists like Gil Elvgren and Alberto Vargas, so I was asked to illustrate Arcee in that style.
The lithograph sold out so fast it was later turned into a series of statues by Palisades Toys!" — Robbie Armstrong

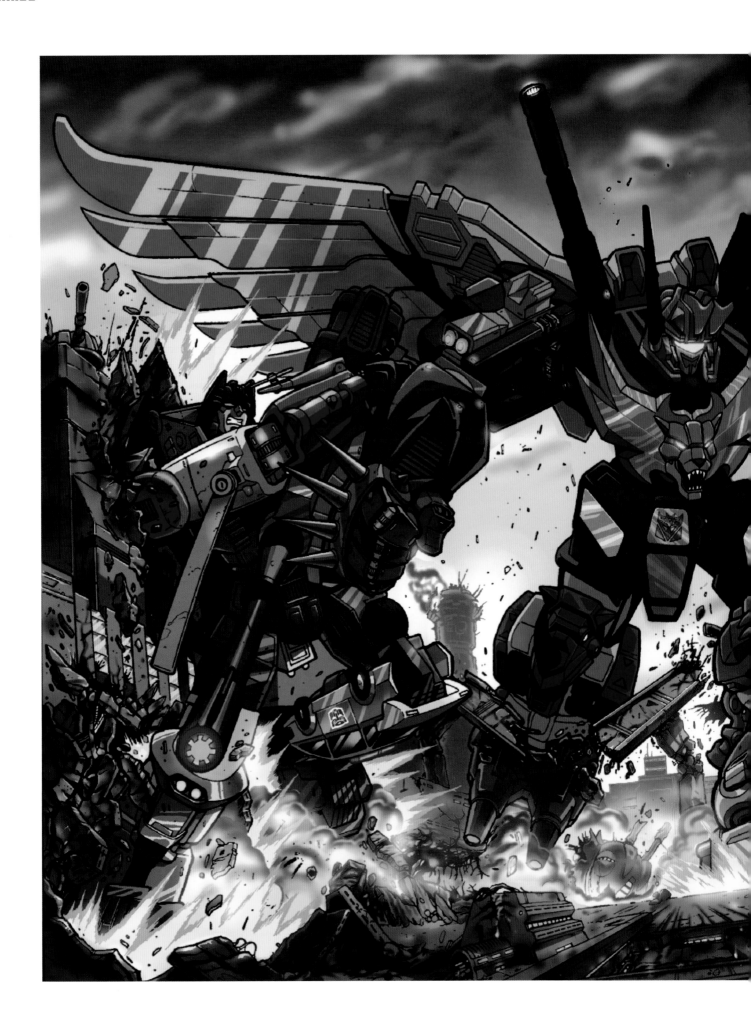

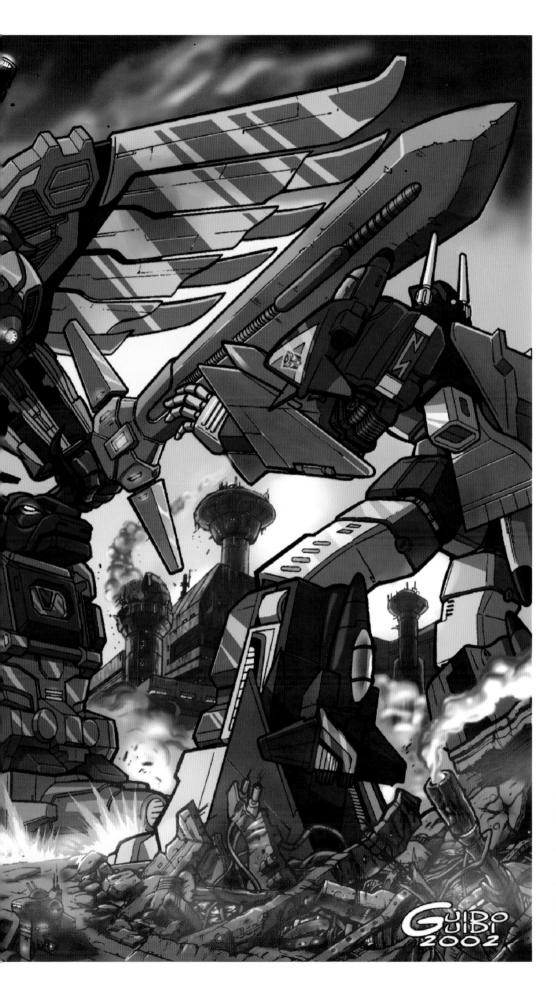

Left: Lithograph, Predaking, Dreamwave Productions | Guido Guidi

"Still very proud of this piece after sixteen years! This Predaking lithograph was my very first professional Transformers work. I was asked to pitch some illustration ideas. I looked at my G1 Predaking sitting on my shelf among the other Transformers figures, and I thought to create something to celebrate the character, that would do him justice in representing his sheer size and power, especially compared with his other fellow combiners. I think I nailed it!"
— Guido Guidi

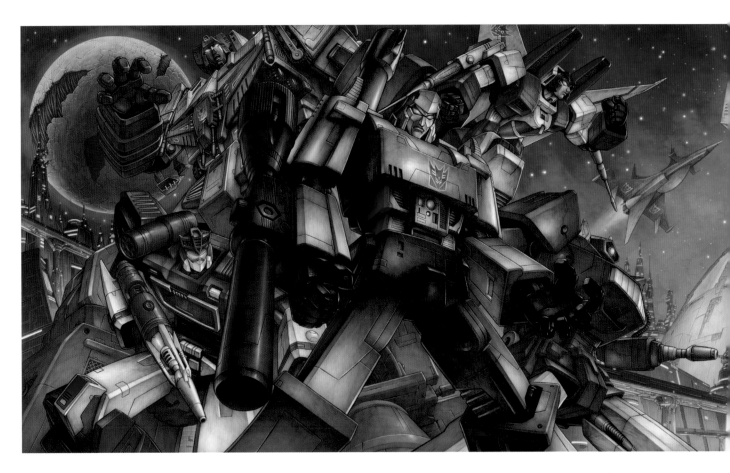

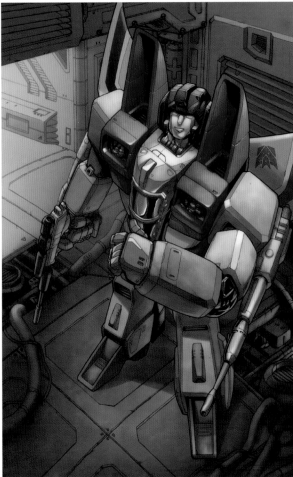

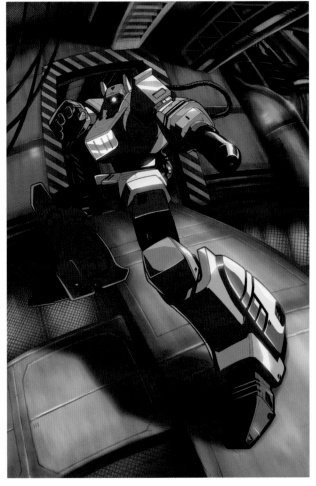

Top: Cover art, *Genesis: The Art of the Transformers*, Image Comics | Jin-Ichi Nakamura

Below, from left: Poster, Starscream, Shockwave, Dreamwave Productions | Pat Lee

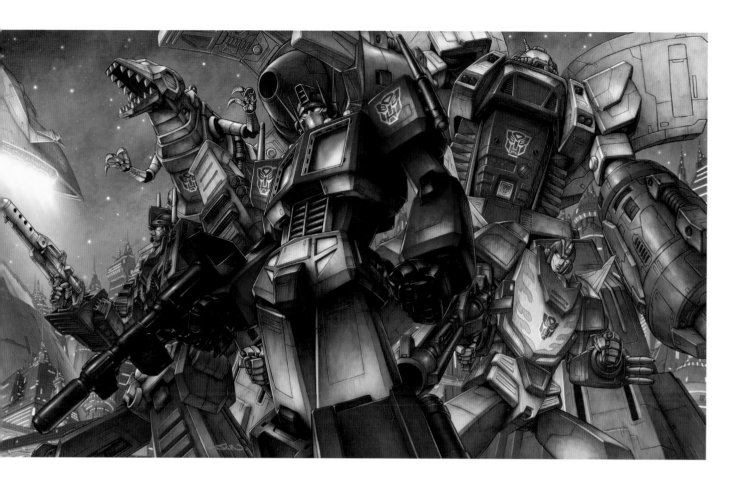

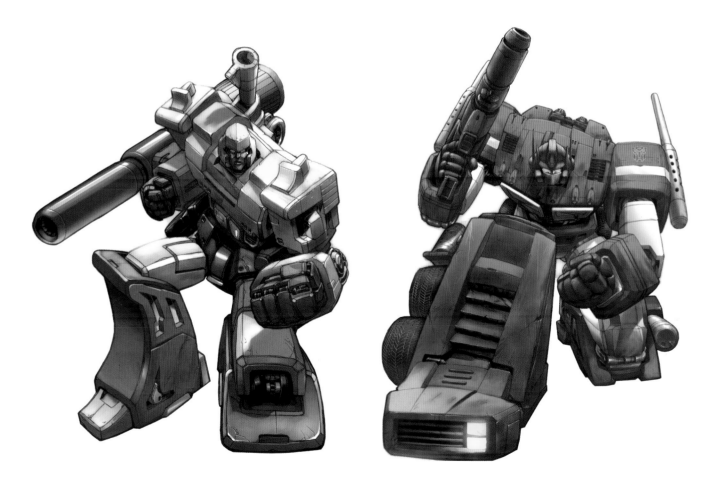

From left: Character art, Megatron, Optimus Prime, Dreamwave Productions | Pat Lee

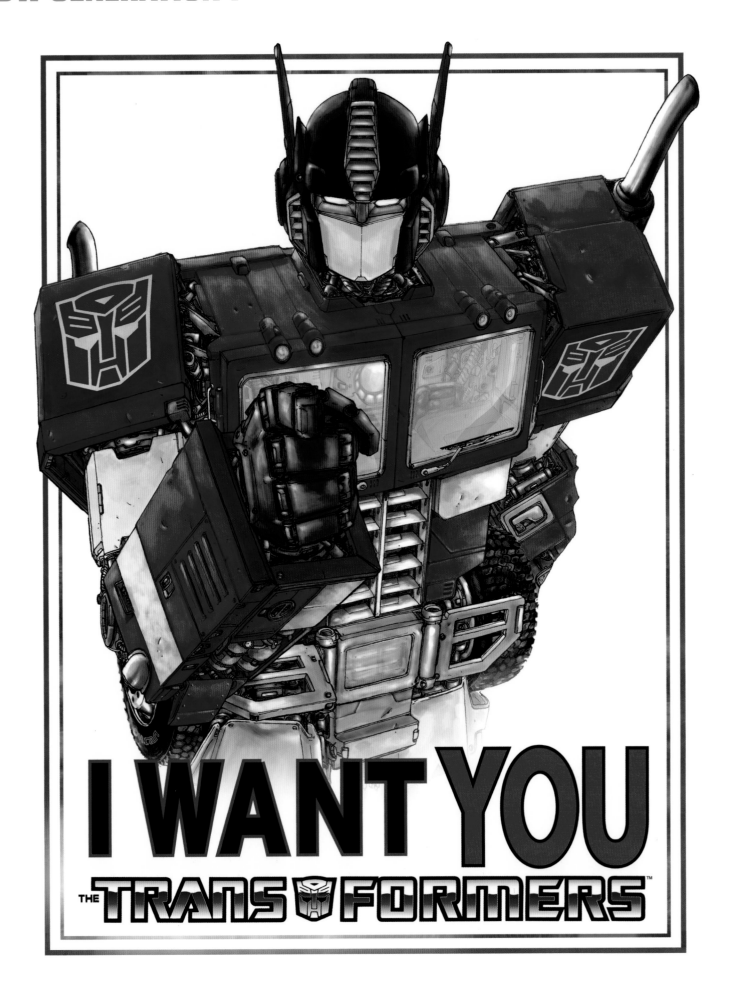

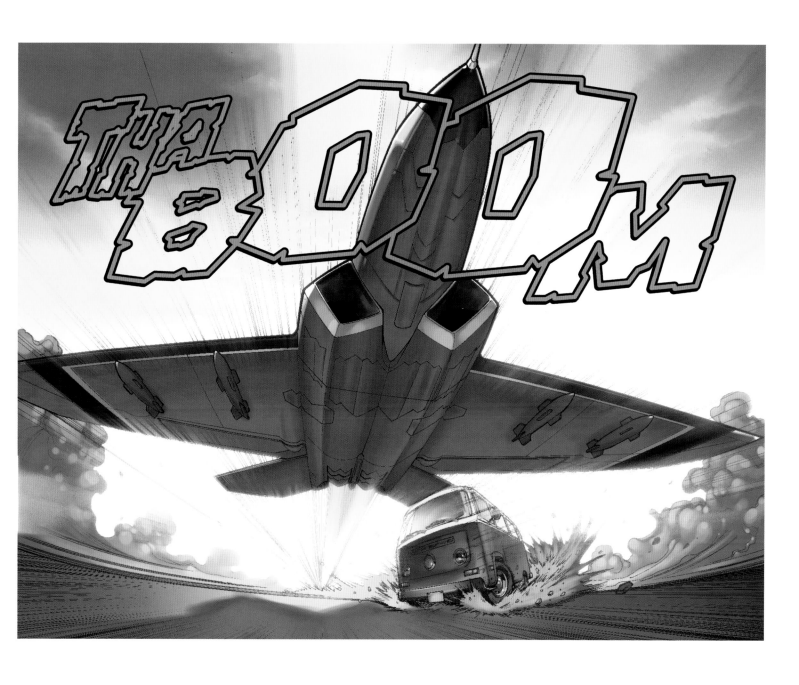

Opposite: Early Promotional Art, IDW Publishing | MLX

Above: Interior art, *The Transformers: Infiltration* #0, IDW Publishing | E.J. Su & John Rauch

"The Thundercrack spread was the first double spread of *Infiltration*. I not only wanted to show the enormous threatening nature of Decepticon, but also the sense of an alien entity much like a flying saucer looming overhead of a small vehicle. The goal was to create a scene with intense intimidation from the human point of view, which is what *Infiltration* is all about, we as the readers need to feel that duress from the unknown." — E.J. Su

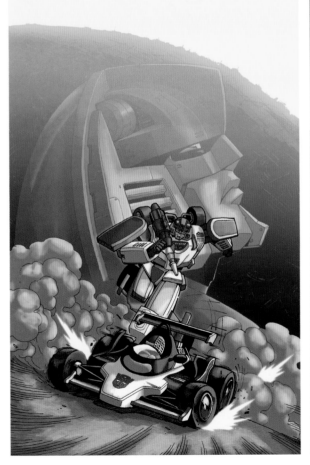
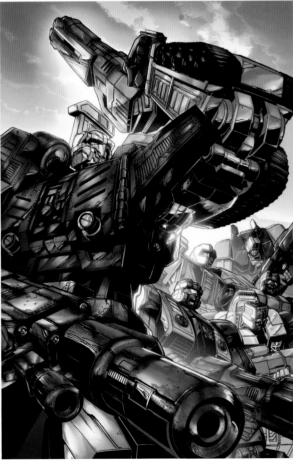

Clockwise from top left: Cover art, *Transformers: Escalation* #1, IDW Publishing | E.J. Su; *Spotlight: Kup*, IDW Publishing | Nick Roche & Josh Burcham; *Spotlight: Sixshot*, IDW Publishing | James Raiz; *Spotlight: Mirage*, IDW Publishing | Guido Guidi & Josh Burcham

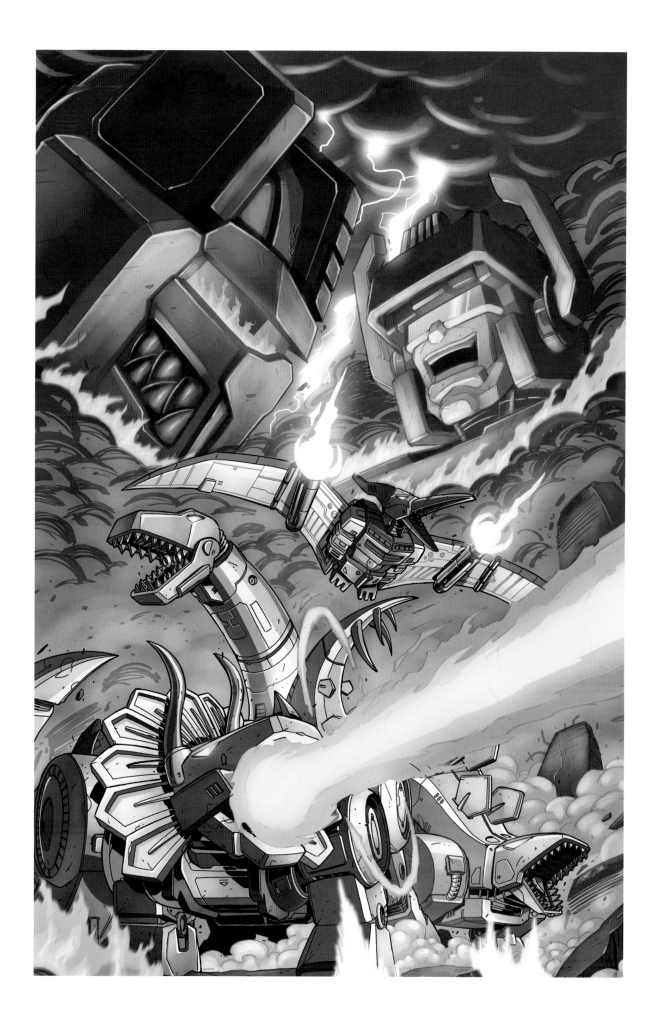

Above: Cover art, *The Transformers: Maximum Dinobots* #1, IDW Publishing | Marcelo Matere & Priscilla Tramontano

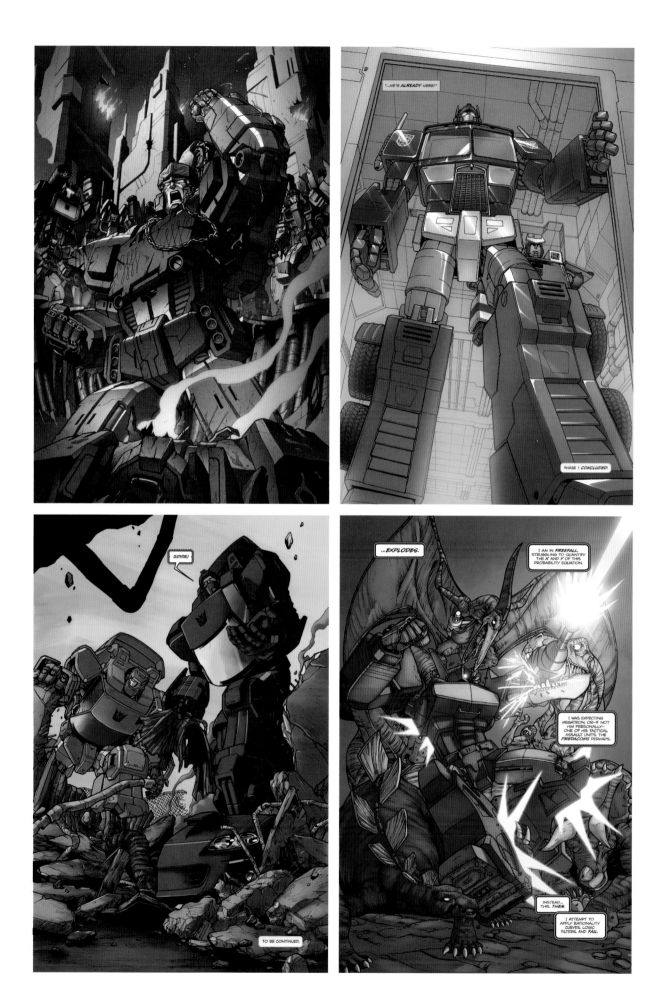

Opposite: Interior art, *The Transformers: Devastation* #6, IDW Publishing | E.J. Su & Josh Burcham

Clockwise from top left: Interior art, *Transformers* #31, IDW Publishing | Casey Collar & Joana Lafuente; *The Transformers: Infiltration* #6, IDW Publishing | E.J. Su & John Rauch; *The Transformers: Spotlight: Shockwave*, IDW Publishing | Nick Roche & Josh Burcham; *The Transformers: Infiltration* #1, IDW Publishing | E.J. Su & Rauch & Josh Burcham

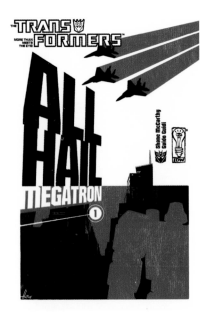

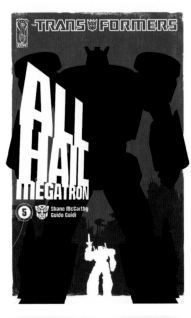

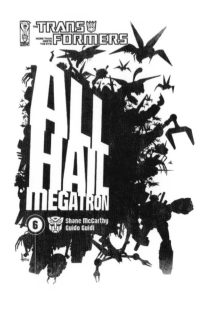

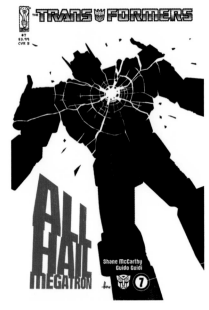

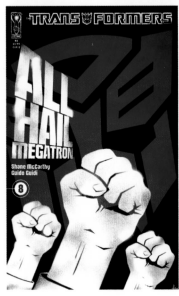

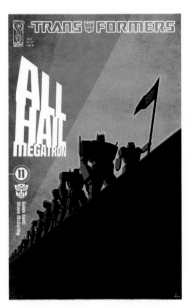

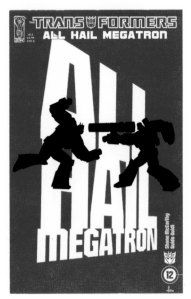

This page: Cover art, *The Transformers: All Hail Megatron:* #1, #3, #4, #5, #6, #7, #8, #11, #12, IDW Publishing | Trevor Hutchison

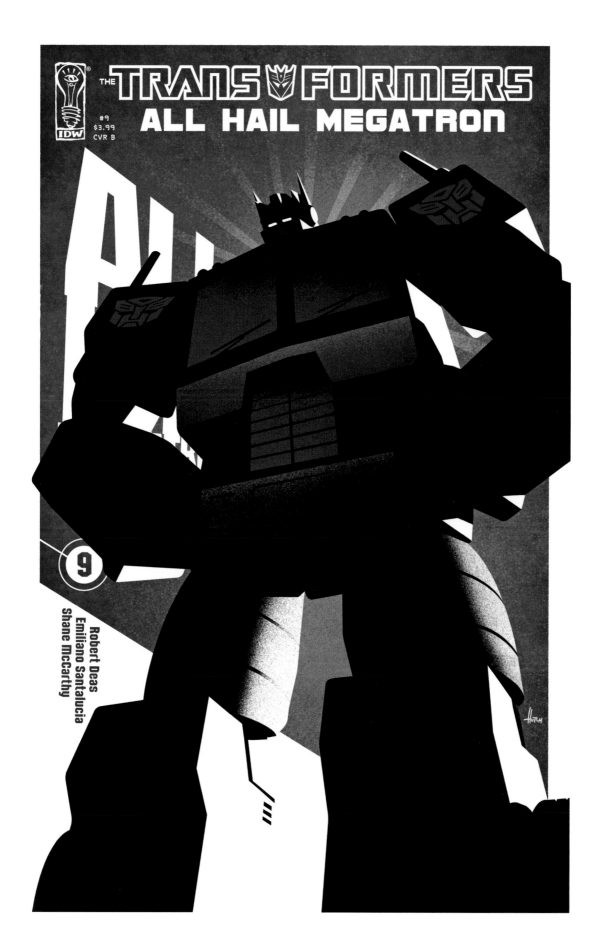

Above: Cover art, *The Transformers: All Hail Megatron* #9, IDW Publishing | Trevor Hutchison

"For *All Hail Megatron*, which was seen as a new starting point for readers, we aimed to produce a series of covers that were eye-catching and different to the usual range of covers seen on the shelves at comic book stores. To capture the series' theme of leadership, I created these simple, symbolic designs that evoked vintage propaganda art. I wanted to incorporate large areas of flat color and a restrained color palette to draw attention; if everything is yelling at you, the thing that stands out is the quiet thing in the corner." — Trevor Hutchison

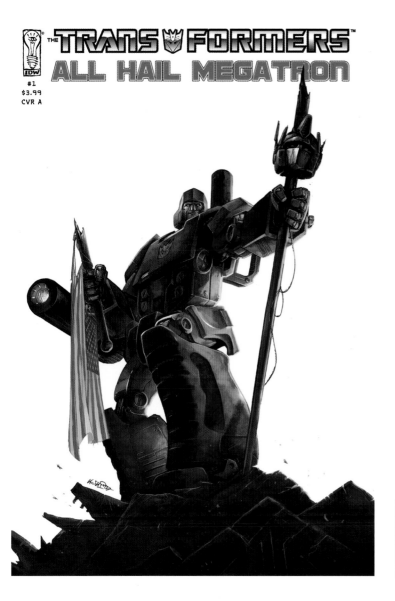

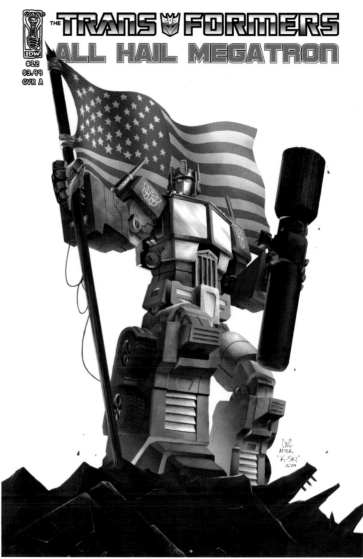

Opposite: Cover art, *The Transformers: All Hail Megatron* #6, IDW Publishing | Casey Coller & Joana Lafuente

From left: Cover art, *The Transformers: All Hail Megatron* #1, *The Transformers: All Hail Megatron* #12, IDW Publishing | Klaus Scherwinski, Casey Coller & Joana Lafuente

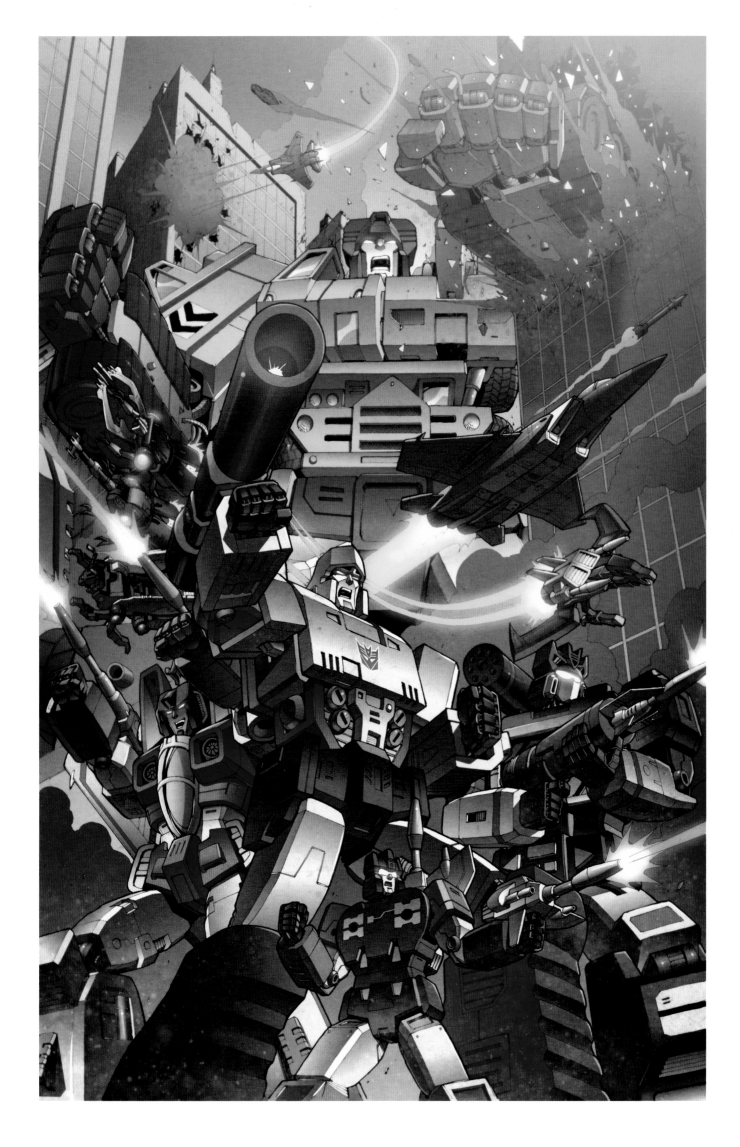

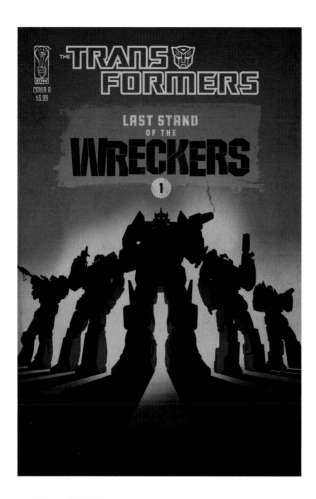
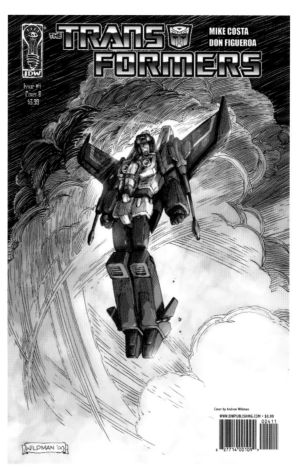

Opposite: Interior art, *The Transformers* #31, IDW Publishing | Casey Coller & Joana Lafuente

Top: Cover art, *The Transformers: Last Stand of the Wreckers* #1, IDW Publishing | Trevor Hutchison;
The Transformers #4, IDW Publishing | Andrew Wildman

Below: Cover art, *The Transformers* #22, IDW Publishing | Alex Milne & Josh Perez

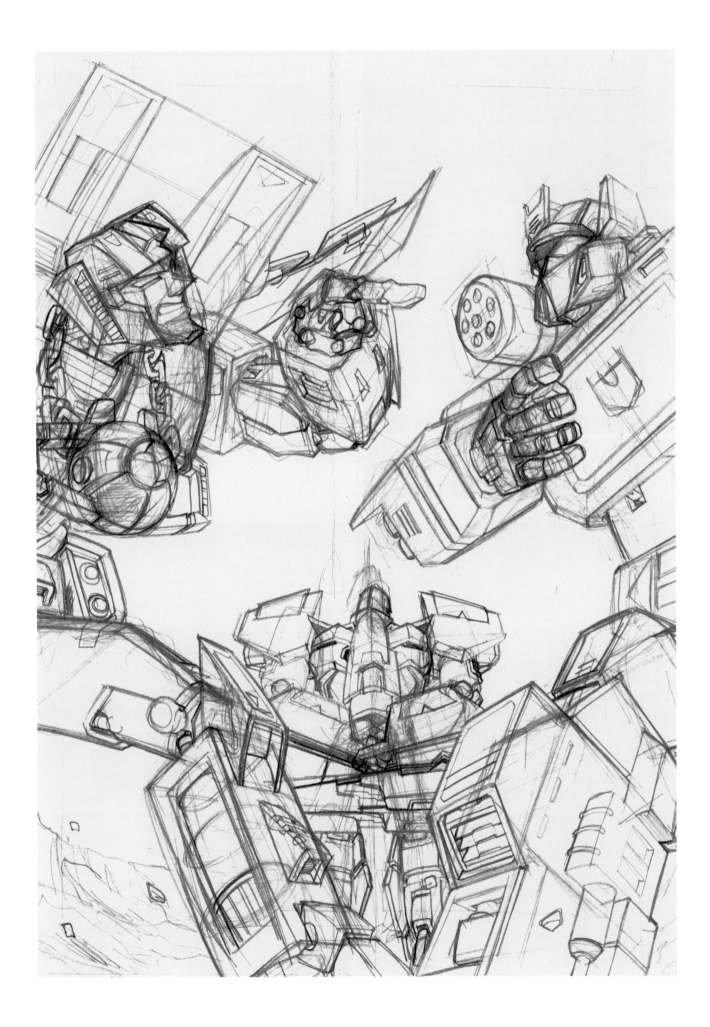

Above: Pencil sketch, *The Transformers* #15, IDW Publishing | Nick Roche

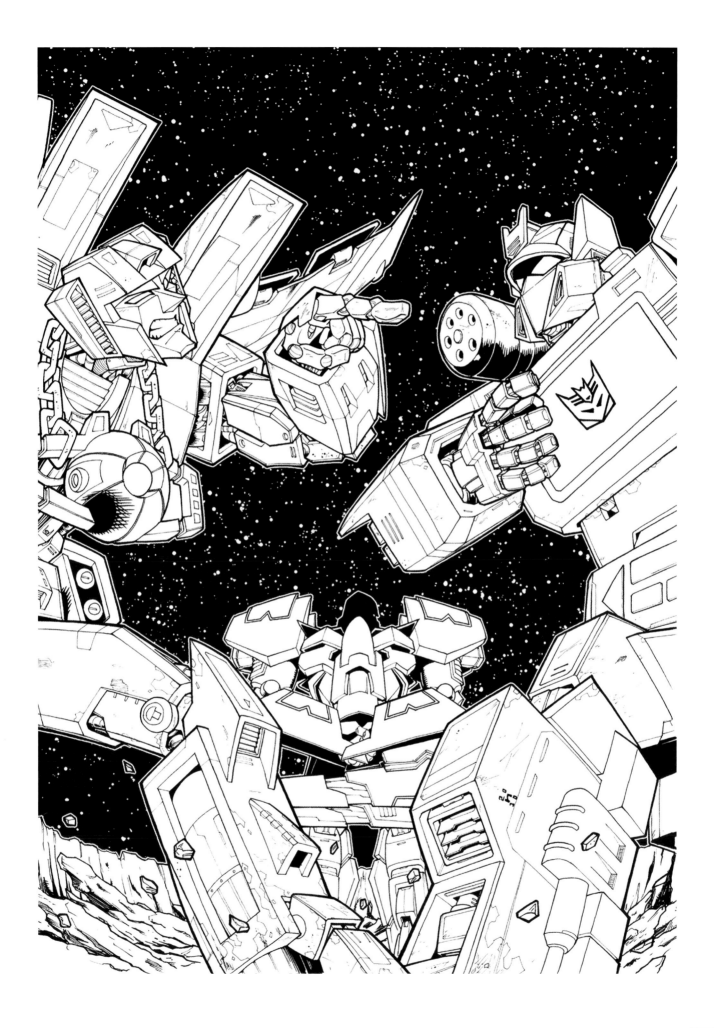

Above: Line art, *The Transformers* #15, IDW Publishing | Nick Roche

This Page: Interior art, *The Transformers* #28, IDW Publishing | Livio Ramondelli
Opposite: Interior art, *The Transformers* #26, IDW Publishing | Livio Ramondelli

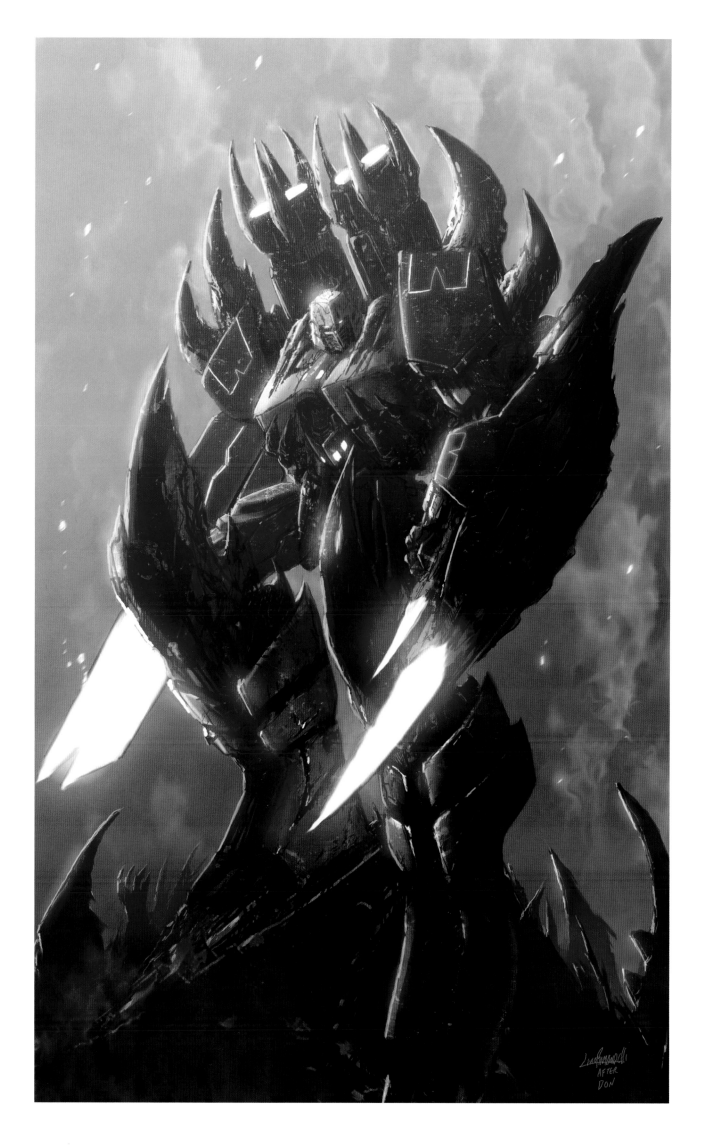

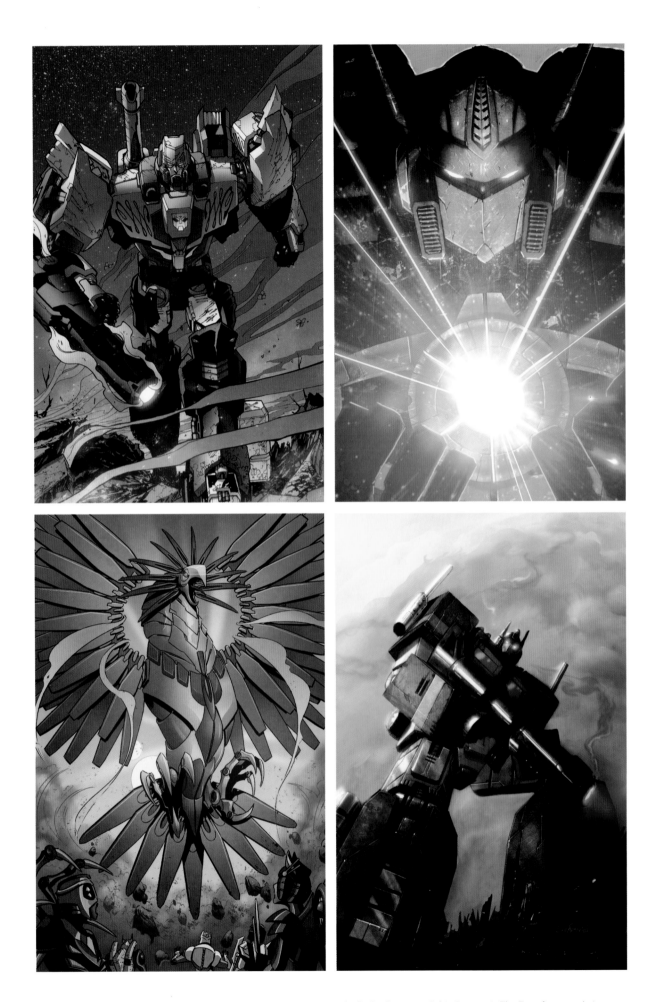

Top left: Interior art, *Transformers: More Than Meets The Eye* #54, IDW Publishing | Alex Milne & Joana Lafuente

Clockwise from top right: Cover art, *The Transformers: Autocracy* #10, *The Transformers: Best of Optimus Prime*, IDW Publishing | Livio Ramondelli, Livio Ramondelli; Interior art, *The Transformers: Windblade* #6, IDW Publishing | Corin Howell & Thomas Deer

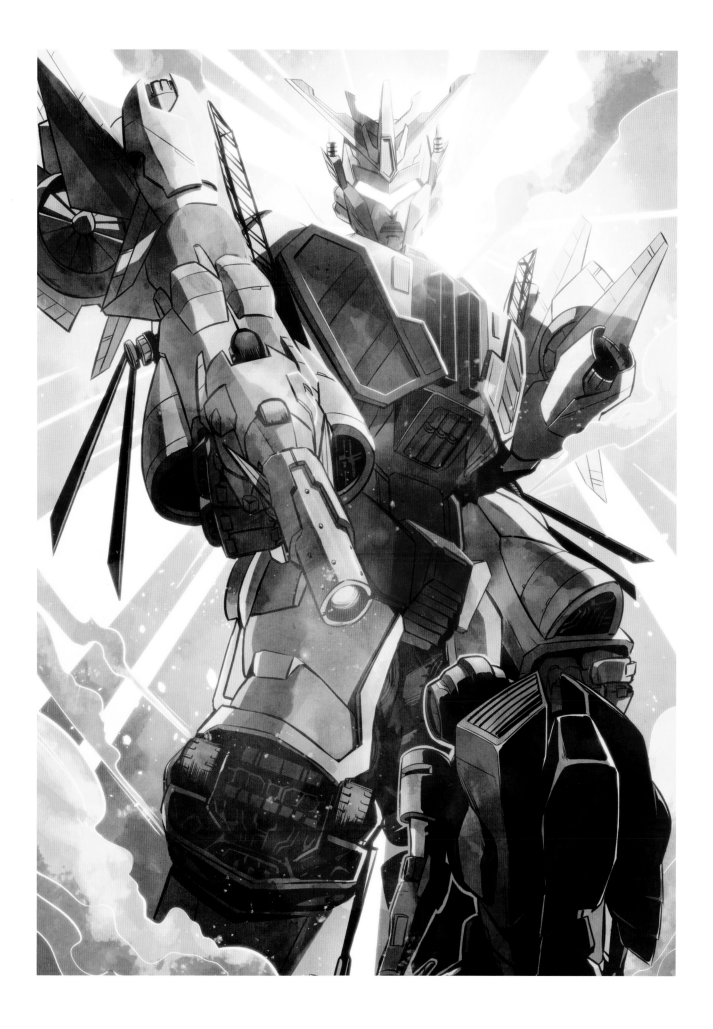

Above: Interior art, *Transformers: Combiner Hunters* #1, IDW Publishing | Sara Pitre-Durocher & Yamaishi

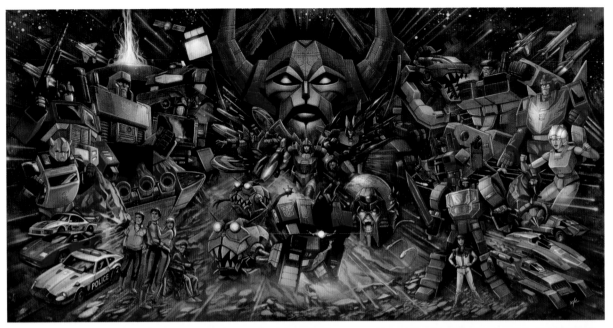

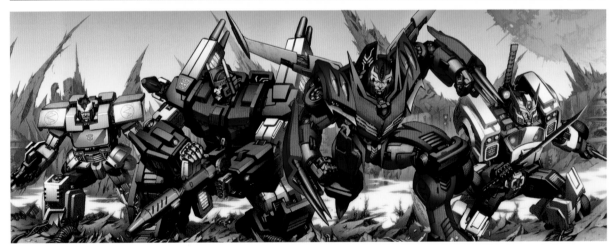

Top: Cover art, *The Transformers: Robots in Disguise* #34, *The Transformers: Primacy* #3, *The Transformers: More Than Meets The Eye* #34, IDW Publishing | Ken Christiansen

Middle: Cover art, *The Transformers: Windblade* #1, *The Transformers: More Than Meets The Eye* #28, *The Transformers: Robots In Disguise* #28, IDW Publishing | Livio Ramondelli

Bottom: Cover art, *The Transformers: More Than Meets The Eye* #1, IDW Publishing | Alex Milne & Josh Perez

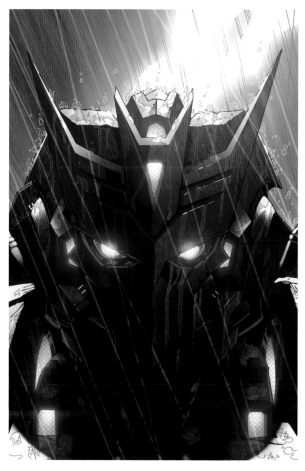

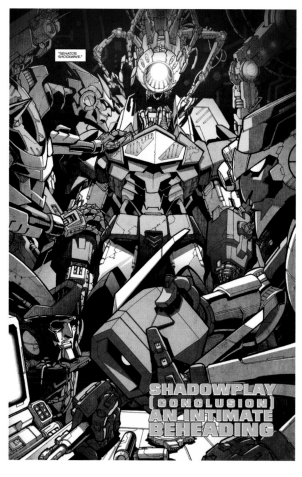

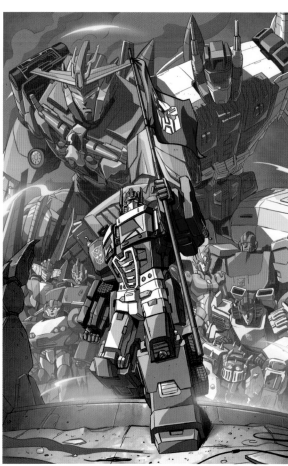

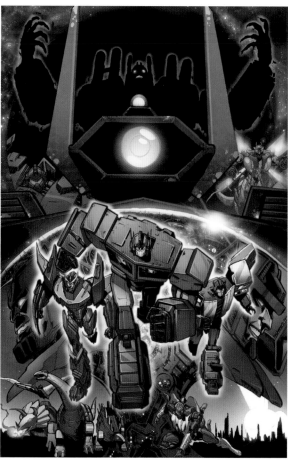

Clockwise from top left: Cover art, *The Transformers* #7, IDW Publishing | Alex Milne & Josh Perez;
Interior art, *The Transformers: More Than Meets The Eye* #11, IDW Publishing | Alex Milne & Josh Burcham;
Cover art, *The Transformers: Dark Cybertron* #1, IDW Publishing | Phil Jimenez & Romulo Fajardo Jr.;
Interior art, *The Transformers* #49, IDW Publishing | Sara Pitre-Durocher & Josh Perez/Josh Burcham

Above: Line art, *The Transformers: Windblade* #1, IDW Publishing | Casey Coller

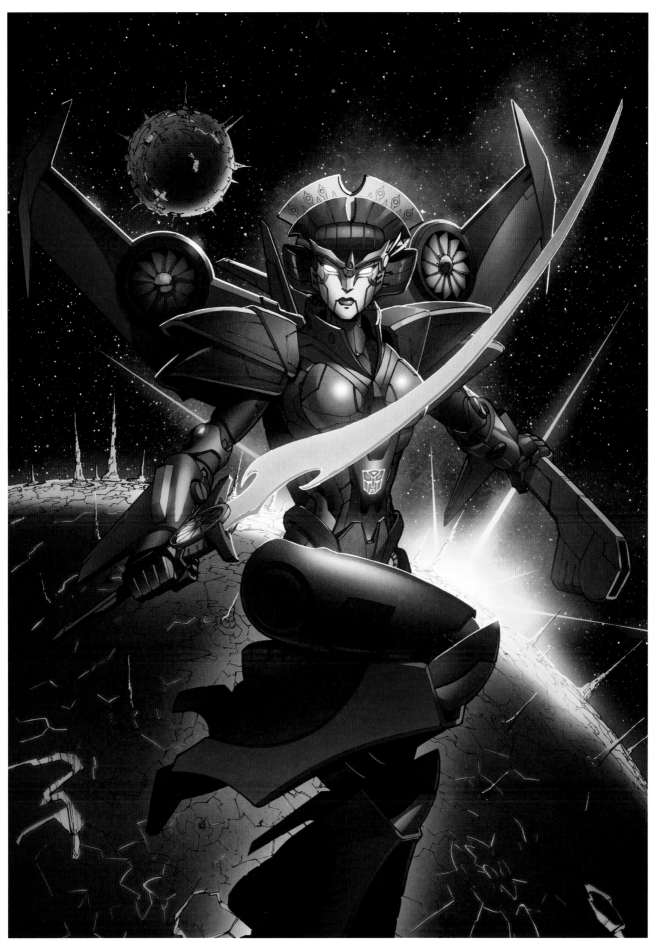

Above: Cover art, *The Transformers: Windblade* #1, IDW Publishing | Casey Coller & Joana Lafuente

"Windblade #1 was released alongside *More than Meets The Eye* #28 and *Robots in Disguise* #28, which featured Megatron and Optimus Prime respectively. I knew Windblade had to be able to look like she belonged with those two iconic characters. I tried to stay very true to her character design, while giving her an ominous presence as an important character posed in front of Cybertron. Joana Lafuente's vibrant, gorgeous colors really solidified the epic feel of the images." — Casey Coller

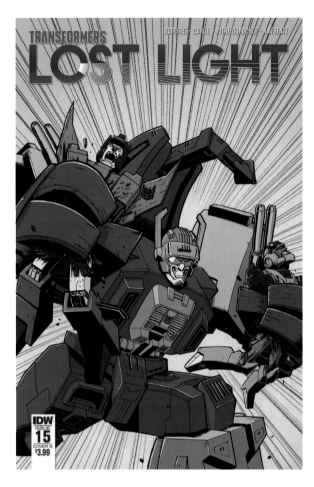
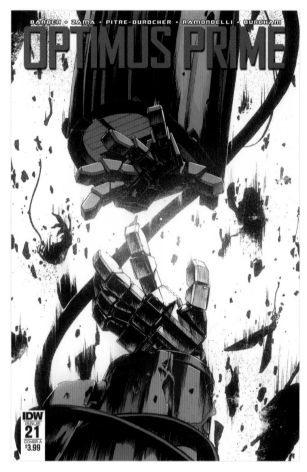
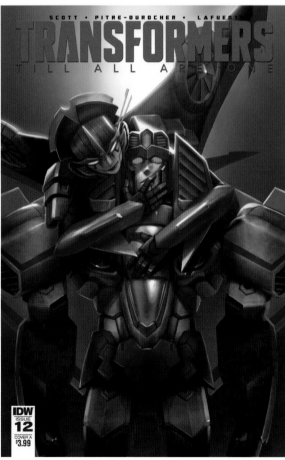
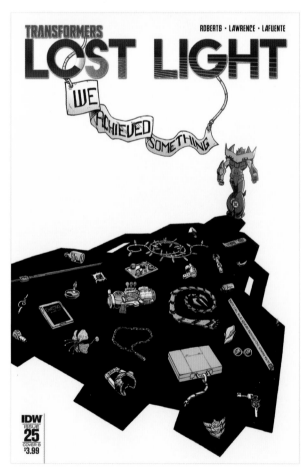

Clockwise from top left: Cover art, *Transformers: Lost Light* #15,
IDW Publishing | Nick Roche & Josh Burcham; *Optimus Prime* #21,
IDW Publishing | Kei Zama & Josh Burcham; *Transformers: Lost Light*
#25, IDW Publishing | Nick Roche & Josh Burcham; *Transformers: Till
All Are One* #12, IDW Publishing | Sara Pitre-Durocher

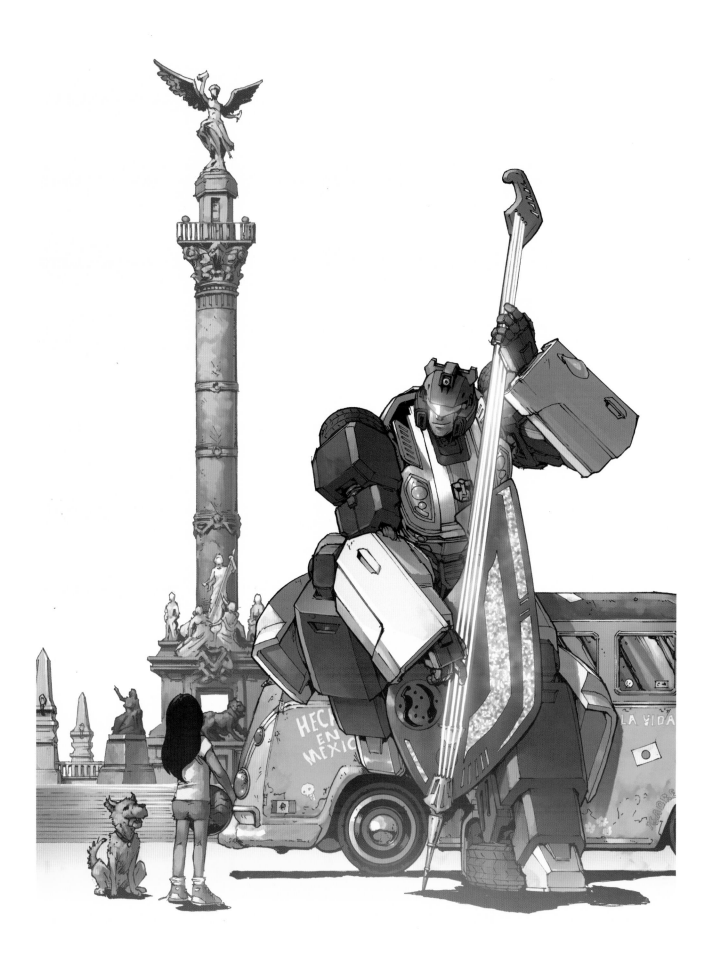

This page: Cover, *Optimus Prime* #4, IDW Publishing | Andrew Griffith & Josh Perez

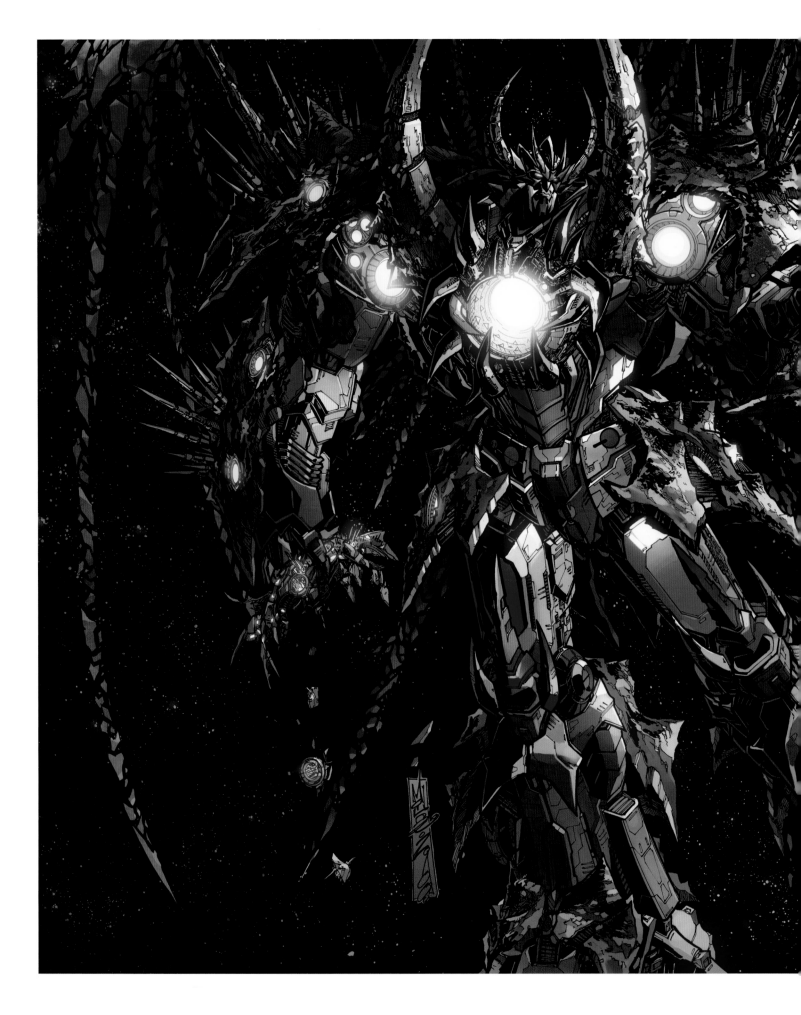

Above: Promotional art, *Unicron*, IDW Publishing | Alex Milne

"I was asked by IDW to make a promo image of Unicron in robot mode that could be shown off at C2E2 2018. I came up with a few layouts and the one with him holding the Earth in one hand and a destroyed Cybertron in the other was what they decided to run with. Later I learned that the image would also be used for the SDCC issue 1 exclusive cover as well." — Alex Milne

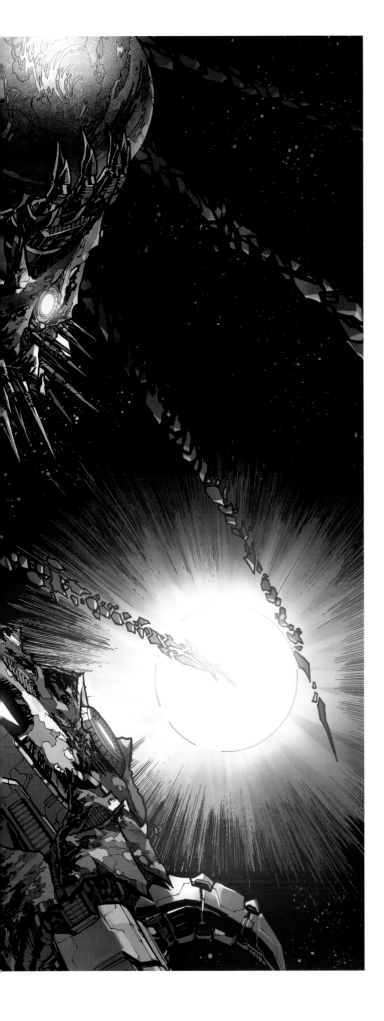

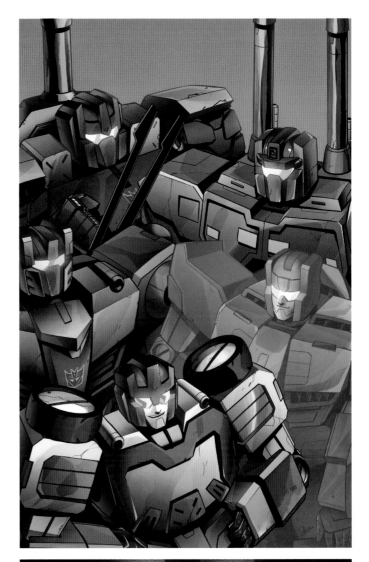

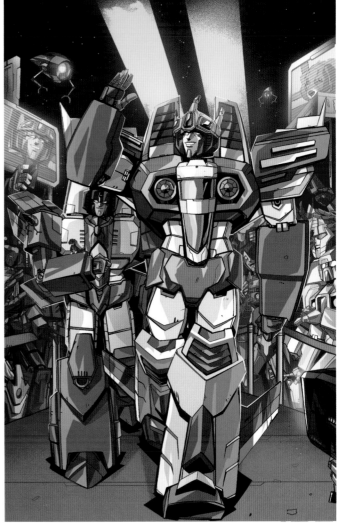

From top: Cover art, *Till All Are One #10*, *Optimus Prime 2018 Annual*, IDW Publishing | Priscilla Tramontano

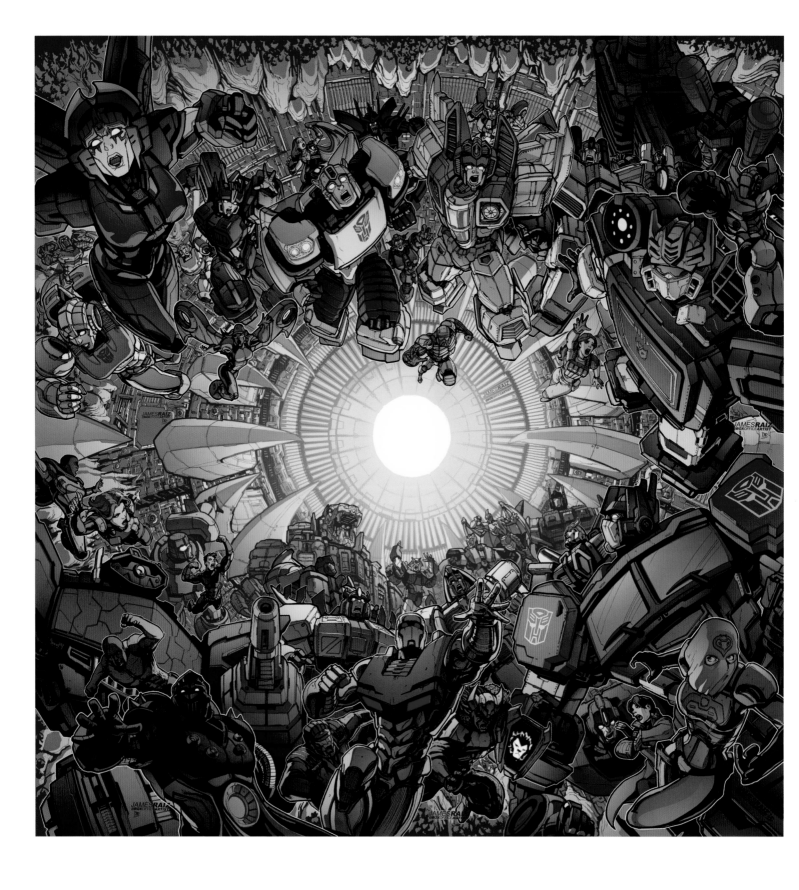

Above: Cover art, *Unicron* #1-6, IDW Publishing | James Raiz & David Garcia Cruz

Opposite: Cover art, *Historia*, IDW Publishing | Sara Pitre-Durocher

"Illustrating a cover to close the chapter on this Transformers 'verse was both an incredible privilege and a lot of pressure. These stories and their characters ended up meaning so much to so many people, and I tried to capture as much of that as I could." — Sara Pitre-Durocher

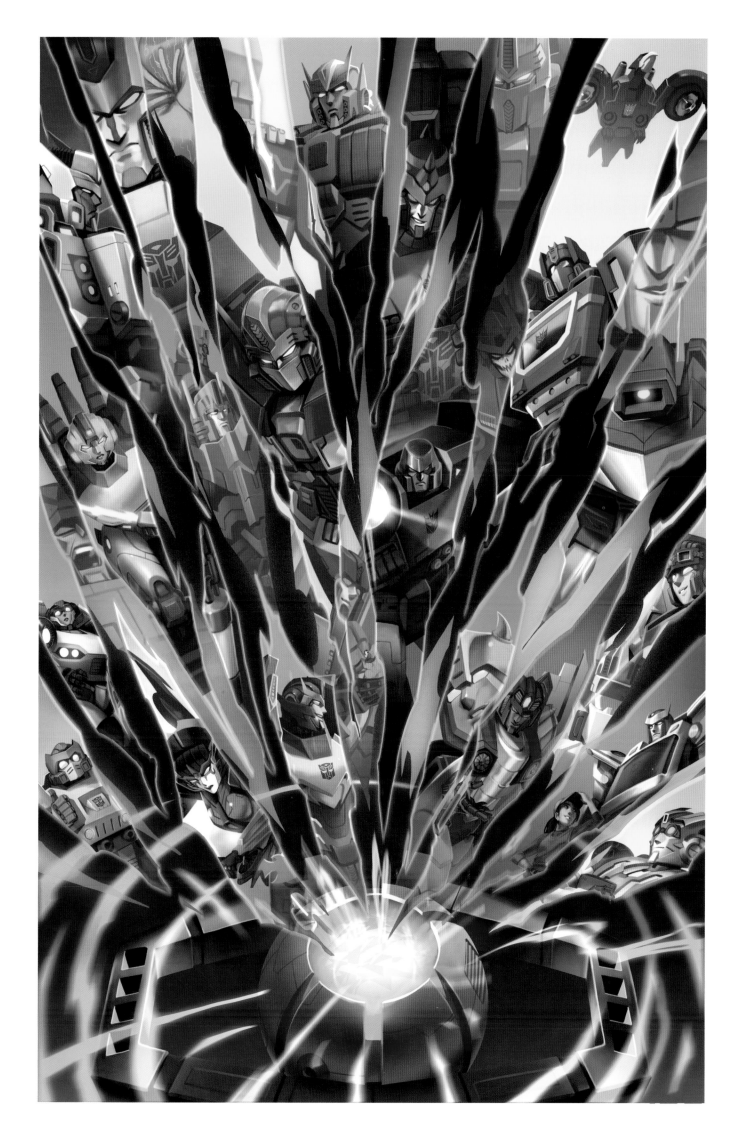

From left: Cover art, *Transformers Prime: Beast Hunters* #8, *Transformers: Robots in Disguise* #3, IDW Publishing | Ken Christiansen, Priscilla Tramontano

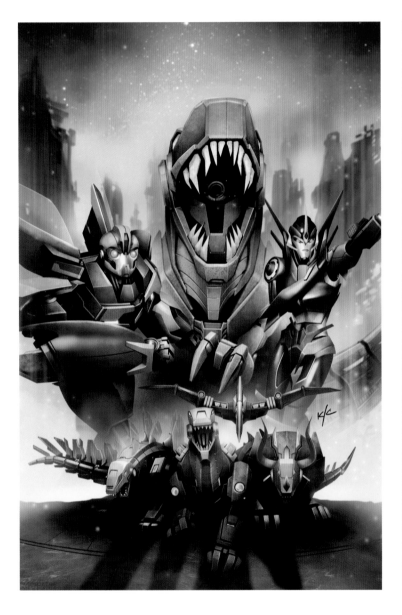

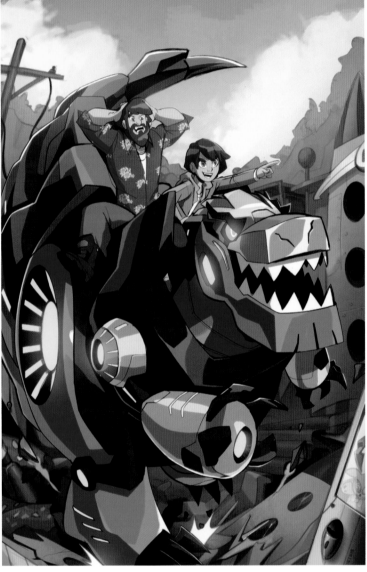

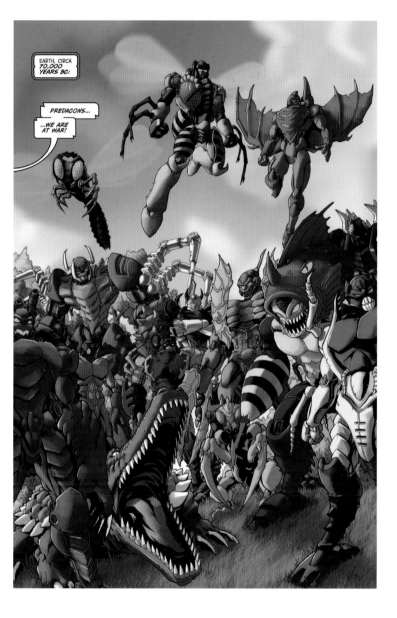

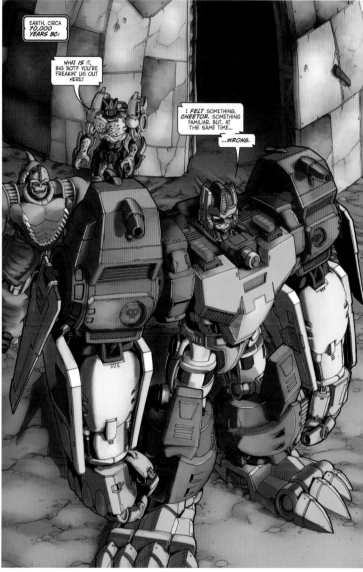

From left: Interior art, *Transformers: Beast Wars: The Ascending* #2, *Transformers: Beast Wars: The Ascending* #3, IDW Publishing | Don Figueroa & Josh Burcham

Following: Cover art, *Transformers: Beast Wars: The Ascending* #1, IDW Publishing | Don Figueroa & Mark Bristow

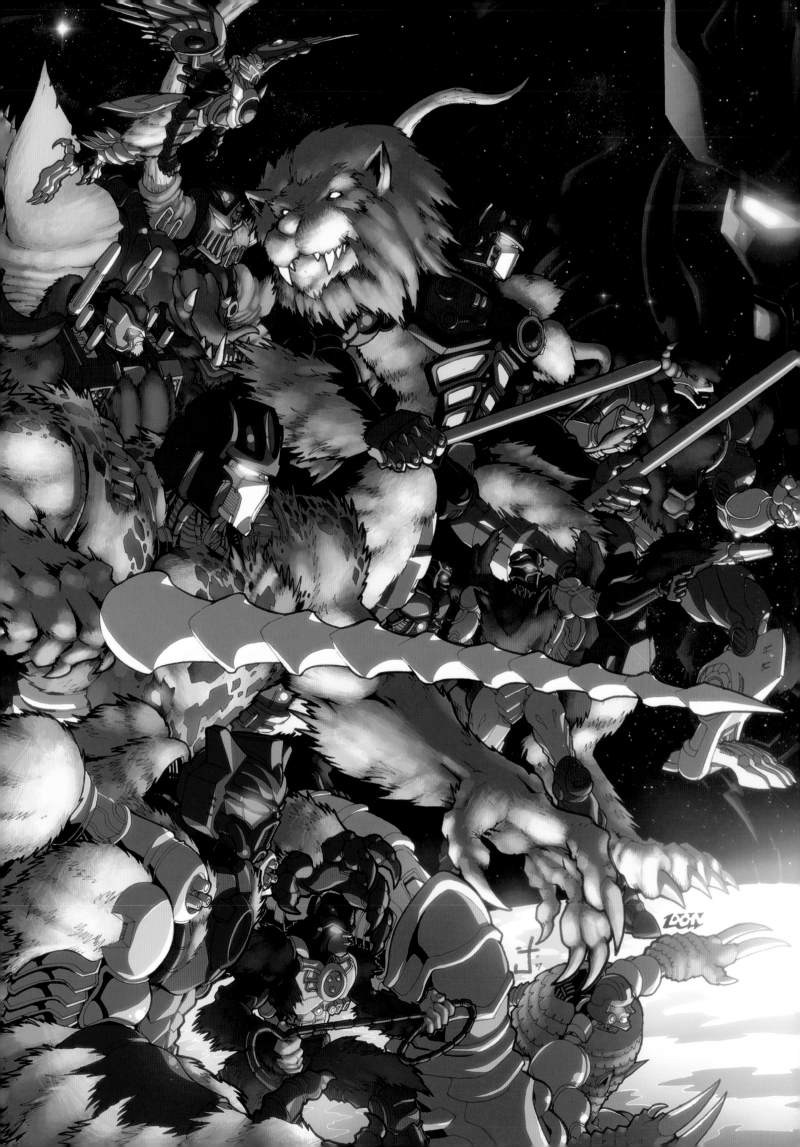

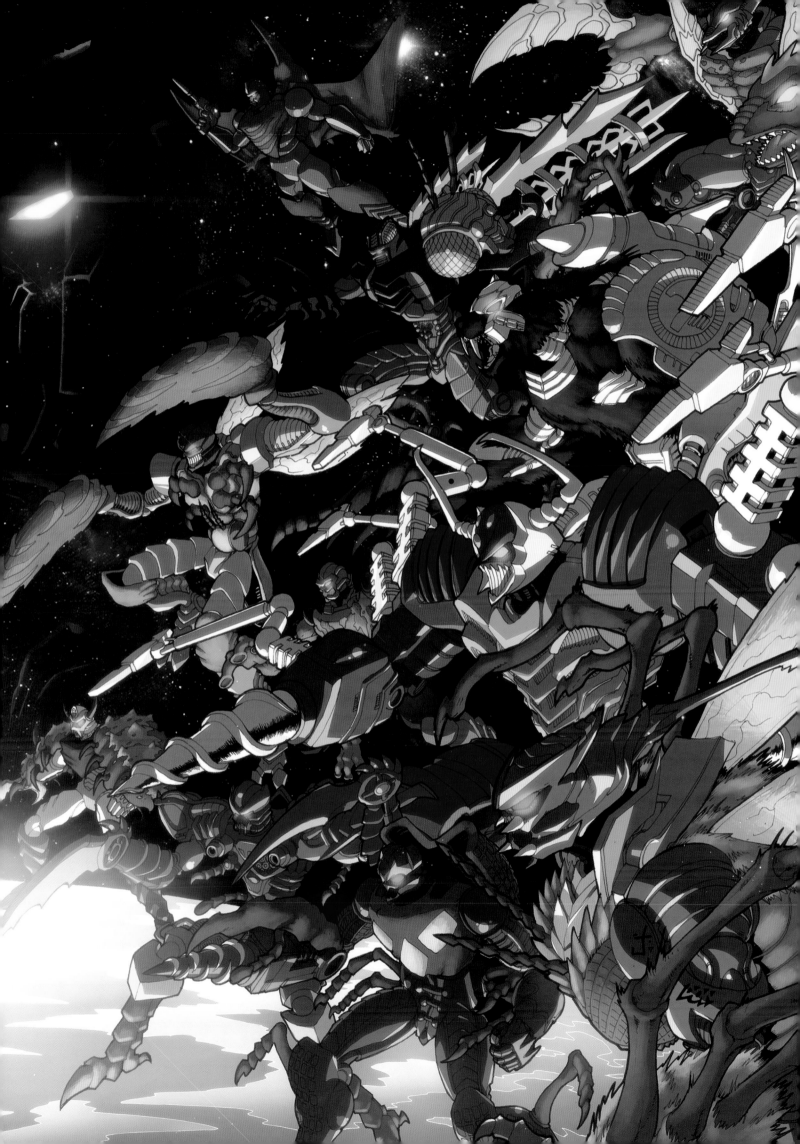

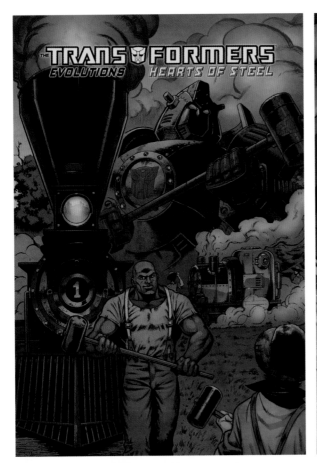

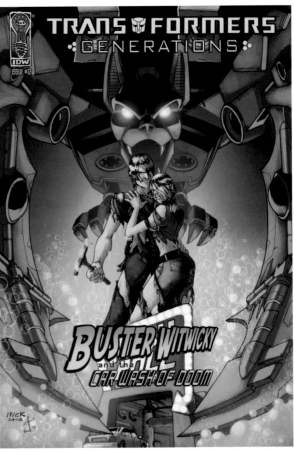

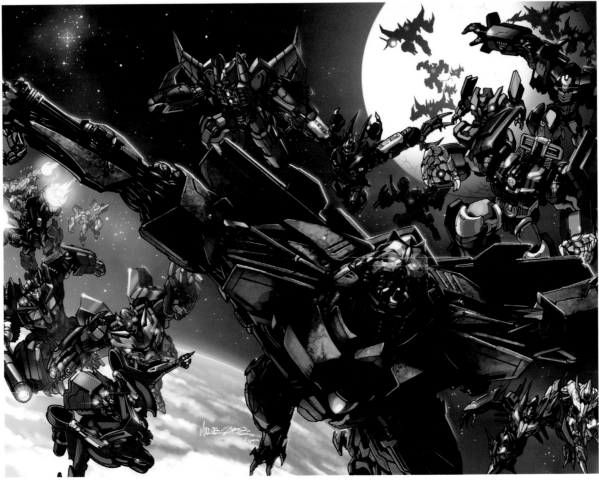

Top: Cover art, *The Transformers Evolutions: Hearts of Steel* #1, *Transformers Generations* #12, IDW Publishing
| Guido Guidi, Nick Roche & Josh Burcham

Below: Cover art, *Transformers: Reign of Starscream* #5, IDW Publishing | Alex Milne & Espen Grundetjern

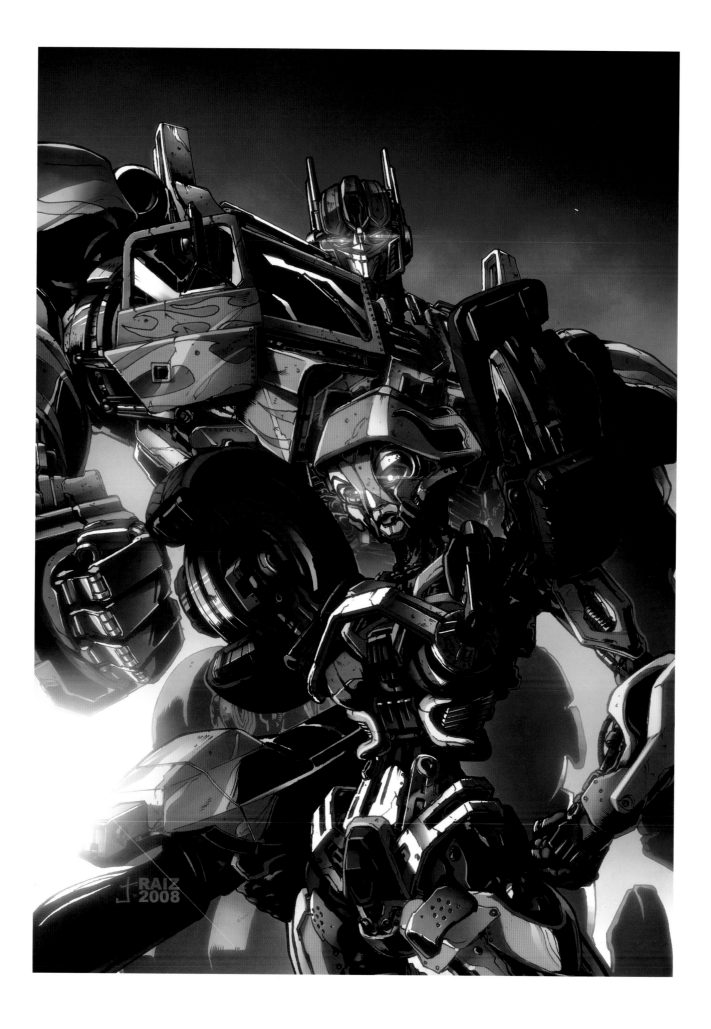

Above: Cover art, *Transformers: Reign of Starscream* #3, IDW Publishing | James Raiz & Josh Burcham

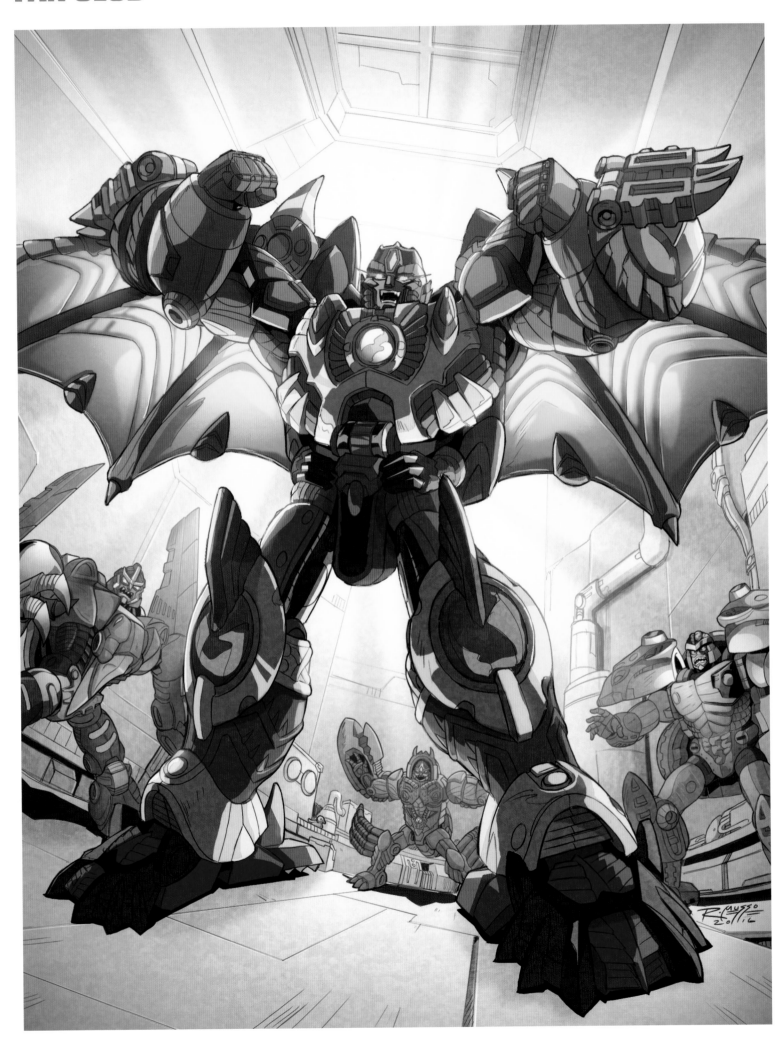

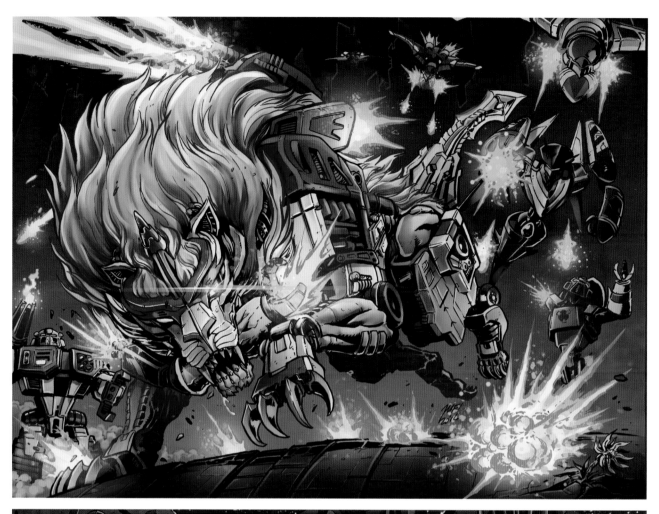

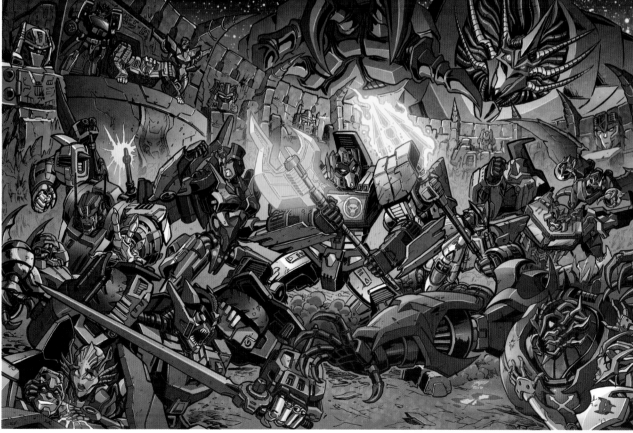

Opposite: Interior art, *Not All Megatrons*, Fun Publications | Robby Musso & Jesse Wittenrich

From top: Interior art, *Derailment*, Fun Publications; *Beast Wars Uprising* lithograph | Matt Frank & Gonçalo Lopes, Matt Frank & Thomas Deer

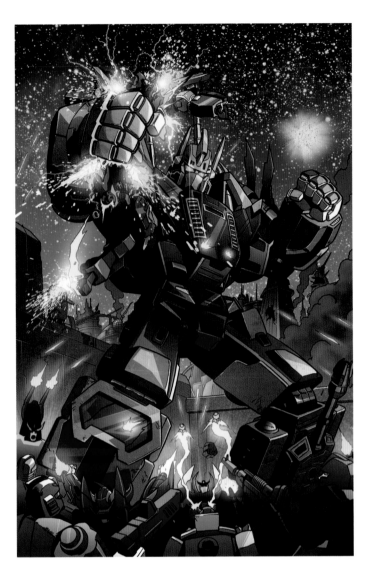

Left: Interior art, *The Coming Storm* part 5, Fun Publications | Dan Khanna & Thomas Deer

Right: Interior art, *Life Finds a Way*, Fun Publications | Matt Frank & Gonçalo Lopes

Below: Cover art, *Reunification*, Fun Publications | Robby Musso & Jesse Wittenrich

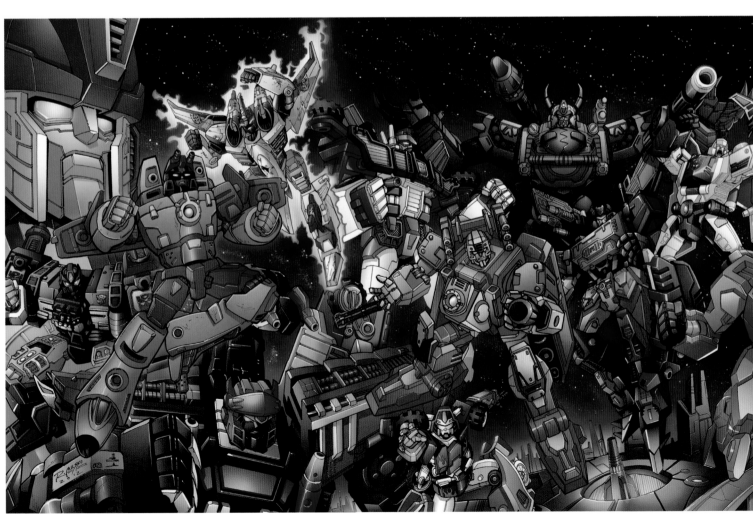

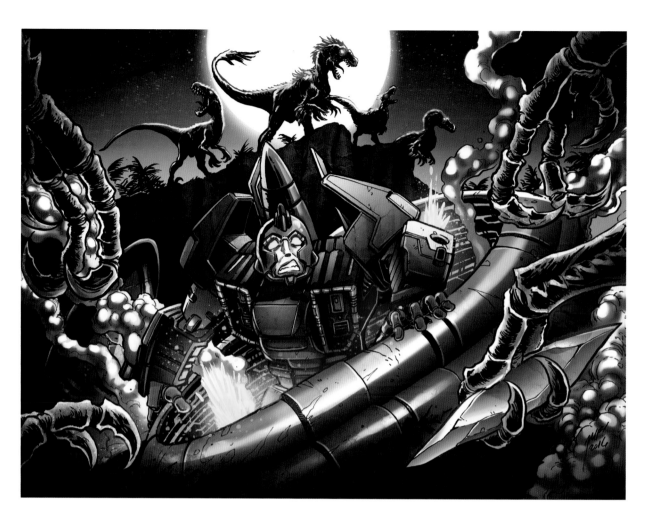

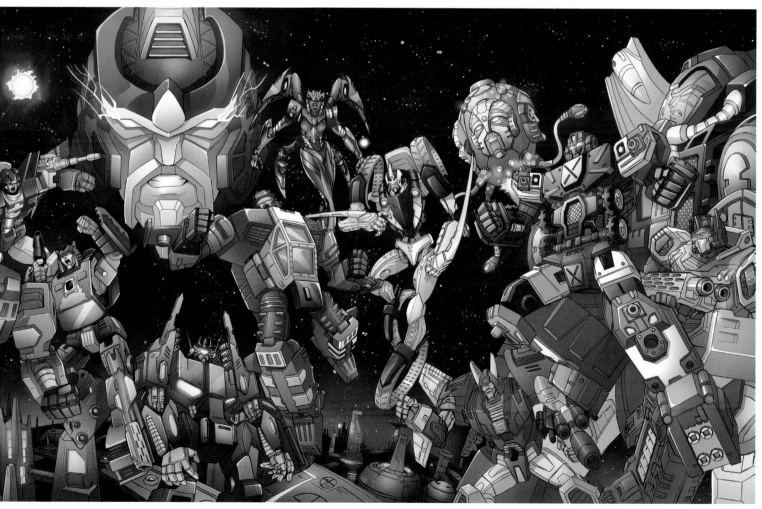

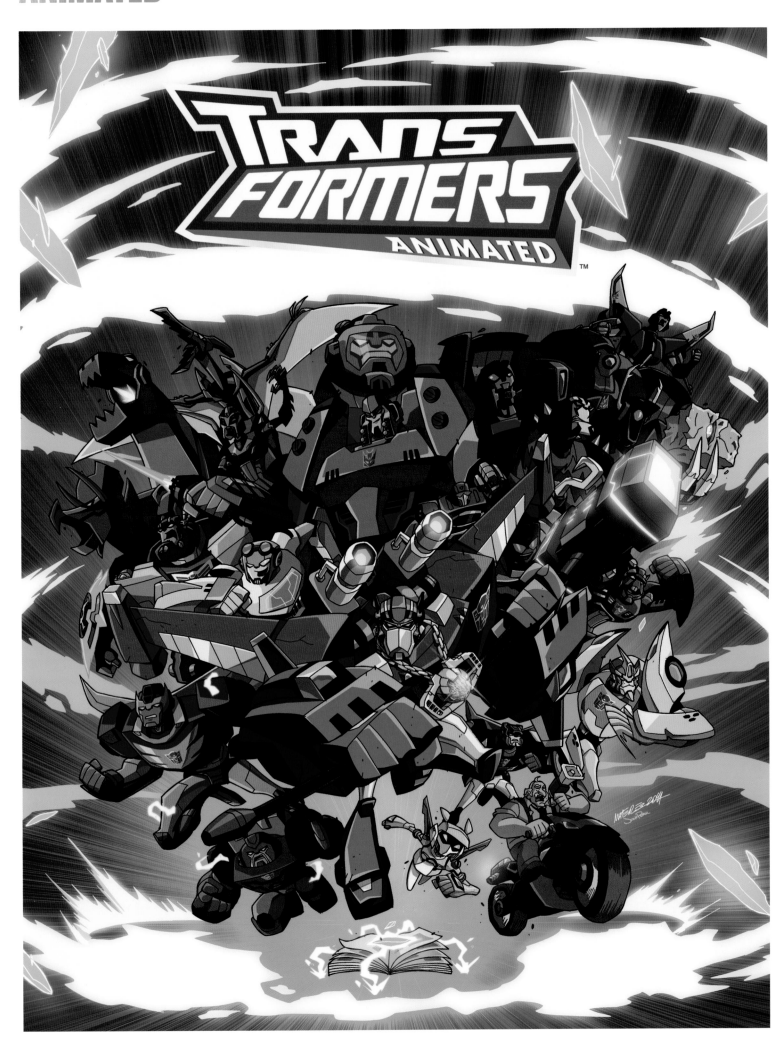

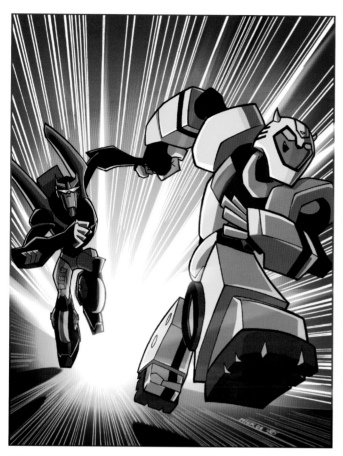

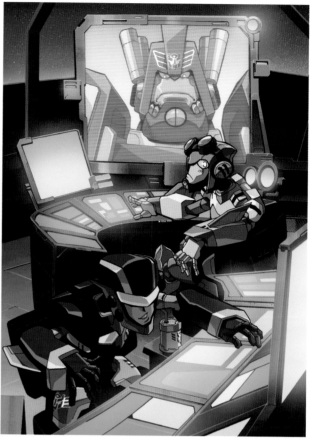

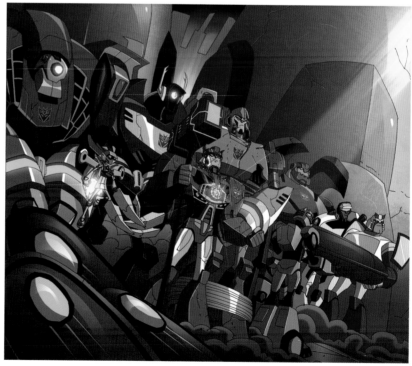

Opposite: Cover art, *The Complete AllSpark Almanac*, IDW Publishing | Marcelo Matere & Josh Perez

Clockwise from top left: Cover art, *The Race*, Titan Magazines | Nick Roche & Kat Cardy; Interior art, *The Return of Blurr* script reading storybook, Fun Publications | Naoto Tsushima & Josh Perez; Interior art, *The Stunti-Con Job*, Fun Publications | Marcelo Matere & Thomas Deer; Cover art, *The Arrival* #4, IDW Publishing | Josh Burcham

"One of the coolest covers I ever worked on! Again I had a chance to draw most of the iconic characters of the *Transformers Animated* series with a really cool concept that came from the show: the Allspark fragments that give life to the robots from the previous books ;) " — Marcelo Matere

THE COVENANT OF PRIMUS

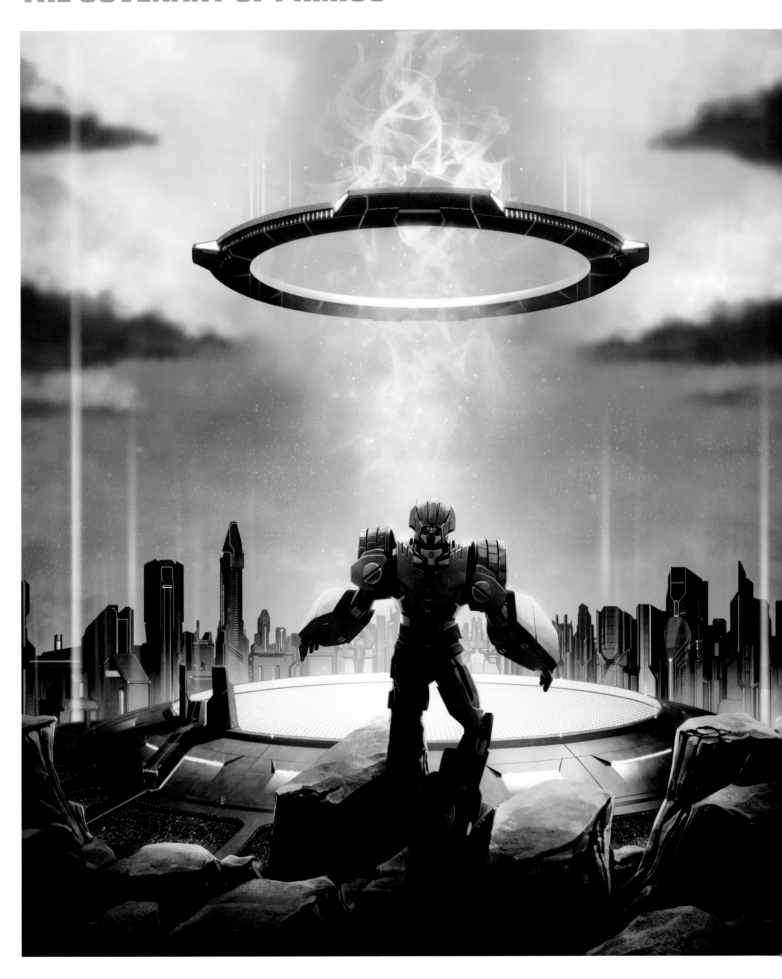

Above: Interior art, *The Covenant of Primus*, Becker & Mayer | Ken Christiansen

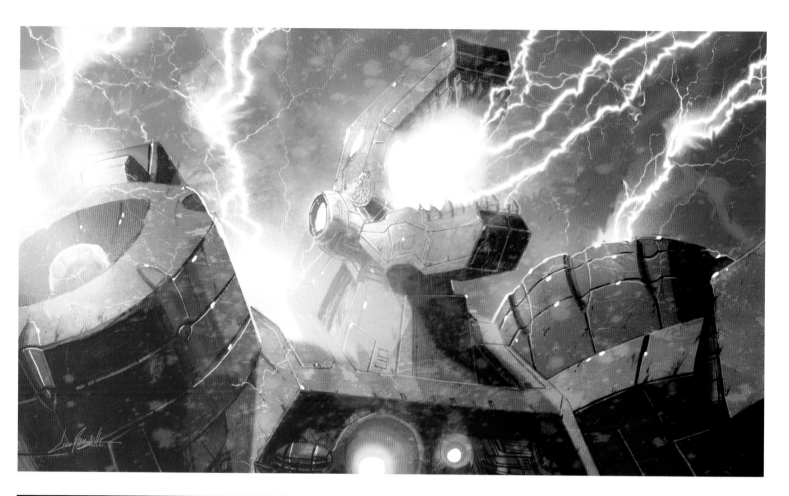

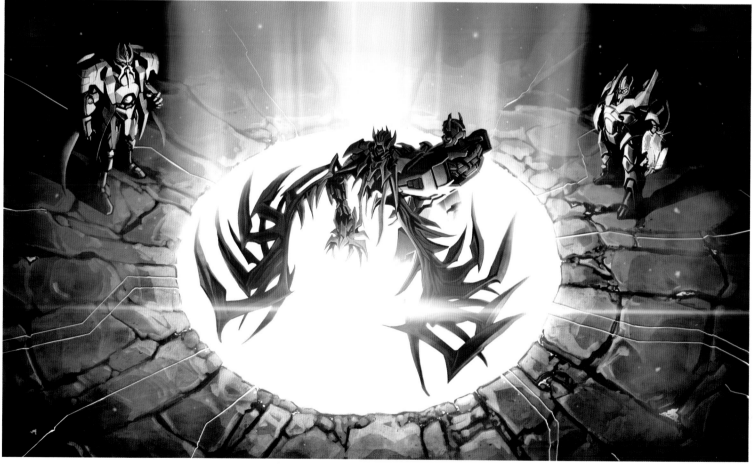

Top: Interior art, *The Covenant of Primus*, Becker & Mayer | Livio Ramondelli
Above: Interior art, *The Covenant of Primus*, Becker & Mayer | Ken Christiansen

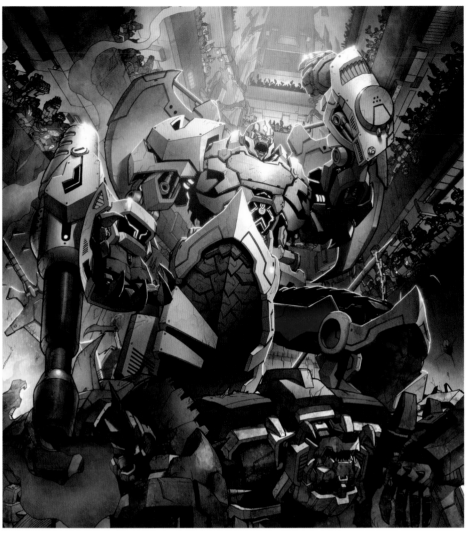

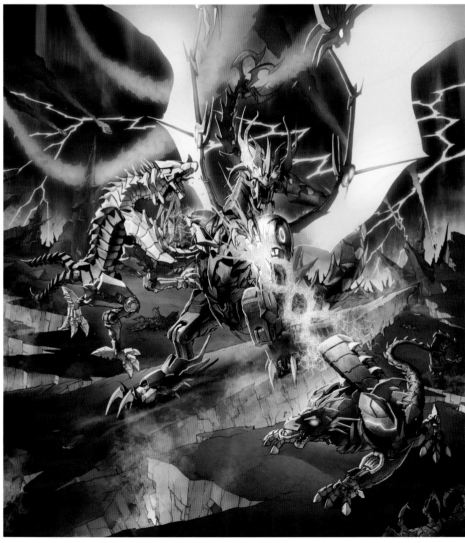

This page: Interior art, *The Covenant of Primus*,
Becker & Mayer | Casey Coller & Joana Lafuente

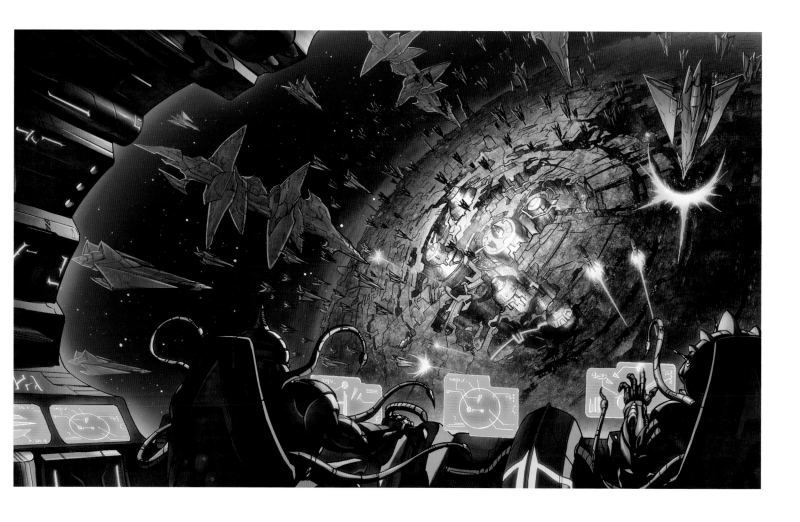

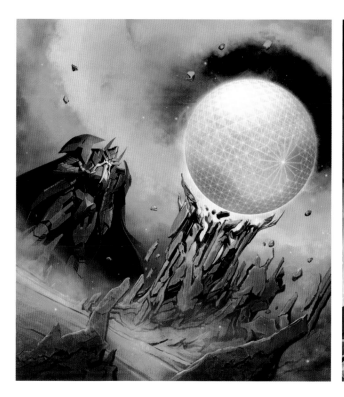 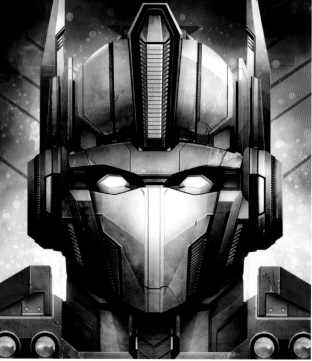

Top: Interior art, *The Covenant of Primus*, Becker & Mayer | Casey Coller & Joana Lafuente

Bottom: Interior art, *The Covenant of Primus*, Becker & Mayer | Ken Christiansen; Unused cover, *The Covenant of Primus*, Becker & Mayer | Ken Christiansen

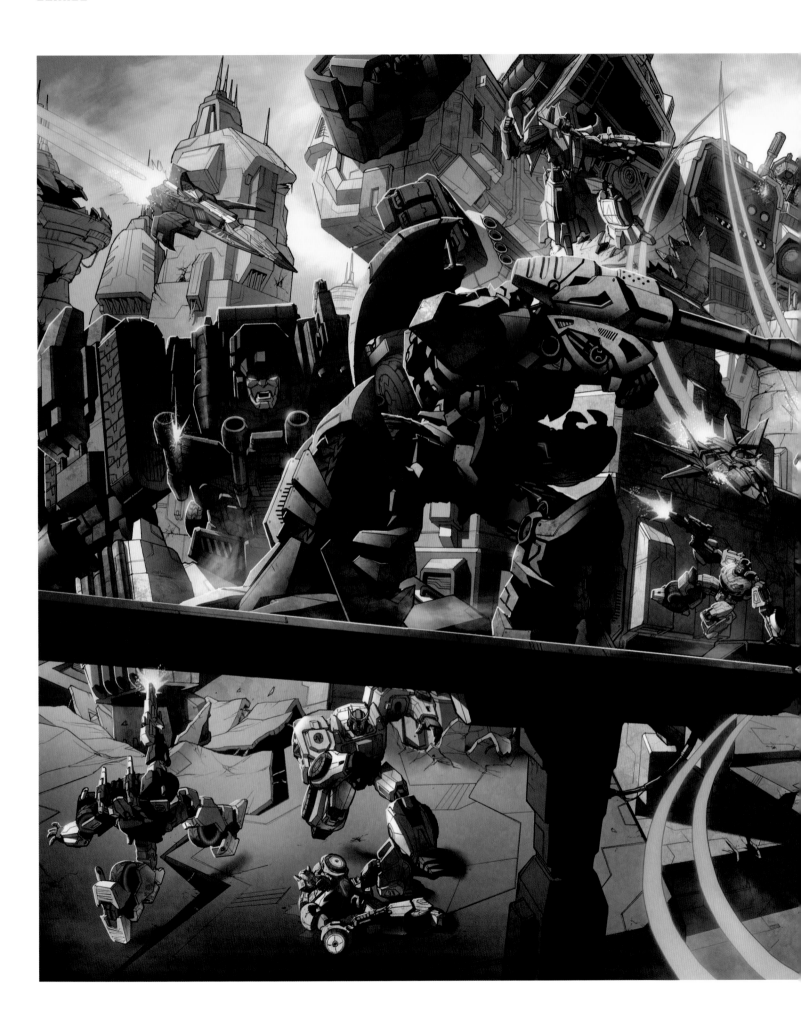

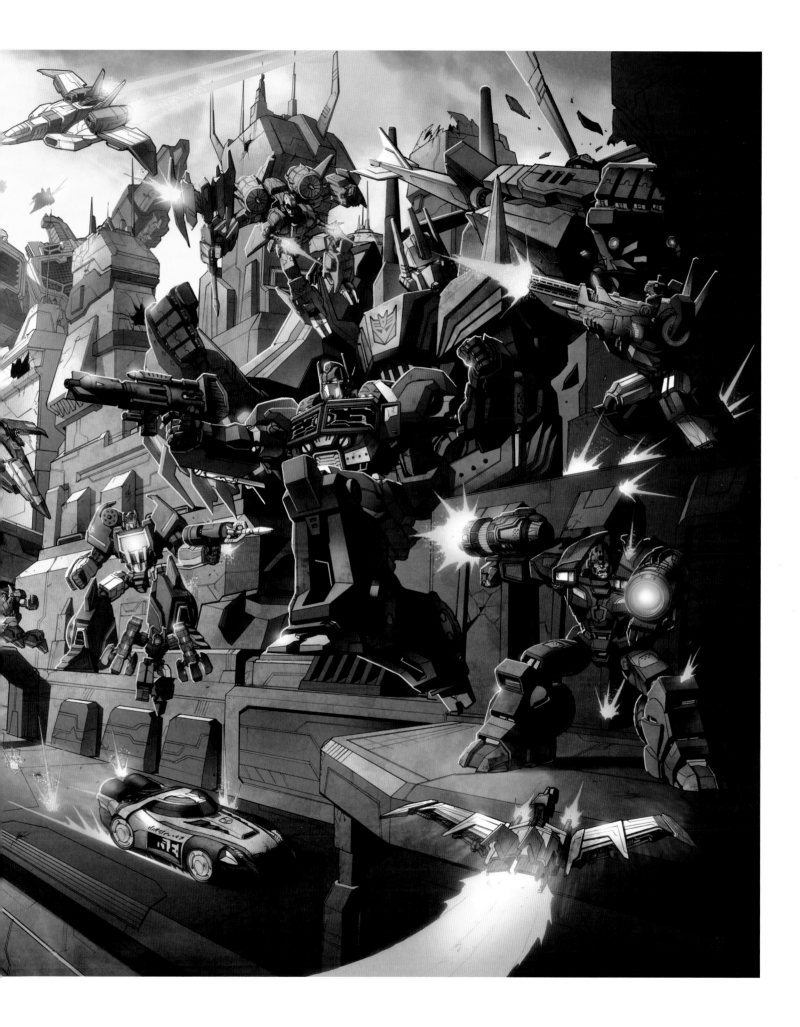

These pages: Interior art, *The Covenant of Primus*, Becker & Mayer | Casey Coller & Joana Lafuente

Popular culture is often considered
to be in conversation with itself,
and the Transformers franchise is
an excellent example of that. Over
the years, Transformers has made
visual nods to material as diverse
as *King Kong*, *Frankenstein*, *Hamlet*,
album covers, and classic comic
book moments.

But references to prior works
aren't limited to external franchises;
iconic imagery in Transformers
tends to repeat itself, with certain
comic covers (particularly Marvel
#1 and #5) and scenes from the
1986 animated movie being nodded
to again and again over the years.
It can be fascinating seeing the
same basic structure used for
different characters and continuities
throughout the years.

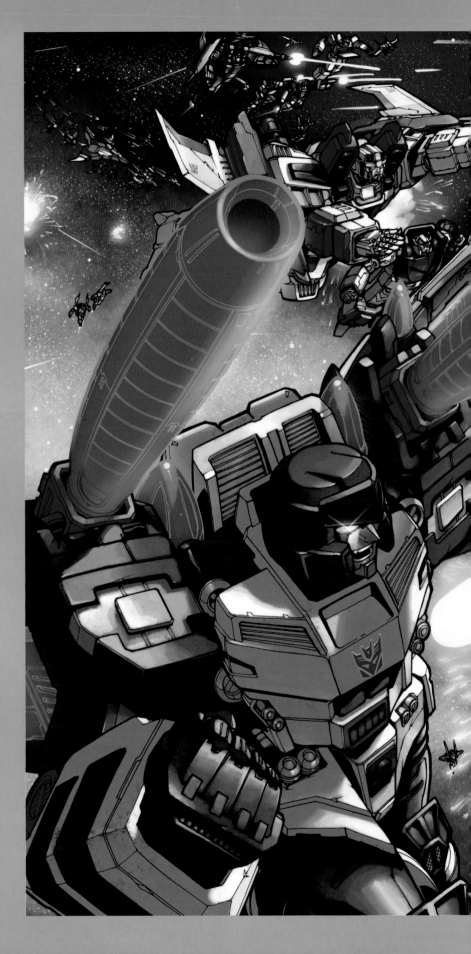

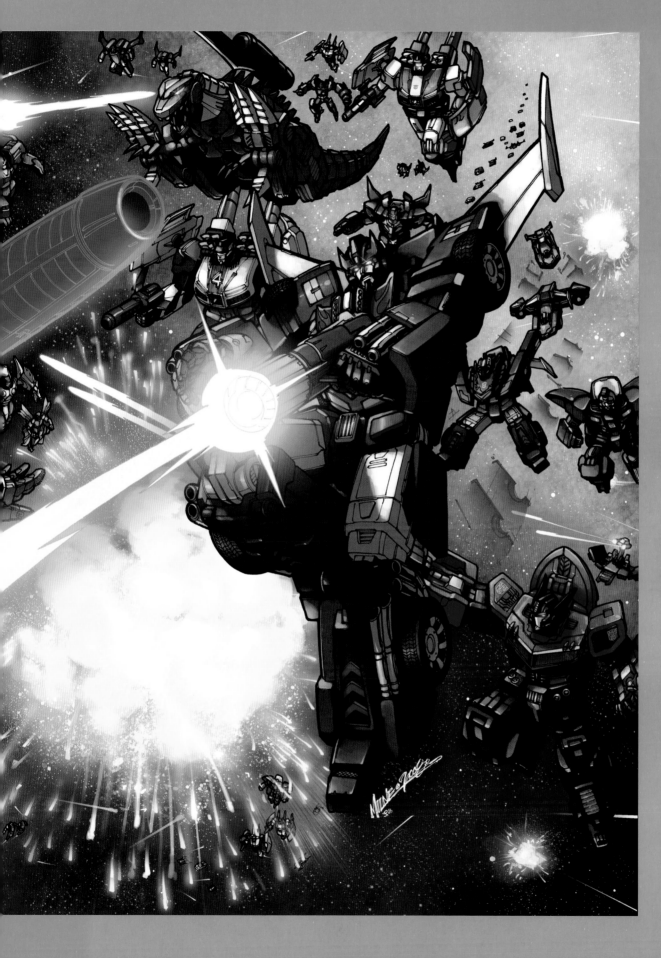

Above: Lithograph, *Shattered Glass*, Botcon 2008, Fun Publications | Alex Milne & Josh Perez

Left: Promo art, Optimus Prime, *Transformers: Titans Return* | Christopher Antoin

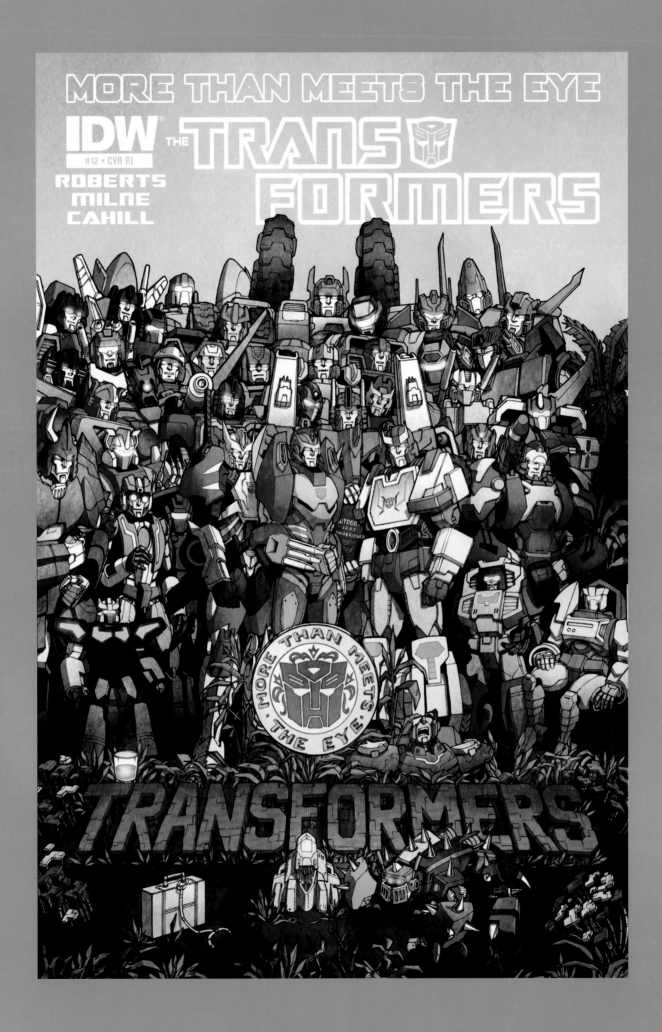

Above: Cover art, *Transformers: More Than Meets The Eye* #12, IDW Publishing | Casey Coller & Joana Lafuente

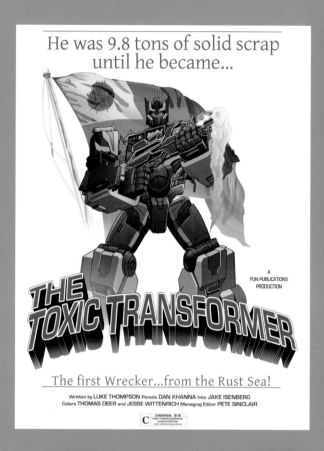

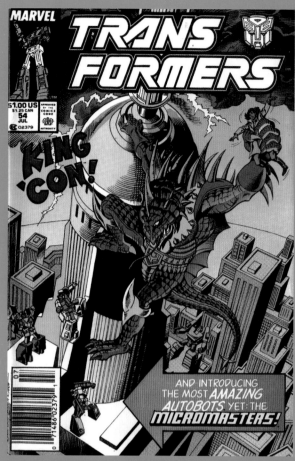

Clockwise from top left: Cover art, *The Toxic Transformer*, Fun Publications | Dan Khanna & Thomas Deer; *Transformers* #54, Marvel Comics | Jose Delbo & Danny Bulanadi; *Transformers: Robots In Disguise* #12, IDW Publishing | Casey Coller & Joana Lafuente; *Transformers: All Hail Megatron* #13, IDW Publishing | Nick Roche & Liam Shalloo

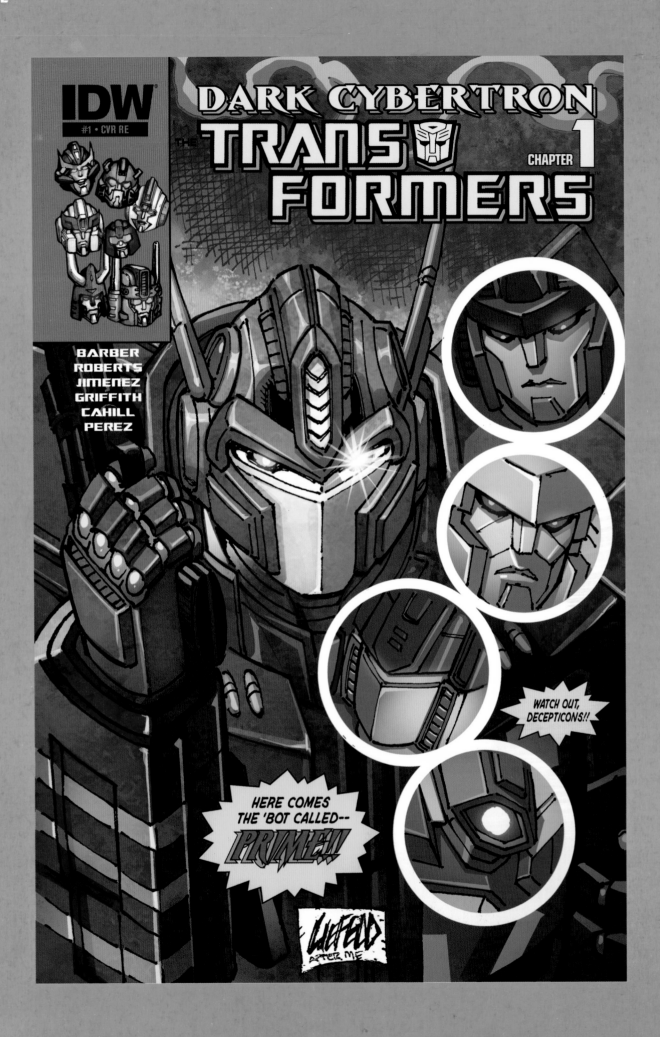

Above: Cover art, *Dark Cybertron* #1, IDW Publishing | Rob Liefeld & Romulo Fajardo Jr.

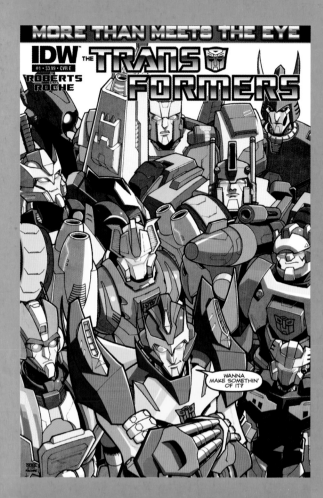

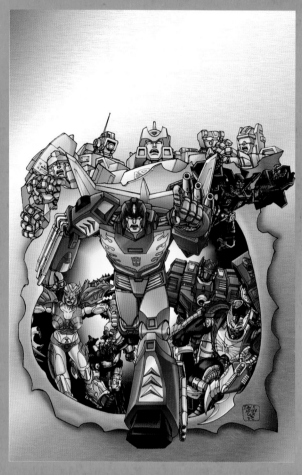

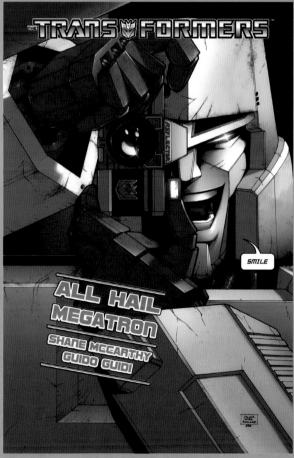

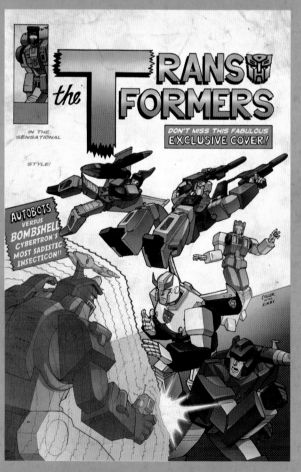

Clockwise from top left: Cover art, *The Transformers: More Than Meets The Eye* #1, IDW Publishing | Nick Roche & Josh Burcham; *Transformers: The Wreckers* #1 (revised), 3H Productions | Dan Khanna; *The Transformers* #12, IDW Publishing | Casey Coller & John-Paul Bove; *The Transformers: All Hail Megatron* #1 (early draft), IDW Publishing | Casey Coller & Josh Burcham

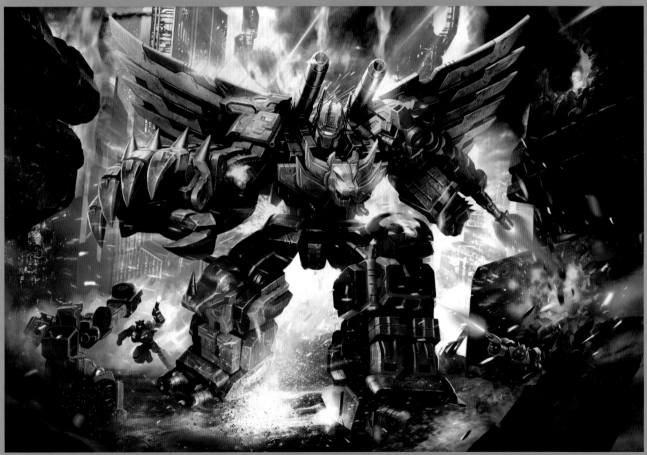

Top: Key art, *Transformers: Combiner Wars* | Christopher Antoin
Above: Package art, Predaking, *Power of the Primes*

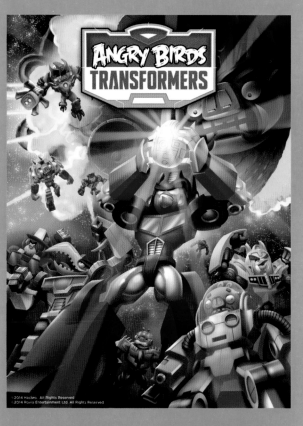

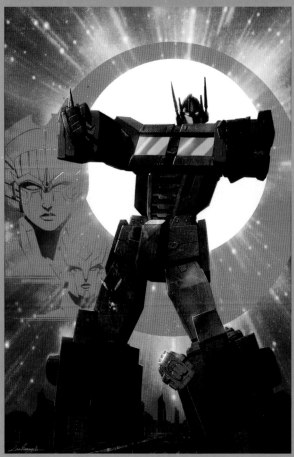

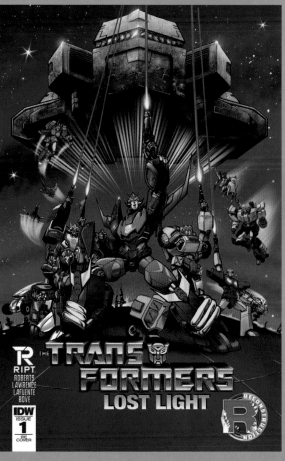

Clockwise from top left: Cover art, *Transformers: The Reign of Starscream* #1, IDW Publishing | Gabriel Rodriguez;
Angry Birds Transformers promotional image, Rovio Entertainment; *The Transformers: Lost Light* #1, IDW
Publishing | Timothy Lim; *The Transformers: Till All Are One* #1, IDW Publishing | Livio Ramondelli

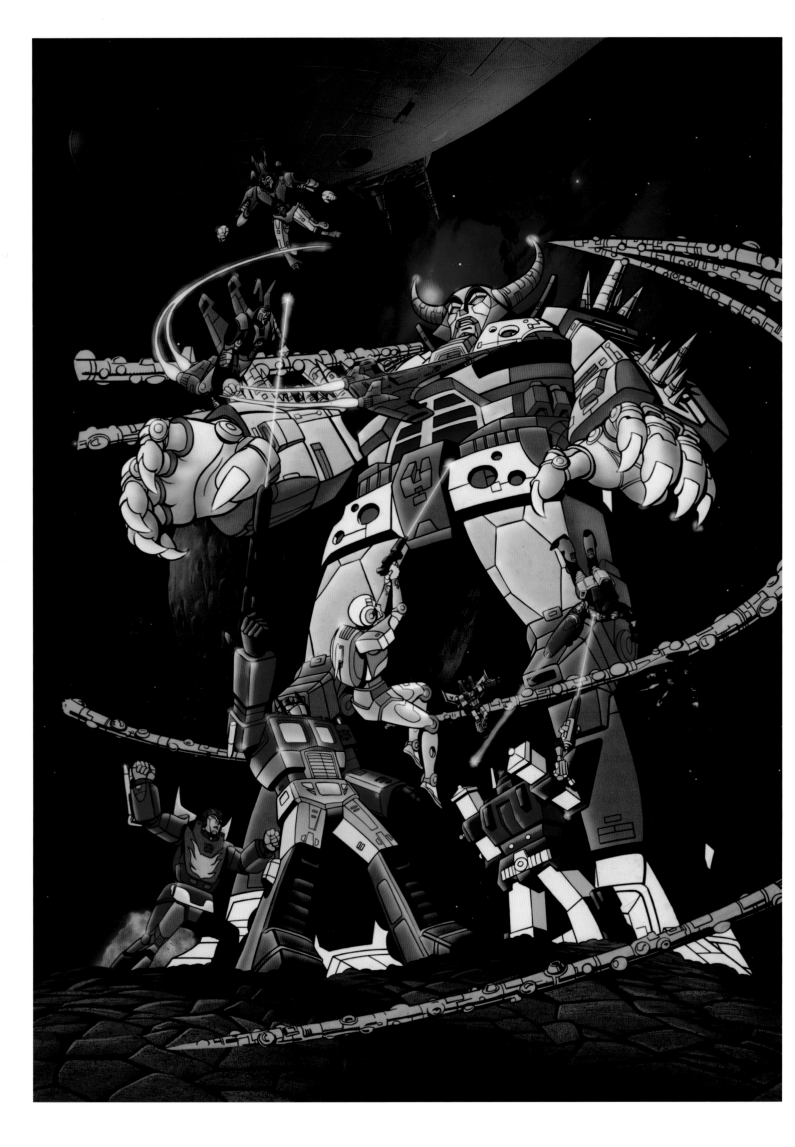

hen Transformers launched in 1984, there was a tri-part campaign to raise awareness of the brand-new toy property: advertisements, comics, and a sixteen-episode animated series that ran in the fall of 1984. *The Transformers* ran for four years, eventually airing ninety-eight episodes and a feature film. To many old-school fans, *The Transformers* cartoon of 1984 through 1987 was, and is, the definitive interpretation of the Transformers franchise. The characters showcased therein would be revisited again and again, often with characterization and backstories drawn directly from the series. One needs only look at the aesthetic of the Japanese Masterpiece line of toys, with their over-the-top faithfulness to the original animation models, to see just how influential *The Transformers* series has been to everything that came later. It's also the most consistently repackaged Transformers series, with various releases on VHS, LD, DVD, and Blu-ray, often supported by new artwork.

The Transformers was produced jointly by Marvel Productions, the animation group affiliated with Marvel Comics, and Sunbow Productions, a subsidiary of the Griffin Bacal advertising agency. To bring the toys to life, animation models needed to be created for the main cast. Takara artist Shōhei Kohara had already created a handful of models for early Transformers advertisements, including a 30-second spot for the first issue of *The Transformers* from Marvel Comics, but the rest of the cast would need to be fleshed out. Starting from Kohara's work, lead designer Floro Dery and his team created models for dozens of main characters and hundreds of guest stars, as well as building out the backgrounds of Earth, Cybertron, and the occasional alien world for the first two seasons of the show. Dery's work on the movie is particularly noteworthy, in that the character designs started with him and only then became toys, rather than the reverse as with the rest of the series. *The Transformers: The Movie* marked a turning point for the show. While seasons 1 and 2 took place (for the most part) on contemporary Earth, the movie fast-forwarded nineteen years into the future to the far-off year of 2005,

taking place across a wider galactic canvas. The third and (brief) fourth season continued in this era, and continued to explore an interplanetary scope.

But all good things come to an end, and *The Transformers* wrapped up in November of 1987 with the three-part episode *The Rebirth*—the aforementioned brief season 4. To be sure, the show would come back, often slightly repackaged for syndication, but that was it for new Transformers cartoons in the US for almost a decade. Japan was a different story. The first two seasons of the cartoon had been imported in 1985, with the third season imported as a separate, sequel series, *Transformers 2010*. By the time 1987 rolled around, things began to diverge more dramatically. Japan skipped the three-episode fourth season in favor of a brand new 35-episode series called *The Headmasters,* which covered many of the same characters. This was followed up by *Super God Masterforce* in 1988, and then *Victory* in 1989. They too wound down, with a final direct-to-video episode called *Transformers Zone* in 1990 focusing on Micromasters. Each series was a sequel to the one that had gone before; although each season told its own story and (for the most part) featured its own characters, they formed an interconnected continuity that persists in Japan to this day.

Time passed, and Transformers disappeared from US shelves. The Generation 2 revival of the early '90s was a moderate success, but featured little in the way of new animation. It wasn't until 1996 that Transformers would once again grace the airwaves with a new cartoon, created to support the new direction of the line: *Beast Wars*! Just as the Beast Wars toys were a dramatic departure from the previous toy line, so too was the *Beast Wars* cartoon different from the original *Transformers* show.

Rather than traditional cel-based animation, *Beast Wars* was fully computer rendered, one of the first television shows ever produced this way. Autobots and Decepticons were out, Maximals and Predacons were in. Gone too were the sprawling casts that had defined every season and series of Generation 1 (*The Rebirth* alone featured 45 new characters and dozens of older ones), replaced with smaller core teams. Though the cast size was dictated by the economic realities of CGI versus hand-drawn animation, this smaller focus led to

more character development and tighter stories. The artwork beautifully complemented the action and would win production designer Clyde Klotz an Emmy.

Although originally envisioned as a stand-alone series with minimal connection to what went before, *Beast Wars* would eventually incorporate numerous elements from the G1 cartoon and comic as story editors Bob Forward and Larry Ditillio became aware of the existing Transformers fandom and began interacting with them online. *Beast Wars* lasted three seasons, running from 1996-1999 and developed by Mainframe Entertainment. It was followed up by two seasons of *Beast Machines*, developed by the same production company and featuring the same cast. A new writing team was brought in, headed by Bob Skir and Marty Isenberg. The lore of G1 was an even greater part of the background in this series, with several specific plot elements drawn directly from the original *Transformers* cartoon.

By 2001, *Beast Machines* had wrapped up and Hasbro's next major Transformers endeavor, *Armada*, was still a year away. Fortunately, *Beast Wars* had proved to be an even bigger hit in Japan than it was in the US, providing a wealth of potential content to import as a placeholder. The first season of *Beast Wars* was brought over to Japan as a more-or-less straight dub, but the second season was considered too short. While Japan waited for the US to produce more episodes, they created *Beast Wars II*, then *Beast Wars Neo*, two traditional cel-based series taking place in the distant future. These were followed by the localization of *Beast Wars* seasons 2 and 3 into their own sequel series, *Beast Wars Metals*.

The next series, and the last Japanese-original *Transformers* cartoon ever broadcast, was another hand-drawn series called *Car Robots*. Though it took place on present-day Earth, the antagonists were Predacons hailing from an ambiguous Beast-era timeframe. All three Japanese series featured a mixture of brand-new toys alongside existing toys unused in the North American *Beast Wars* cartoon. It was *Car Robots* that was chosen to fill in the gap between *Beast Machines* and *Armada*, brought over to America as *Robots in Disguise*. Though the English dub added in numerous references to existing Transformers concepts, it was unambiguously a complete reboot, with a new brand-new Optimus Prime and his Autobots battling a brand-new Megatron and his Predacons. The whimsical storytelling, anime art style, and the return of contemporary vehicle-based alt modes proved a hit with adult and child fans alike.

In 2002 Hasbro revealed the *Armada* toy line, another reboot and the third major Transformers continuity. Autobots and Decepticons were back, joined by a third faction: the Mini-Cons. Small Transformers who could "Powerlinx" with their larger brethren to provide a huge boost in capabilities, the Mini-Cons were highly sought after by both Autobots and Decepticons. The Armada toy line was naturally supported by its own animated series. *Armada*, as well as its sequels *Energon* and *Cybertron*, which were co-produced by Takara. Collectively known as the Unicron Trilogy, these three series ran from 2002 to 2006. Though *Armada* was hand-drawn, *Energon* and *Cybertron* featured a mixture of shaded CGI and hand-drawn animation. Each series was 52 episodes long, though the occasional episode aired only in Japan.

The next series to air was *Transformers Animated*. Production was brought back to the states, falling to Cartoon Network. The unique artistic sensibilities of Derrick Wyatt, along with the writing talents of Marty Isenberg and producer Matt Youngberg, brought another new continuity to life. The visual style couldn't have been more different from what had been seen during the *Unicron Trilogy*. Gone were the computer renders, replaced with expressive robots with unique silhouettes.

The line-wide gimmicks that had driven toys and storytelling for the past few years were replaced with a character-specific focus. Though initially skeptical of this radical new aesthetic direction, the fans were quickly won over once they saw the new style in action, aided by a story and character focus not seen since *Beast Wars*. Ultimately *Animated* ran for three seasons, from 2007 through 2009.

Something had changed with the Transformers brand, though, and that something was the live-action film franchise. The phenomenal success of the movies came too late to inform *Transformers Animated*, but was a powerful influence on the next series, *Transformers Prime*. Once again, computer animation was used. The decade that passed after the end of the Beast era brought major improvements to the art form. While the animation of *Beast Wars* was decent for its time, the models and walk cycles look dated to modern eyes.

Not so with *Prime*! No effort was spared in the making of this series, and it shows. Over its four-year run (2010 through 2013, spanning sixty-five episodes and a direct-to-video finale) it garnered an astounding eight Emmy awards celebrating the background designs of Vince Toyama and Jason Park, the character animation of Arato Kato and Yasuhiro Motoda, the character design of Jose Lopez, the storyboards of Kirk Van Wormer, and the color design of Christophe Vacher. The influence of the films was strong, with a movie-inspired team and a serious tone. Peter Cullen, who voiced Optimus Prime in the original G1 series and the films, was brought back to reprise his role once more. Nonetheless, *Prime* took

NO EFFORT WAS SPARED IN THE MAKING OF THIS SERIES, AND IT SHOWS.

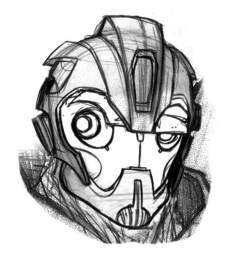
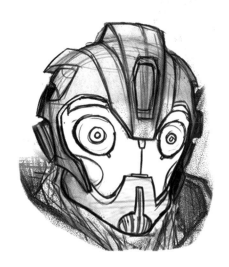
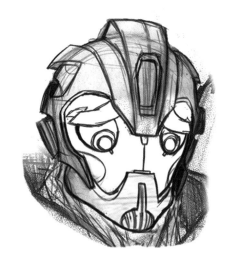
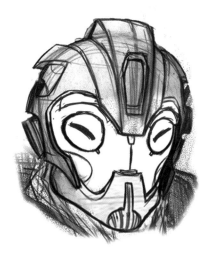

Above: Character designs, Bumblebee expressions, *Transformers: Prime*

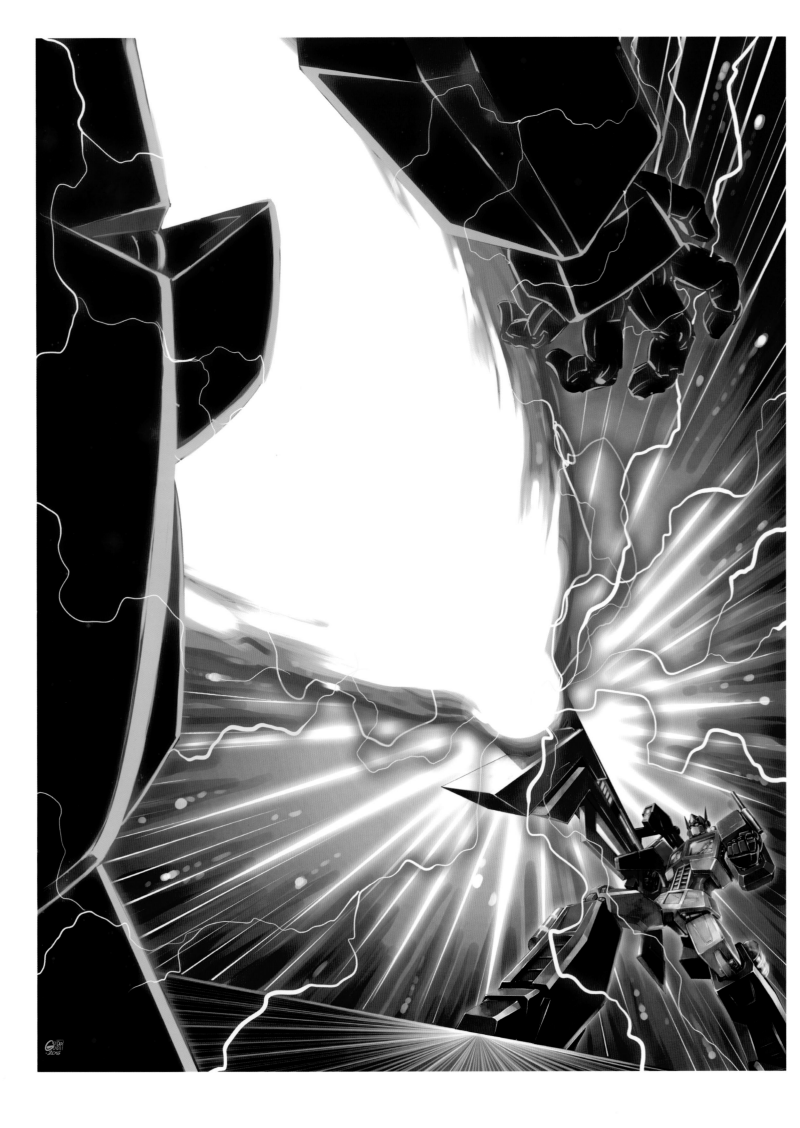

place in its own new universe, albeit one that was closely aligned with the video games (*Fall of Cybertron* and *War for Cybertron*) and novels produced contemporaneously.

Prime's success was such that it warranted both a sequel and a spin-off series. *Robots in Disguise* (no relationship at all to the *Car Robots* dub from 2001) took place shortly after *Prime*. A mixture of traditional and computer animation, *Robots in Disguise* broke many Transformers storytelling conventions: Bumblebee was given command of the team rather than Optimus, and it featured primarily new characters rather than reinterpretations of legacy characters. It ran for seventy-one episodes, from 2014 through 2017. Meanwhile, *Rescue Bots*, a series pitched at younger viewers, took place contemporaneously with *Prime*. Unlike all previous Transformers series, *Rescue Bots* featured no Decepticons, instead focusing on a group of Autobots who were primarily tasked with helping out humans. At four seasons and 104 episodes, it's the longest running of any Transformers television show, running from 2011-2016.

Hasbro did not confine its animation efforts to traditional broadcast and cable television. In addition to a handful of DVDs included with various Transformers toys over the years, in 2016, Hasbro Studios and Machinima coproduced the first of three CGI web series to promote the contemporary Prime Wars toy lines. *Combiner Wars* kicked off with eight episodes of about five minutes each. When that proved successful, two sequel series, *Titans Return* and *Power of the Primes,* were announced and released in 2017 and 2018, respectively. These seasons were considerably longer, ten episodes of about eleven minutes.

And the adventure continues! Recently, Hasbro renewed its partnership with Cartoon Network to produce *Cyberverse*, another Bumblebee-focused series that began in 2018. *Rescue Bots* received a sequel series this year as well, *Rescue Bots Academy*. Both these series retained the 11-minute format begun in *Titans Return*, a departure from the 22-minute format that dominated from 1984 through 2017. It's amazing to contemplate that, since the debut of *Beast Wars* back in April of 1996, there hasn't been a single year without new *Transformers* on television. It's a trend that feels likely to continue for a good long while, and frankly, that's just prime.

Opposite: Promo poster, Optimus Prime, *Transformers: Combiner Wars* | Guido Guidi

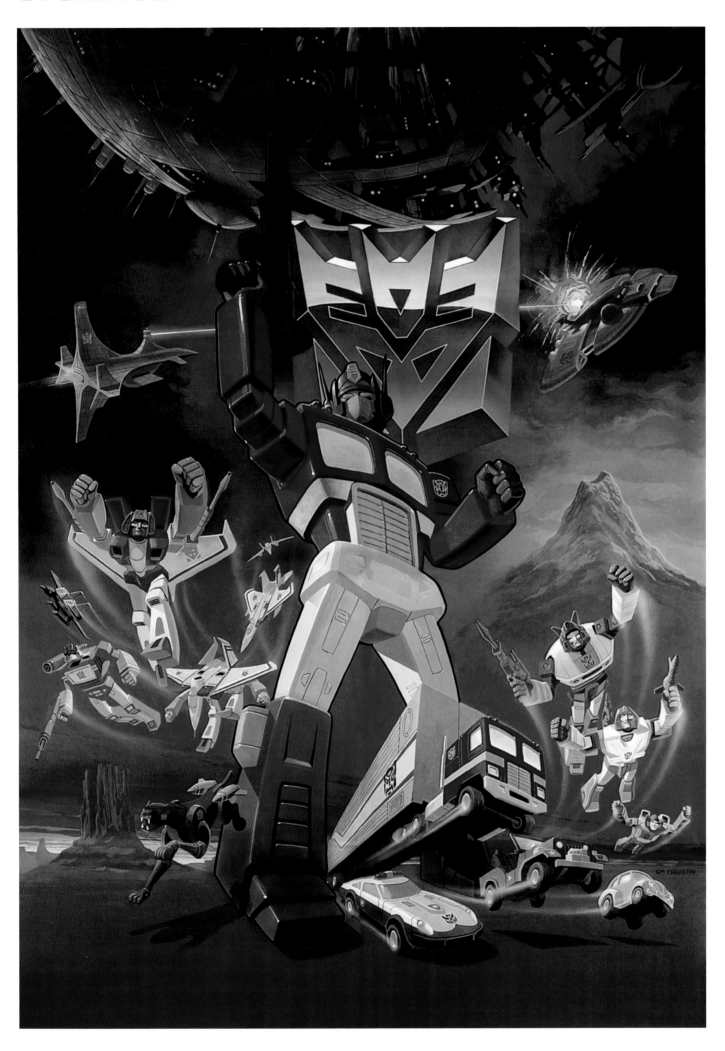

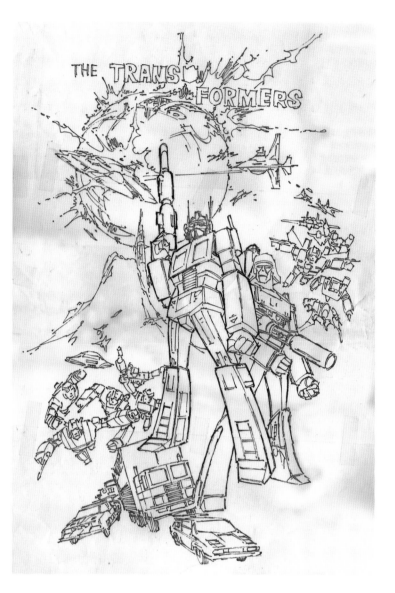

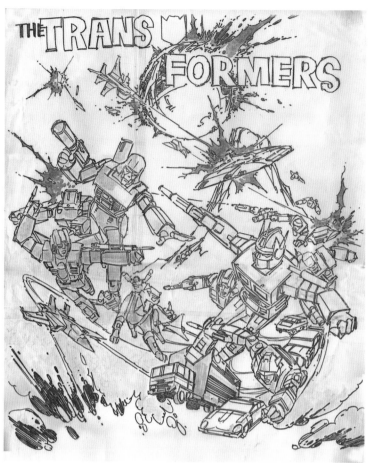

Opposite: Poster, *The Transformers* | G.M Egglestone
This page: Poster sketches, *The Transformers* | G.M. Egglestone

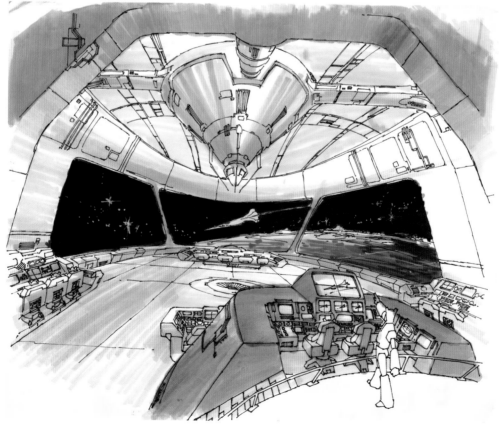

Opposite: Location art, Ark exterior, *The Transformers*

From top: Location art, Decepticon headquarters, Ark bridge, *The Transformers*

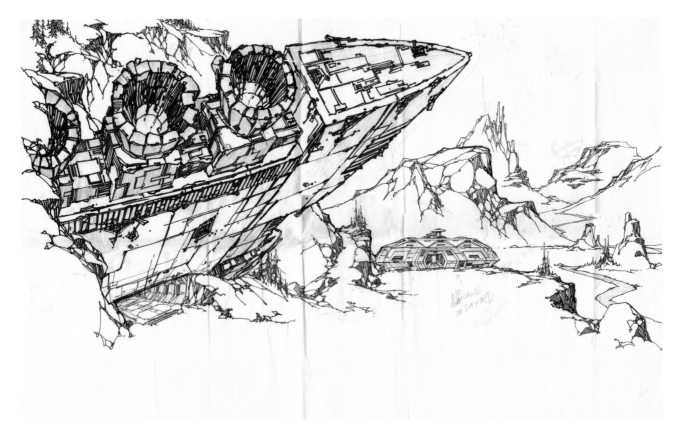

From top: Location art, Ark exterior, Cybertron, *The Transformers*

IACON

This page: Location art, Iacon, *The Transformers*

700-52 "ELITA ONE"

700-52 "ELITA ONE IN VEHICLE MODE"

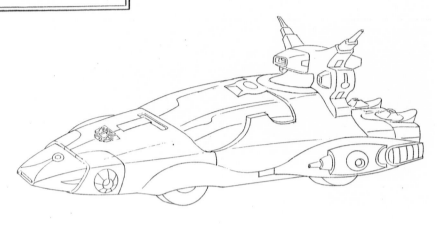

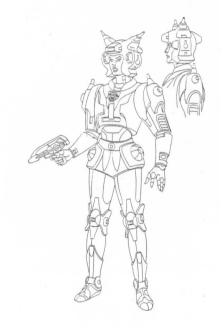

page 454

700-58 " ORION PAX "
(TALL YOUNG MALE ROBOT)

700-58 " ORION PAX "
(LARGE TRANSPORT VEHICLE)

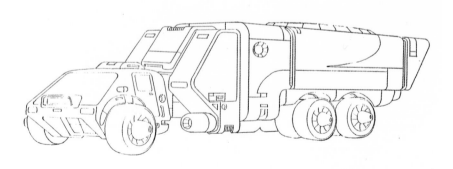

page 509

Clockwise from top left: Character designs, Elita 1 Vehicle Mode, Elita 1 Bot Mode, Orion Pax Bot Mode, Orion Pax Vehicle Mode, *The Transformers*

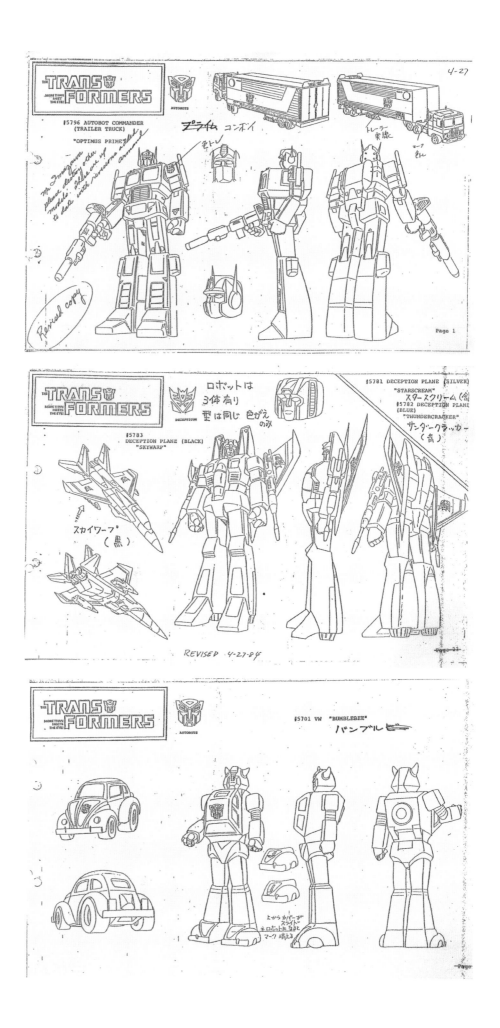

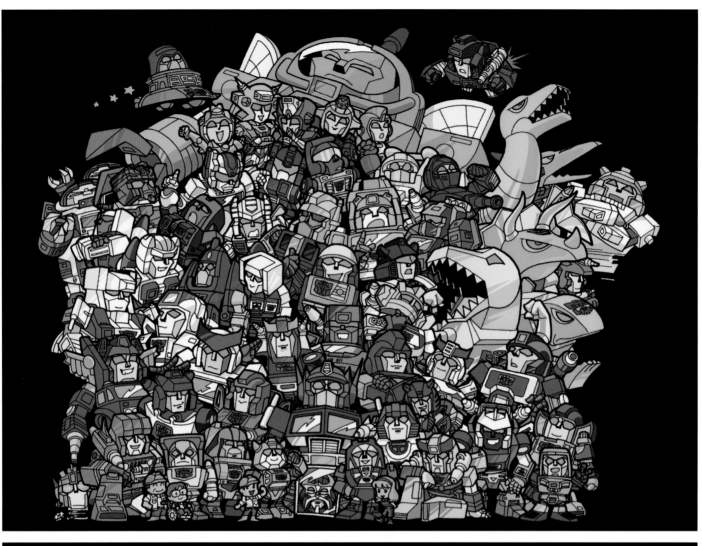
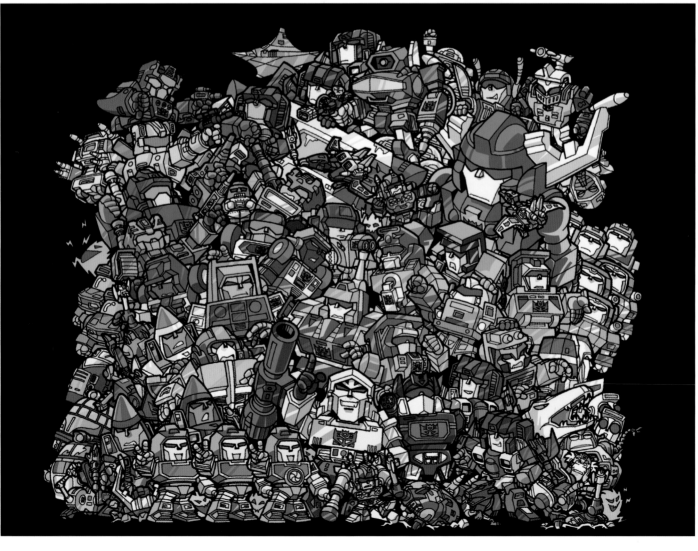

BOMB-TIPPED ARROW

BETA
700-74

CAPT. MARISSA FAIRBORN
(COMMANDER EARTH DEFENSE COMMAND RECUE SHIP)
700-66 DAY-ONE
TRANSFORMERS MINI-SERIES

LIGHTPOLE W/ BAT LIKE
R-13 ②

SLIZARDO

MARA-AL-LITH.

PERISCOPE

TWIN LASER CANONS

SENTRYBOT #1-2&3
700-97 (R-28&30)

Opposite, from top: Promo art, *Fight! Super Robot Lifeform Transformers* (Convoy laserdisc), *Fight! Super Robot Lifeform Transformers* (Megatron laserdisc), Generation 1 | Hidetsugu Yoshioka

Above: Model sheets, third season, *The Transformers*

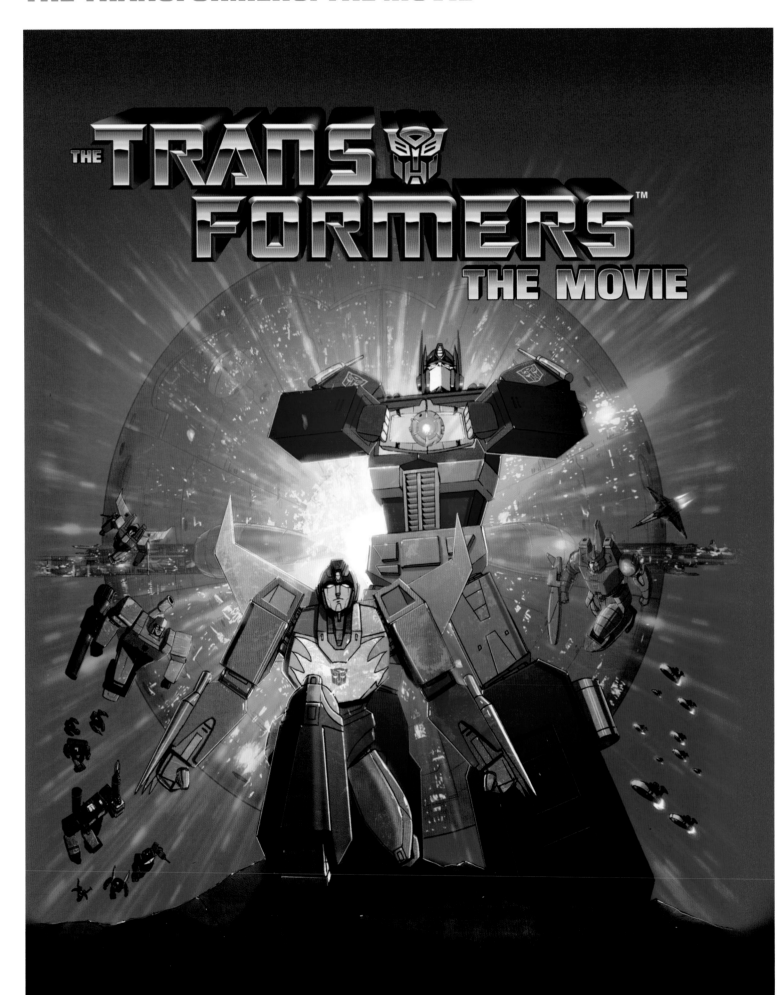

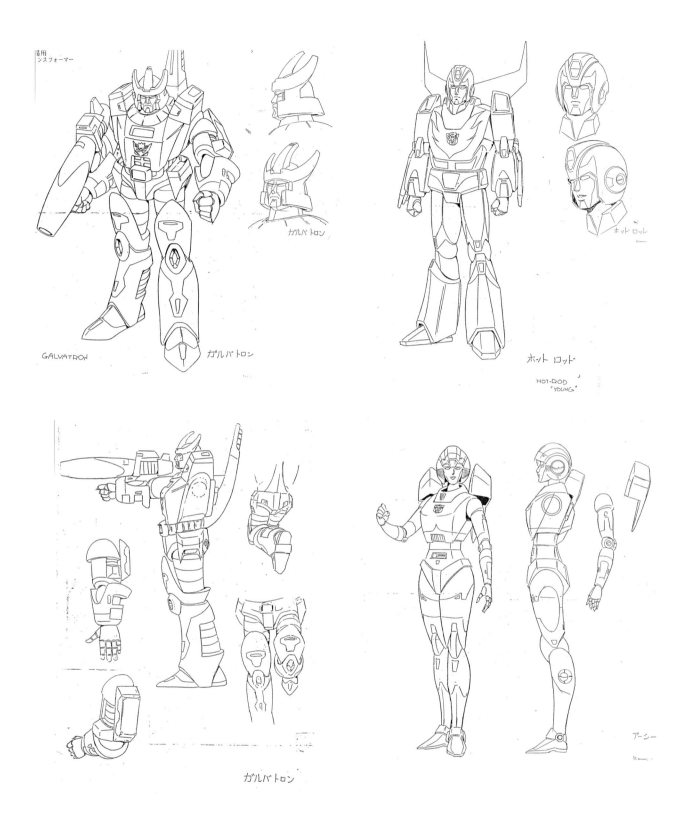

易用
ンスフォーマー

GALVATRON

ガルバトロン

ガルバトロン

ホット ロット

HOT-ROD
‹YOUNG›

ガルバトロン

アーシー

Opposite: DVD cover, *The Transformers: The Movie* | Livio Ramondelli

Clockwise from top left: Character designs, Galvatron, Hot Rod, Arcee, Galvatron profile, *The Transformers: The Movie*

"When I was a kid, our local video rental place only had one copy of the Transformers animated movie. That concept alone sounds insane today. But I re-rented it countless times, and it was a movie that meant so much to me growing up. So many moments from the film are seared into my soul, as they are for many people who grew up with this movie. To be asked to do the cover for the Blu-ray many years later felt very special to me. I've been beyond flattered to be asked by many people if the original line art is available to buy, but this is one piece I'm going to keep." — Livio Ramondelli

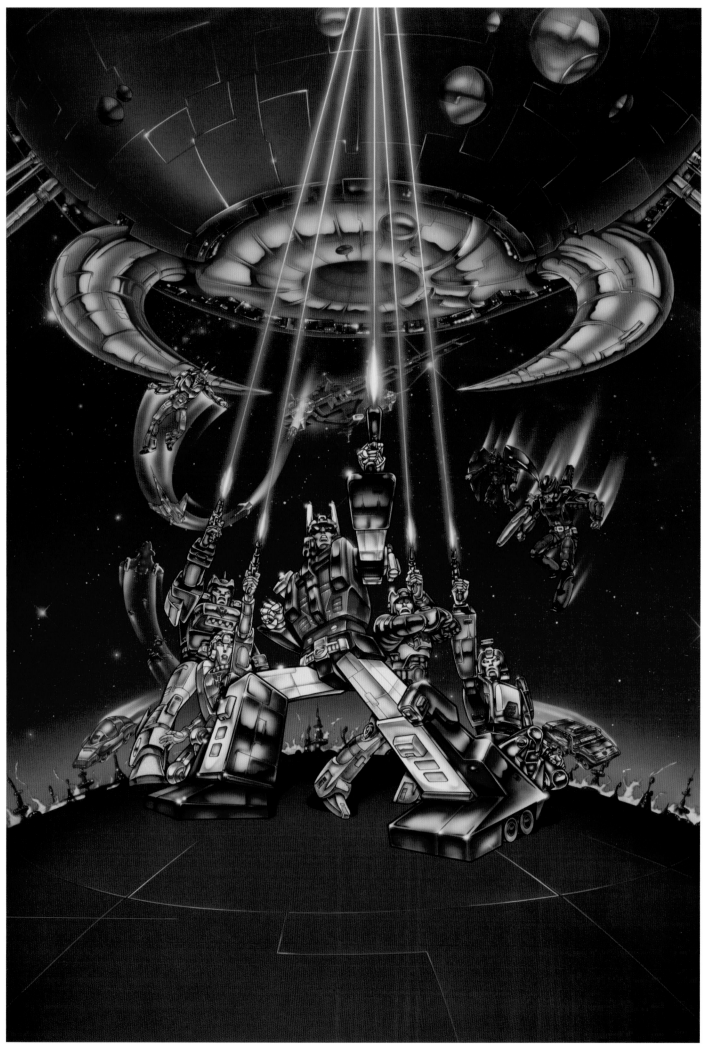

Above: United States Poster, *The Transformers: The Movie*

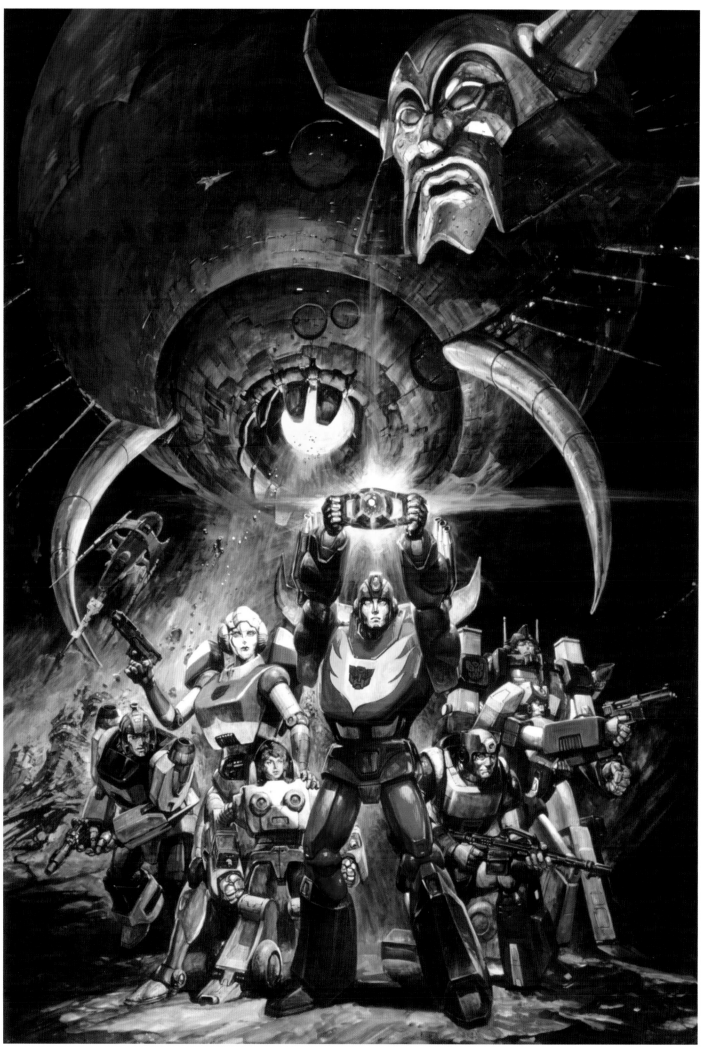

Above: Japan Poster, *The Transformers: The Movie*

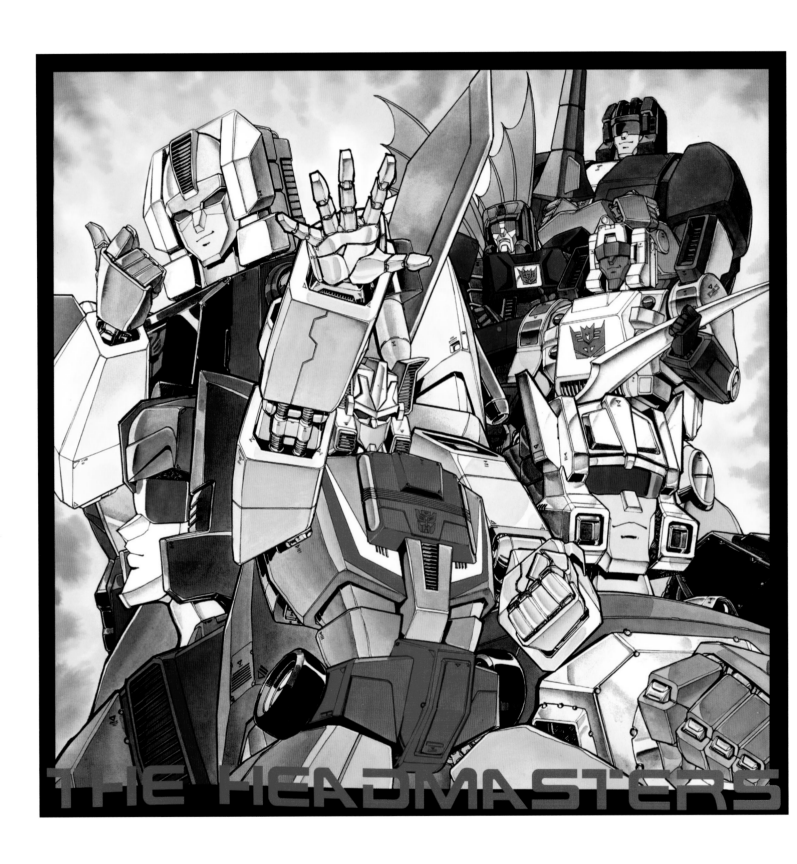

THE HEADMASTERS

Above: Promo art, *The Transformers: The Headmasters*

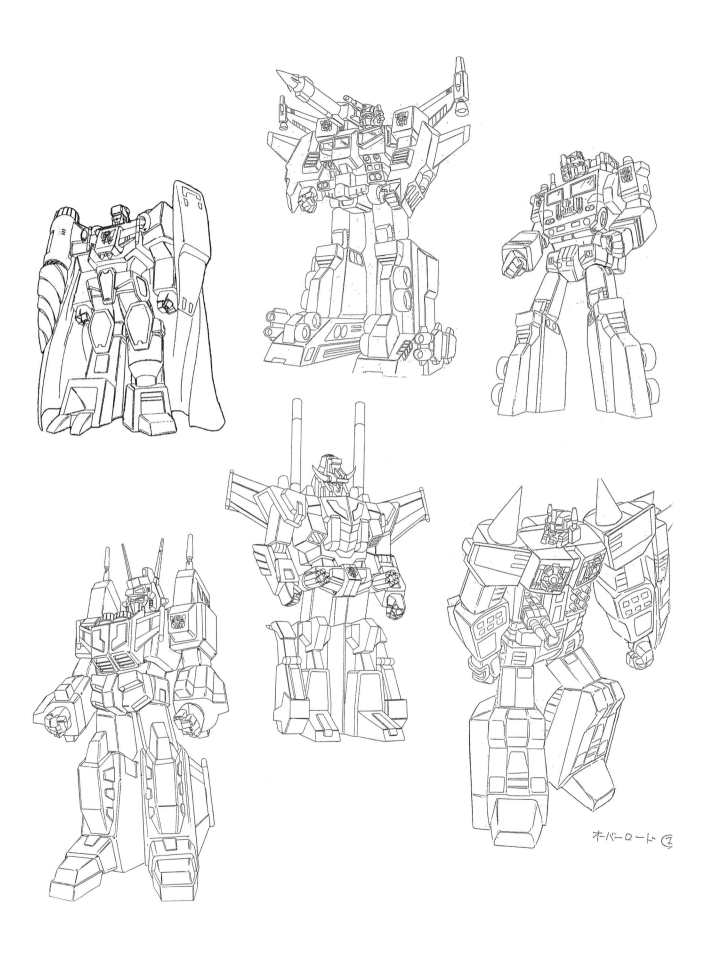

オーバーロード ⑦

Clockwise from top left: Character designs, Devastar, *Transformers: Zone*; God Ginrai, Super Ginrai, Overlord, *Super-God Masterforce*; Victory Leo, Star Saber, *Transformers: Victory*

Above: Character Renders, Maximals & Predacons group shots, *Beast Wars*

Opposite: Character Render, Tigerhawk, *Beast Wars*

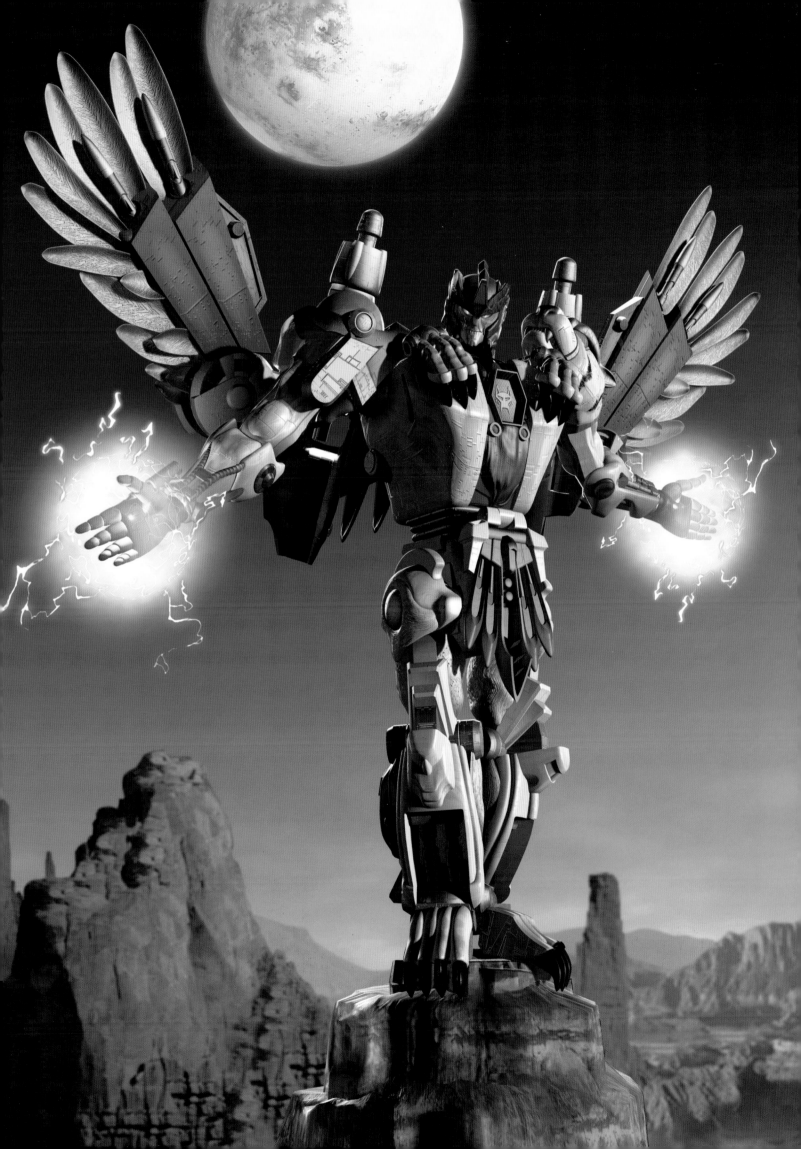

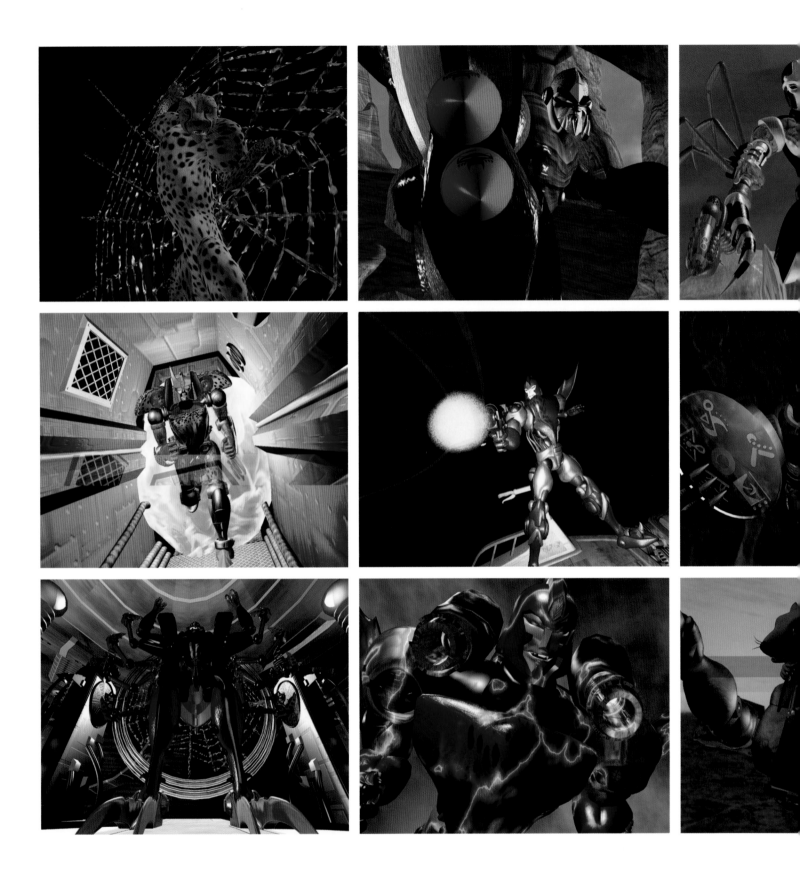

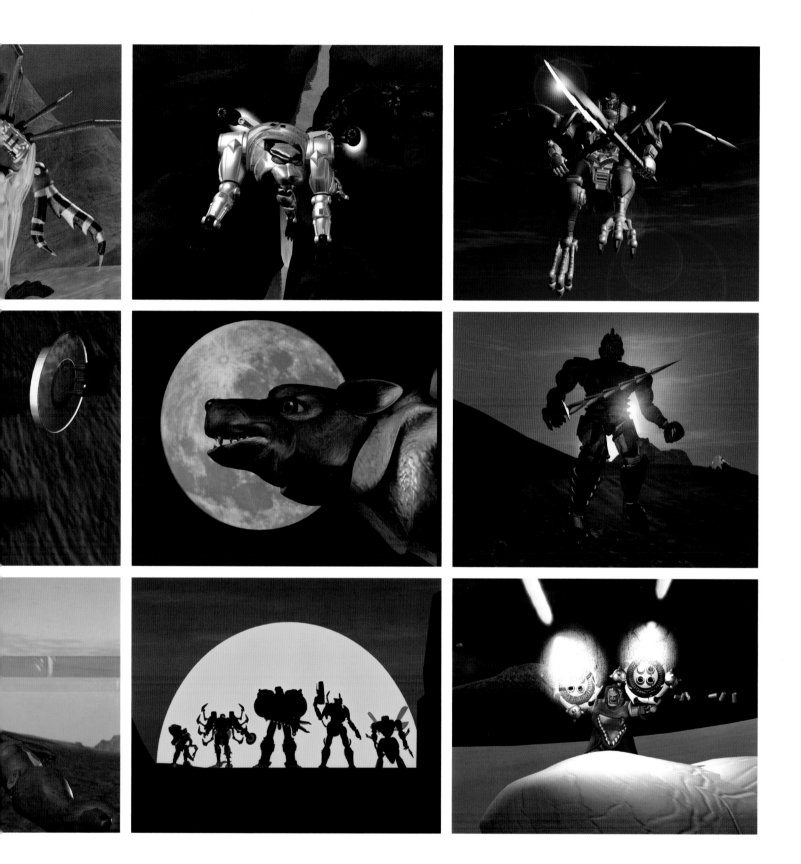

These pages: Screenshots, *Beast Wars*

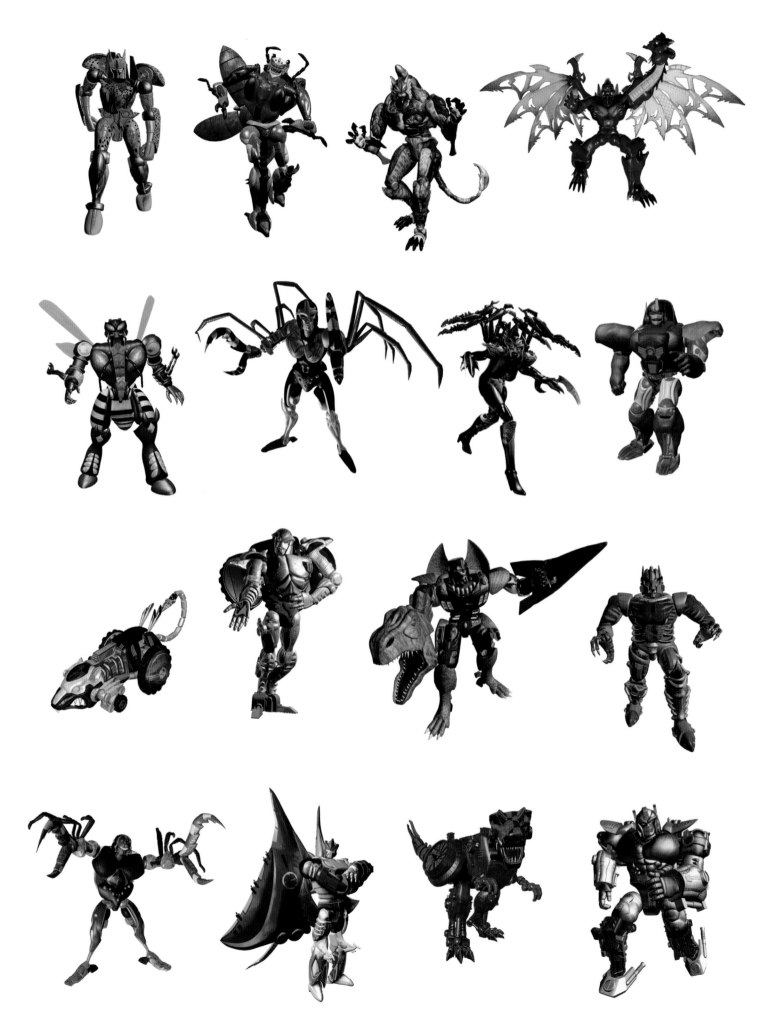

Opposite from top left: Character renders, Cheetor, Inferno, Transmetal 2 Cheetor, Transmetal 2 Megatron, Waspinator, Blackarachnia, Transmetal 2 Blackarachnia, Optimus Primal, Transmetal Rattrap Beast Mode, Transmetal Rattrap Bot Mode, Megatron, Dinobot, Tarantulas, Depth Charge, Transmetal Megatron Beast Mode, Transmetal Optimus Primal, *Beast Wars*

Above: Character render, Waspinator, *Beast Wars*

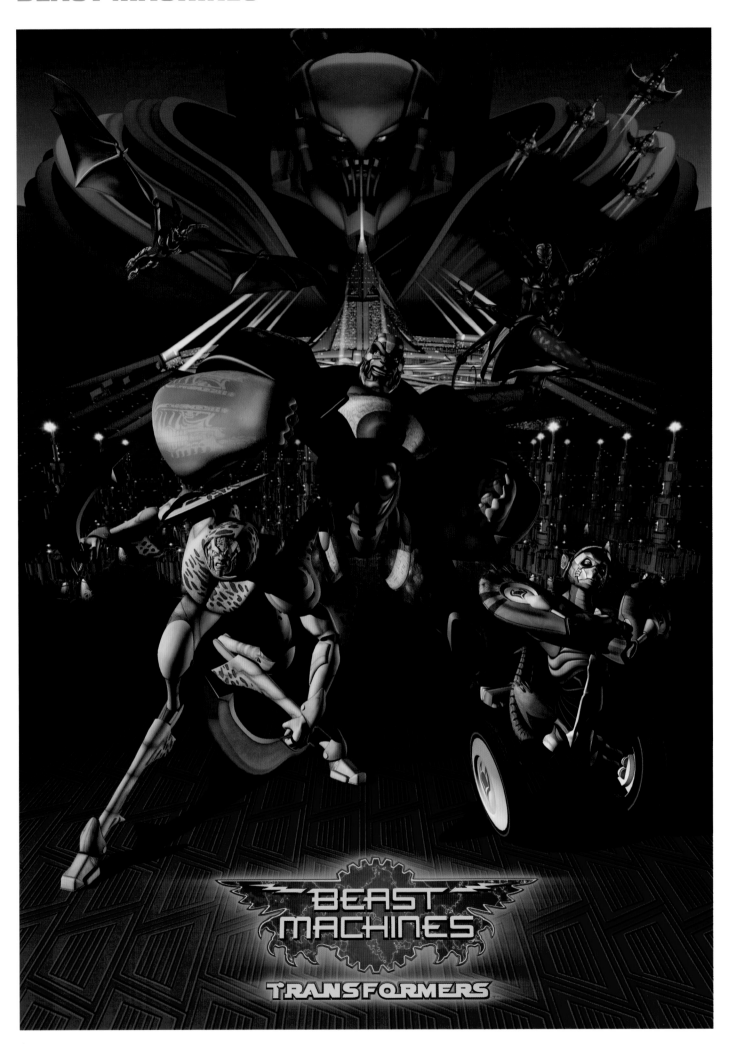

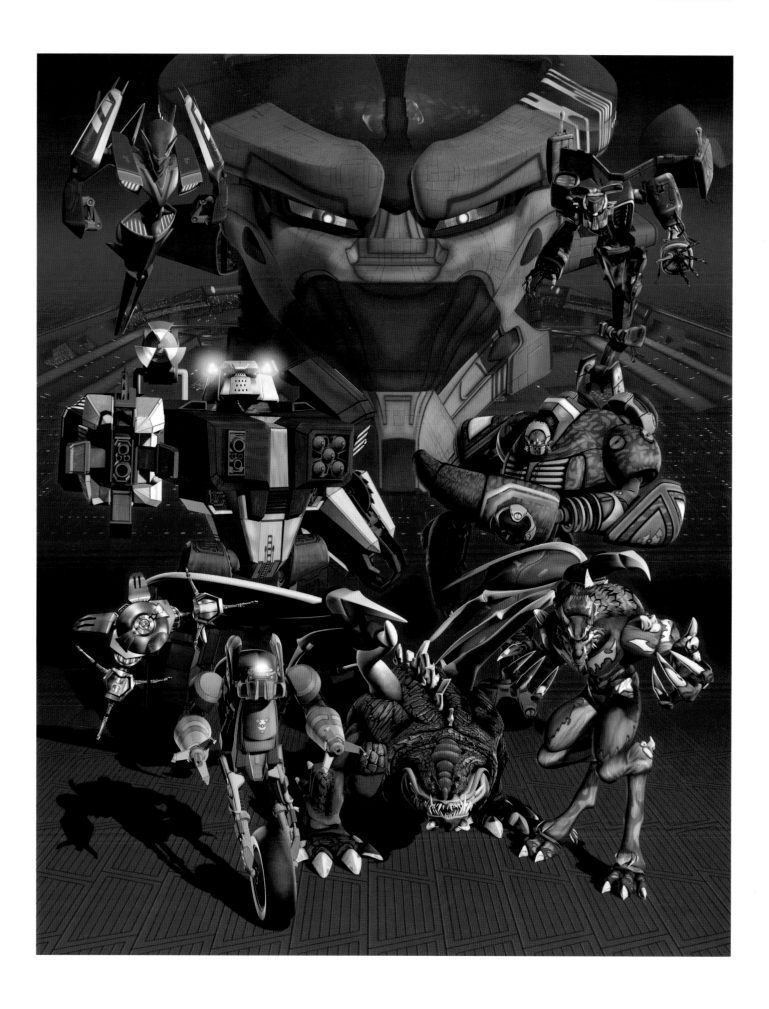

Opposite: Poster, *Beast Machines*

Above: Poster, Vehicons group shot, *Beast Machines: Transformers*

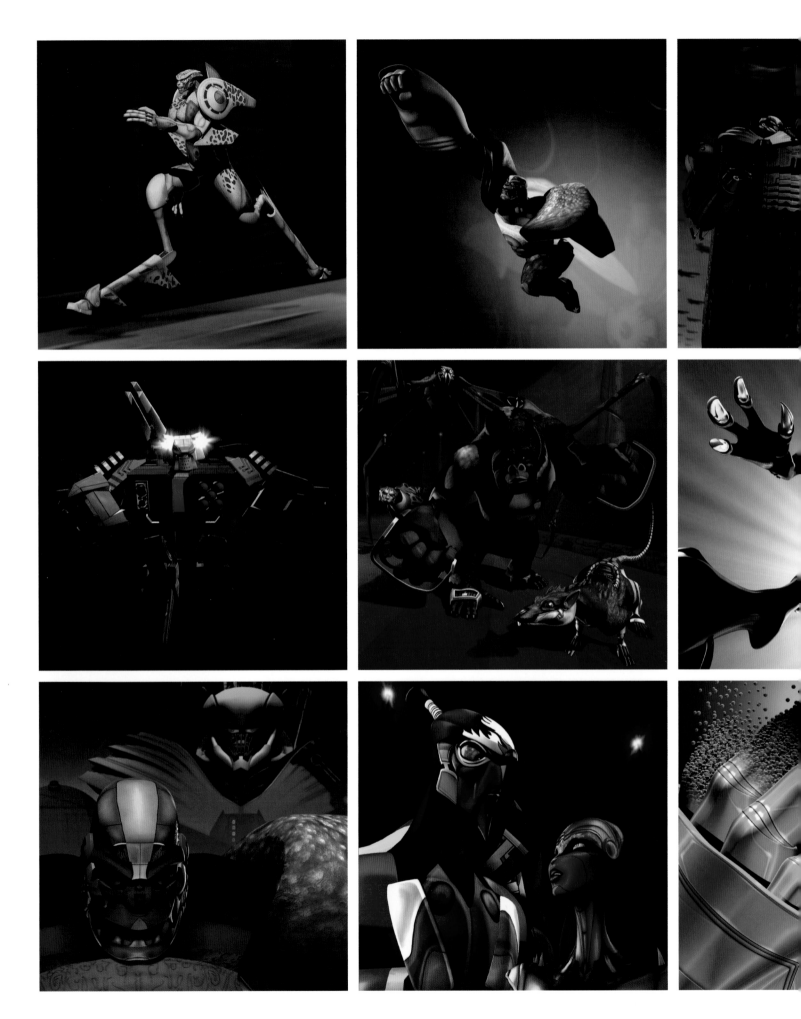

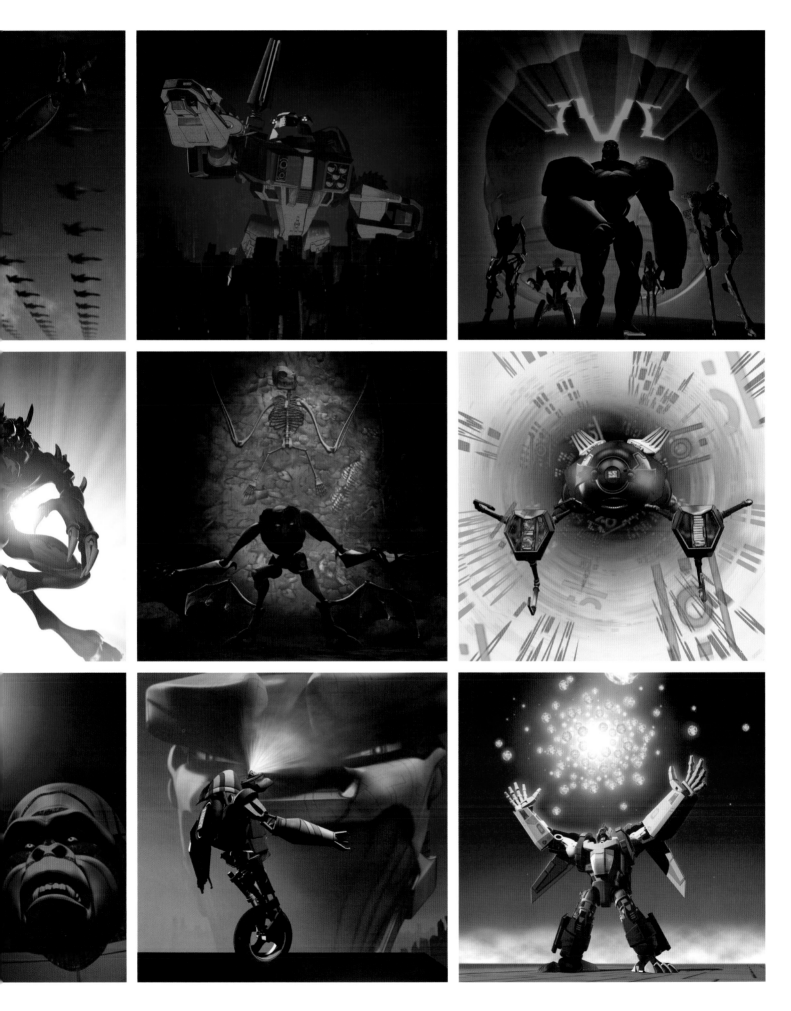

These pages: Screenshots, *Beast Machines: Transformers*

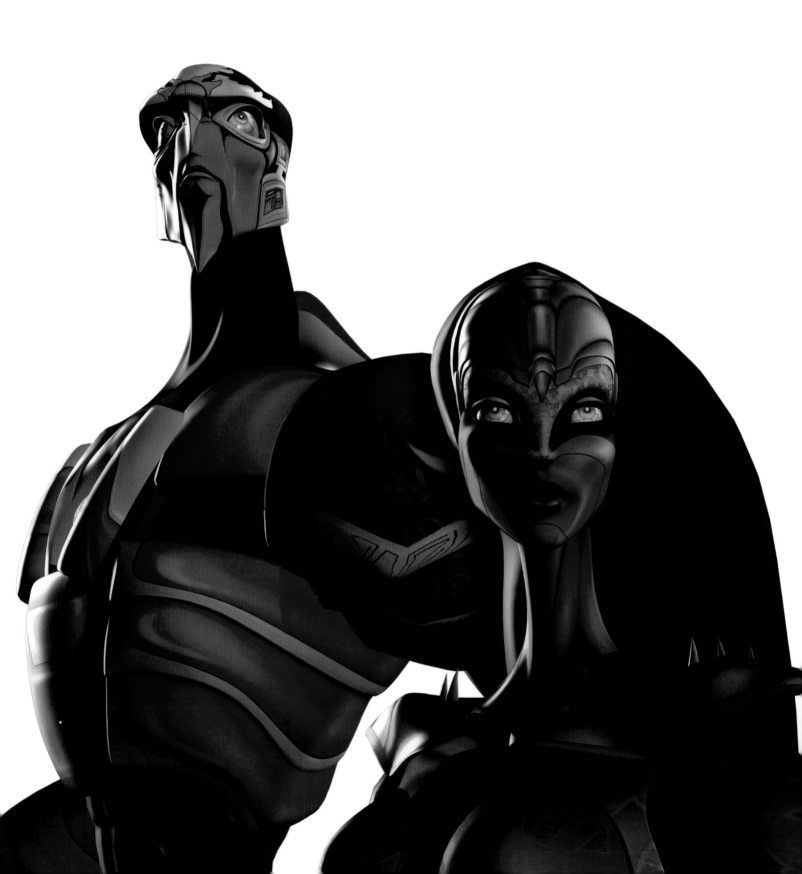

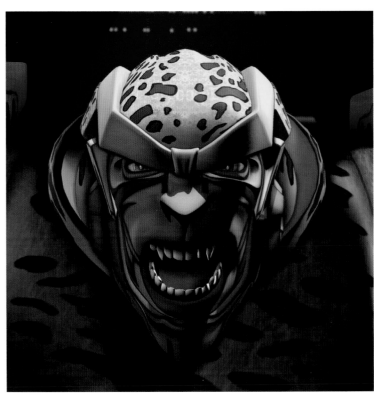

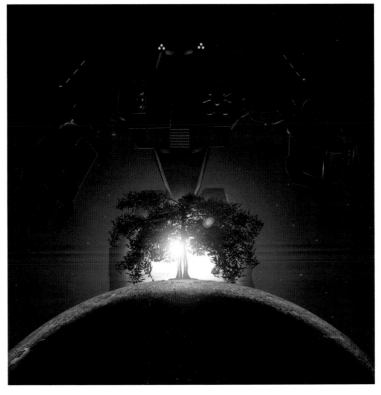

Opposite: Character renders, Silverbolt & Blackarachnia, *Beast Machines: Transformers*
Above: Screenshots, *Beast Machines: Transformers*

Clockwise from top left: Character renders, Jetstorm, Megatron Beast Form, Tankor, Thrust, *Beast Machines: Transformers*

Opposite: Screenshot, *Beast Machines: Transformers*

BEAST WARS II

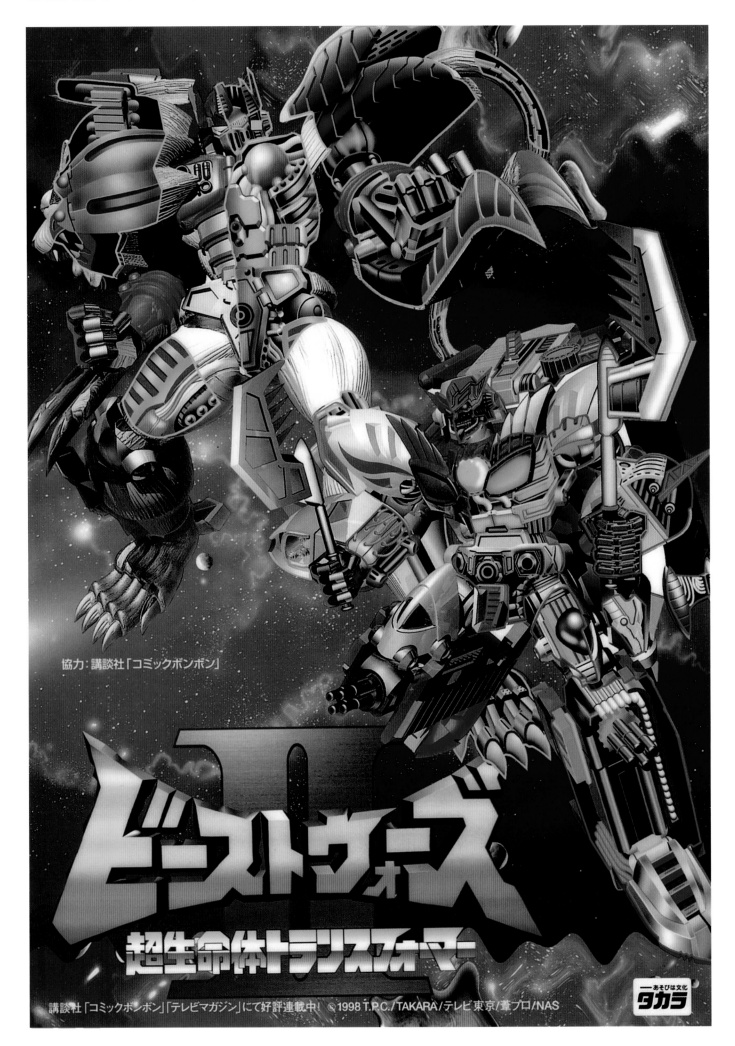

協力：講談社「コミックボンボン」

講談社「コミックボンボン」「テレビマガジン」にて好評連載中！ ⓒ 1998 T.P.C./TAKARA/テレビ東京/葦プロ/NAS

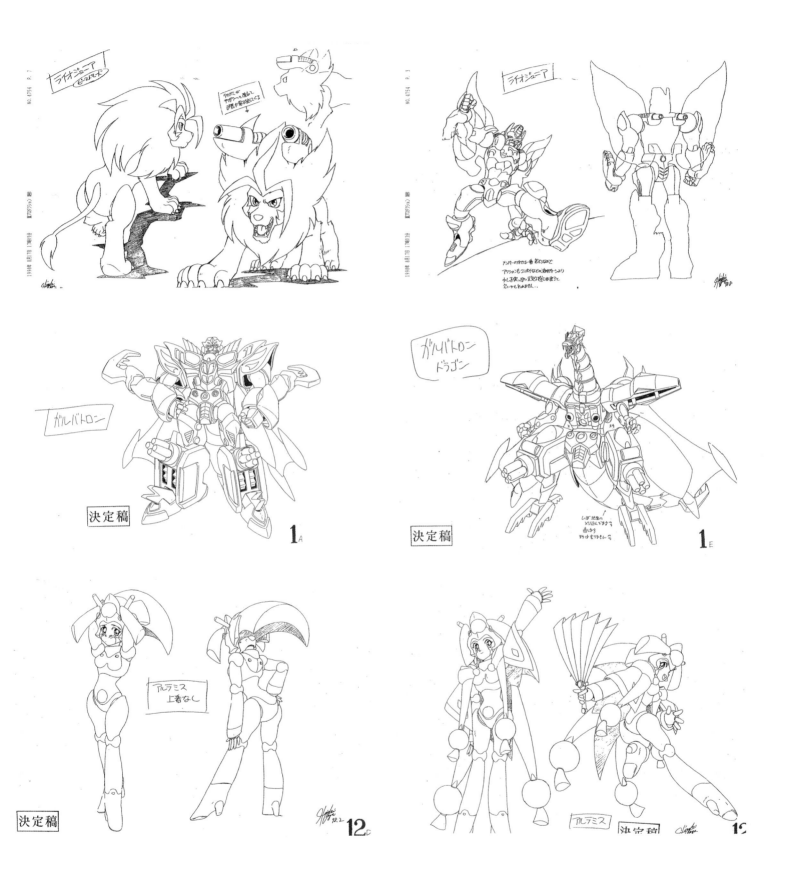

Opposite: Promo art, *Beast Wars II*

Clockwise from top left: Character designs, Lio Junior Beast Mode, Lio Junior Bot Mode, Galvatron Beast Mode, Artemis, Artemis, Galvatron Bot Mode, *Beast Wars II*

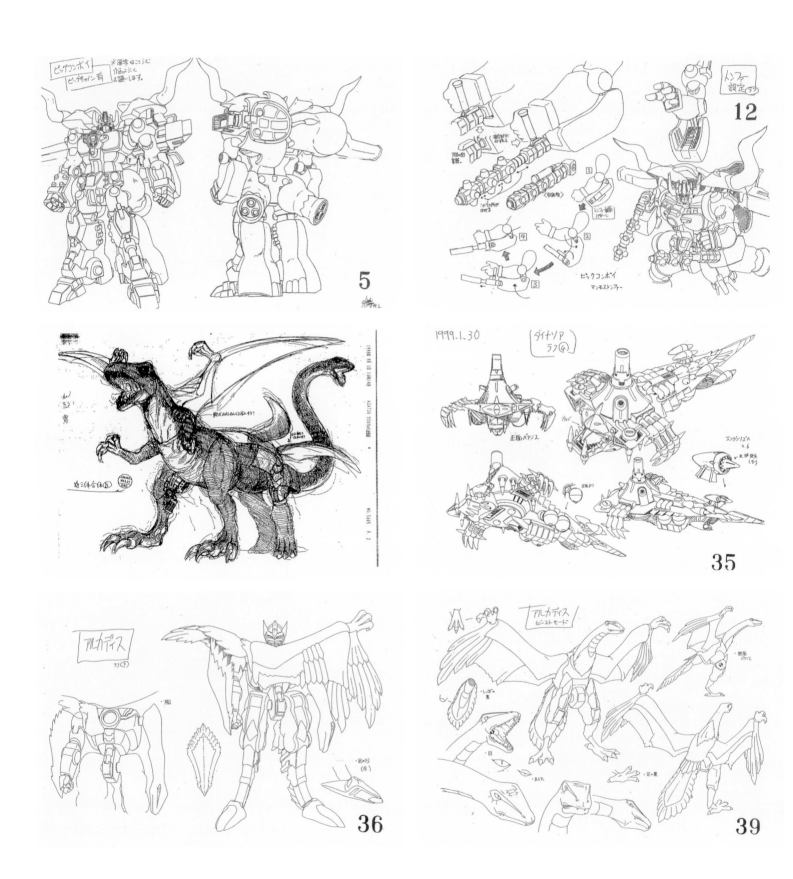

Clockwise from top left: Character designs, Big Convoy, Big Convoy detail, *The Dinosaur*, Archadis Beast Mode, Archadis Bot Mode, Magmatron Magmasaur Mode, *Beast Wars Neo*

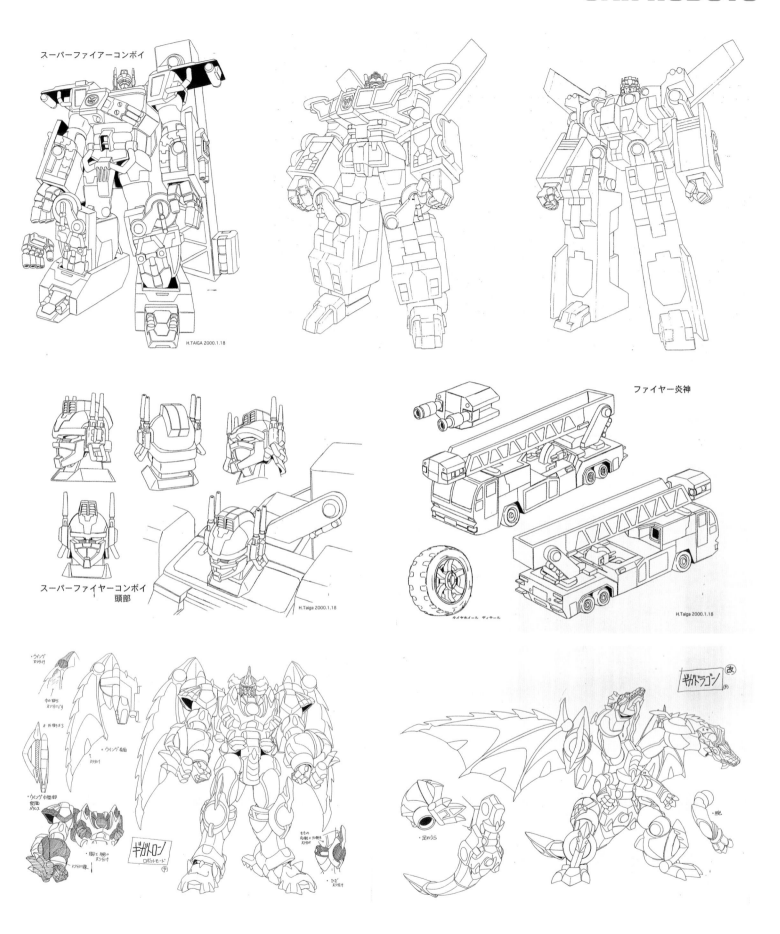

スーパーファイアーコンボイ

スーパーファイヤーコンボイ
頭部

ファイヤー炎神

ギガトロン
ロボットモード

ギガドラゴン

Clockwise from top left: Character designs, Fire Convoy, God Fire Convoy, God Magnus, Fire Convoy Vehicle Mode, Gigatron Beast Mode, Gigatron Bot Mode, Fire Convoy head detail, *Transformers: Car Robots*

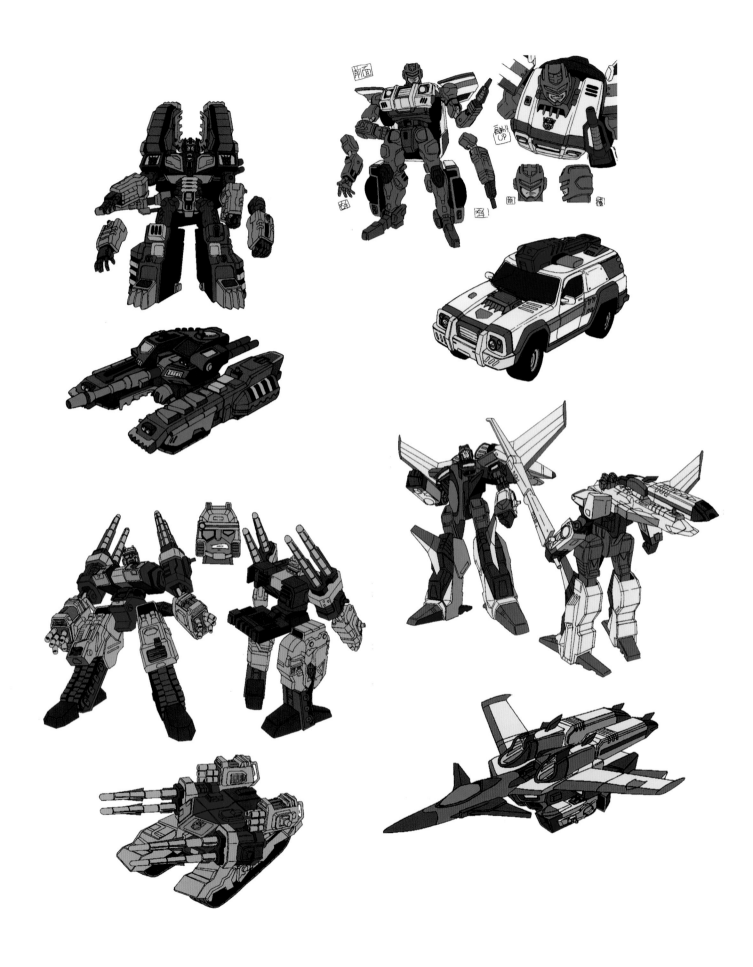

Clockwise from top left: Character designs, Megatron, Ratchet, Starscream, Demolishor, *Transformers: Armada*

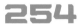

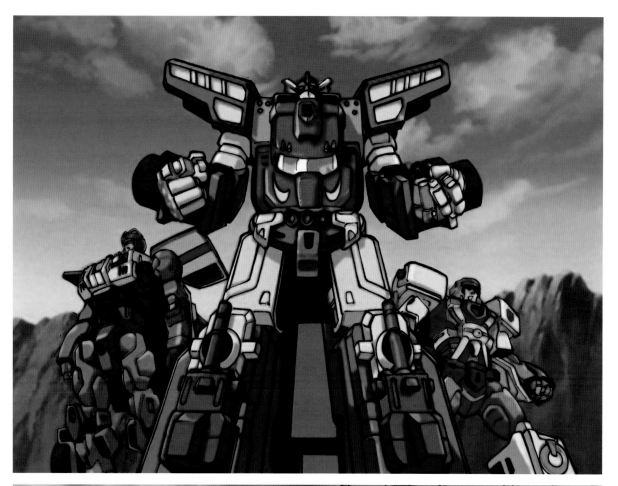

This page: Screenshots, *Transformers: Armada*

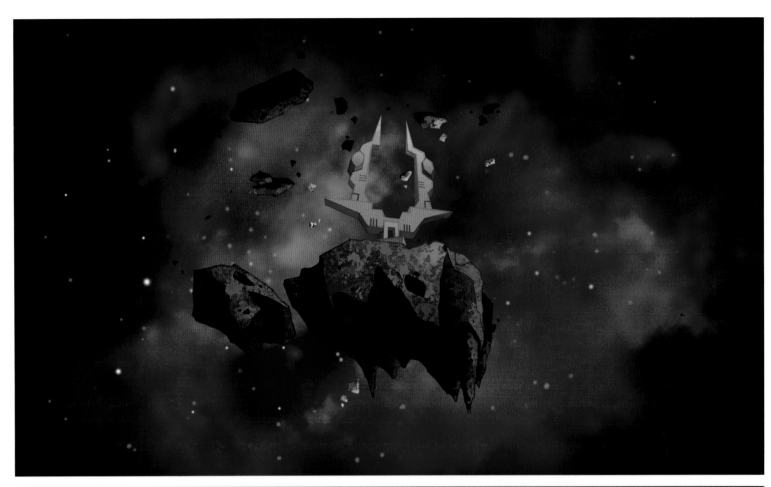

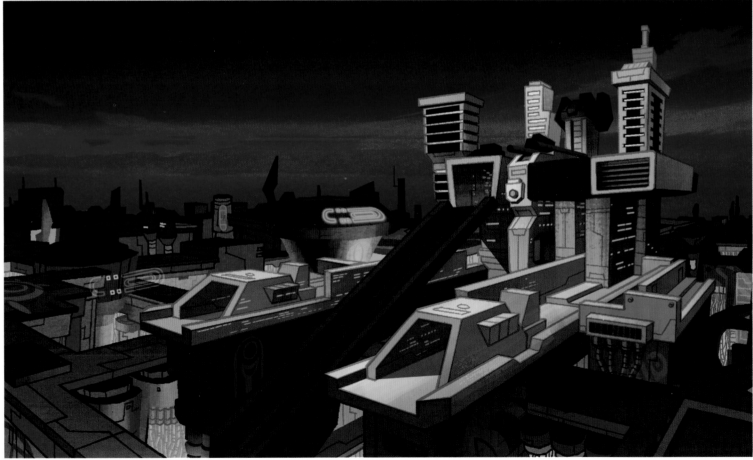

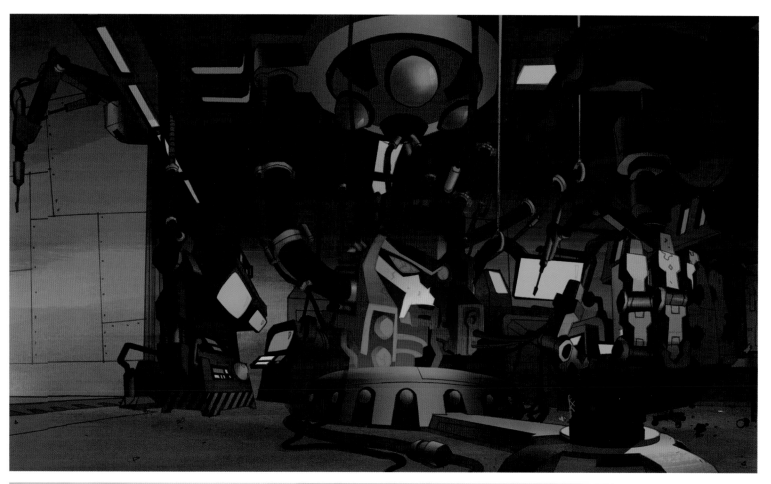

ANIMATION

These pages, clockwise from top left: Backgrounds, Space Bridge, Sumdac's Laboratory, Dinobot Island, Metroplex, *Transformers Animated*

257

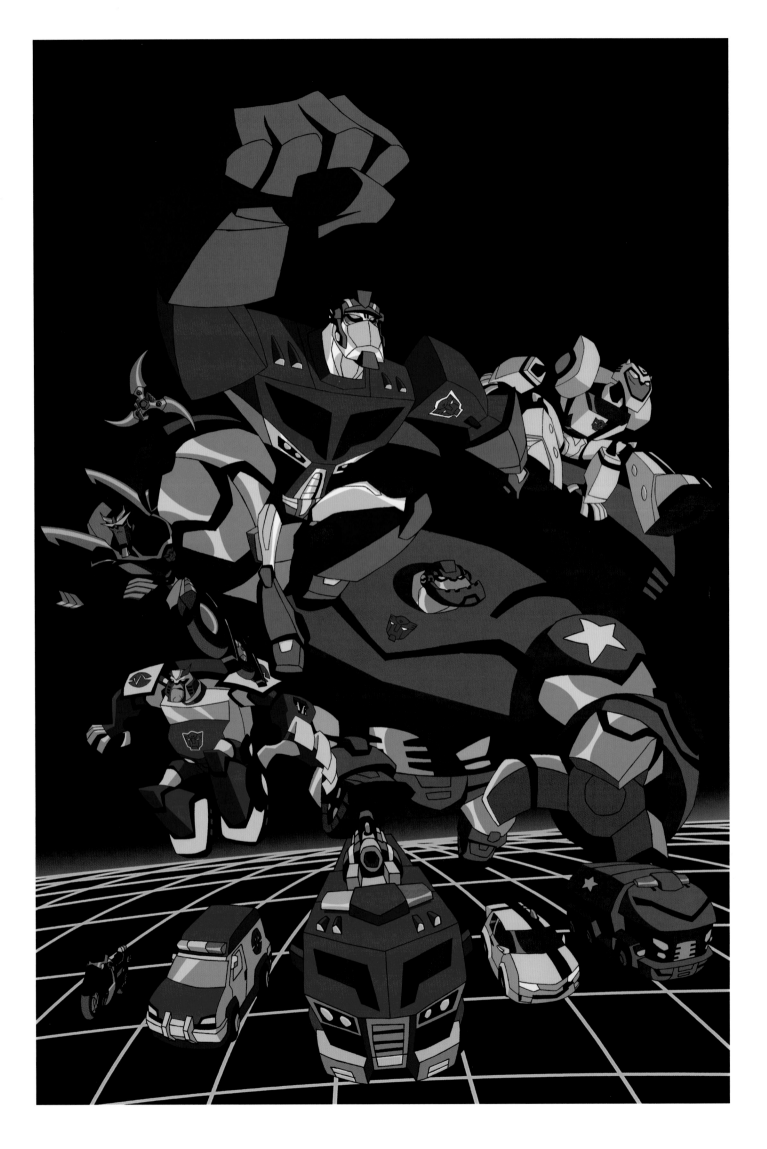

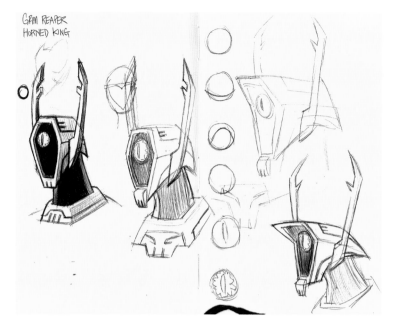

GRIM REAPER
HORNED KING

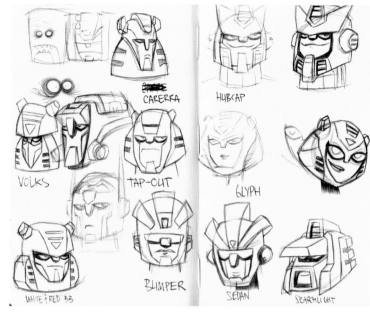

VOLKS

CARERFA

HUBCAP

TAP-OUT

GLYPH

WHITE & RED BB

BUMPER

SEDAN

SEARCHLIGHT

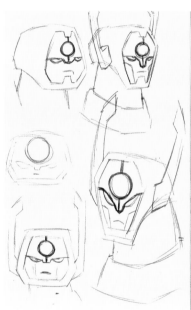

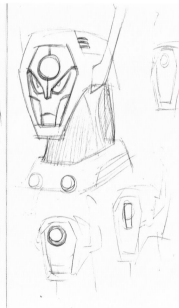

Opposite: Poster, *Transformers Animated* | Derek Wyatt
Clockwise from top left: Rough sketches, Shockwave, Various, Shockwave, Wreck-Gar, *Transformers Animated* | Derek Wyatt

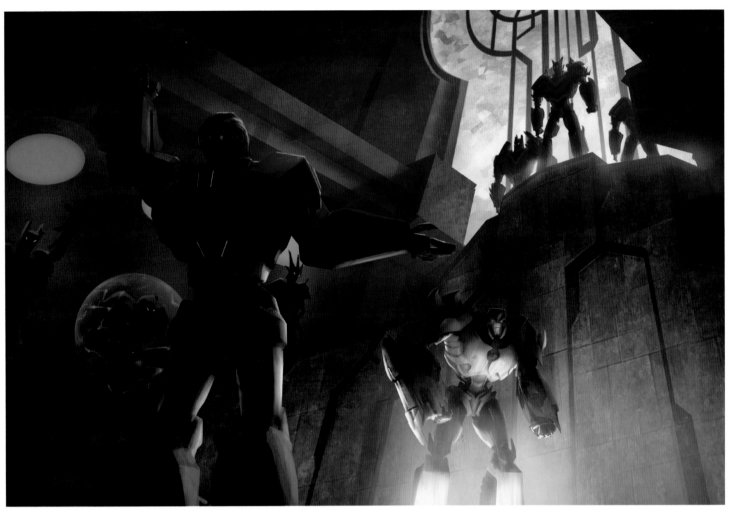

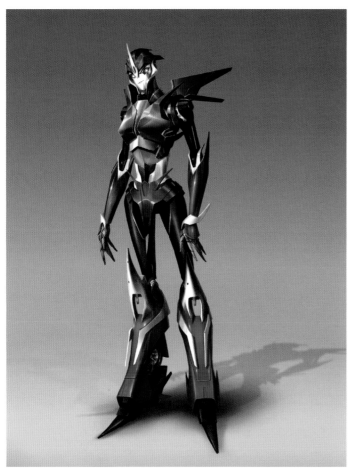
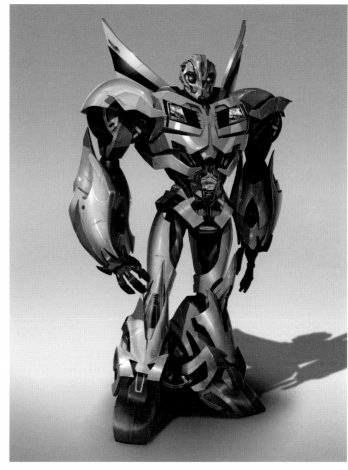
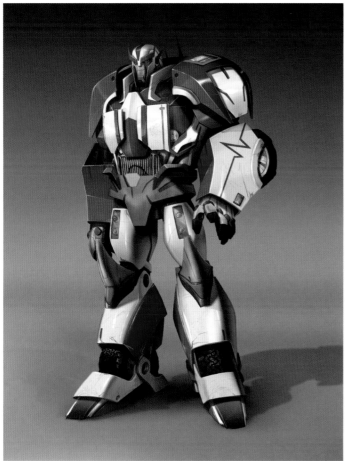
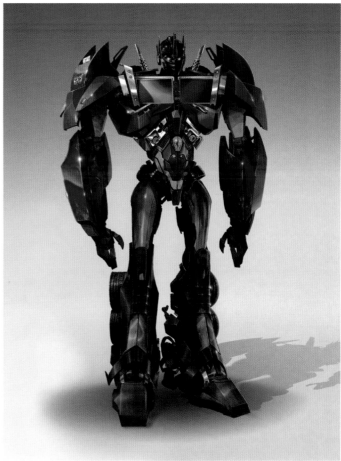

Opposite: Matte paintings, *Transformers: Prime*
Clockwise from top left: Character renders, Arcee, Bumblebee, Optimus Prime, Ratchet, *Transformers: Prime*

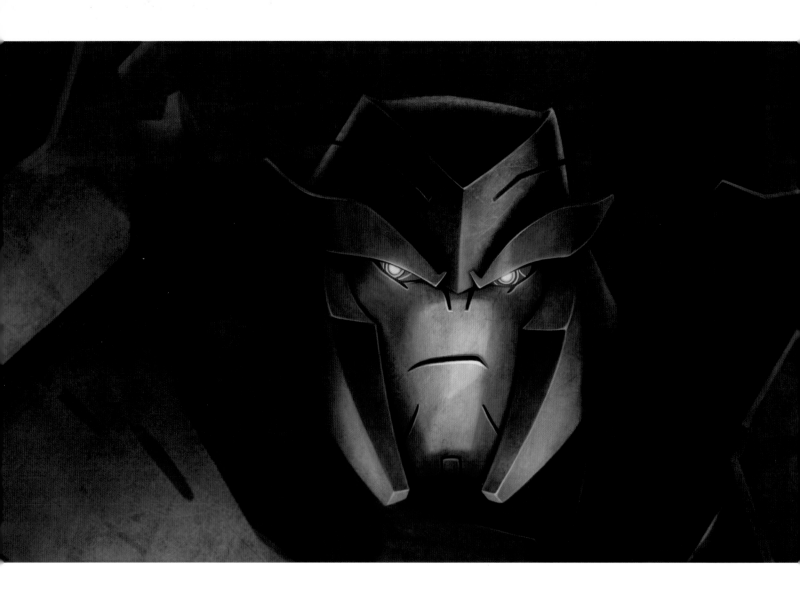

Top: Screenshot, Megatron, *Transformers: Prime*

Above: Concept art, Megatron's facial expressions, *Transformers: Prime*

Opposite: Development art, *Transformers: Prime*

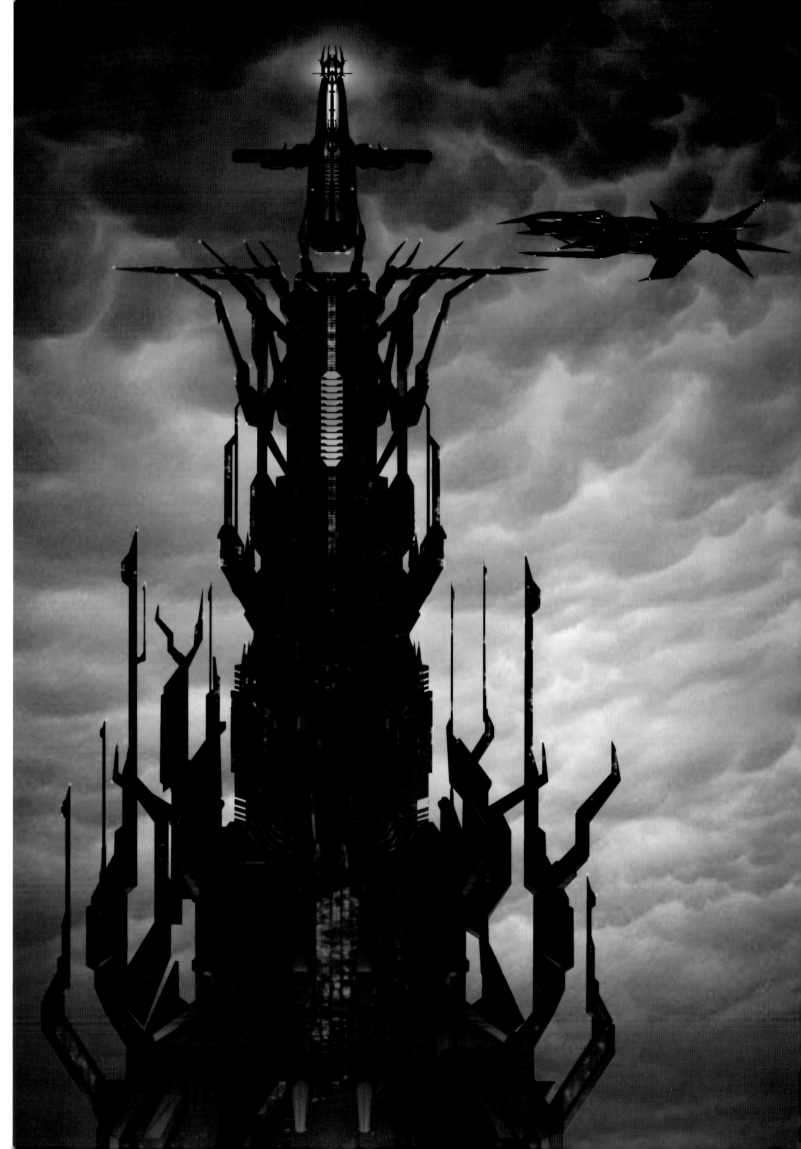

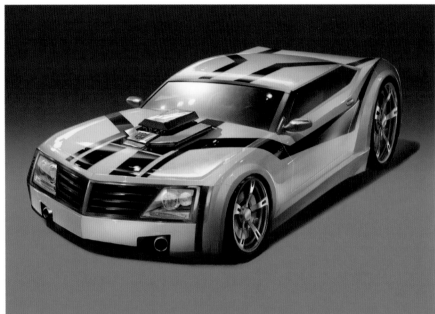

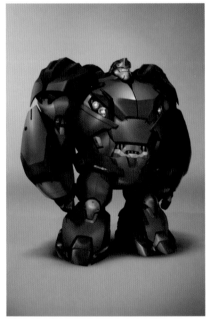

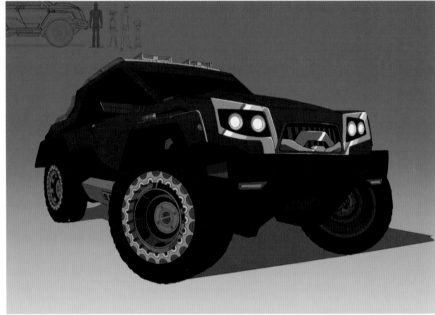

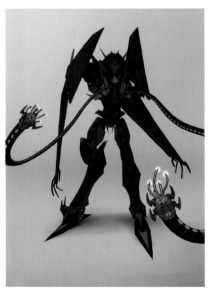

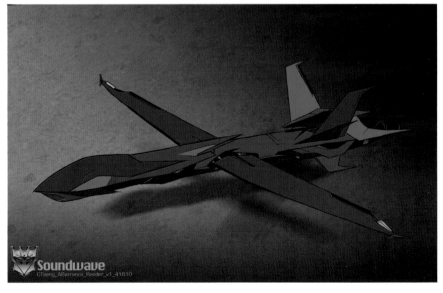

Top: Development art, Bumblebee modes, *Transformers: Prime*

Middle: Development art, Bulkhead modes, *Transformers: Prime*

Below: Development art, Soundwave modes, *Transformers: Prime*

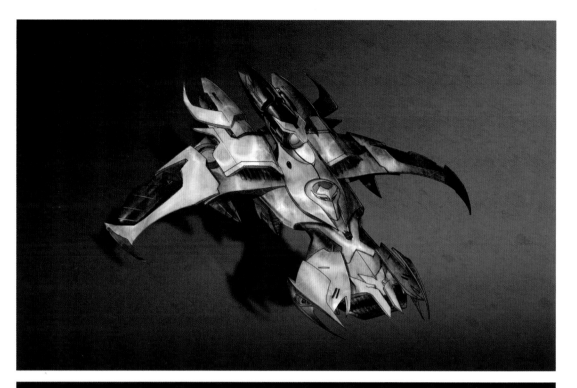

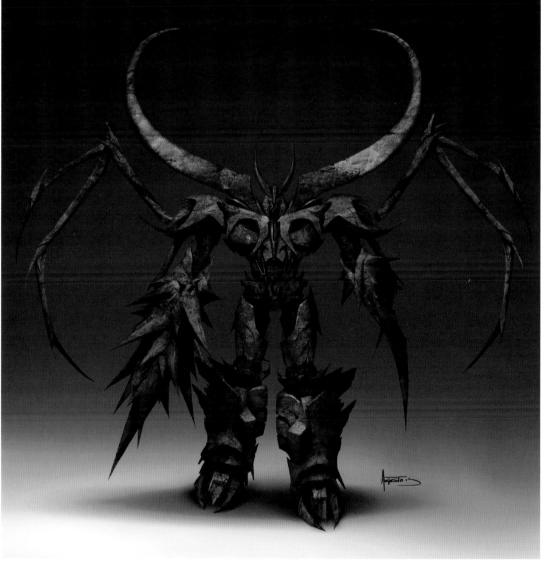

Top: Development art, Megatron, *Transformers: Prime*

Below: Development art, Unicron, *Transformers: Prime*

Following: Matte painting, Megatron & Optimus Prime, *Transformers: Prime*

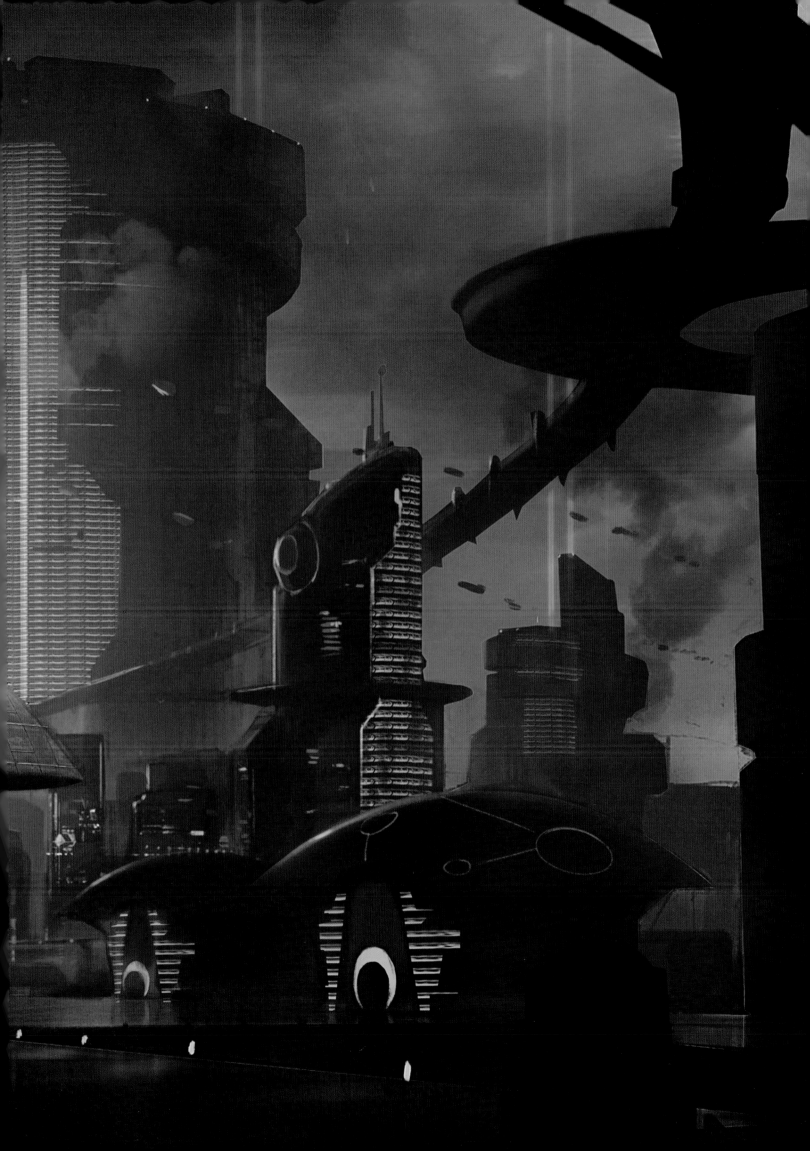

Clockwise from top left: Development art, Blades, Heatwave, Boulder and Chase, *Transformers: Rescue Bots*

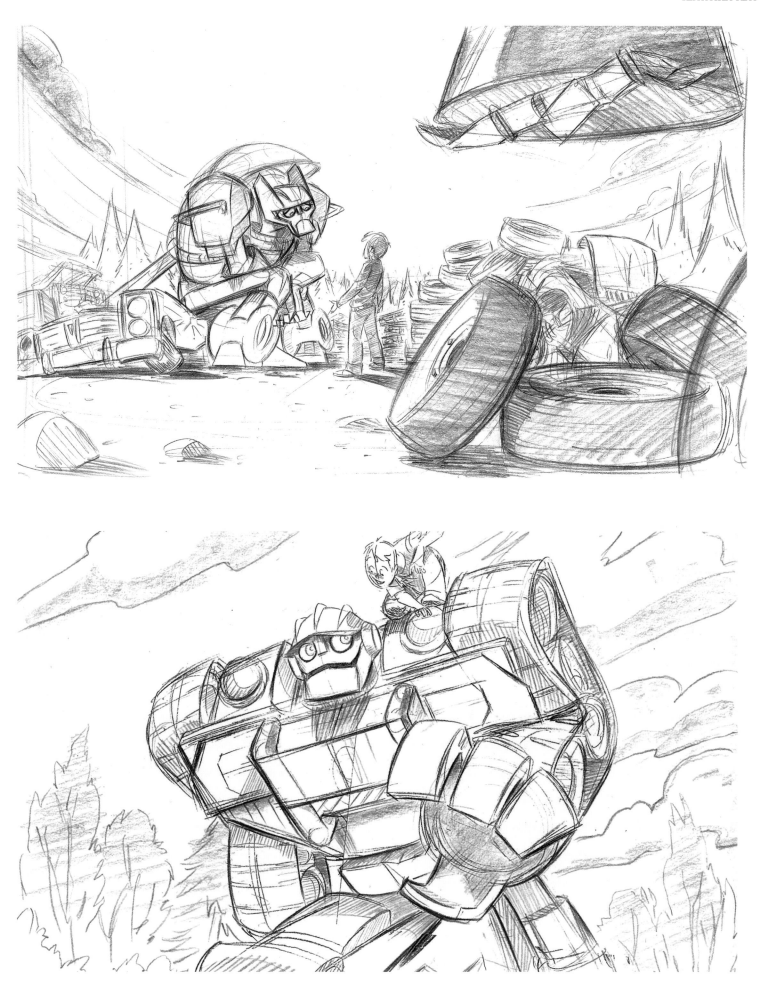

This page: Rough sketches, Blades and Cody, Boulder and Cody, *Transformers: Rescue Bots*

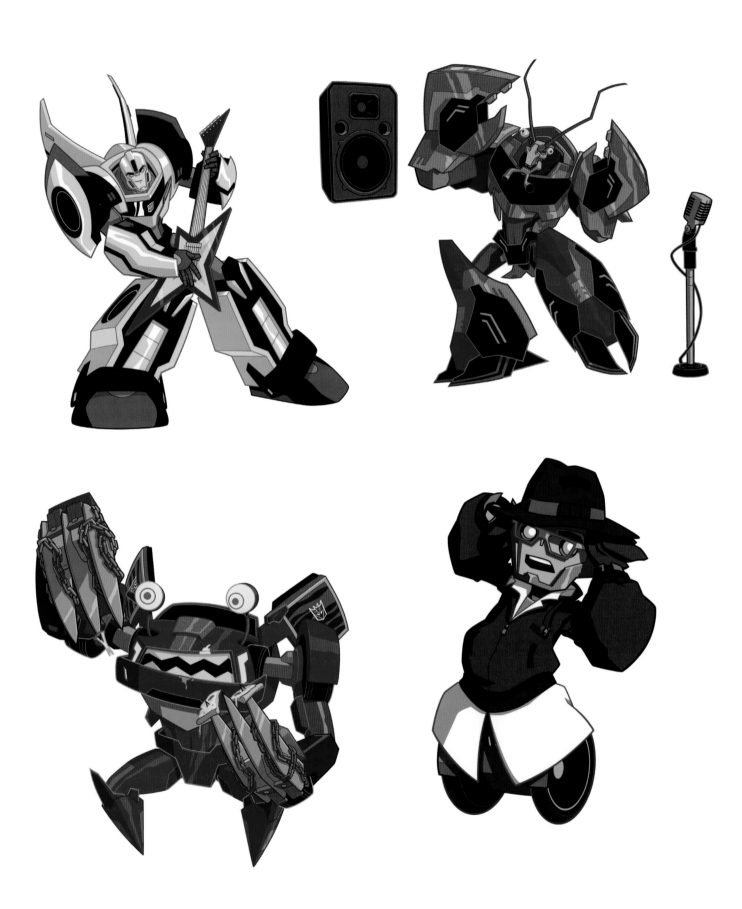

Clockwise from top left: Character art, Bumblebee, Bisk, Fixit, Clampdown, *Transformers: Robots In Disguise*

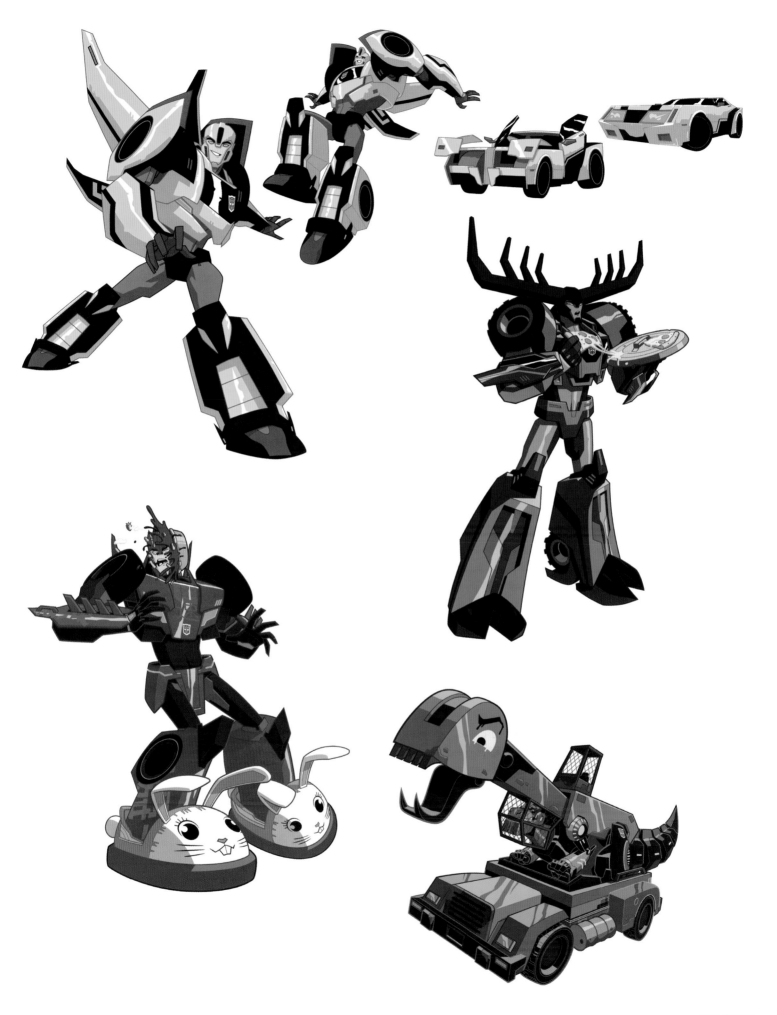

Clockwise from top left: Character art, Bumblebee, Thunderhoof, Grimlock, Sideswipe, *Transformers: Robots In Disguise*

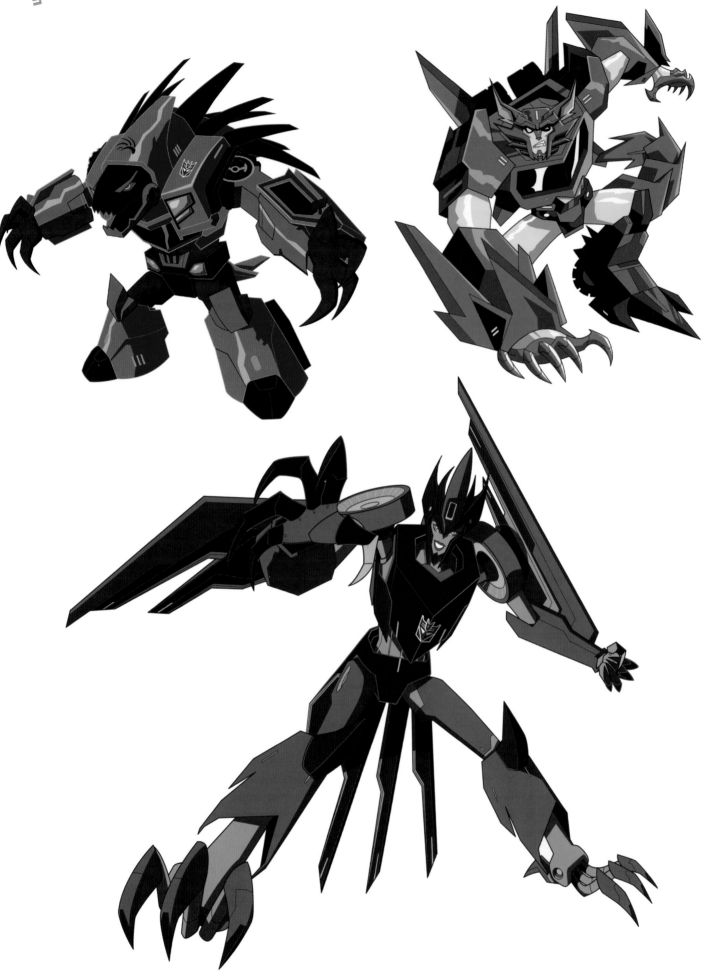

Clockwise from top left: Character art, Quillfire, Steeljaw, Filch, *Transformers: Robots In Disguise*

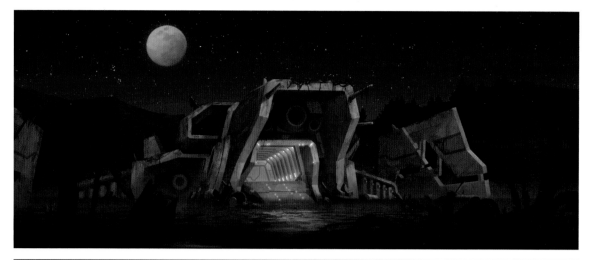

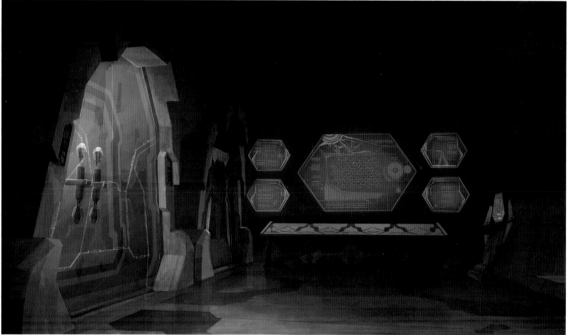

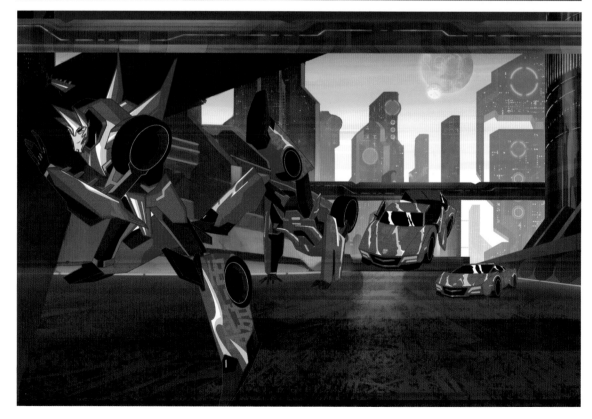

From top: Location art, Decepticon Island, Weapon Storage, Road & Sideswipe, *Transformers: Robots In Disguise* | Sona Sargsyan

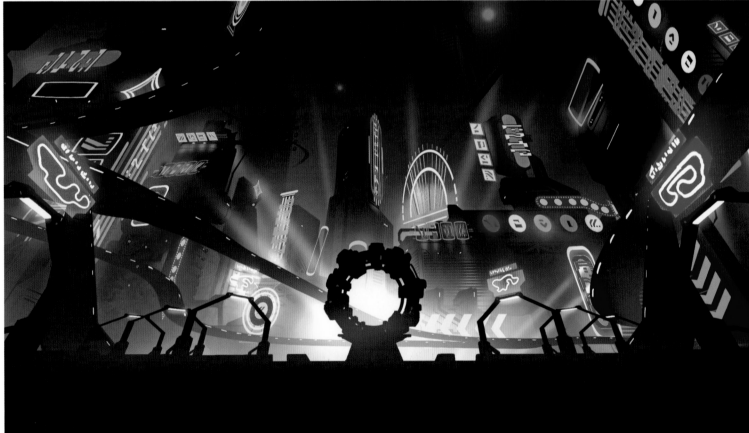

This page: Location art, Cybertron exterior, *Transformers: Cyberverse*

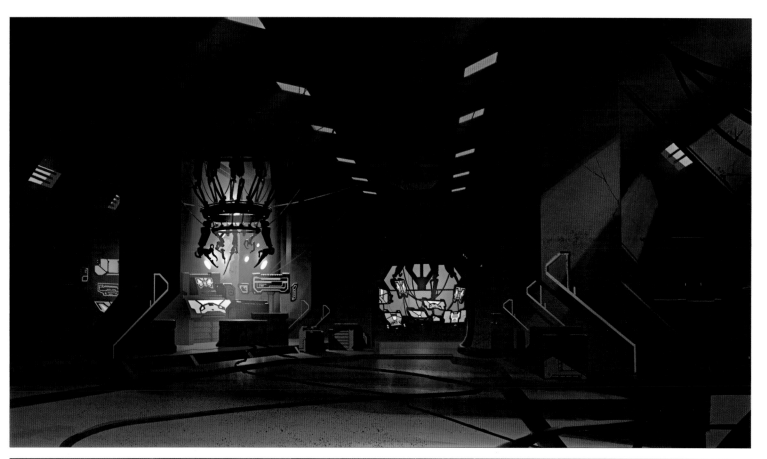

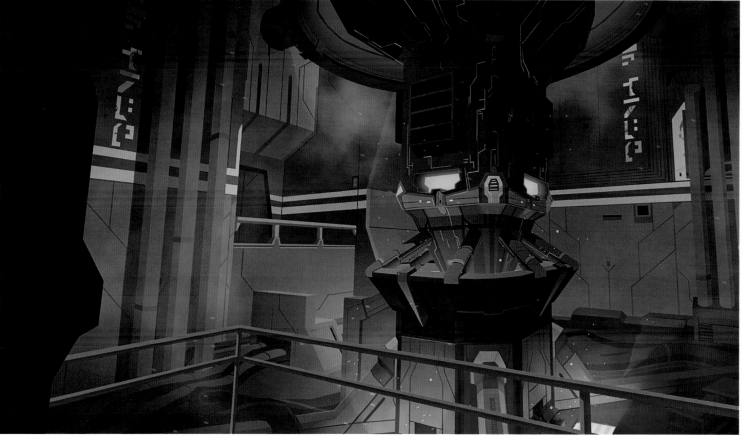

This page: Location art, Cybertron interior, *Transformers: Cyberverse*

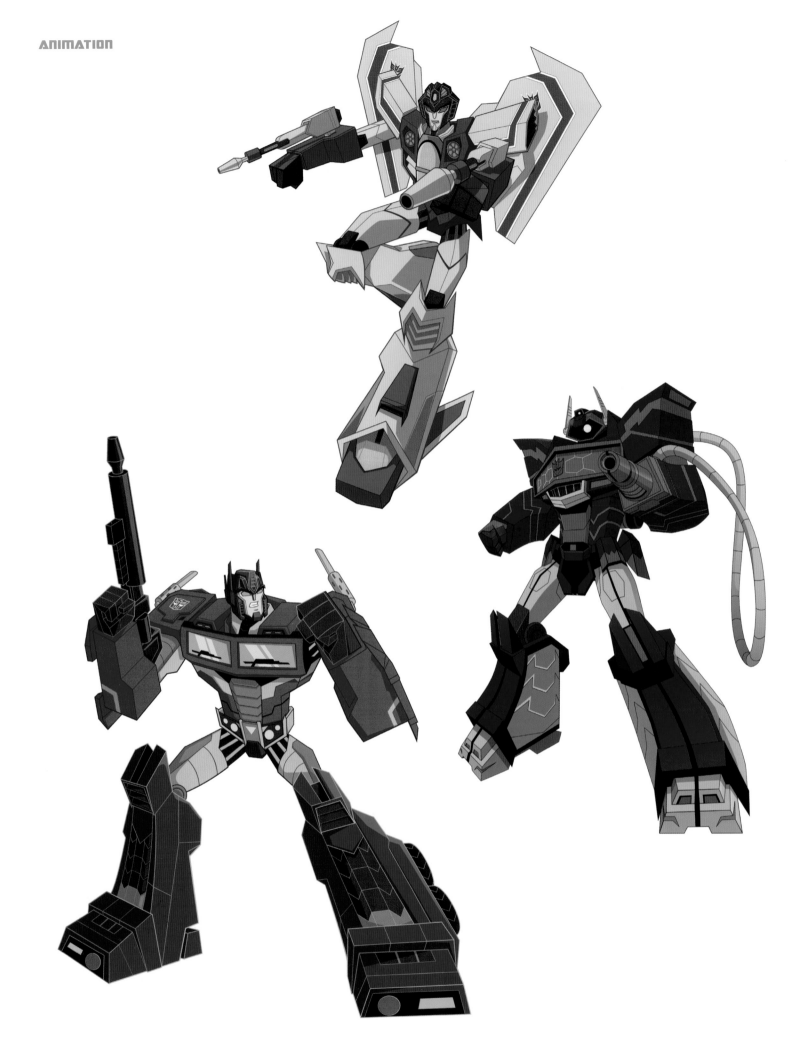

Clockwise from top: Character art, Starscream, Shockwave, Optimus Prime, *Transformers: Cyberverse*

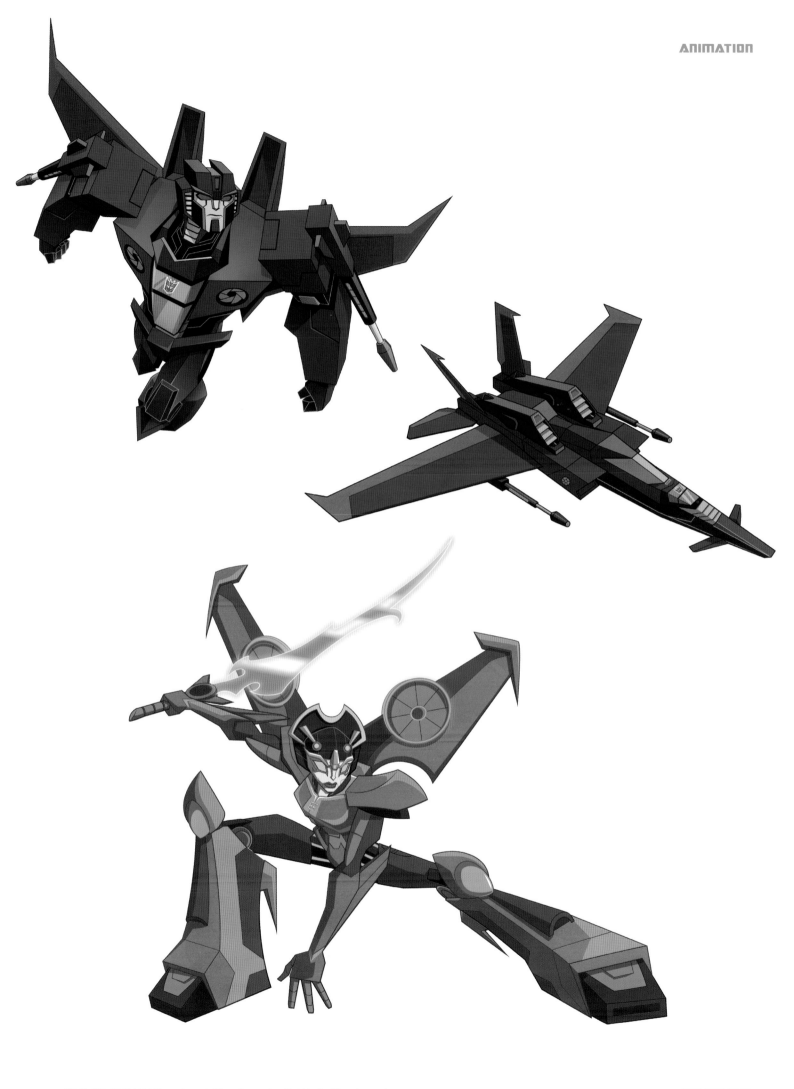

Clockwise from top: Character art, Thundercracker Bot Mode, Thundercracker Vehicle Mode, Windblade, *Transformers: Cyberverse*

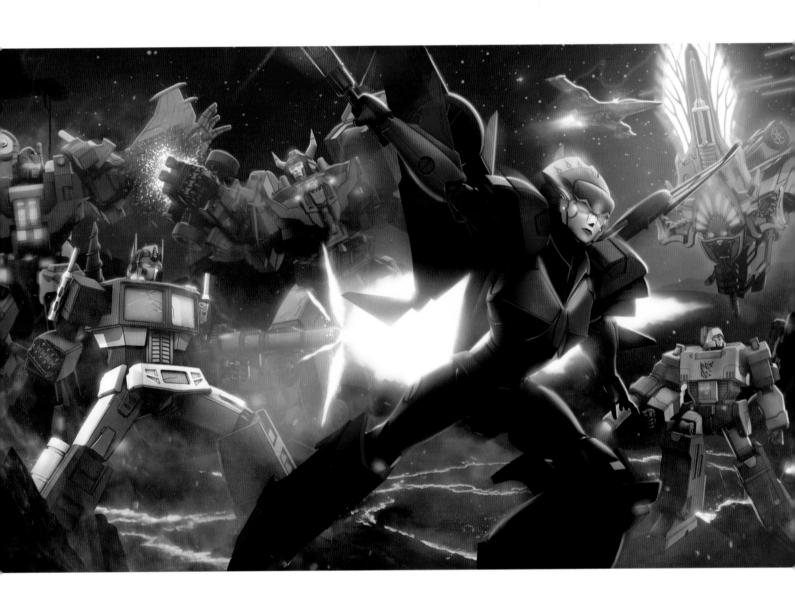

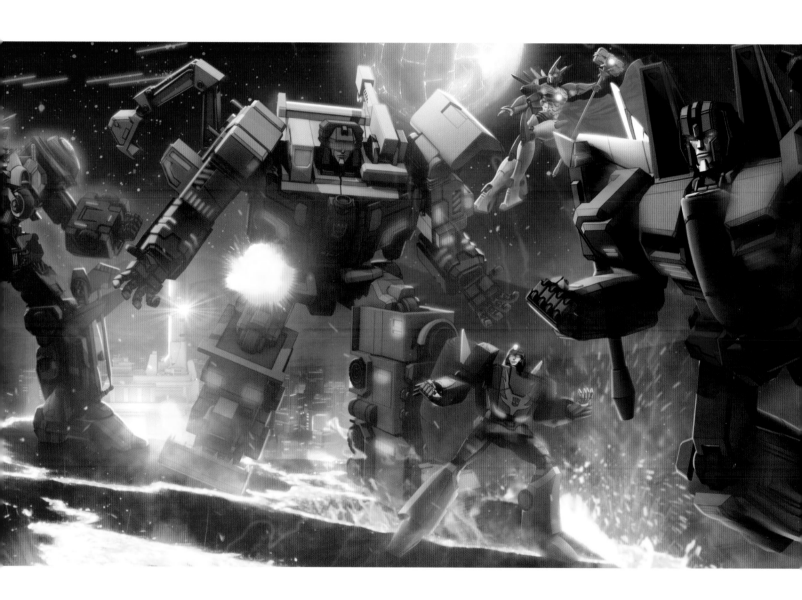

These pages: Promo art, *Transformers: Combiner Wars* | Christopher Antoin

"Featuring all eleven characters from *Combiner Wars* squaring off, this piece was divided into 5 posters and released during the show's run. The concept was simple enough, but creating a scene that could be split up and remain compelling proved to be a real Transformer-sized challenge for me!" — Christopher Antoin

Following: Promo poster, *Transformers: Combiner Wars* | Skan Srisuwan

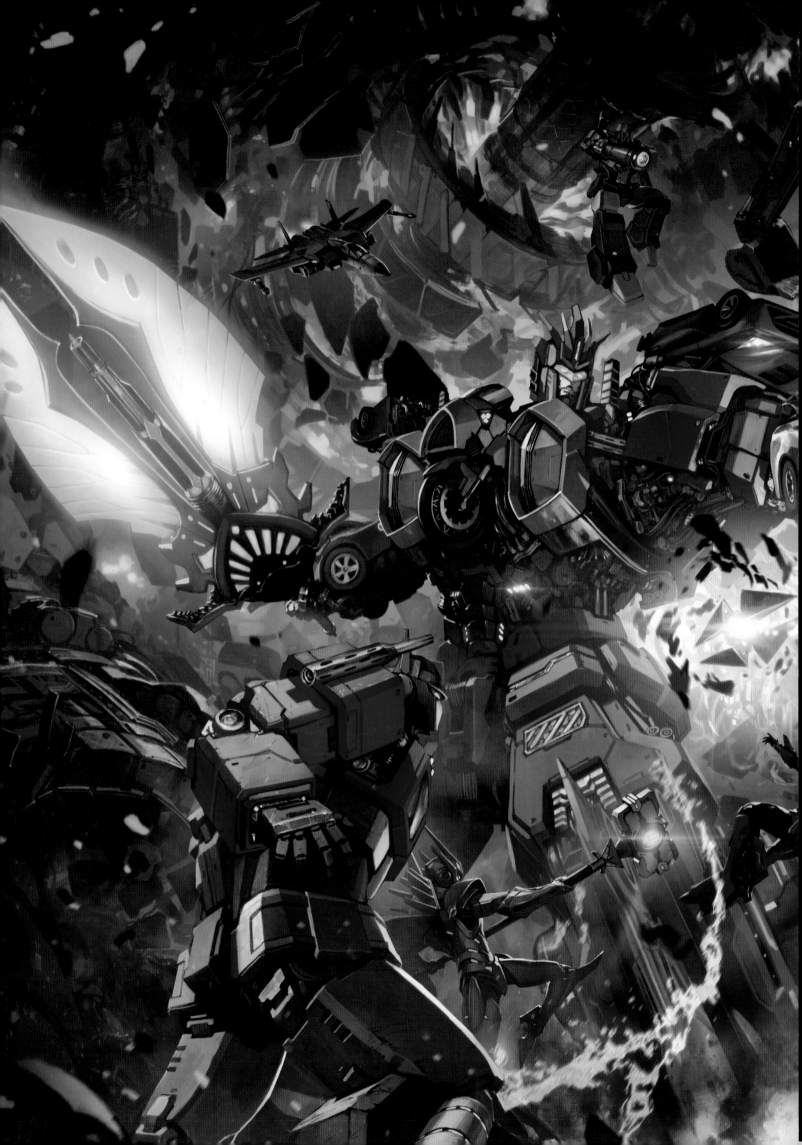

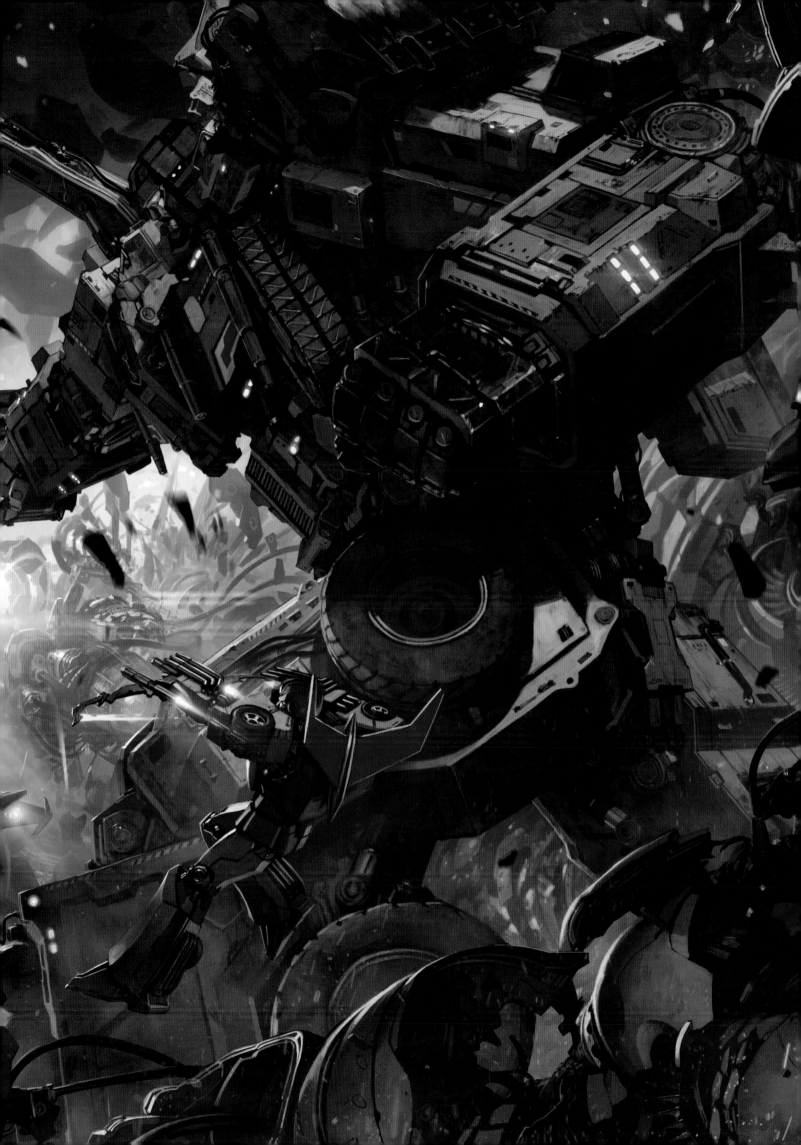

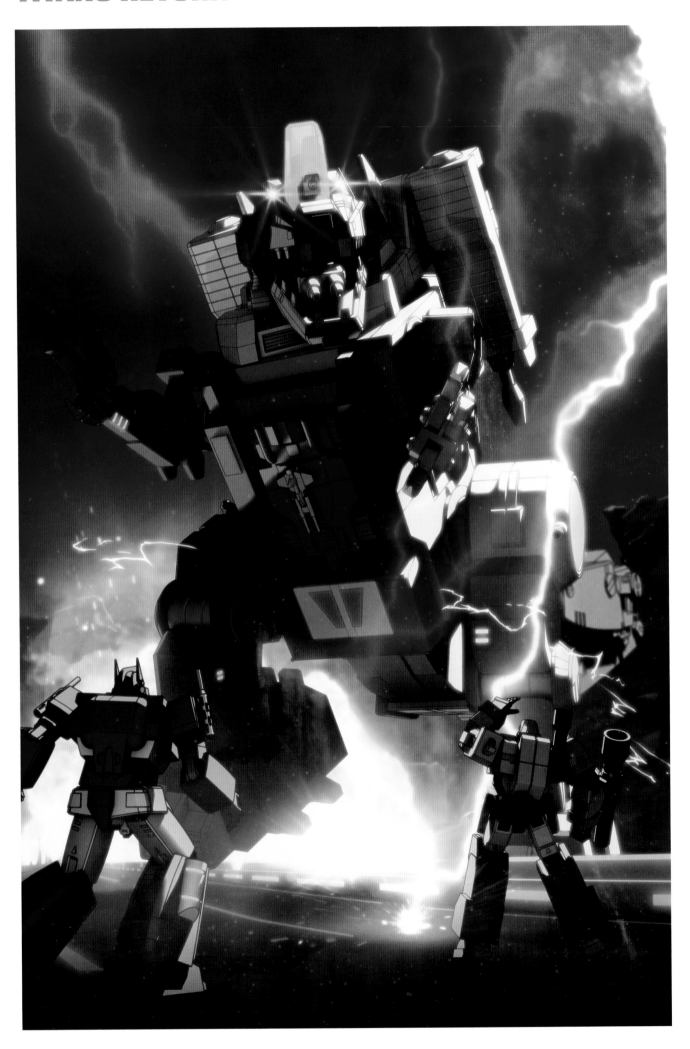

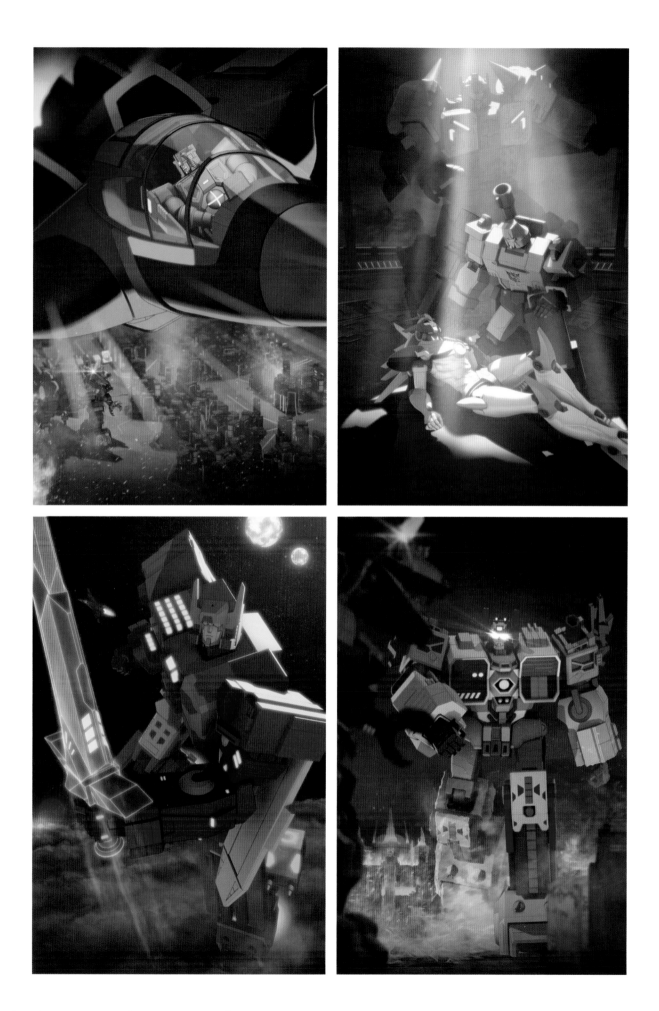

Opposite: Promo art, *Transformers: Titans Return* | Christopher Antoin

Clockwise from top left: Promo art, Emissary, Megatron, Metroplex, Fortress Maximus, *Transformers: Titans Return* | Christopher Antoin

Top: Color concepts, Trypticon, Metroplex, *Transformers: Titans Return* | Guido Guidi

Bottom: Color concepts, Solus Prime, Optimal Optimus, *Transformers: Power of the Primes* | Guido Guido

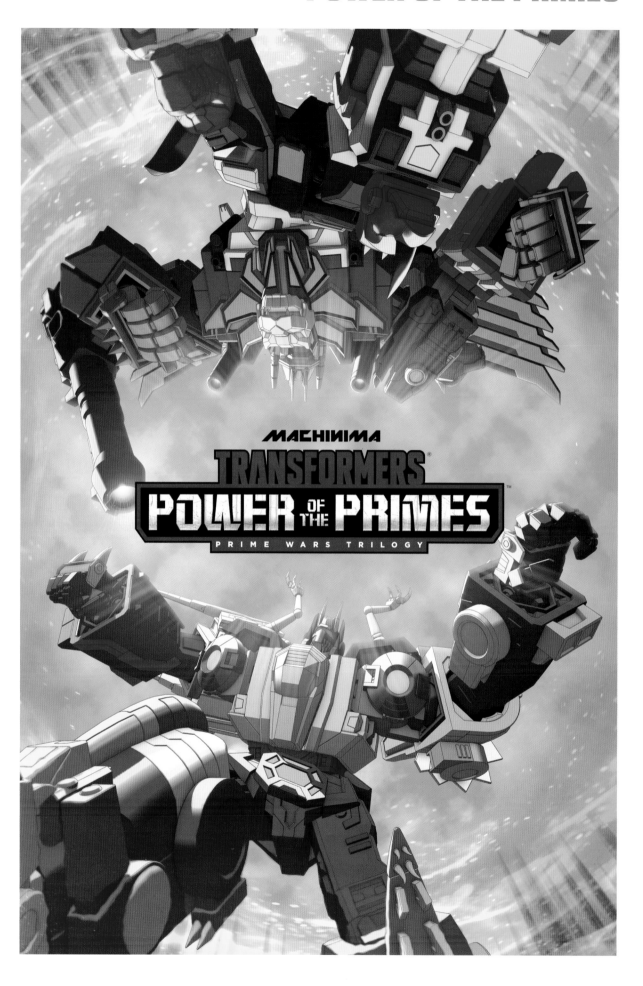

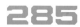

Above: Promo art, *Transformers: Power of the Primes* | Christopher Antoin

Following: Promo art, group shot, Solus Prime, *Transformers: Power of the Primes* | Christopher Antoin

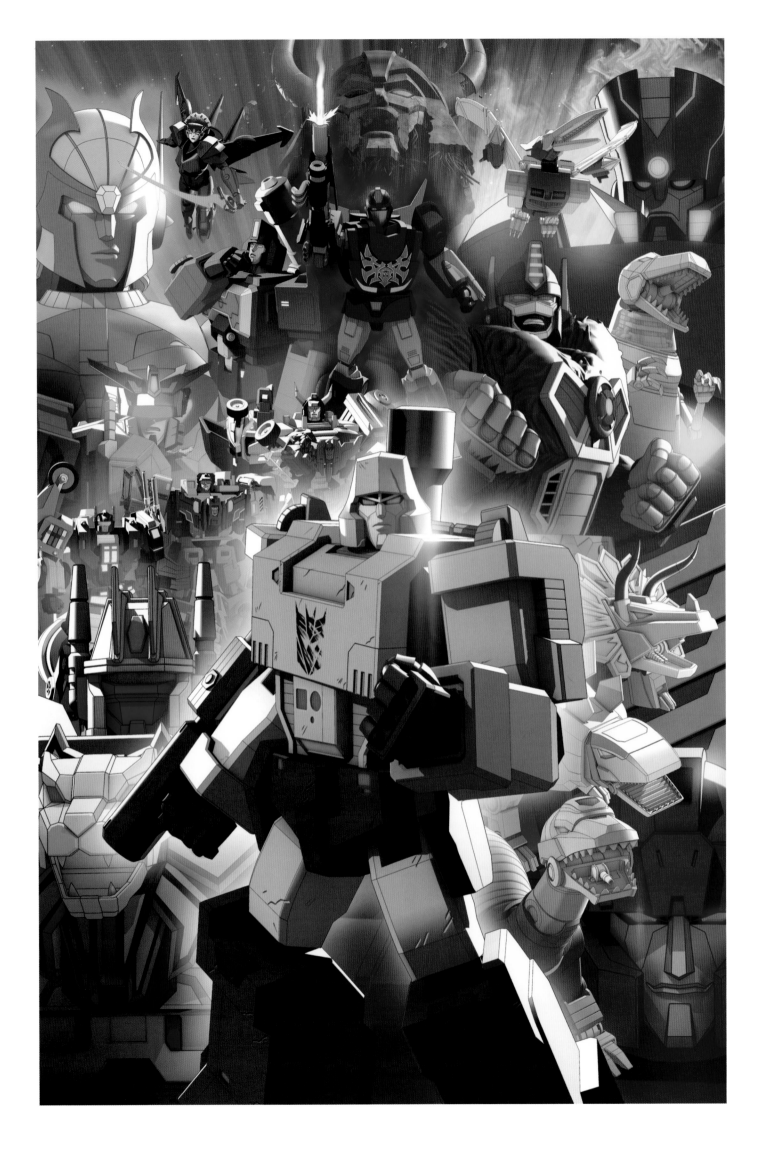

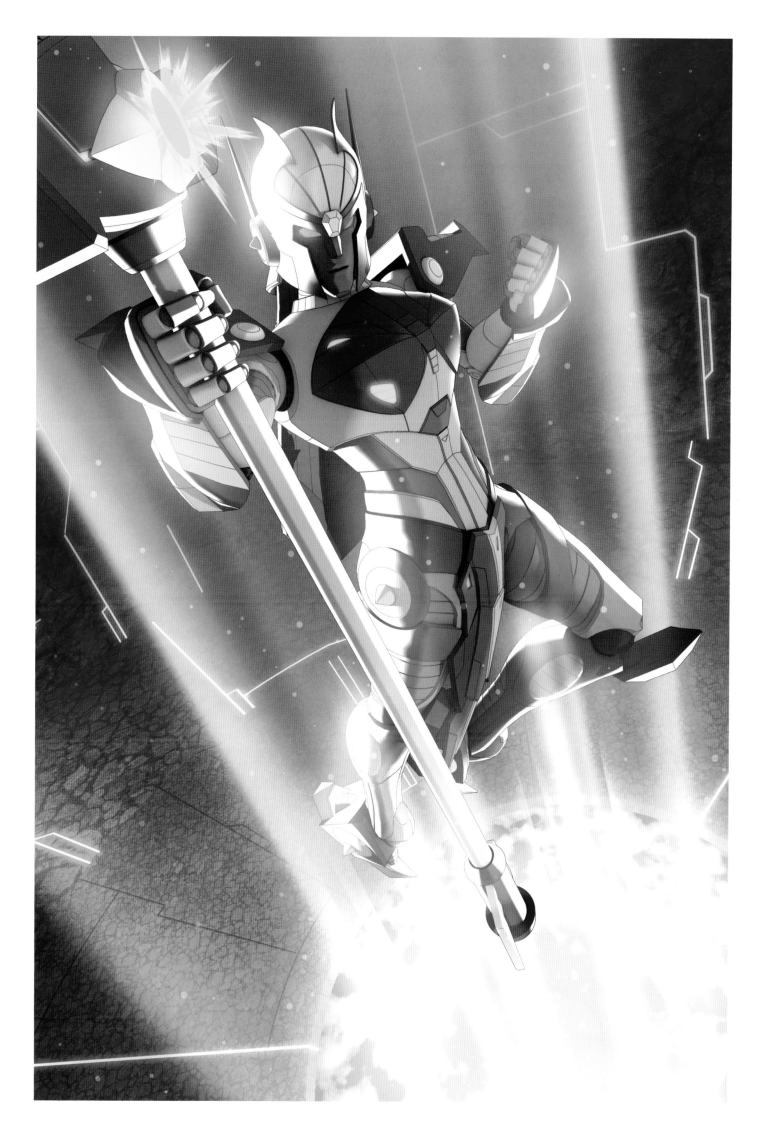

From the very beginning, the denizens of Cybertron have shared their universe with characters from other franchises. The initial Marvel Comics miniseries way back in 1984 contained numerous references to other Marvel properties, including a prominent guest spot from Spider-Man in issue #3. This relationship with Marvel would continue off and on for years, including a series of transforming toys and a crossover miniseries with the Avengers in 2008. Over the decades, the Transformers would wind up shaking hands with properties as diverse as *Star Trek*, *Star Wars*, *Mars Attacks*, *Mazinger*, *Evangelion*, *The X-Files*, *Mickey Mouse & Donald Duck*, *Hello Kitty*, *Peanuts*, *Street Fighter II*, *Go-Bots*, *Toy Story*, *Ghostbusters*, *Castlevania*, *Metal Gear*, and more, in comics, video games, and even dedicated toys!

Undoubtedly the property with the closest ties to Transformers is Hasbro's G.I. Joe. The original G1 Transformers show featured numerous Joe and Joe-adjacent characters. Marvel Comics, Dreamwave, and Devil's Due Publishing (which held the G.I. Joe license for a time) all featured multiple Transformers/G.I. Joe crossovers. IDW would eventually take this ball and run with it. They produced an amazing stand-alone Transformers vs G.I. Joe series from 2014-2016. But that was a mere prelude to the shared Hasbro universe, which folded together their existing G.I. Joe body of work into the Transformers universe, and then added in such diverse properties as ROM, Action Man, M.A.S.K. (Mobile Armored Strike Kommand), Micronauts, and Visionaries. Now you know, and knowing is half the battle!

288

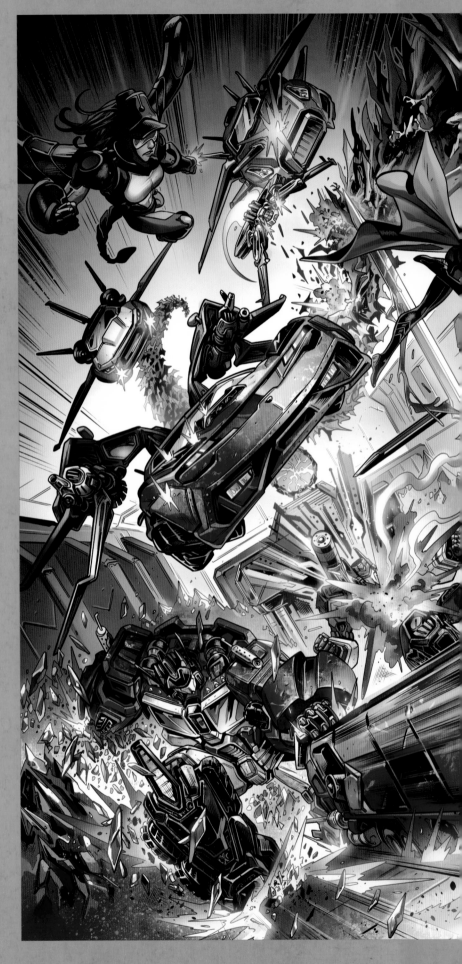

Above: Interior art, *Revolution* #4, IDW Publishing | Fico Ossio & Sebastian Cheng

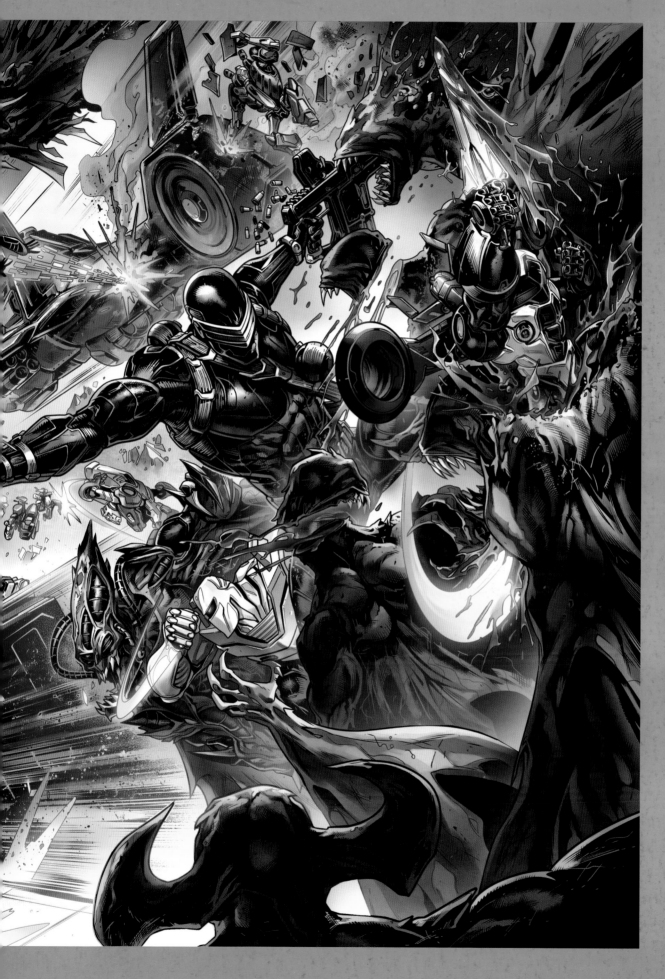

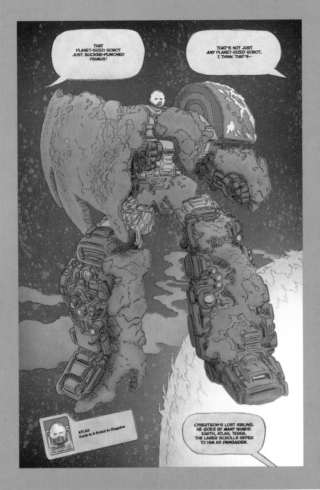

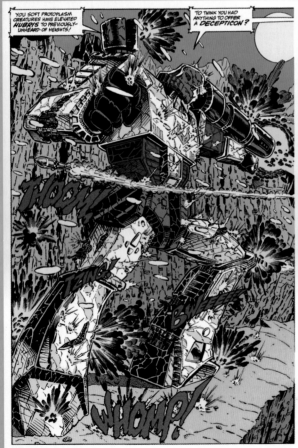

Clockwise from top left: Interior art, *Transformers vs. GI Joe* #13, IDW Publishing | Tom Scioli; Cover art, *Transformers vs. G.I. Joe: The Movie Adaptation*, IDW Publishing | Tom Scioli; Interior art, *G.I. Joe: A Real American Hero* #139, Marvel Comics | Chris Batista, Bob Sharen, Renee Witterstaetter

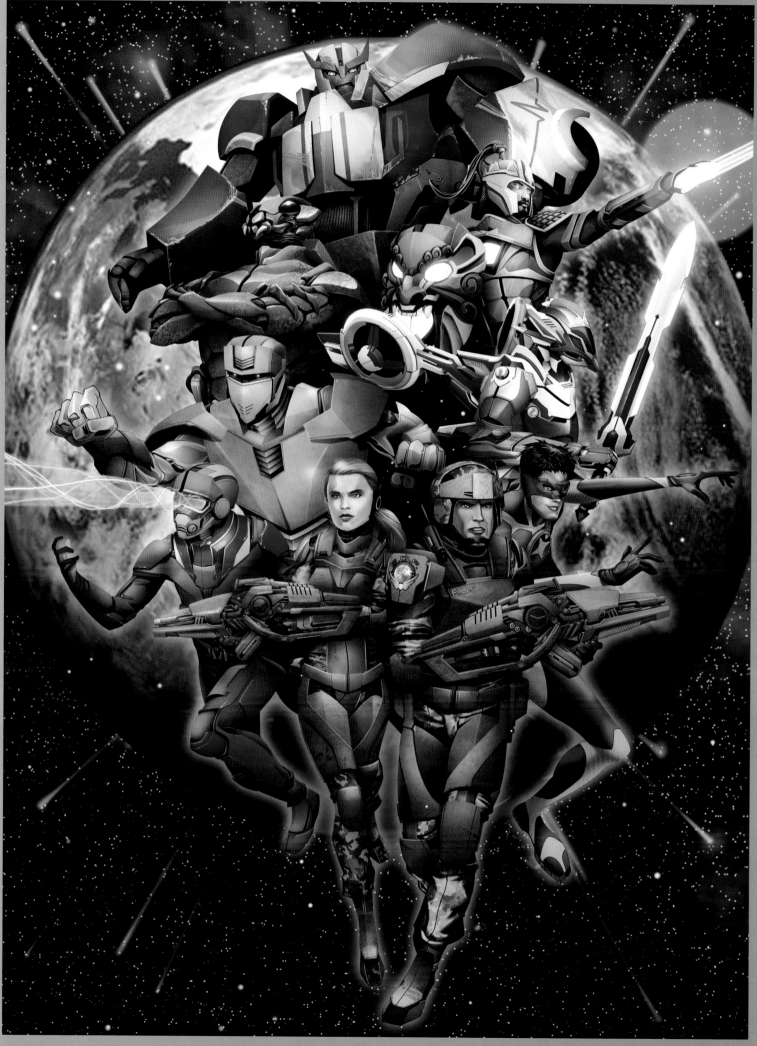

Above: Concept art, *Unit:E*, Hasbro | Ken Christiansen

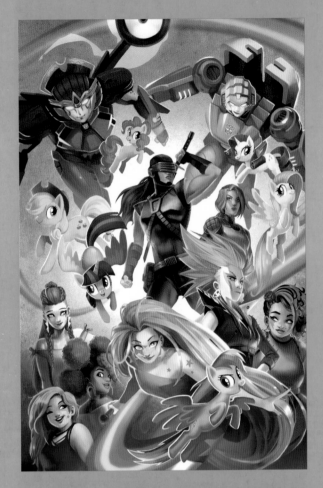

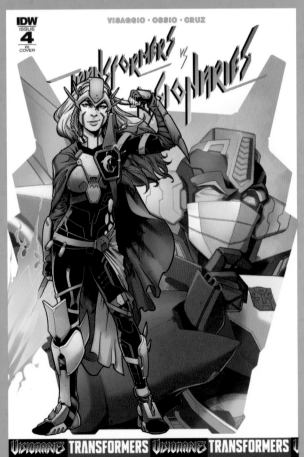

Clockwise from top left: Cover art, *Synergy: A Hasbro Creators Showcase*, IDW Publishing | Sara Pitre-Durocher; Package art, Marissa Fairborn & Afterburner, Fun Publications | Robert Q. Atkins & Jesse Wittenrich; Cover art, *Transformers Visionaries #4*, IDW Publishing | Brendan Cahill; Cover art, *Classic GI Joe volume 14*, IDW Publishing | Jonboy Meyers & Anthony Washington

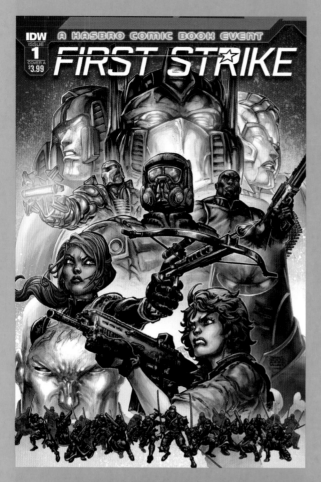

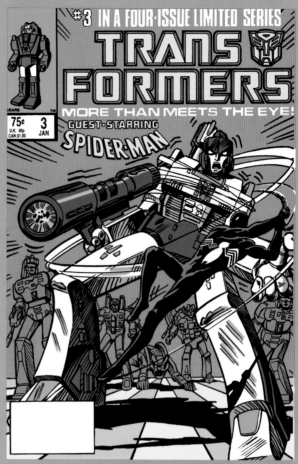

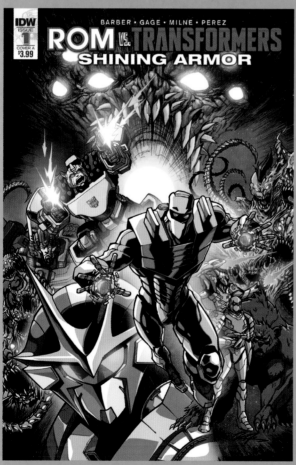

Clockwise from top left: Cover art, *First Strike* #1, IDW Publishing | Max Dunbar & Freddie E. Williams II; Cover art, *Transformers* #3, Marvel Comics | Michael Golden; Cover art, *Action Force* #26, Marvel UK | Jeff Anderson; Cover art, *Rom vs. Transformers: Shining Armor* #1, IDW Publishing | Alex Milne & Josh Perez

Following pages: GoBots crossover, Fun Publications | Christopher Colgin

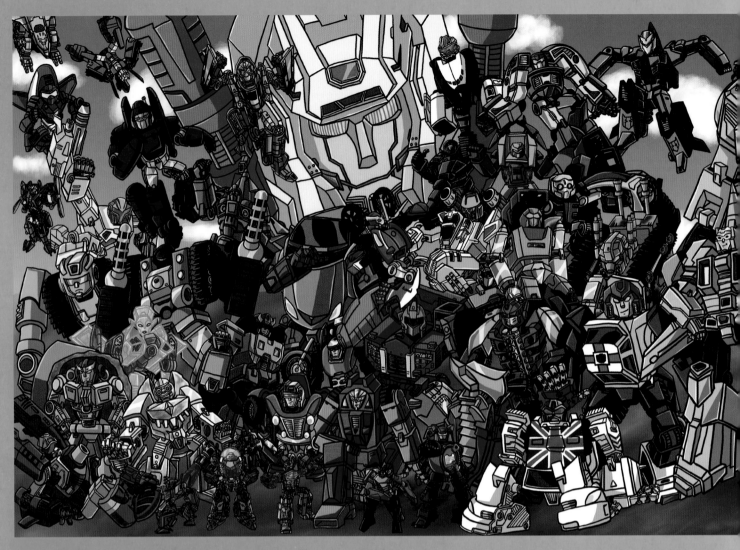

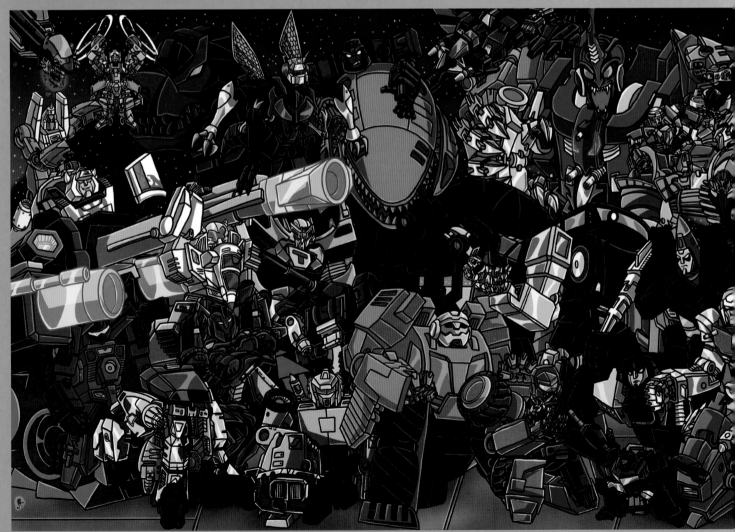

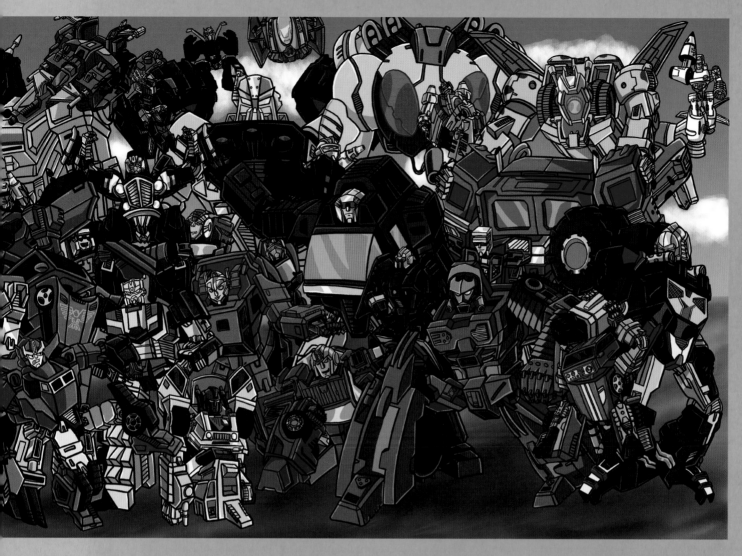

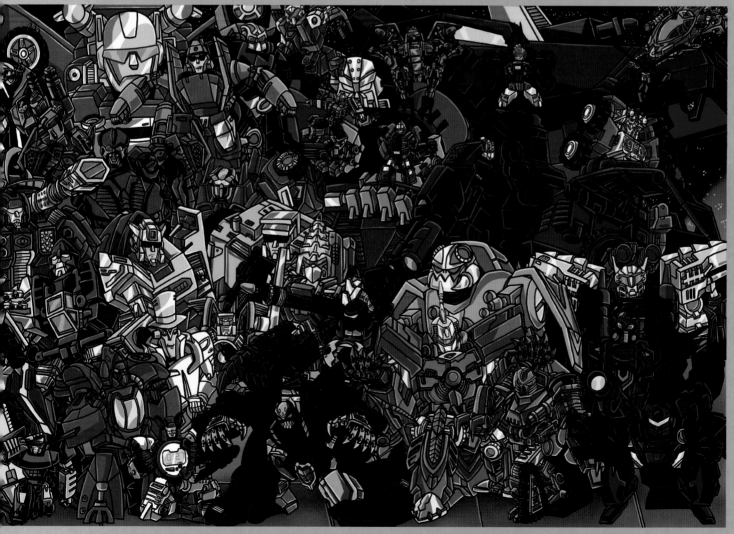

GAMES

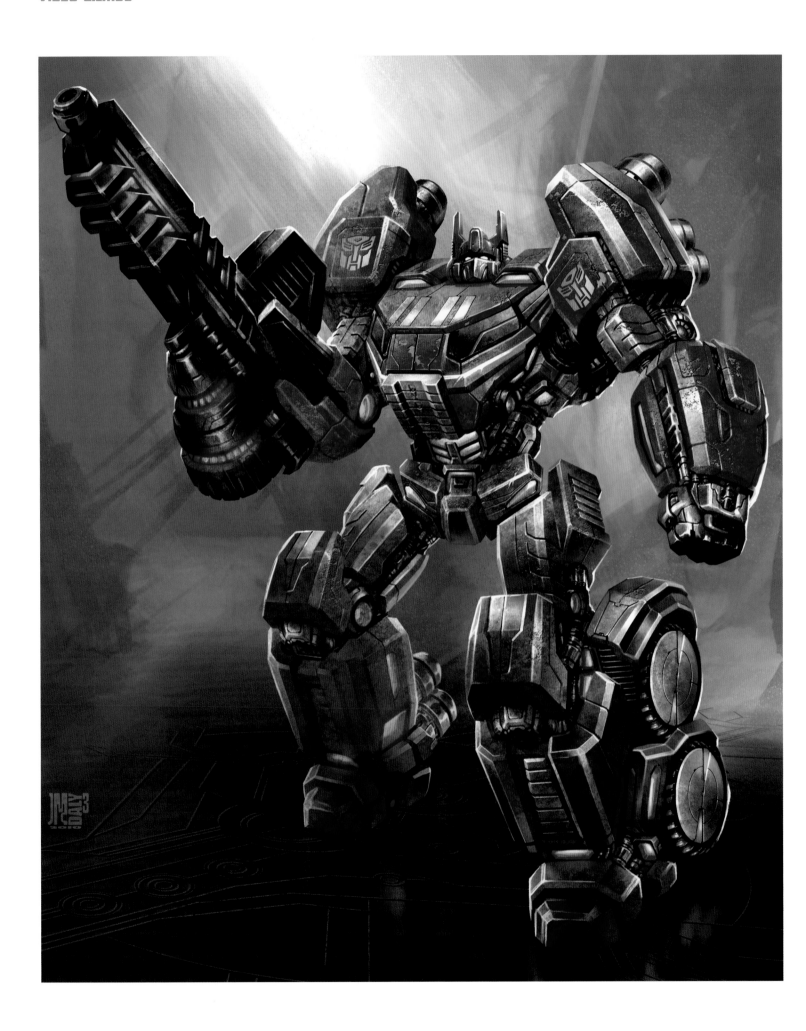

t should come as no surprise to discover that Transformers has a rich history with video games. The first licensed Transformers game was for the Commodore 64. Designed by Denton Designs, it was called simply *Transformers.* In this 8-bit adventure, you control one of five Autobots as you travel through a simple world of walkways. A year later, Activision brought us *Battle to Save the Earth*, also for the C64 platform. It featured a gorgeous airbrushed cover in the style of the box art, and more elaborate gameplay, though still quite rudimentary by today's standards. The year 1986 also brought the first of two Nintendo Famicom—the Japanese version of the Nintendo Entertainment System—games, *Mystery of Convoy.* A year later, Famicom got a *Headmasters* game, which pretty much wrapped up Transformers gaming for about a decade. Both Famicom games were exclusive to Japan, and both were notorious for their frustrating gameplay.

Transformers returned to video games in a big way with *Beast Wars.* First up was *Beast Wars Transformers* for the PlayStation and eventually the PC. Released in 1997, *Beast Wars Transformers* was a third-person shooter. *Beast Wars Transmetals* followed in 2000 (1999 in Japan), a fighting game released for both the PlayStation and the Nintendo 64, albeit with significant differences. There was also *Duel Fight Transformers Beast Wars: Beast Warriors' Strongest Decisive Battle*, a Japanese-exclusive fighting game released for the Game Boy Color system. This was a big departure from the previous games—you were free to play as a Maximal or a Predacon, where earlier games forced you to play as a good guy. The many years between the initial G1 releases and these *Beast Wars* games had brought about much improvement in computer gaming, though from a purely aesthetic perspective the graphics available on the processors of this era are still blocky when compared to comic art.

But that was fated to change. In 2004, another game titled *Transformers* was released for the PlayStation 2. Featuring the characters from *Armada*, this game was more story-oriented than previous offerings, and was the first Transformers game to be released to general critical praise. *Armada* also received a small Flash game, distributed with a CD-ROM, called *The Energon Within.* As the barriers to creating video games with simple physics fell, more and more simple games like this would appear, flare briefly, and vanish.

The next big wave of Transformers gaming came in the form of various movie tie-ins where games big and small, for every major platform, retold the story of the assorted *Transformers* films, bringing the unique aesthetic of the films to the small screen. Later series, including *Animated, Prime, Robots in Disguise*, and *Rescue Bots*, would also receive tie-in games.

In 2010, High Moon Studios released *War for Cybertron*, followed in 2012 by its sequel, *Fall of Cybertron.* Taking place in a continuity adjacent to *Transformers Prime*, these games took the player to the early days of the war. As the titles implied, the action took place on Cybertron, so characters were given alien alt modes. By any measure, these were truly great games, taking full advantage of what makes Transformers unique in terms of both lore and mechanics. For the first time, Transformers video games were expanding on the story in a meaningful way. The look and feel of the game stands up to anything the franchise has to offer. The game series was supported by books, toys and comics, making it far and away the most influential Transformers game series to date.

By the mid-2010s, technology had progressed to the point where even mobile games could be gorgeous. *Transformers Legends*, a card battle game, was made available on the Android platform in 2012 and iOS in 2013. It was perhaps most notable for its gorgeous art, some of which was reused as the package art for *Combiner Wars. Earth Wars*, a strategy game released in 2016, was notable for having veteran scribe Simon Furman pen the dialogue. Another mobile game, *Forged to Fight*, debuted in 2017 and let characters from all eras duke it out.

In addition to the mobile games above, *Transformers Devastation*, released for multiple platforms in 2015, allowed the player to take control of the action and battle in an aesthetic heavily inspired by the original G1 cartoon, and was truly spectacular to behold. More than any other major medium, the technology underlying gaming has evolved in leaps and bounds. There are literally over a million times as many colors in *Devastation* than in the earliest offerings. In a medium that changes so quickly, it's difficult to imagine just what the future of Transformers gaming might look like, but it sure is fun to try!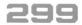

Previous: Development art, Metroplex, *Transformers: Fall of Cybertron*
Opposite: Development art, Optimus Prime, *Transformers: War for Cybertron*

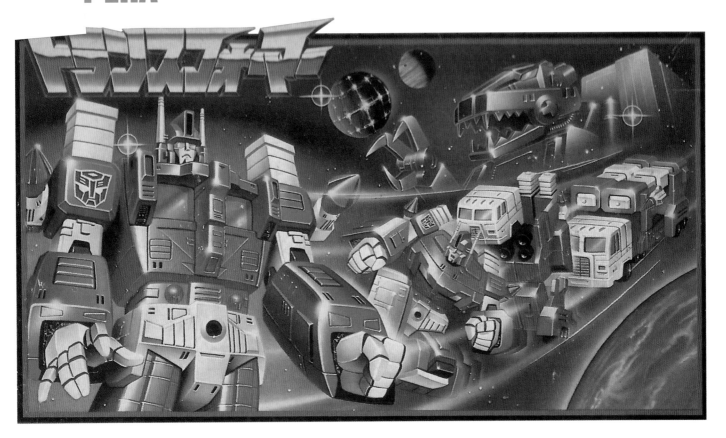

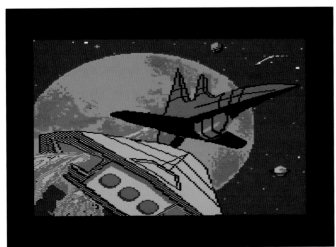

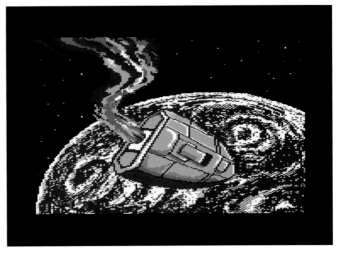

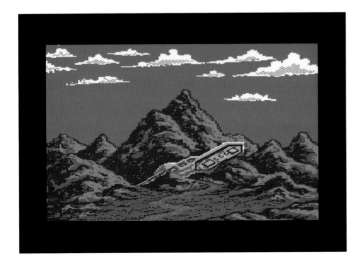

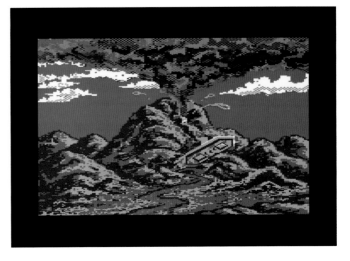

Clockwise from top: Package art, *The Transformers: Mystery of Convoy*, Screenshots, *The Transformers: The Battle to Save the Earth*

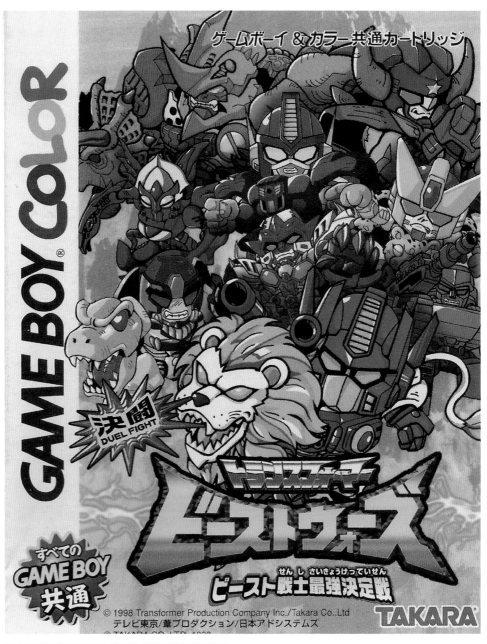

ゲームボーイ＆カラー共通カートリッジ

GAME BOY COLOR

GAME BOY®

決闘 DUEL FIGHT

すべての
GAME BOY
共通

© 1998 Transformer Production Company Inc./Takara Co.,Ltd
テレビ東京/葦プロダクション/日本アドシステムズ

ビースト戦士最強決定戦

TAKARA

BEAST WARS
TRANSFORMERS

HASBRO
Interactive

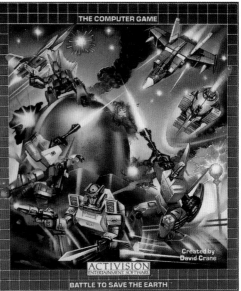

THE COMPUTER GAME

ACTIVISION
ENTERTAINMENT SOFTWARE

Created by
David Crane

BATTLE TO SAVE THE EARTH

Clockwise from top: Package art, *Ketō Transformers Beast Wars: Beast Senshi Saikyō Ketteisen*;
The Transformers: The Battle to Save the Earth; *Beast Wars: Transformers*

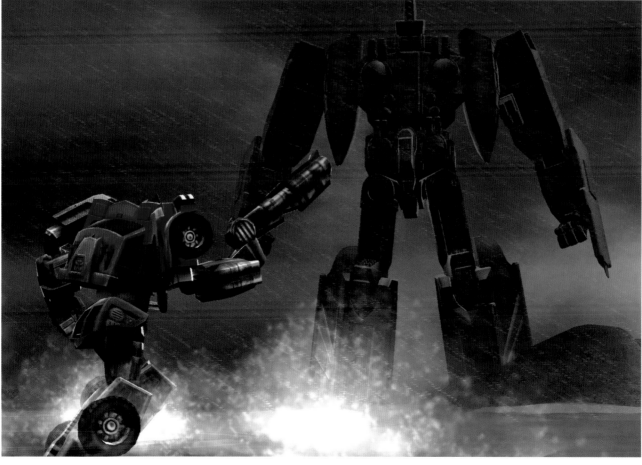

These pages: Screenshots, *Transformers*

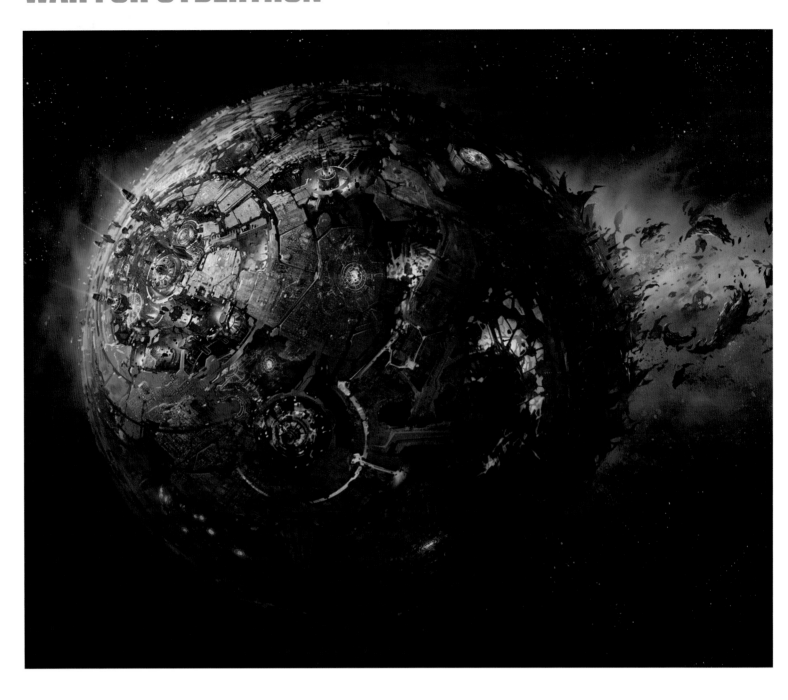

Above: Development art, *Transformers: War for Cybertron*

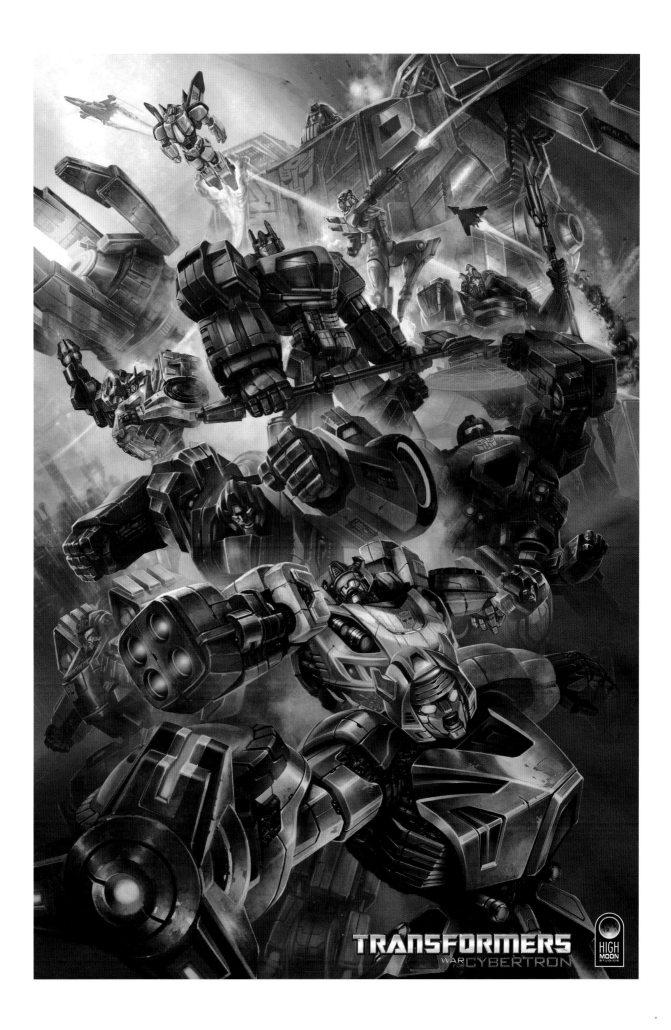

Above: Desktop wallpaper, *Transformers: War for Cybertron*

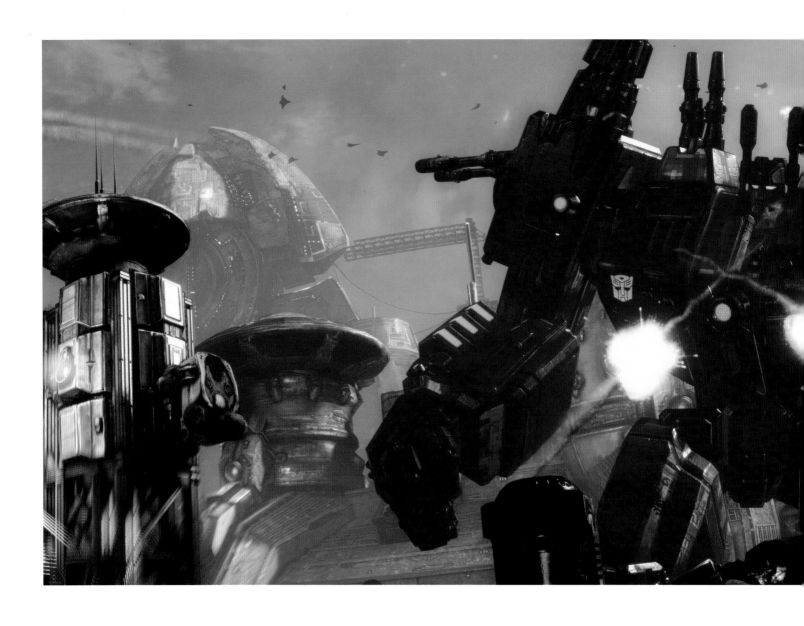

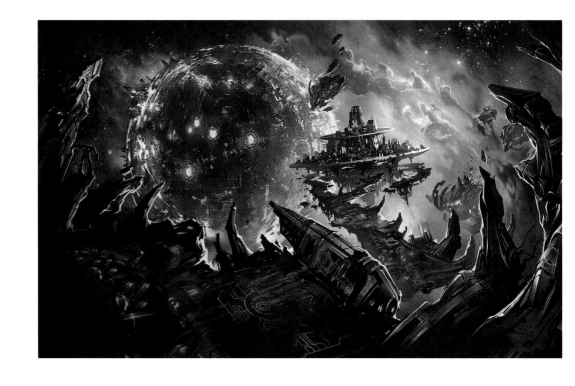

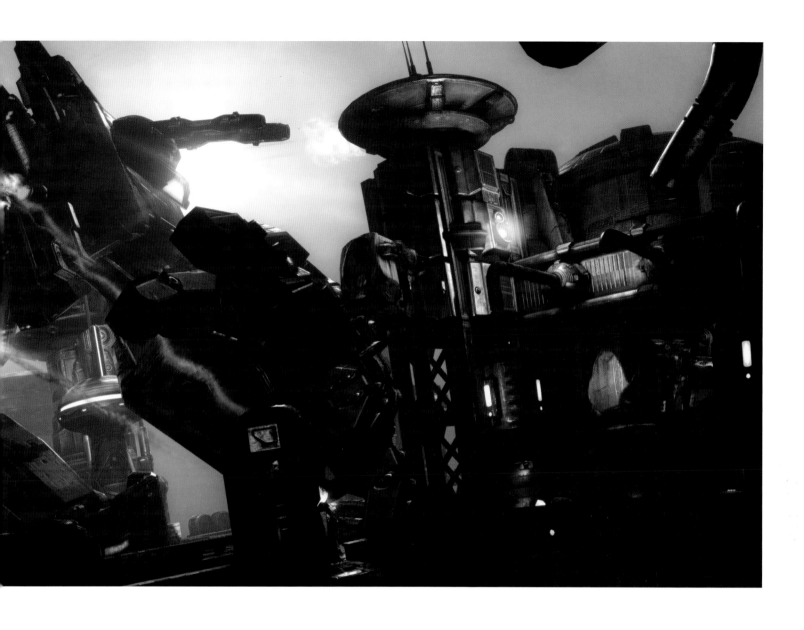

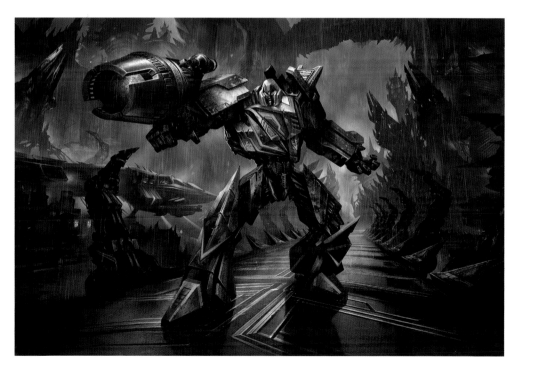

Top: Screenshot, *Transformers: War for Cybertron*

Above: Development art, *Transformers: War for Cybertron*

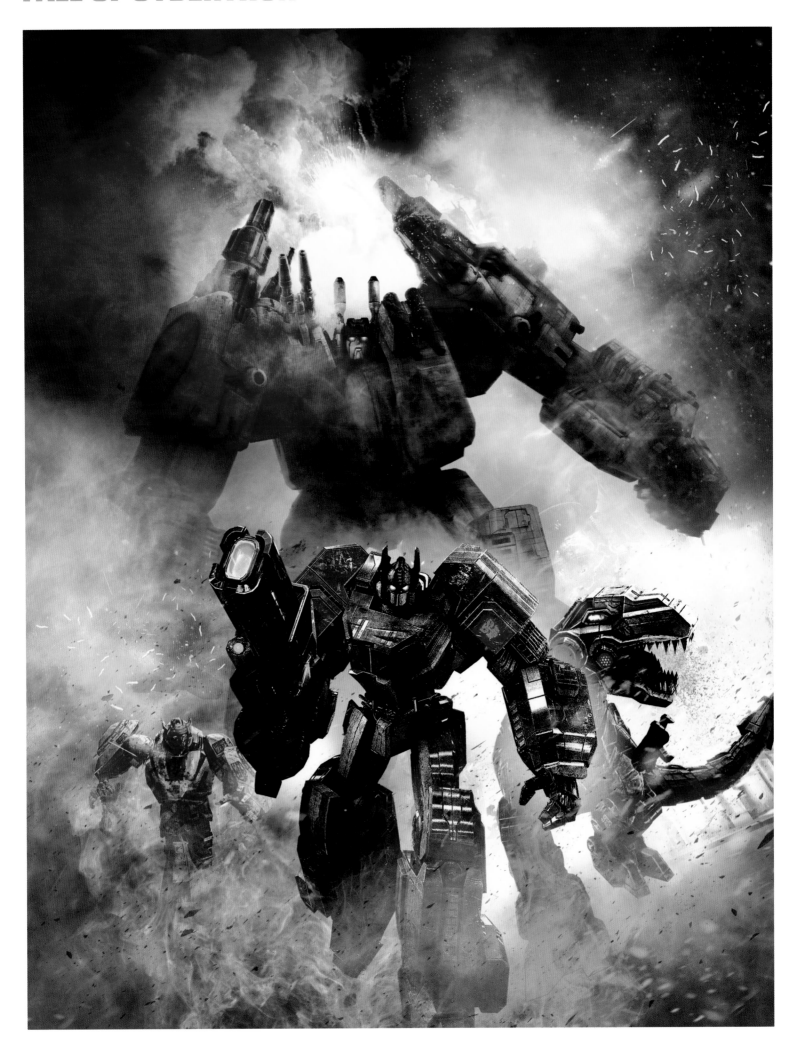

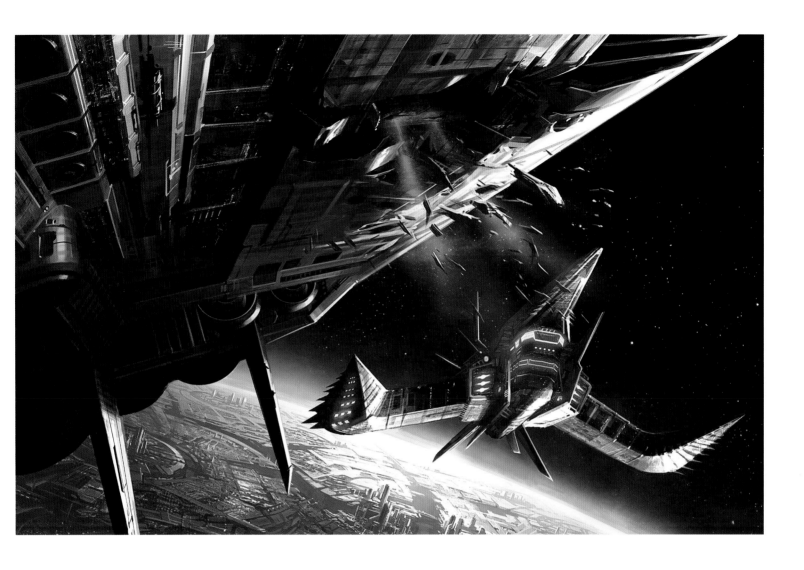

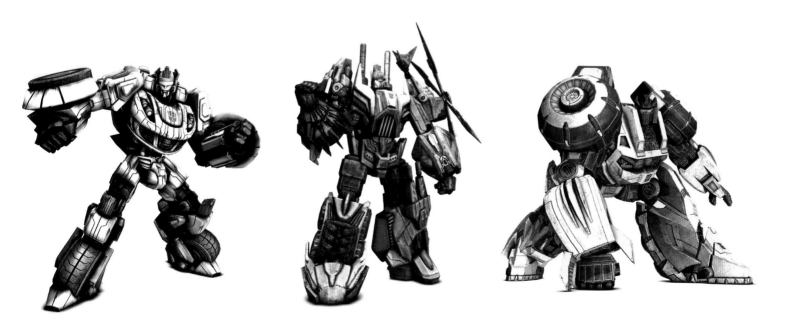

Opposite: Key art, *Transformers: Fall of Cybertron*

Above: Loading screen, Space, *Transformers: Fall of Cybertron*

Below: Character art, Jazz, Bruticus, Grimlock, *Transformers: Fall of Cybertron*

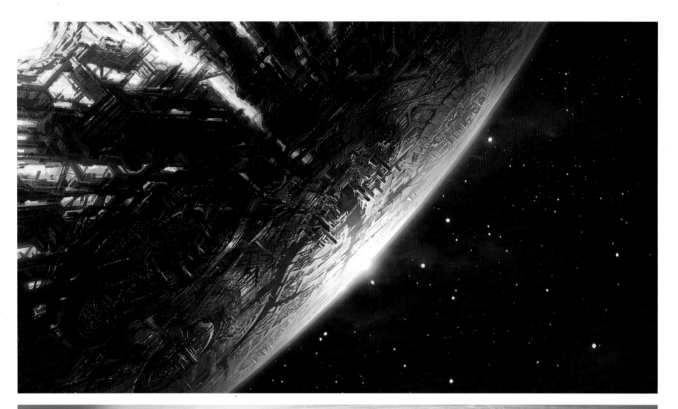

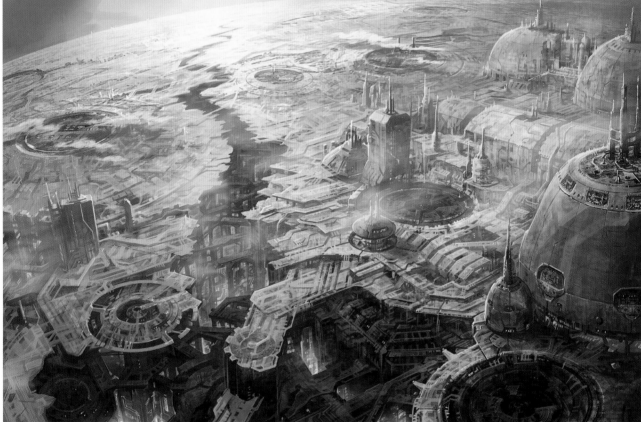

From top: Development art, Cybertron, *Transformers: Fall of Cybertron*; Loading screen, Rust Sea, *Transformers: Fall of Cybertron*

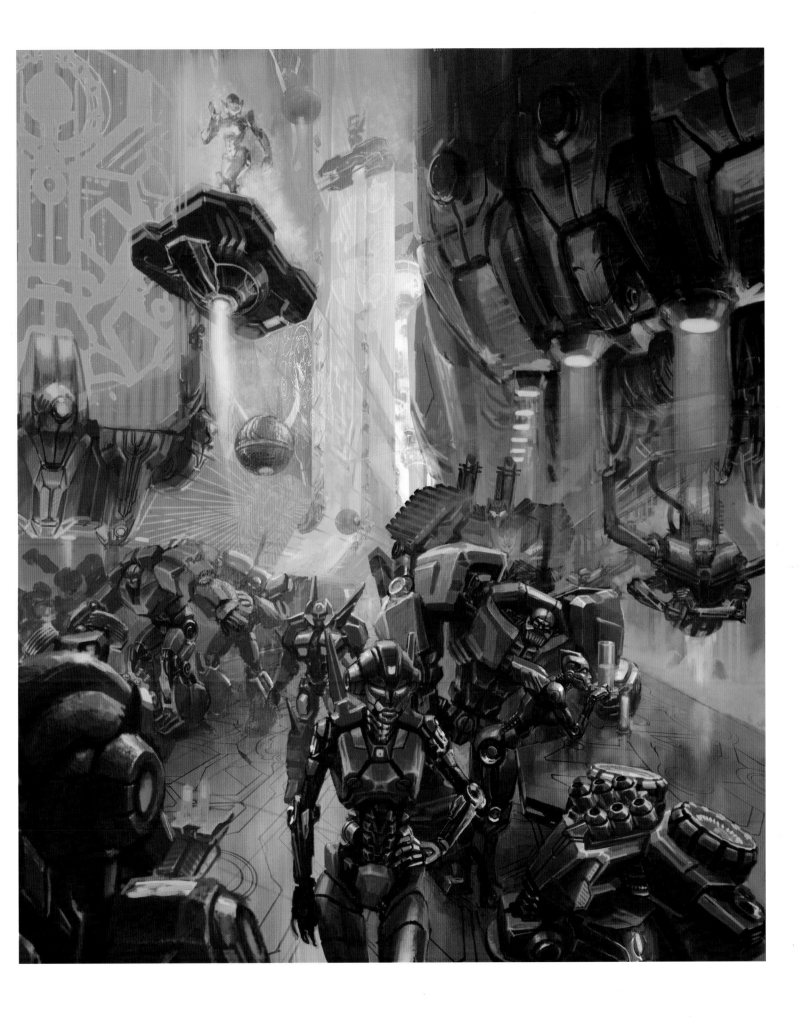

Above: Development art, Cyber City, *Transformers: Fall of Cybertron*

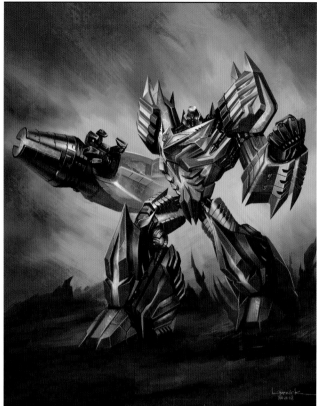

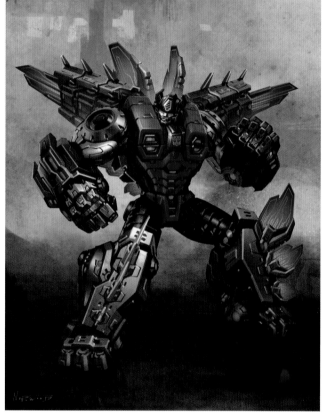

Clockwise from top left: Concept art, Megatron, Grimlock, Snarl, Swoop, *Transformers: Fall of Cybertron*

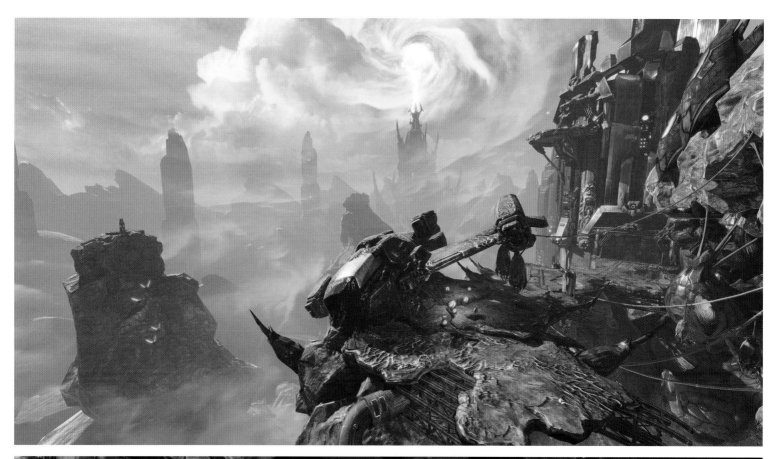

Top: Environment shot, *Transformers: Fall of Cybertron*

Below: Background, *Transformers: Fall of Cybertron*

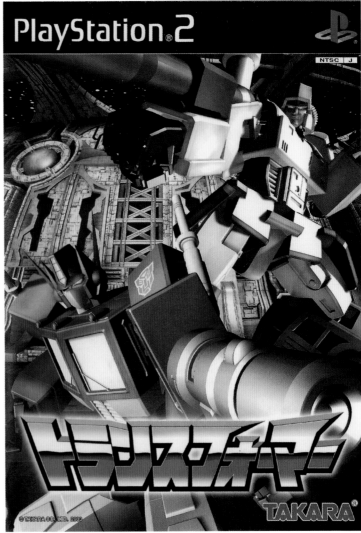

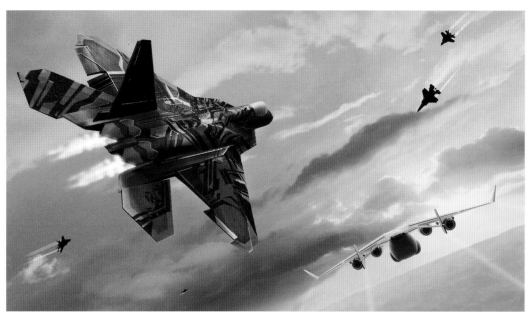

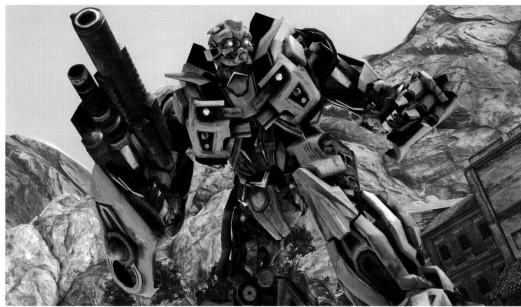

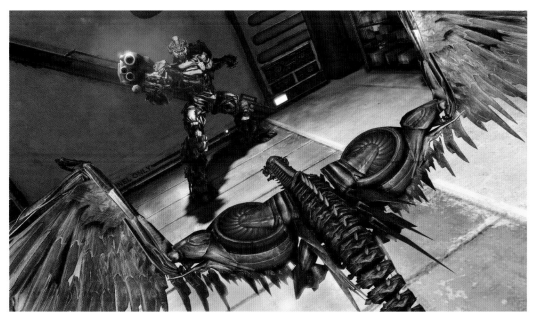

Opposite, top: Promo art, *Transformers*; Cover art, *Transformers*

Opposite, below: Package art, *Transformers: Rise of the Spark*, *Transformers Prime*

From Top: Screenshots, Dogfight, Bumblebee, Laserbeak, *Transformers: Dark of the Moon*

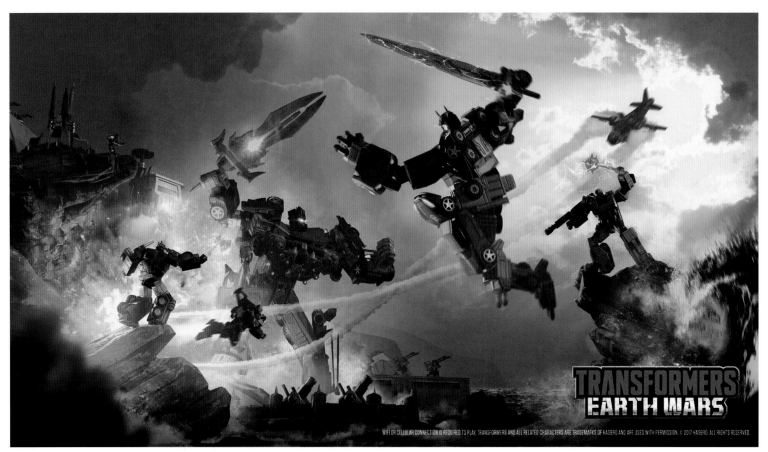

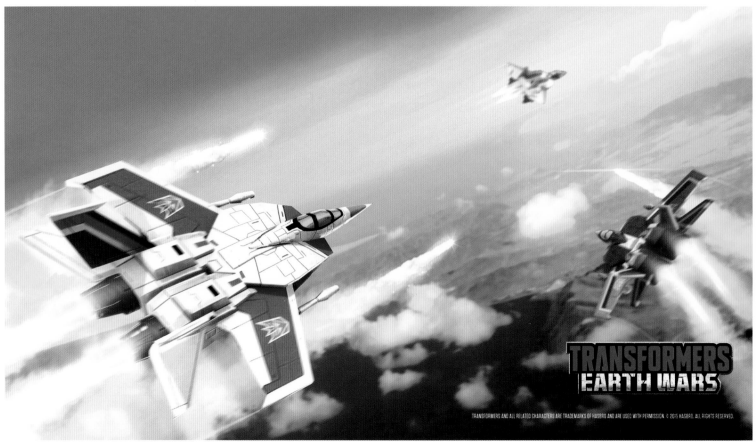

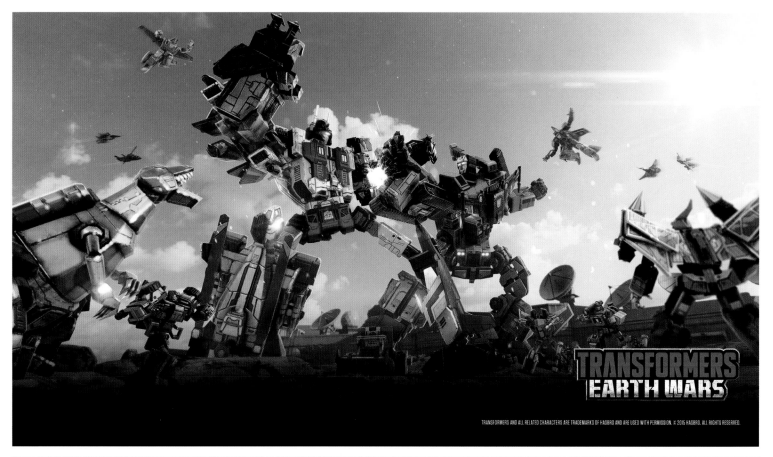

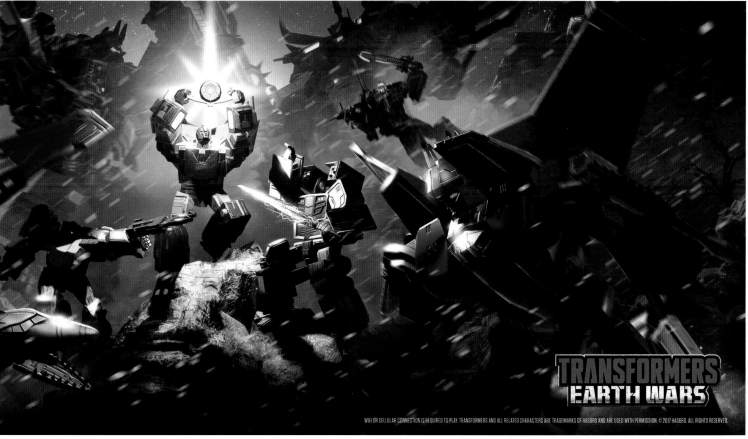

These pages: Promotional images, *Transformers: Earth Wars*

DEVASTATION

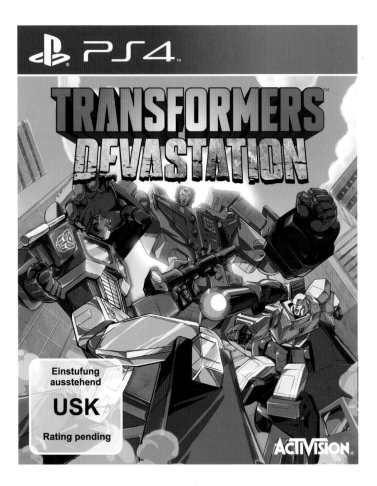

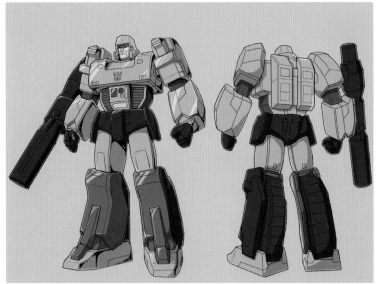

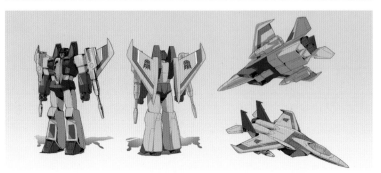

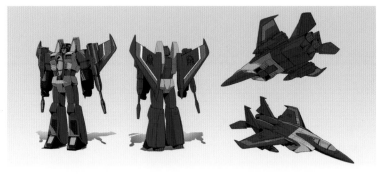

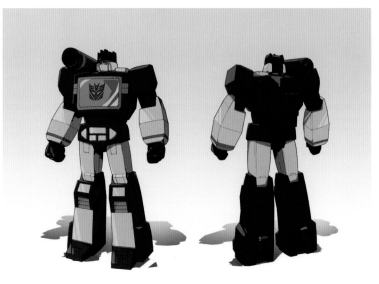

Top: Package art, *Transformers: Devastation*

Below, clockwise from top left: Development art, Megatron, Thundercracker, Soundwave, Starscream, *Transformers: Devastation*

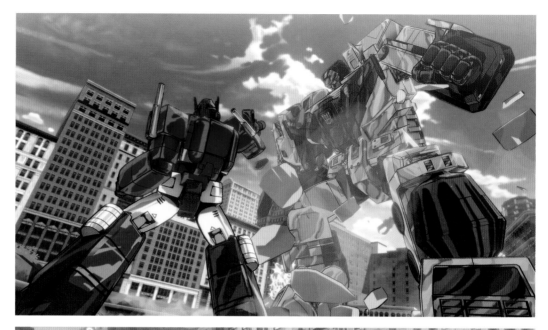

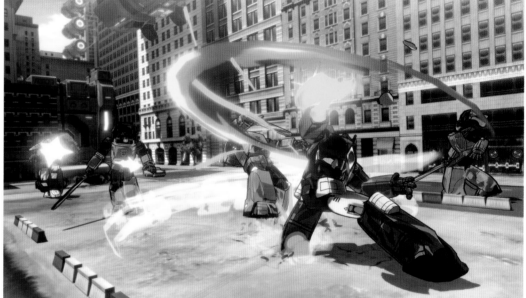

This page: Screenshots, *Transformers: Devastation*

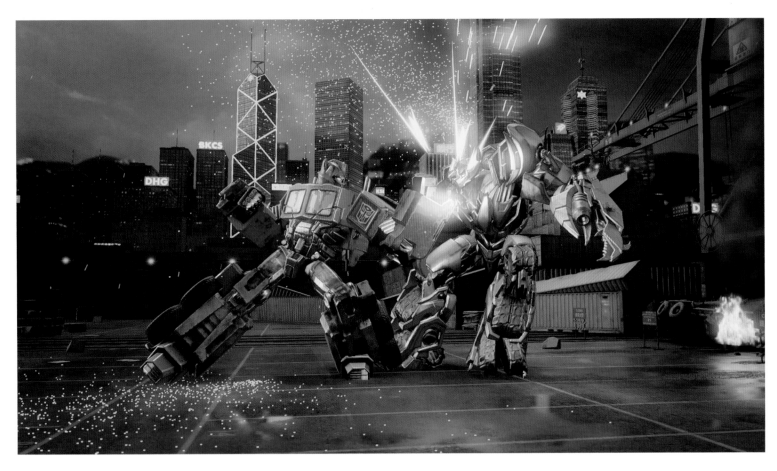

Top: Screenshot, *Transformers: Forged to Fight*
Left: Promo art, *Transformers: Forged to Fight*

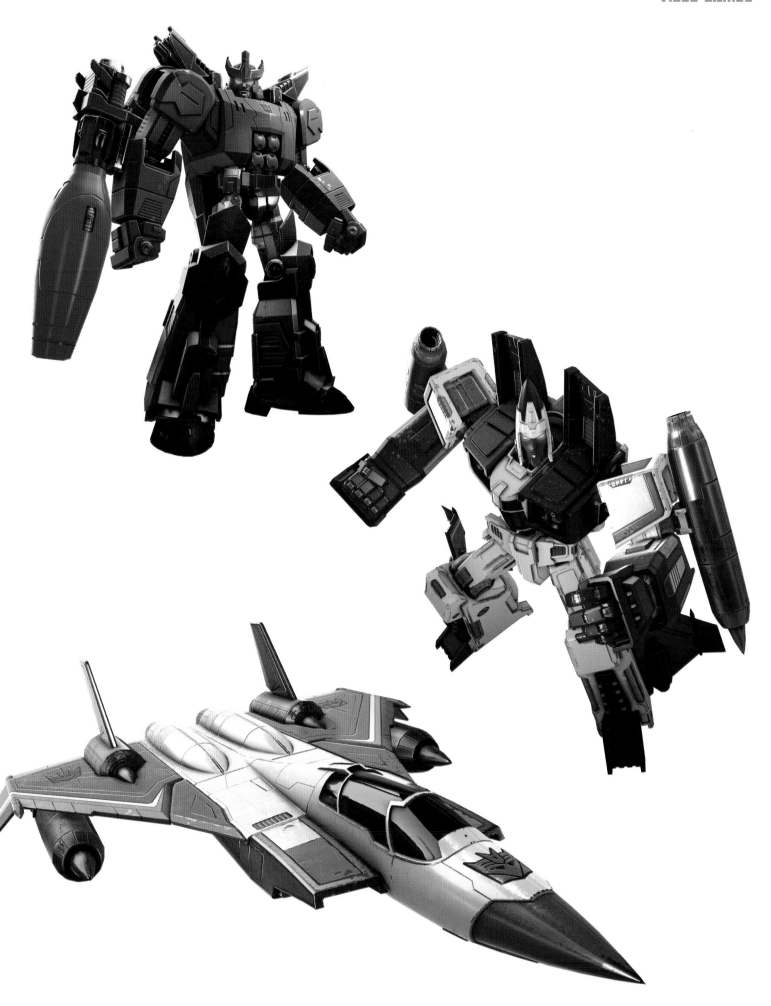

From top: Character renders, Galvatron, Ramjet Bot Mode, Ramjet Vehicle Mode,
Transformers: Forged to Fight

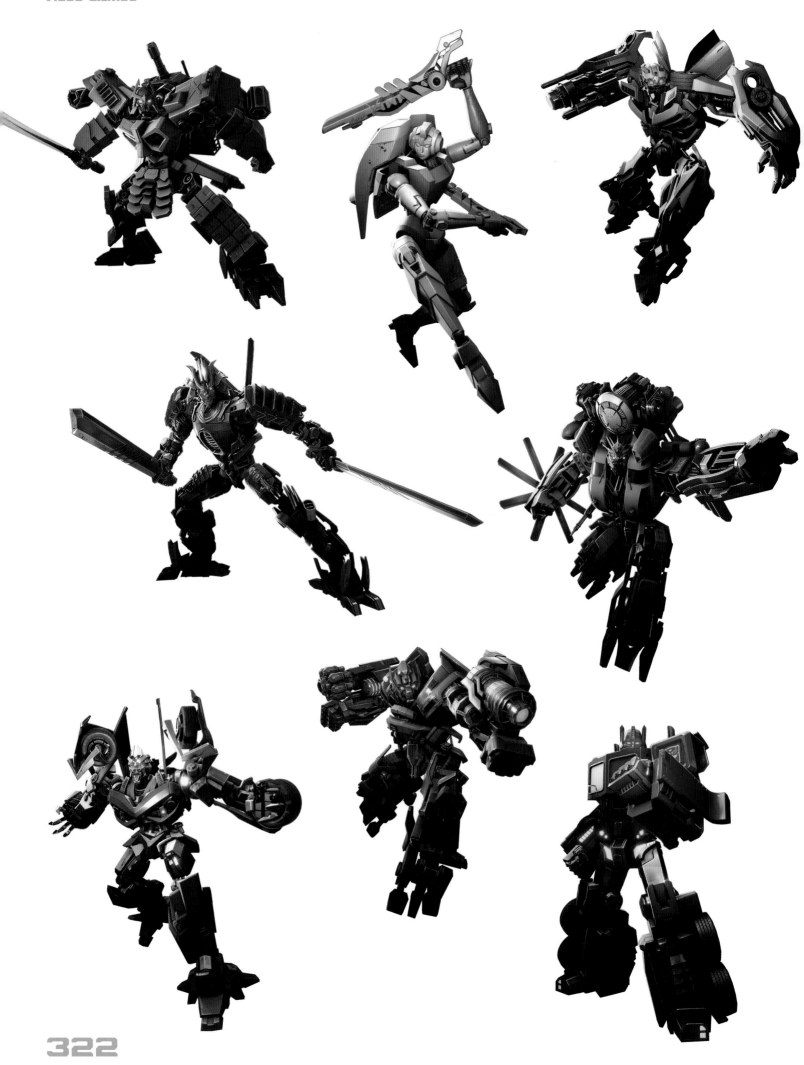

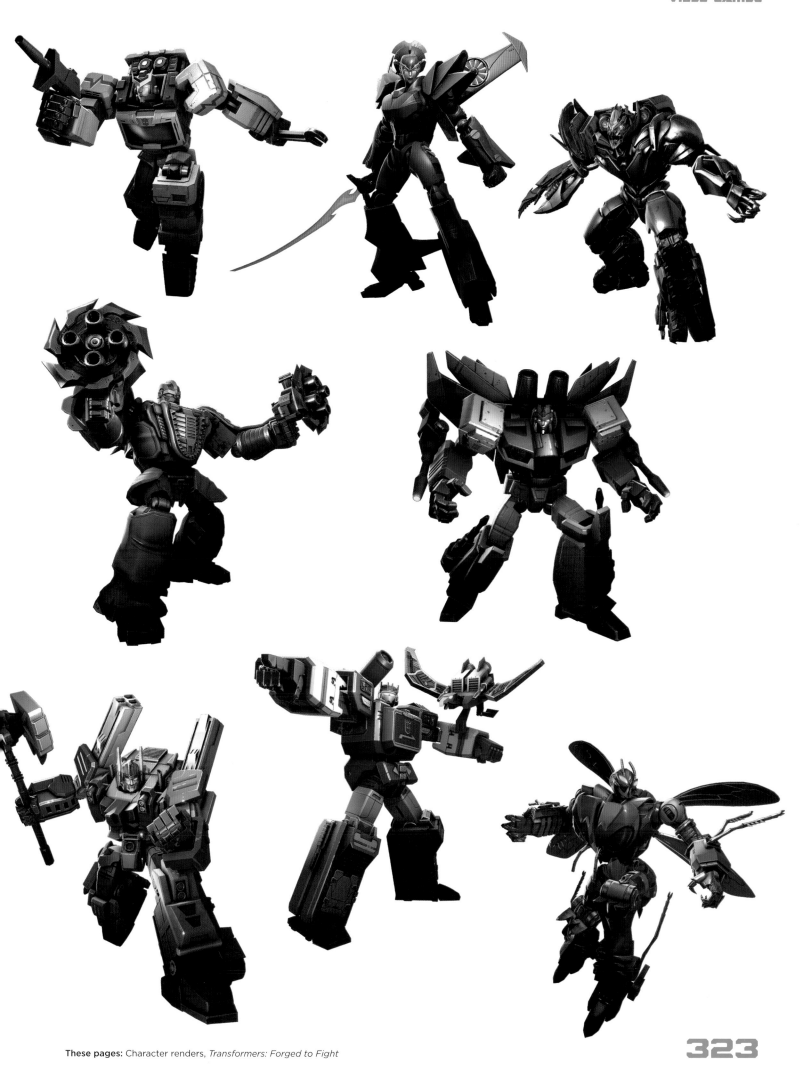

These pages: Character renders, *Transformers: Forged to Fight*

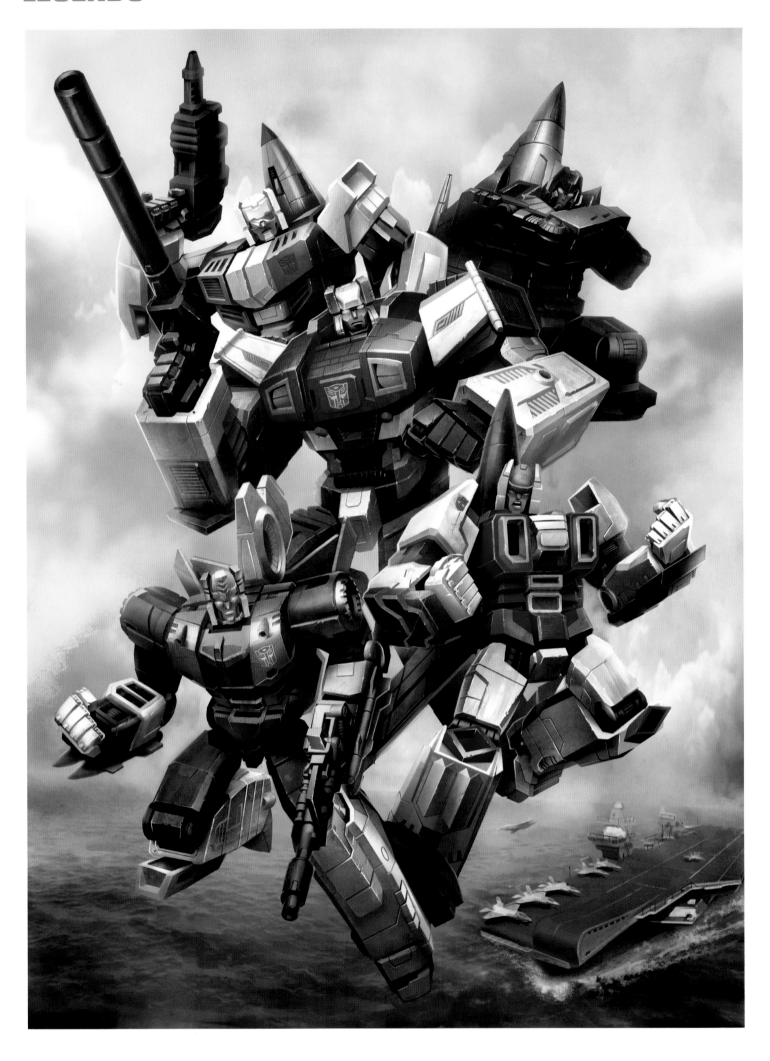

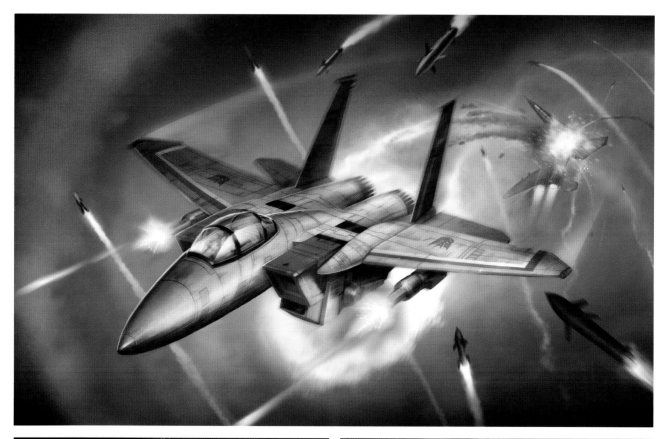

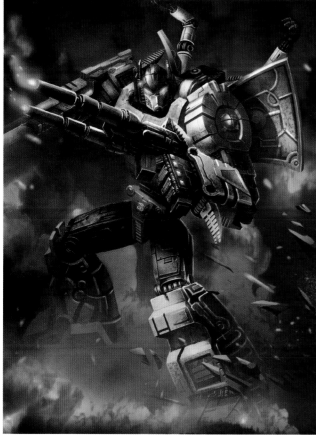

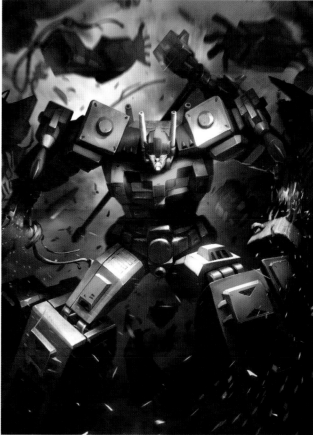

Opposite: Card art, Aerialbots, *Transformers: Legends*

Clockwise from top: Card art, Starscream, Ultra Magnus, Grimlock, *Transformers: Legends*

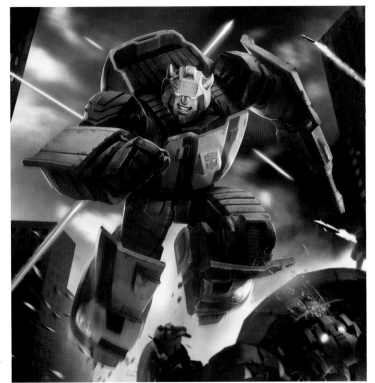

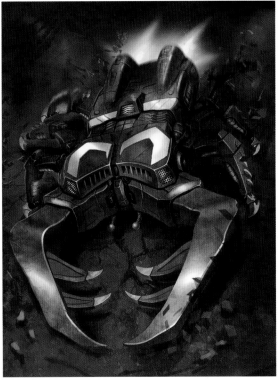

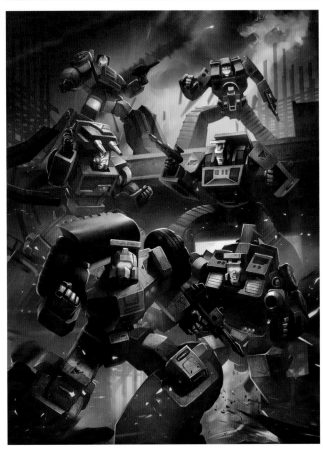

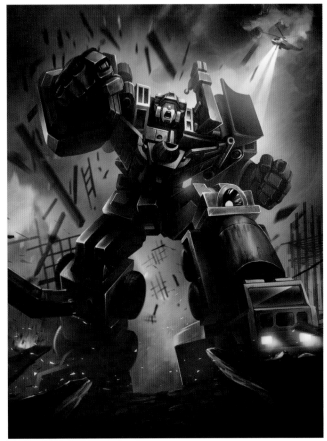

Clockwise from top left: Card art, Bumblebee, Chopshop, Devastator, Constructicons, *Transformers: Legends*

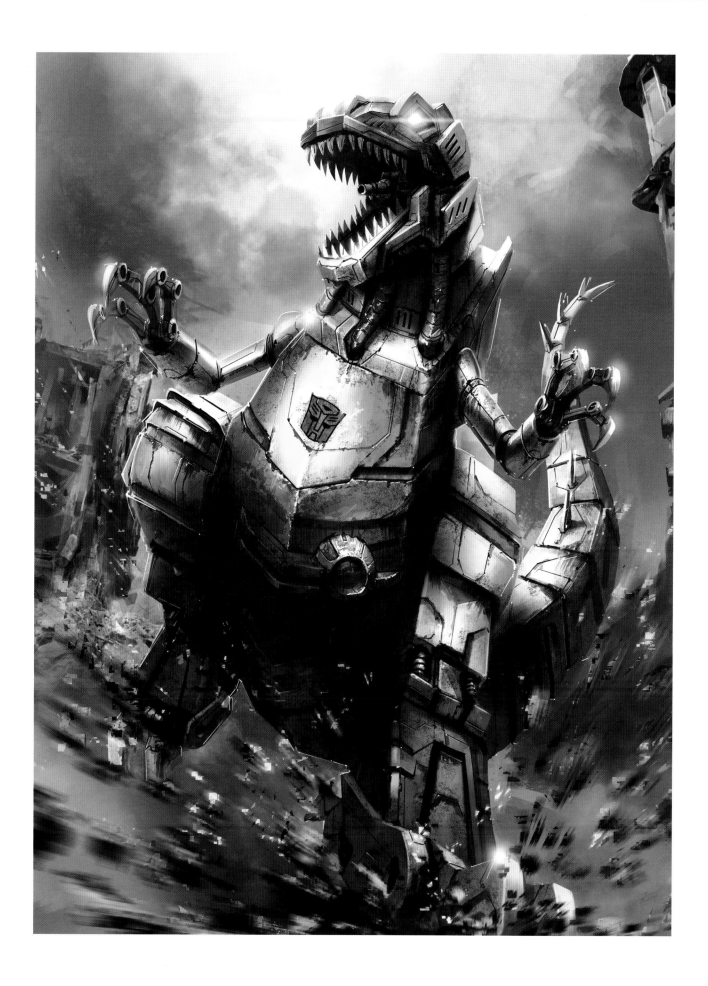

Above: Card art, Grimlock, *Transformers: Legends*

"Mobile gaming company ngmoco, who produced *Legends*, found me via Deviant Art.
It was a childhood dream come true to get to work on my childhood heroes. The first
batches of designs include Soundwave, Grimlock, and Bumblebee. It's been fun seeing
the art reused for backpacks and the new Transformers card game." — Ben Hansen

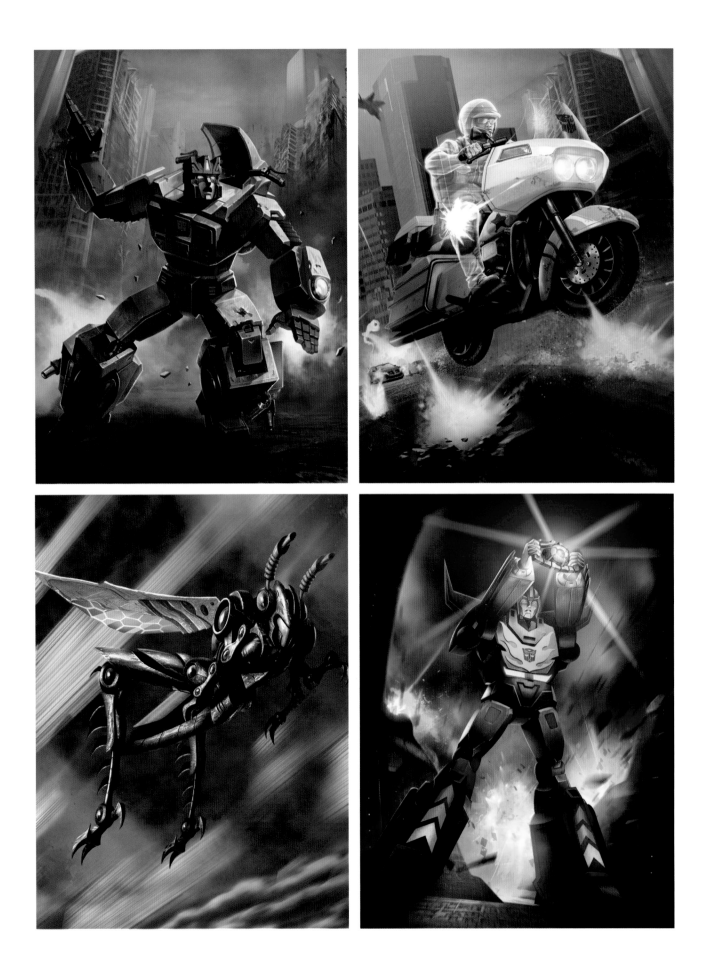

Clockwise from top left: Card art, Groove Bot Mode, Groove Vehicle Mode, Rodimus Prime, Kickback, *Transformers: Legends*

Clockwise from top left: Card art, Swerve, Trypticon, Longhaul Bot Mode, Longhaul Vehicle Mode, *Transformers: Legends*

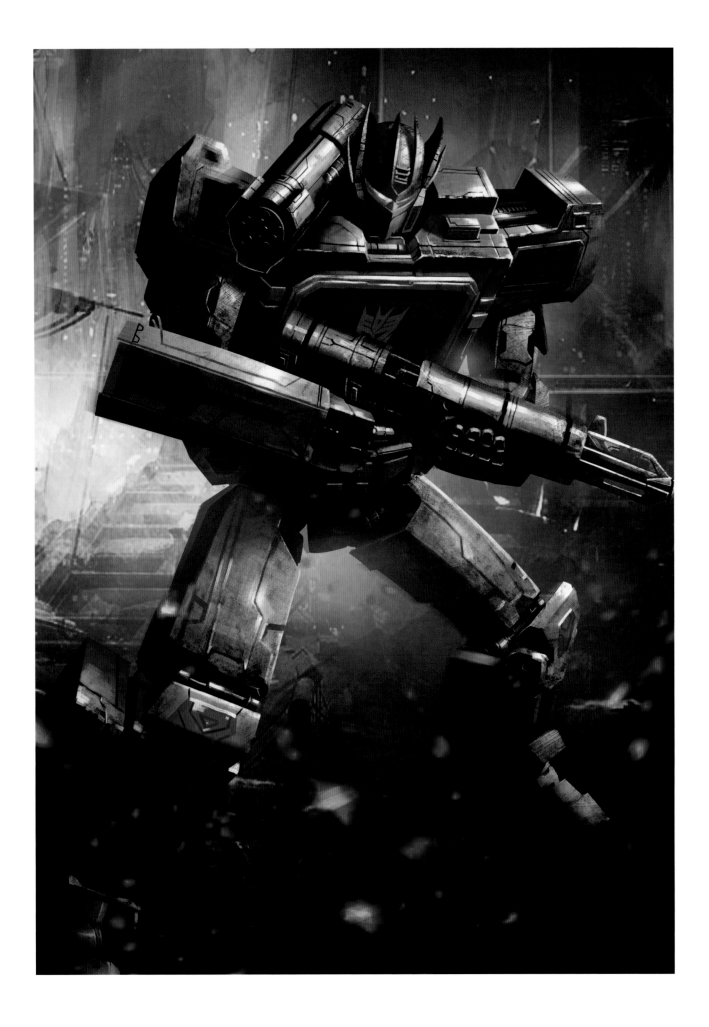

This page: Card art, Soundwave, *Transformers: Legends*

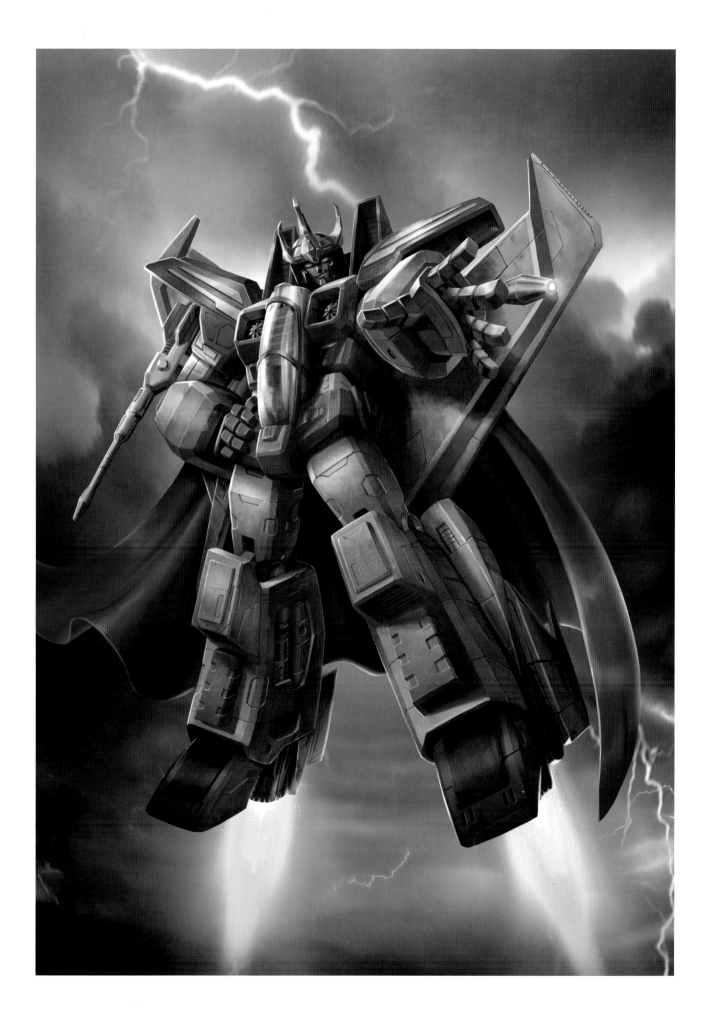

This page: Card art, King Starscream, *Transformers: Legends*

It's difficult to overstate just how massive the Transformers brand was in the '80s, though the flurry of merchandising following the success of the film franchise might give some hint. Although the brand has historically presented mainly through toys, comics, cartoons, video games, and, in modern times, films, it's also found its way onto T-shirts, puzzles, children's books, Colorforms, posters, and more, sometimes featuring never-before-seen pieces.

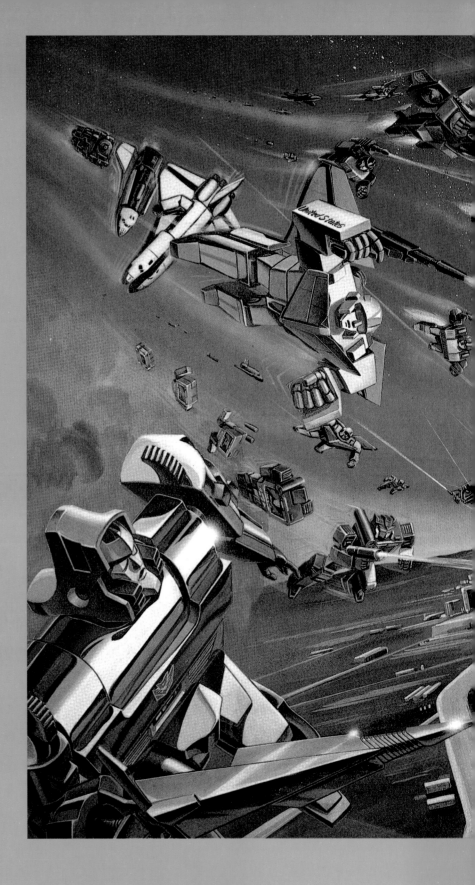

These pages: Early Takara concept art

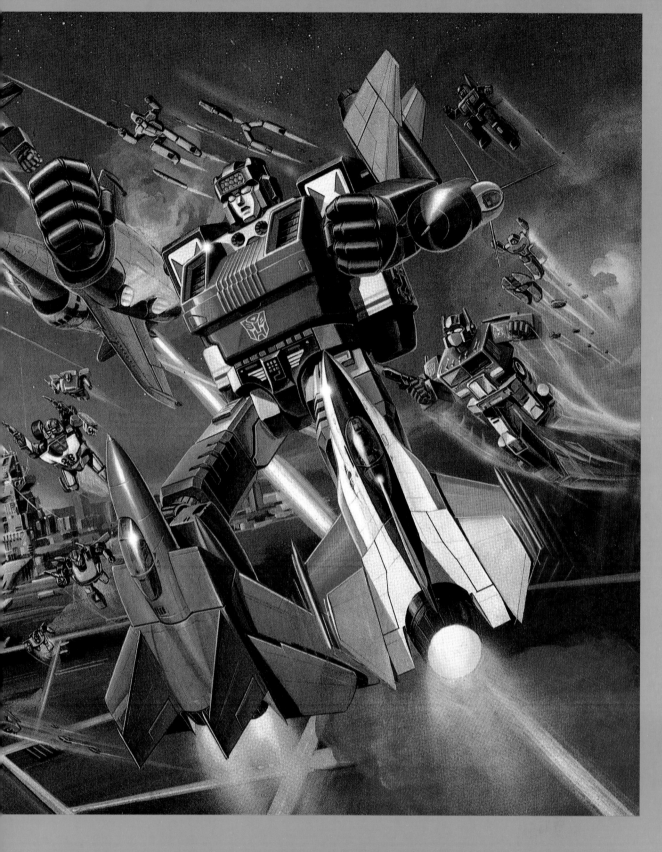

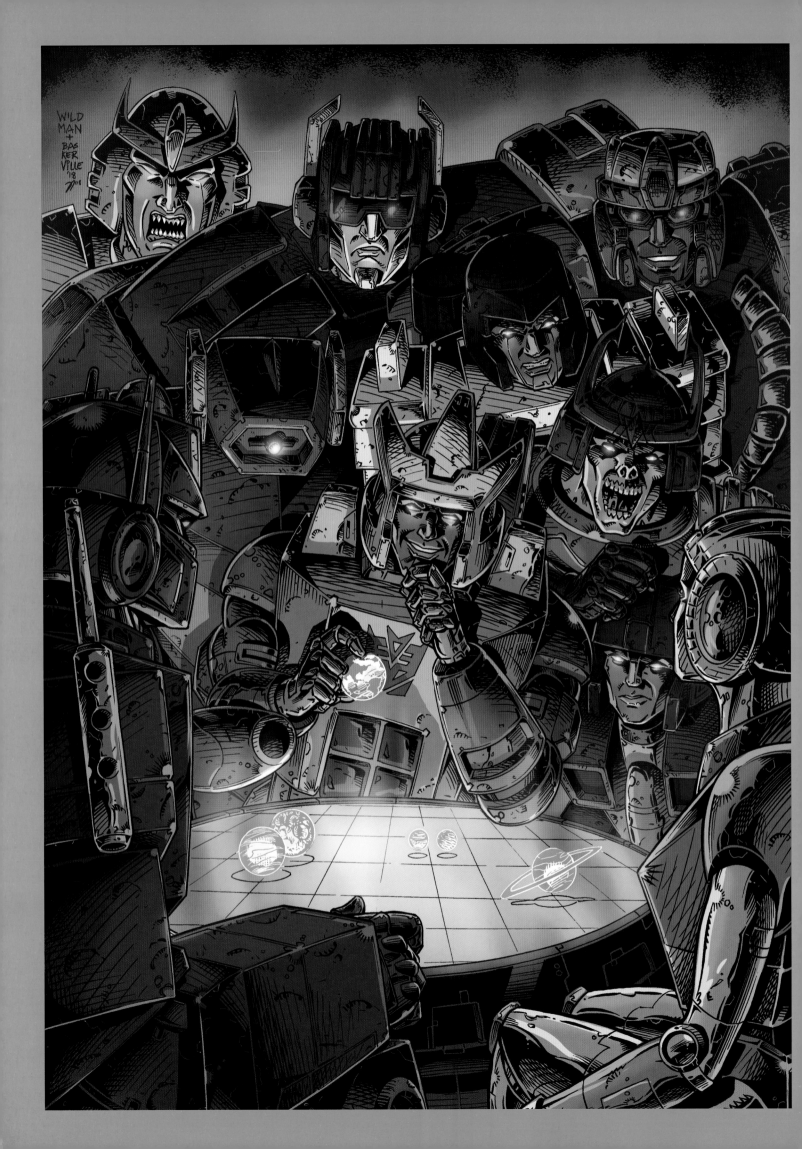

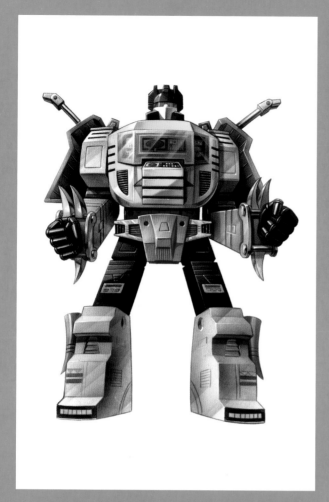

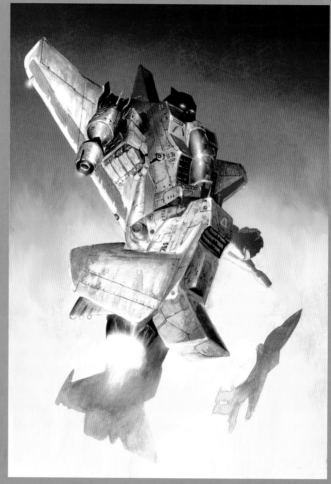

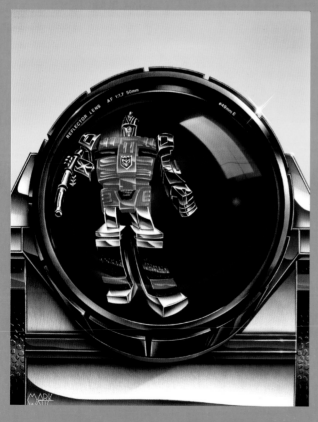

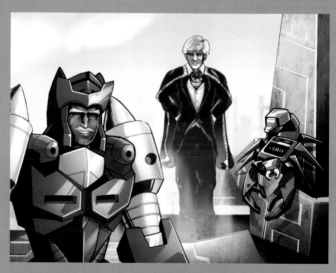

Opposite: High Stakes (revised), Botcon 1997 promotional art, 3H Productions | Andrew Wildman, Stephen Baskerville, John-Paul Bove

Clockwise from top left: Vintage advertisement, Grimlock, *The Transformers* | Greg Wingers; Cover art, *Cybertronian: The Unofficial Transformers Recognition Guide* volume 1, Starscream, Antarctic Press | Chris Allen; Ask Vector Prime farewell video artwork, Fun Publications | Jesse Wittenrich; Mail-order flier, Reflector | Mark Watts

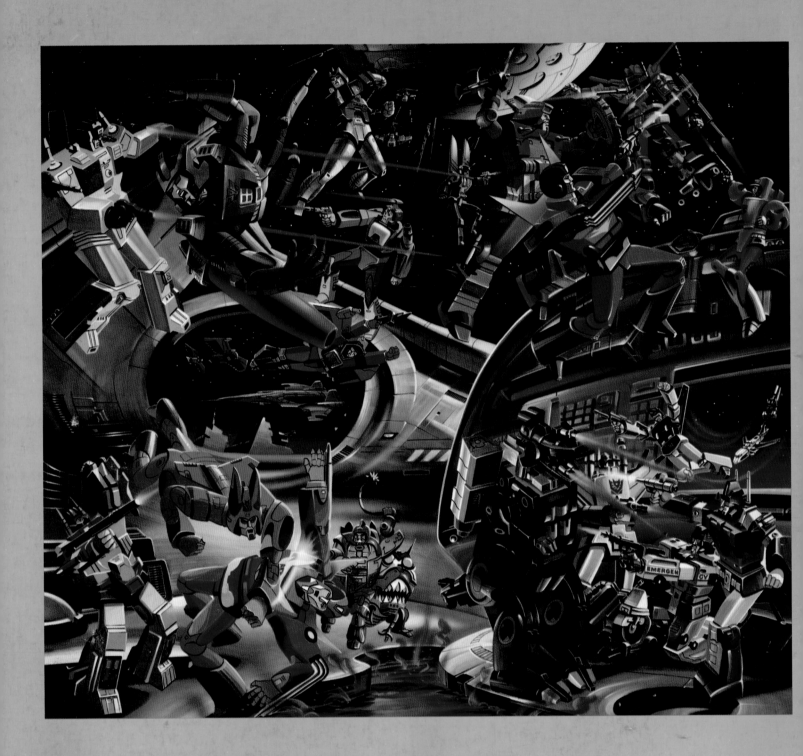

Above: Four-part glow-in-the-dark Decipher the Decepticon sweepstakes poster

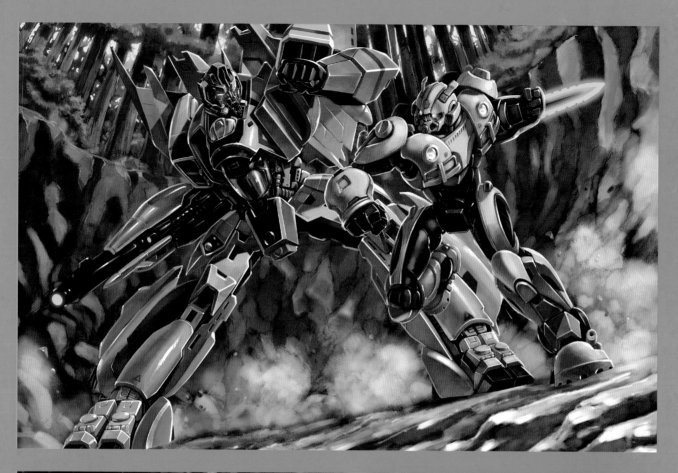

From top: Interior artwork, *Bumblebee: A New Car for Charlie*, Bumblebee vs Blitzwing, Bumblebee | Guido Guidi

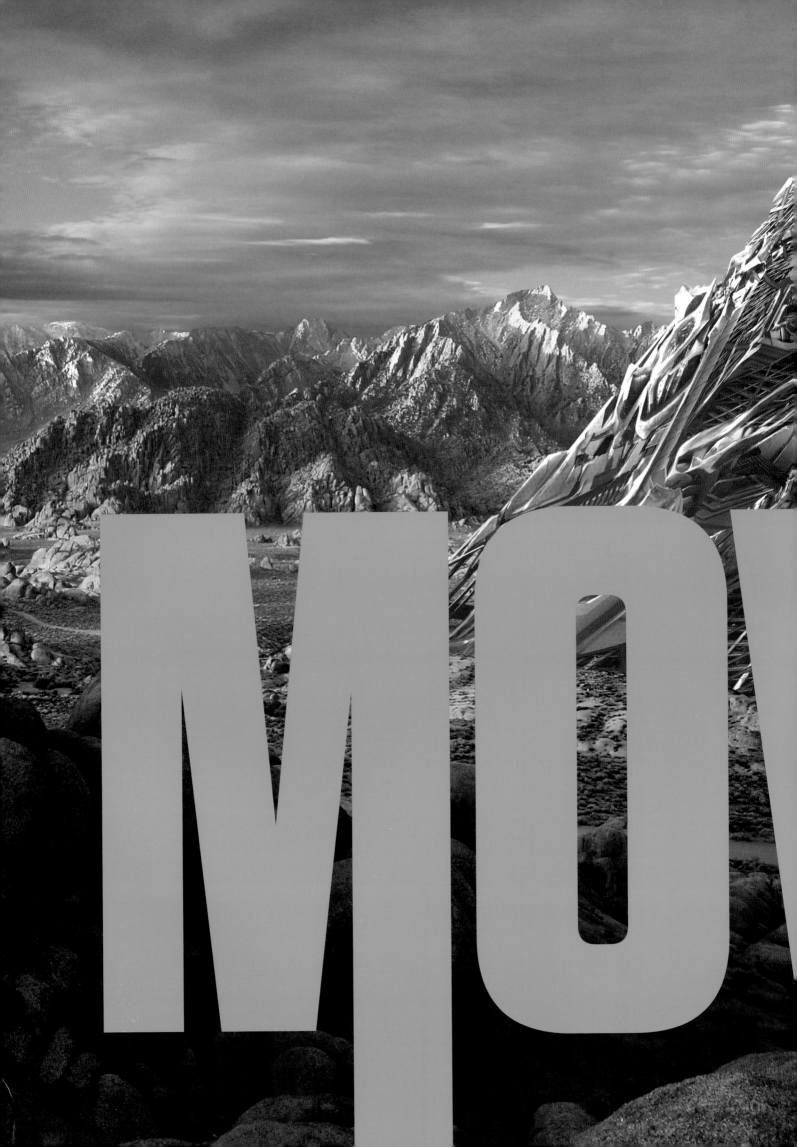

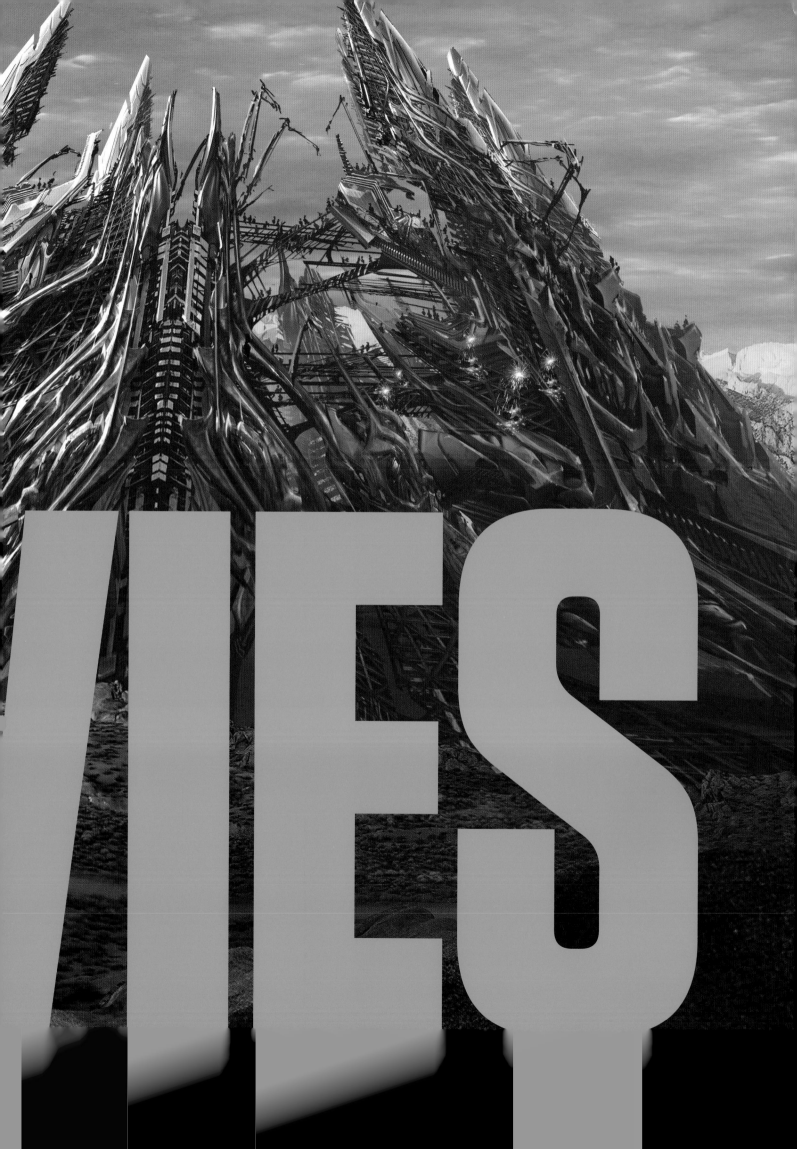

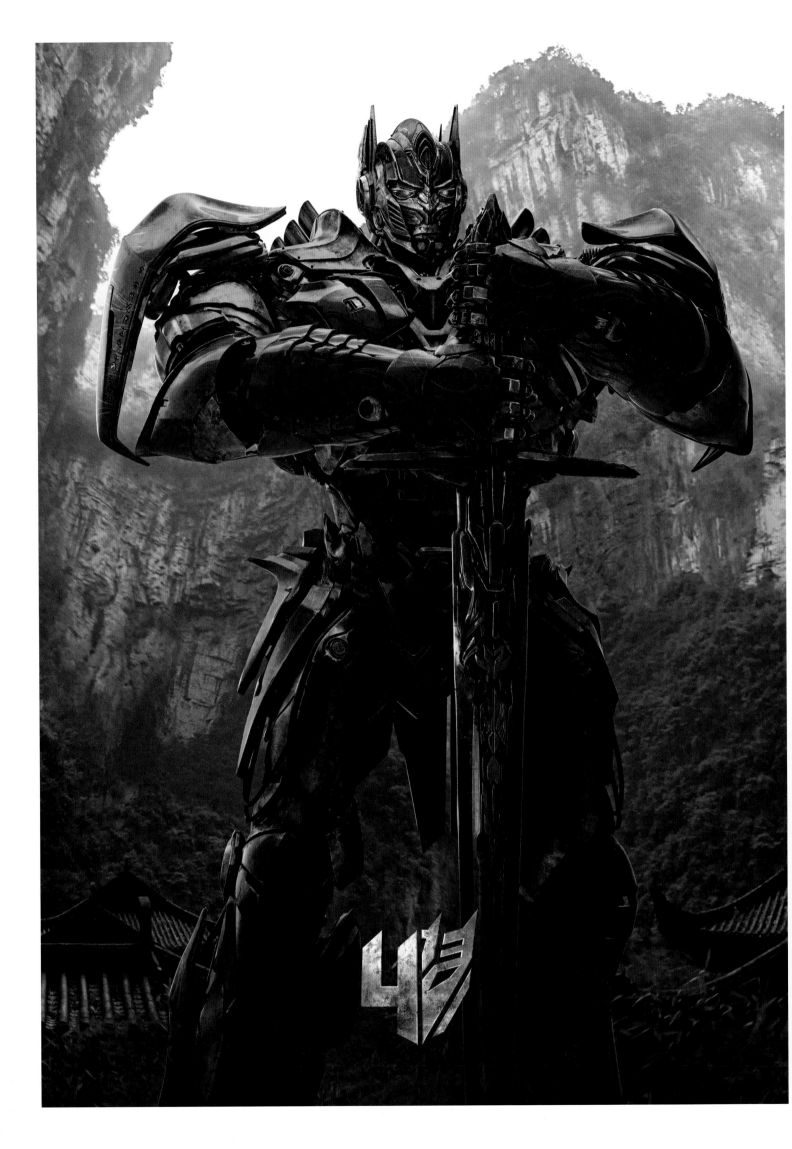

B y the twenty-year mark, the Transformers brand had conquered many frontiers. From toys to comics, from lunchboxes to pajamas, from video games to television, Transformers left a mark virtually everywhere.

Except for the cinema. *The Transformers: The Movie*, while a beloved cornerstone of the Transformers fandom, had been a commercial failure back in 1986. Aside from a pair of one-day-only Japanese *Beast Wars* limited theatrical releases, that had been it for film. But that was fated to change.

Though Transformers had been an enormous brand in the '80s, in the '90s it had struggled to find its footing. *Beast Wars* had been a hit, but its sequel series *Beast Machines* had failed to maintain that growth. The *Unicron Trilogy* (individually *Armada*, *Energon*, and *Cybertron*) provided a course correction for the franchise. Its return to vehicles, core characters, and line-wide gimmicks was a huge success, proving that Transformers could be a brand with a solid upward trajectory. All of that was a necessary prerequisite if Hasbro was to make a serious bid to transition to the realm of live-action films. "We had to make a tasty menu for Hollywood to want to sit at our table," quipped Aaron Archer, Hasbro's then-vice president of intellectual property development.

Their earliest serious meetings were in 2003, when Hasbro put out the call for rough movie treatments. Half a dozen were reviewed, and ultimately Hasbro went with producers Tom DeSanto and Don Murphy. They shopped the idea to all of the major studios, but everywhere the same questions were asked. "Do the robots talk? Are we talking an animated feature? Isn't Transformers for kids? Is this going to be like *Toy Story*?" Fundamentally, the studios didn't understand the property.

Enter Lorenzo di Bonaventura, former president of worldwide production at Warner Bros. He had been working with Hasbro on the G.I. Joe property, and immediately saw the potential of the Transformers brand. It was di Bonaventura who helped get Steven Spielberg interested in the project. Spielberg had a long and positive association with Hasbro, going back to the days of the 1980s *Indiana Jones* toys, and more recently the *Jurassic Park* merchandising. Even better, he knew of Transformers through his kids, and became an enthusiastic advocate for the franchise.

Once Steven Spielberg was involved, pieces began falling into place. He brought writers Alex Kurtzman and Roberto Orci on board to tell the story of "a boy and his car." He also brought in Michael Bay as director, who famously dismissed the concept as a "stupid toy movie" before relenting for the chance to work with the legendary Spielberg.

After a year, the project was starting to take shape. One cold morning in May 2004, in Providence, R.I., members of the Transformers brand team and the Hasbro board gathered in secret. A private jet arrived, with Bay, Kurtzman, Murphy, DeSanto, and other Dreamworks executives on board. All had expressed an interest, none were 100 percent sold.

To answer their questions and assuage any doubts, Hasbro had put together a document they called "Transformers 101," covering the basics of the franchise. Things that seem obvious in retrospect—Transformers are alive, not piloted mechs; the film should revolve around the established mythology of alien robots coming to Earth, rather than toys that come to life— were at the time anything but.

Hasbro also needed to excite these accomplished storytellers, to sell them on the magic. The challenge was overcoming the perception that Transformers was "that thing from the '80s." With footage from their various endeavors over the years, and videos from the official convention BotCon showcasing a rabid and evangelical fanbase, Hasbro demonstrated that Transformers was current, still hip, *relevant*. The excellent Q Scores (an abstract measure of brand popularity) of the Autobot and Decepticon symbols didn't hurt either. Incredibly, "Transformers 101" worked. After the meeting, all agreed that Transformers could be a viable film property. Production began in earnest, and it got big *fast*.

Adapting existing brands for a theatrical release is always a hit-or-miss proposition. The filmmakers have to balance the expectations of the current fans—otherwise, why adapt in the first place—with the need to appeal to new markets. The essence of what makes the property special needs to be distilled down, compressing what might be years or even decades of canon into a run time

Previous: Development art, *Transformers: Revenge of the Fallen* | Ryan Church
Opposite: Theatrical poster, *Transformers: Age of Extinction*

of a mere two to three hours. But the creators also need to weigh the strengths of the new medium; a live-action film is not a 22-minute cartoon, nor is it a 120-page trade paperback. What works in one format won't necessarily translate to another.

The *Transformers* film franchise navigates these myriad concerns and makes it appear effortless. Steven Spielberg's influence comes through strongly, especially in the first film. There is a palpable sense of wonder and terror among the human cast, allowing us as the audience to experience an ever-deepening feeling of reverence. Yes, massive alien robots can walk among us. Yes, massive alien robots can *hide* among us.

This was not an element that was played up in previous Transformers media. In the various cartoons, humans quickly seem to accept the idea of friendly Autobots. Indeed, the adolescents who serve as guides and companions to the Autobots seem almost blasé about their relationship. Contrast to Shia LeBeouf's Sam Witwicky, whose name was drawn from Buster and Spike Witwicky from the 1984 comics and cartoon, respectively. He never lets you forget the strange majesty of these gigantic alien beings, and through his eyes we see the robots anew. Truly, the Transformers franchise had grown up.

With the blockbuster success of the first film, it seemed inevitable that sequels would arrive, and so they did. Each movie was larger than the last. Perhaps inevitably, the films grew to encompass their own themes and identity separate and apart from what had come before. Each of the films concerns itself with history, from 19th-century ship captains to the moon landing to ancient Egypt to World War II to the Cretaceous period to the days of Arthurian legend. The US military is always front and center. A sense of mildly transgressive humor permeates the films as well. All of these elements and more help distinguish the movie iteration of Transformers from the various comic and cartoon offerings in terms of plot, story, and theme.

Aesthetically, the film franchise stands alone among all the myriad iterations of Transformers. Detail is the name of the game, and delivered at a fractal level where no matter how close one zooms in there is always more to see. The incredible level of granular design not only looks amazing, but conveys to the audience the sheer scale of these beings. Importantly, it also grounds them in reality. The stark simplicity of the original Generation 1 cartoon designs may look terrific in the context of a cartoon, but standing next to an actor on the big screen such designs would run a serious risk of looking fake.

Other incarnations, showing their toy roots, tend toward a kind of humans-wearing-car-parts-as-armor motif. Not the films! Here, as often as not, the vehicle parts are sliced and diced to the point that, rather than focusing on recognizable bits of cars or jets, the alternate mode provides more of a textural element. So, too, were human silhouettes consciously abandoned. The essential alienness of the robots was emphasized with their strange gaits, inhuman proportions, and heavy use of negative space. These choices, a radical departure from what had gone before, helped immediately and subconsciously convey to a general audience unfamiliar with the lore that these were living beings, rather than programmed automatons. The fan reaction to such a large departure was, at first, mixed, though with time most have come to appreciate the unique and vibrant contribution of the films to the look and feel of the Transformers brand.

And what of Hasbro? Thrilled, obviously, that their partnership has been, and continues to be, so successful for all involved. If there was anything about the exercise that caught them by surprise, it was the primacy of the films. It was quickly apparent that the Transformers movies would be a huge triumph, a rising tide that would lift all Transformers boats; what was less obvious would be just how overwhelming that triumph would prove. Prior to the Transformers' cinematic offerings, Generation 1 was undoubtedly the beating heart of the brand. Everything that followed seemed to be a continuation, or a retelling, of that part of the franchise. But the movies changed all of that. Suddenly future offerings were expected to be more in line with the films—hence, the more realistic tone and voiceless Bumblebee of *Transformers Prime* and the Shakespearean undertones of *War for Cybertron*. Whatever tomorrow holds for Transformers, the films will undoubtedly continue to be impressive and original creative endeavors.

> ## THIS IS NOT YOUR GRANDMA'S TRANSFORMERS AT ALL.
>
> Ben Proctor, Lead Robot Designer, Transformer 1–4

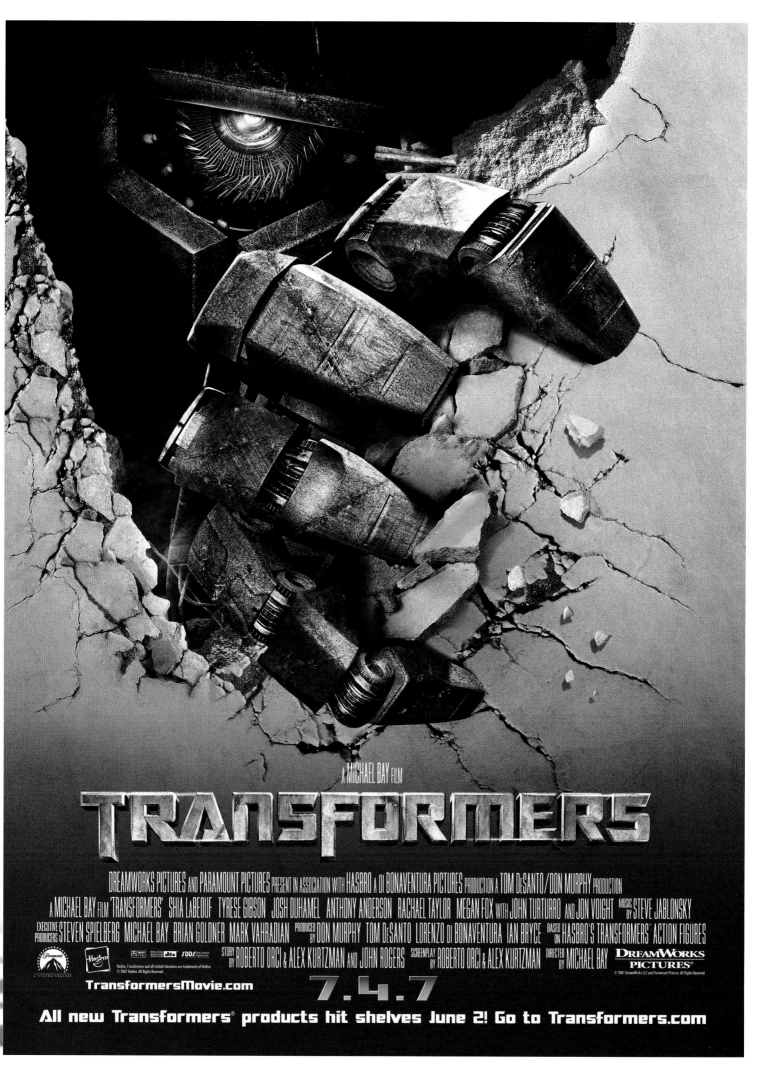

Above: Theatrical poster, *Transformers*

Above: Character renders, Bumblebee vs. Barricade, *Transformers*

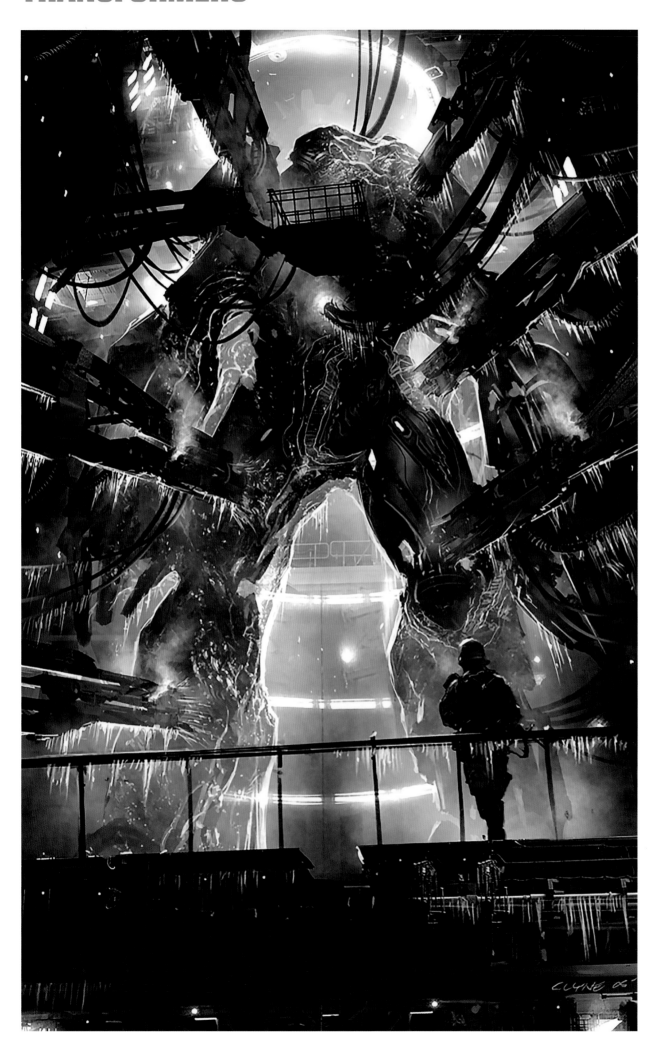

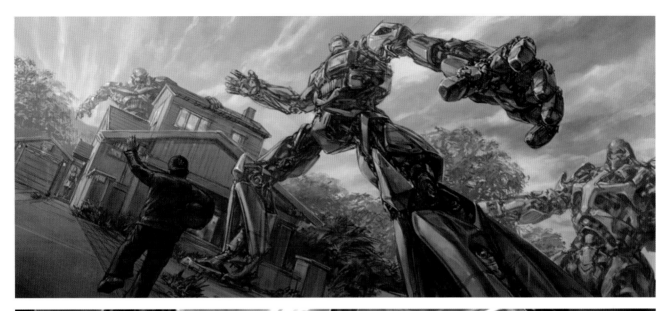

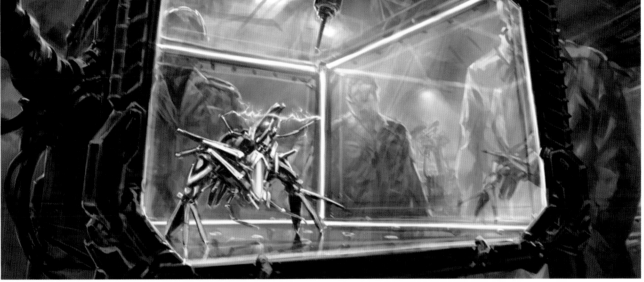

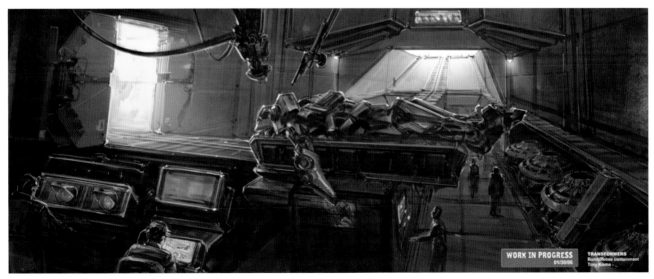

Opposite: Development art, The Ice Man, *Transformers* | James Clyne

Top: Development art, Witwicky house, Transformers

Middle: Development art, Nokiabot comes to life, *Transformers*

Bottom: Development art, Bumblebee containment, *Transformers* | Tony Kieme

"The Ice Man was the one piece that kicked off the entire art department for us. It galvanized the look of that whole set and the feel of everything. James Clyne really took the robot designs and put them into a setting that was like, WOW, that's it!" — Paul Ozzimo

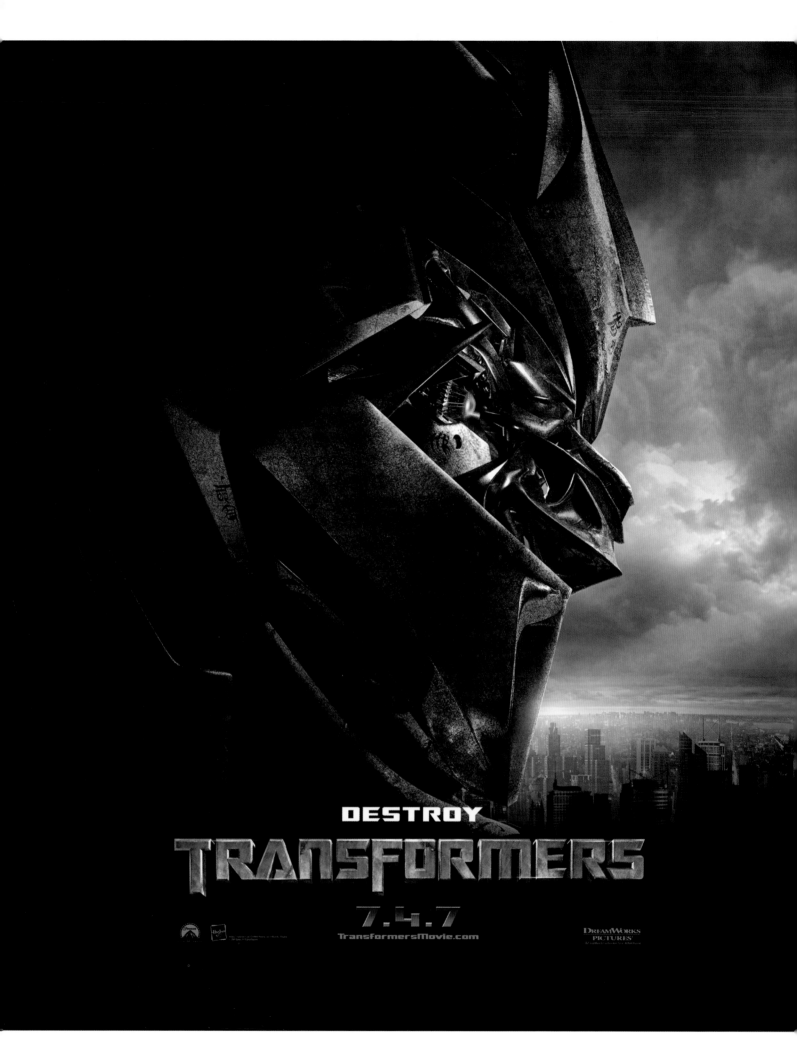

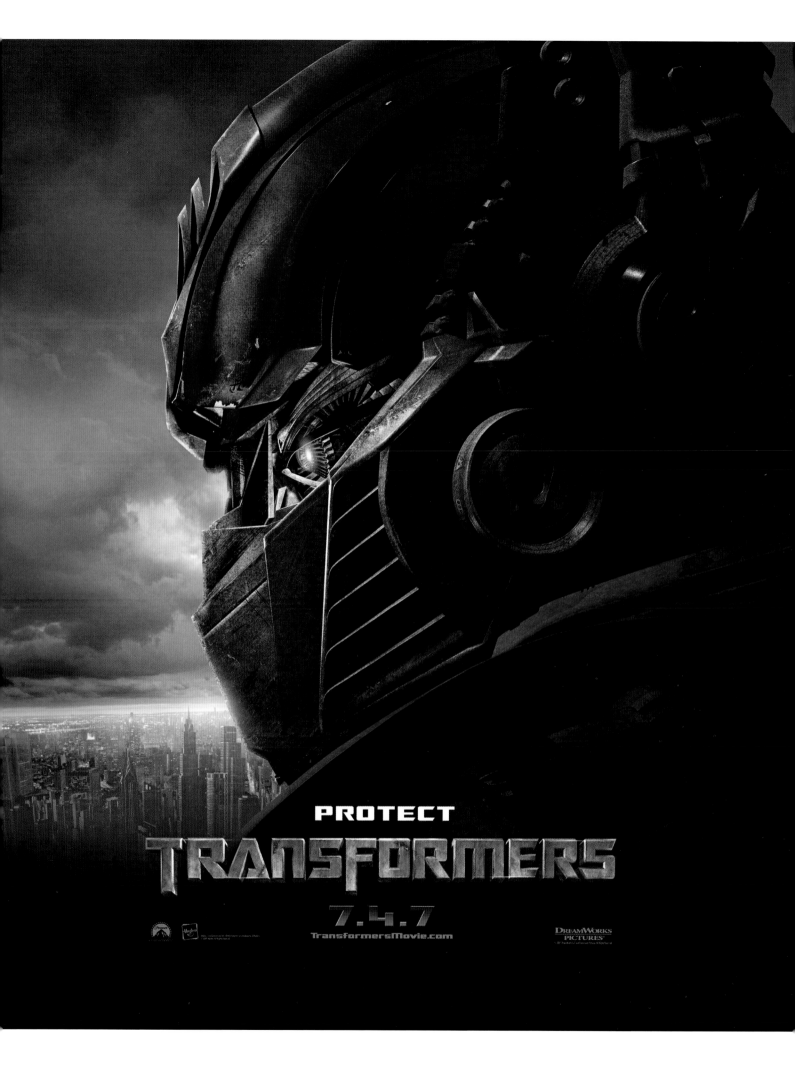

Above: Theatrical posters, *Transformers*

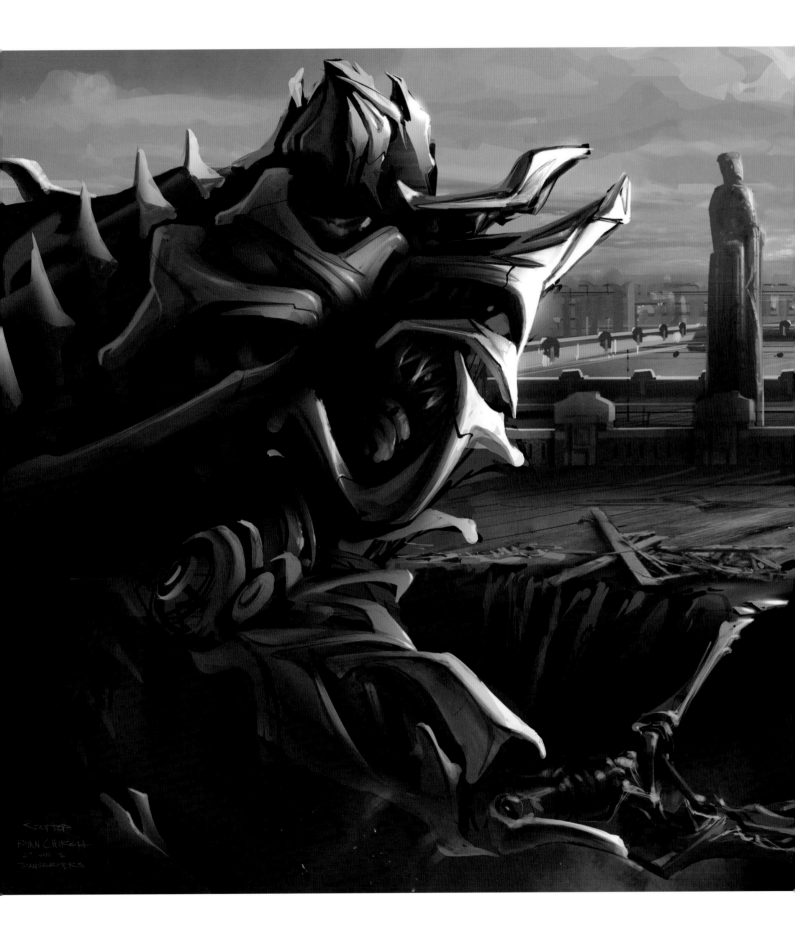

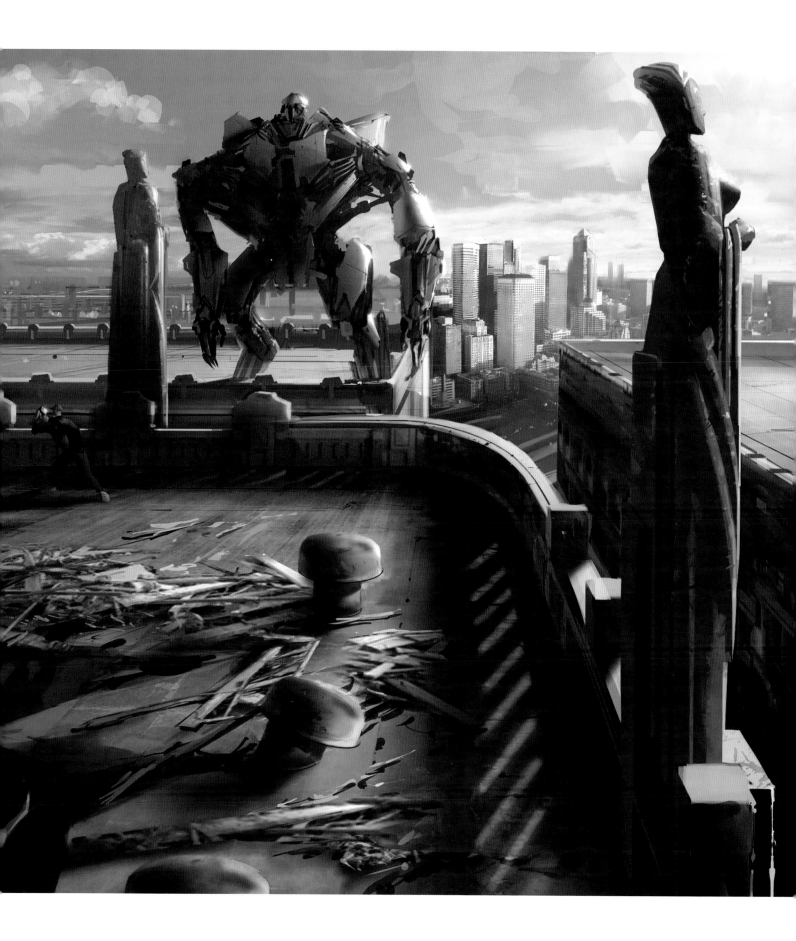

Above: Development art, Rooftop, *Transformers* | Ryan Church

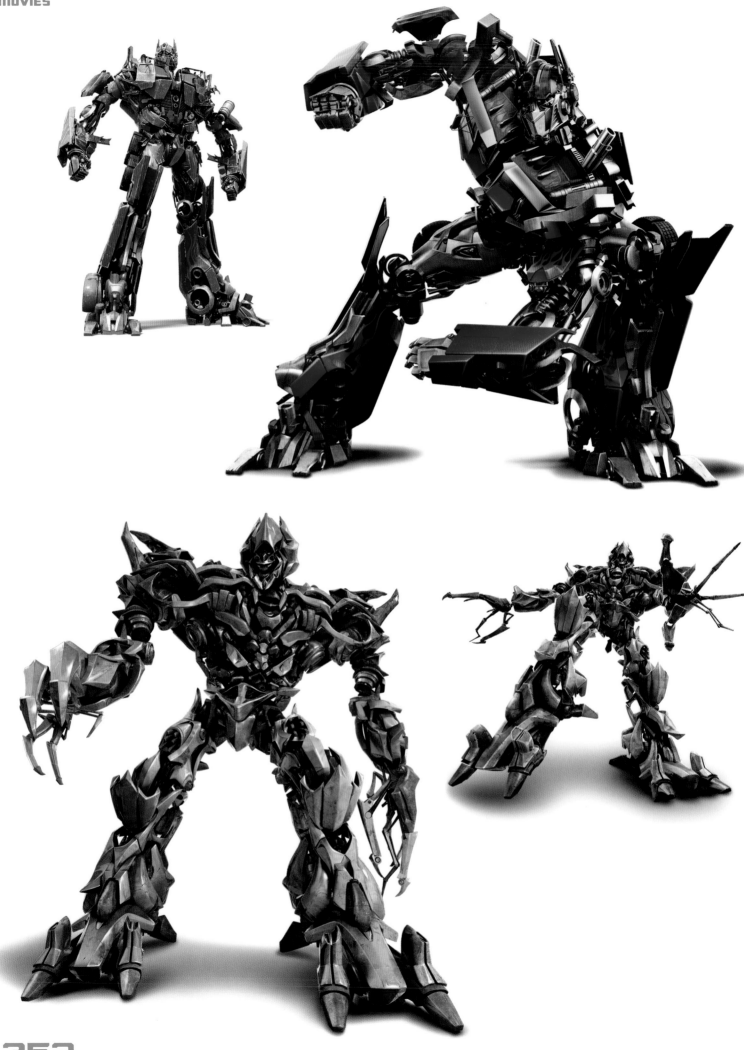

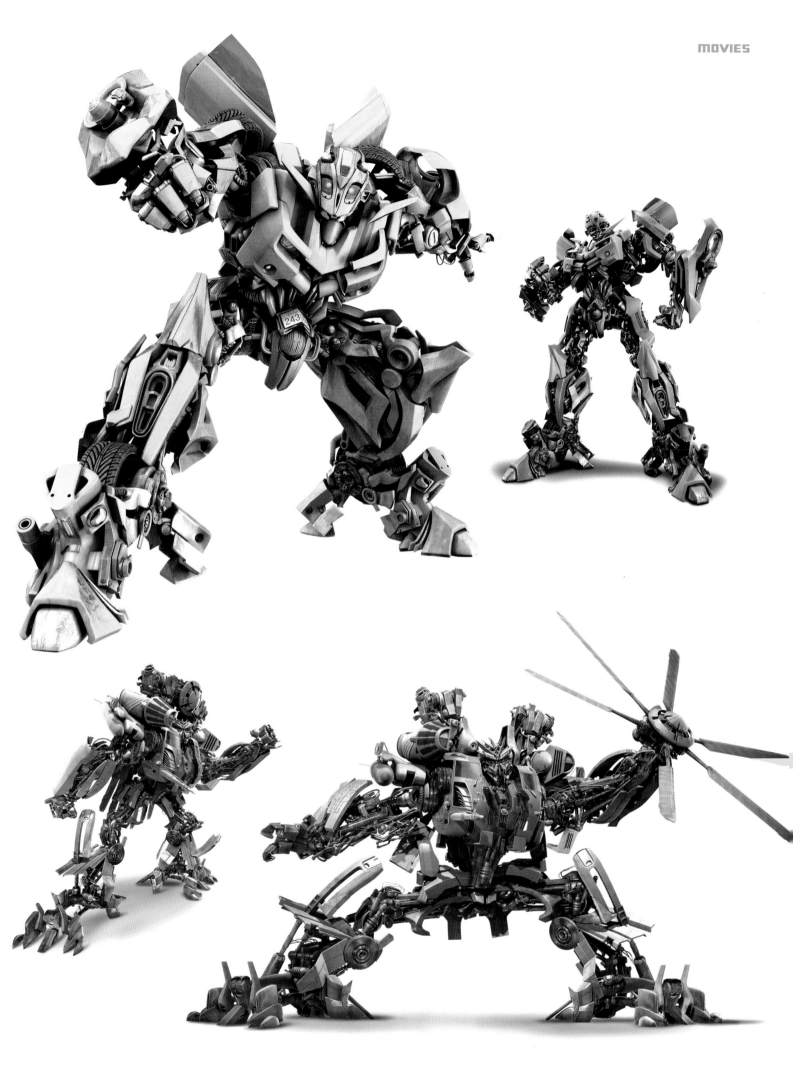

These pages, clockwise from top left: Character renders: Optimus Prime, Bumblebee, Blackout, and Megatron, *Transformers*

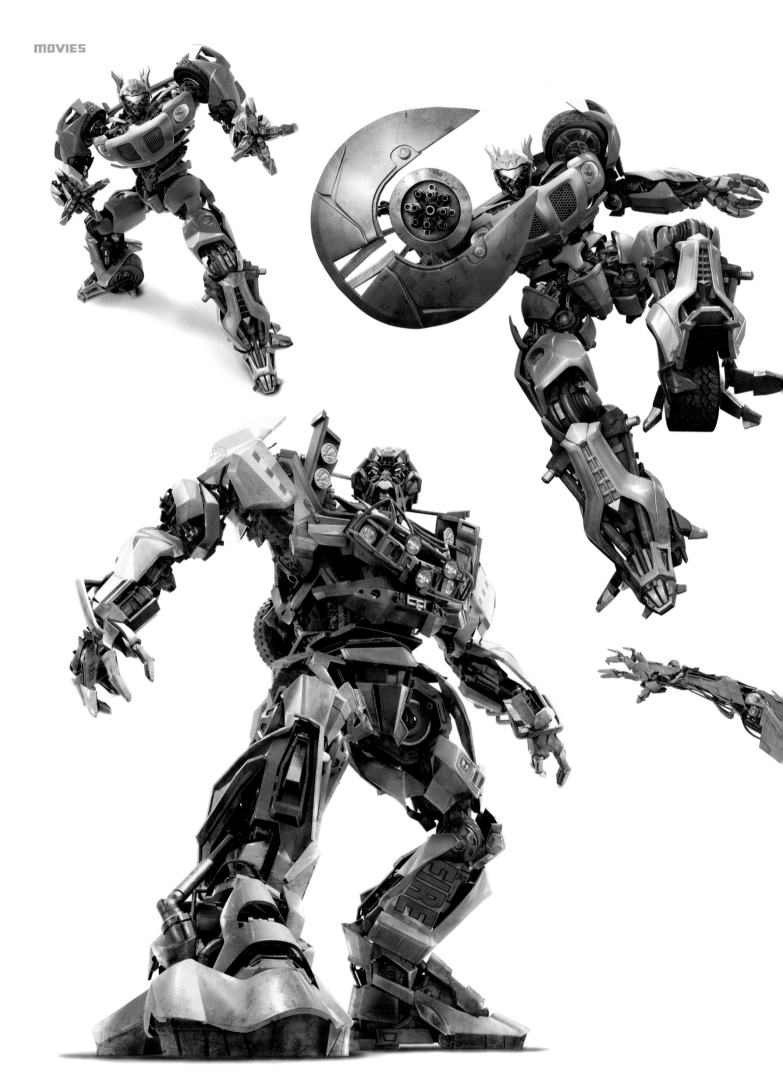

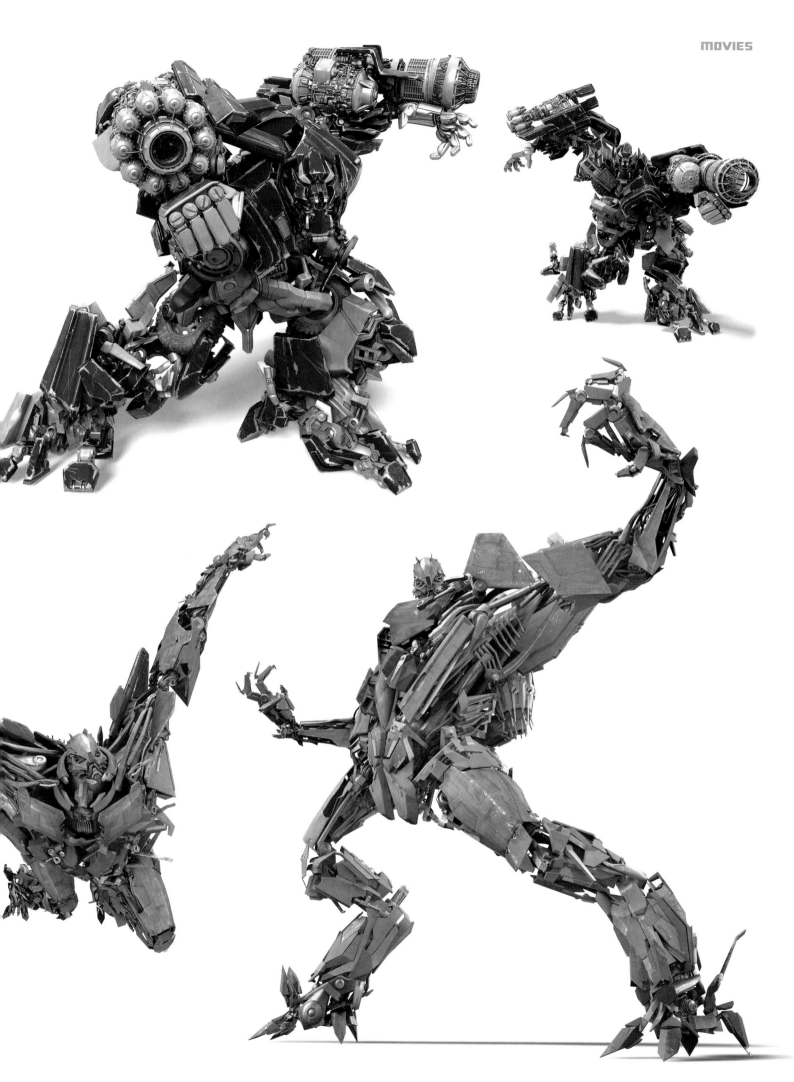

These pages, clockwise from top left: Character renders: Jazz, Ironhide, Starscream, Ratchet, *Transformers*

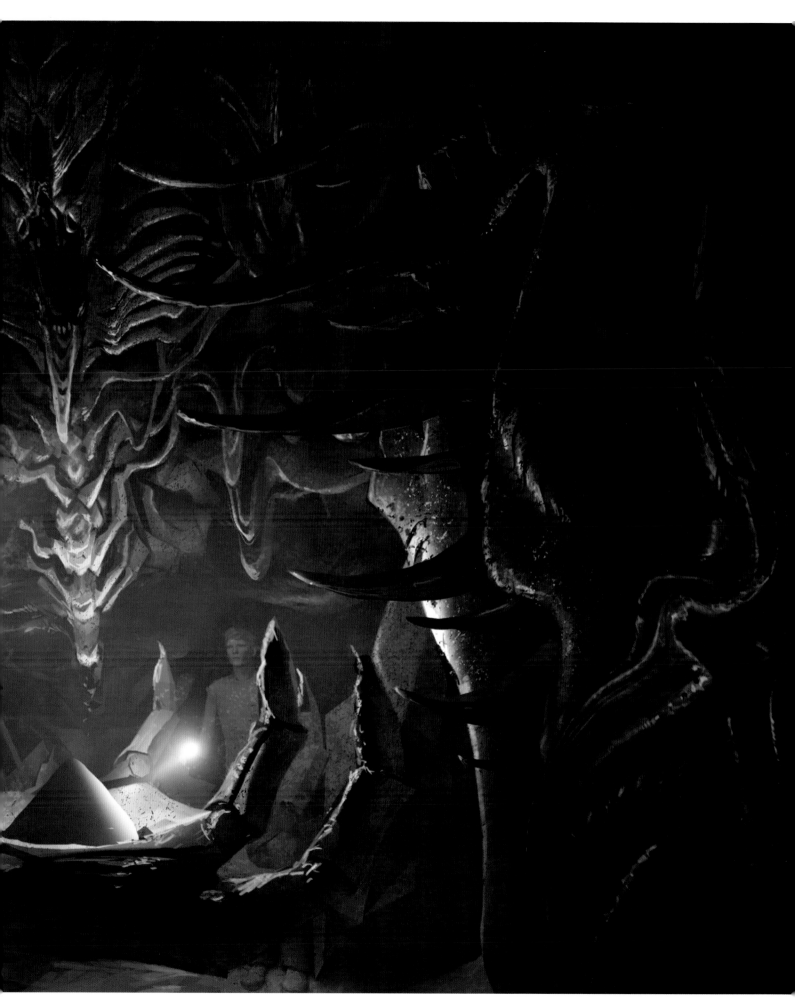

Above: Development art, Tomb of the Primes, *Transformers: Revenge of the Fallen*

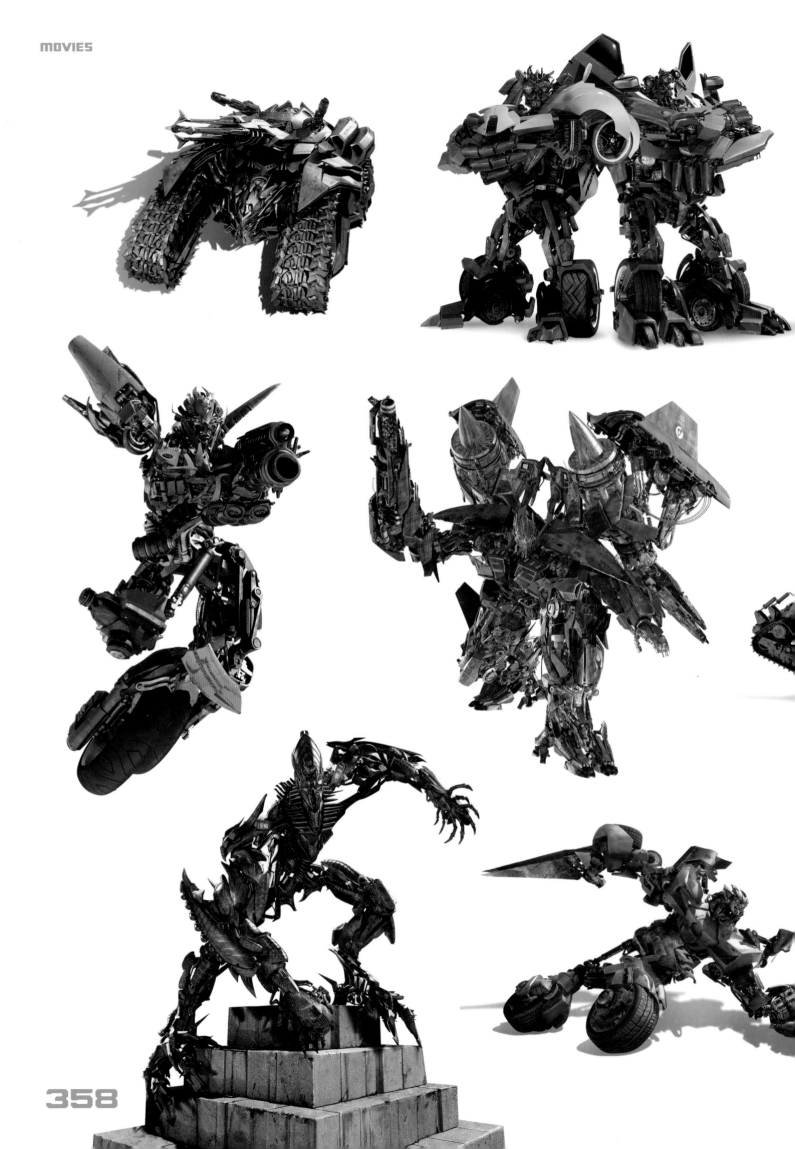

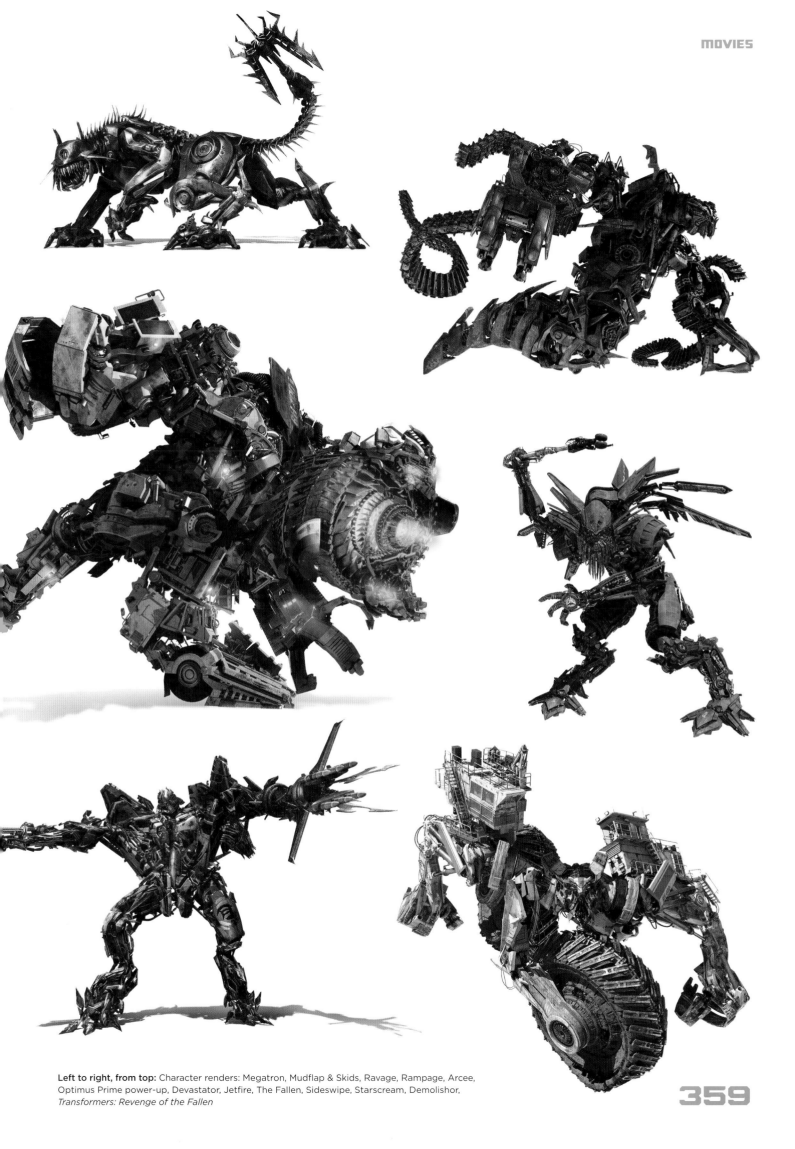

Left to right, from top: Character renders: Megatron, Mudflap & Skids, Ravage, Rampage, Arcee, Optimus Prime power-up, Devastator, Jetfire, The Fallen, Sideswipe, Starscream, Demolishor, *Transformers: Revenge of the Fallen*

359

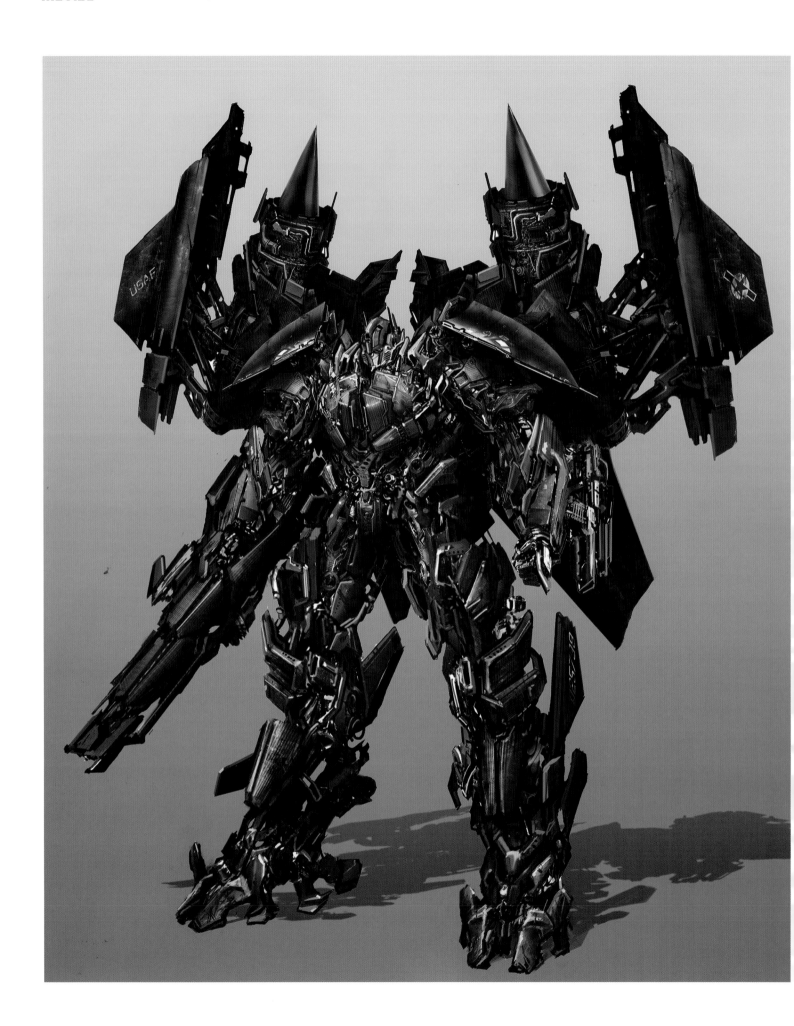

Above: Development art, Optimus Prime, *Transformers: Revenge of the Fallen* | Josh Nizzi

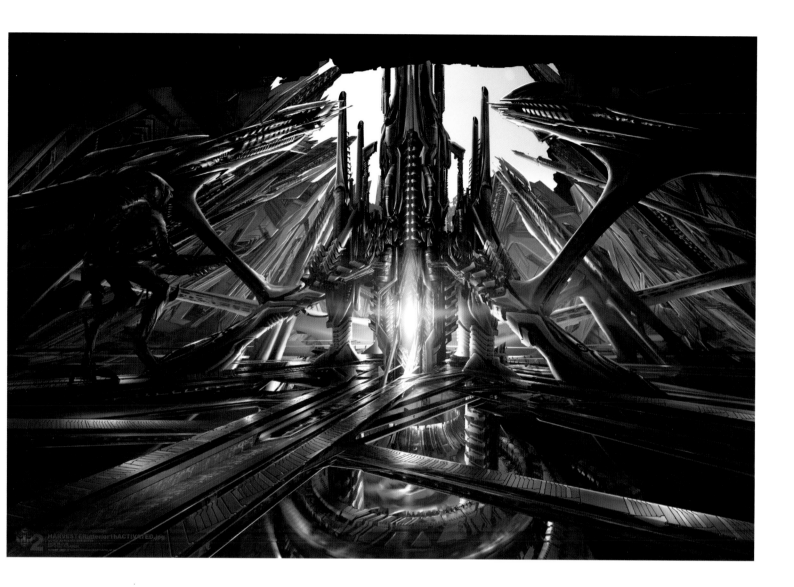

Above: Development art, Star Harvester, *Transformers: Revenge of the Fallen* | Ryan Church

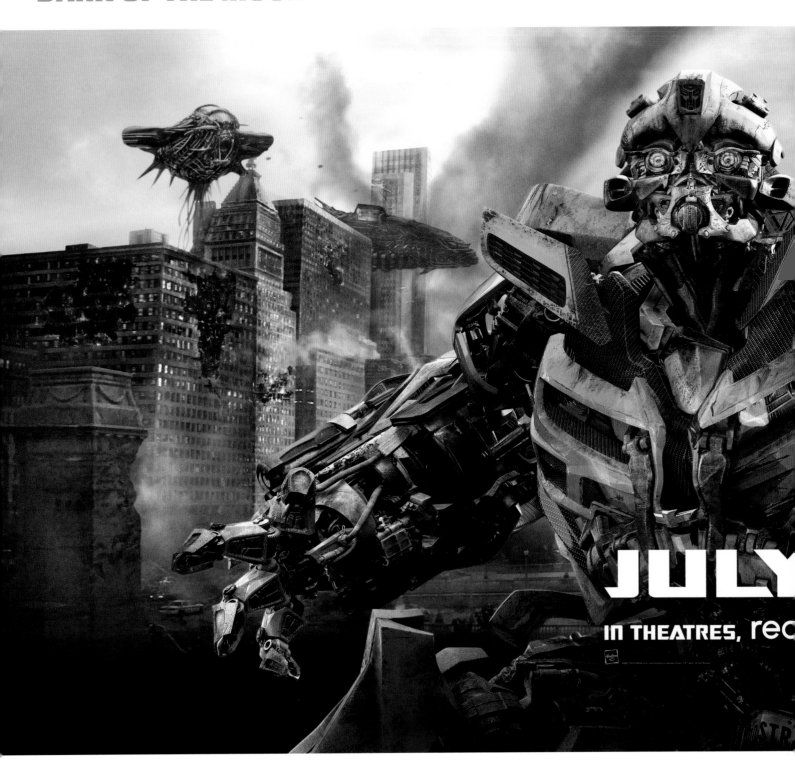

JULY

IN THEATRES, rea

in 3D

AND IMAX 3D

ie.com

Above: Theatrical poster, *Transformers: Dark of the Moon*

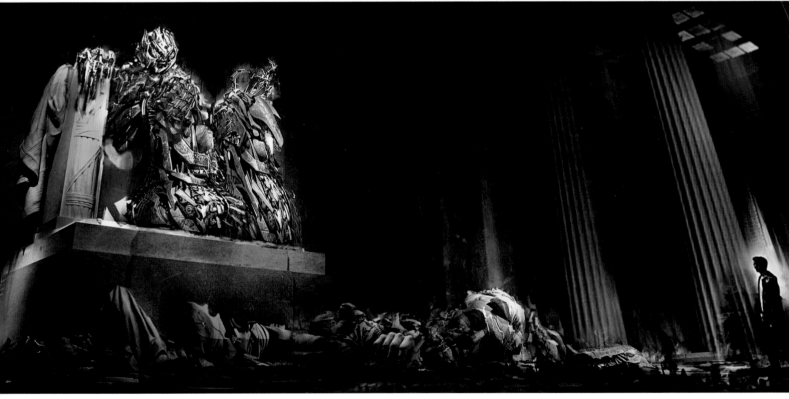

Top: Development art, The Ark crashed on the Moon, *Transformers: Dark of the Moon*
Above: Development art, Megatron at the Lincoln Memorial, *Transformers: Dark of the Moon*

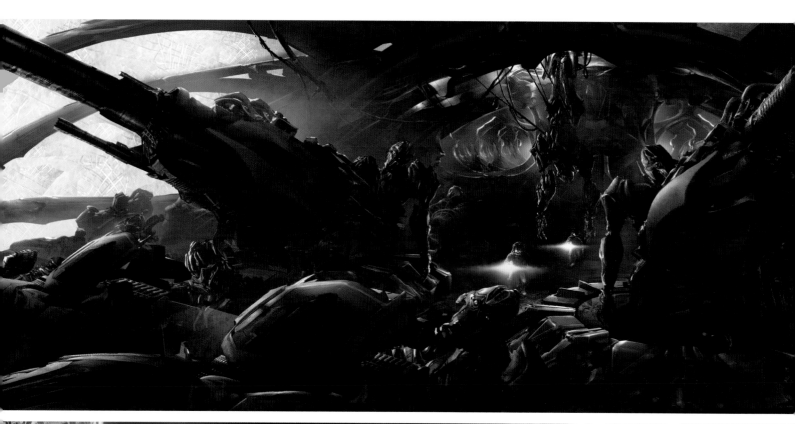

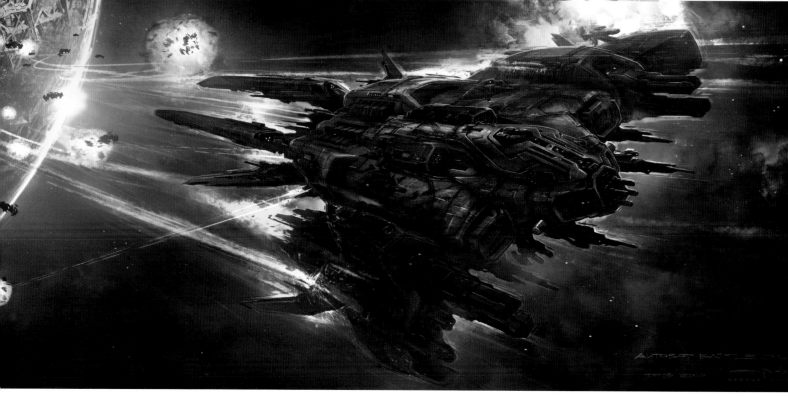

Top: Development art, The Ark interior, *Transformers: Dark of the Moon*

Above: Development art, The Ark departs Cybertron, *Transformers: Dark of the Moon*

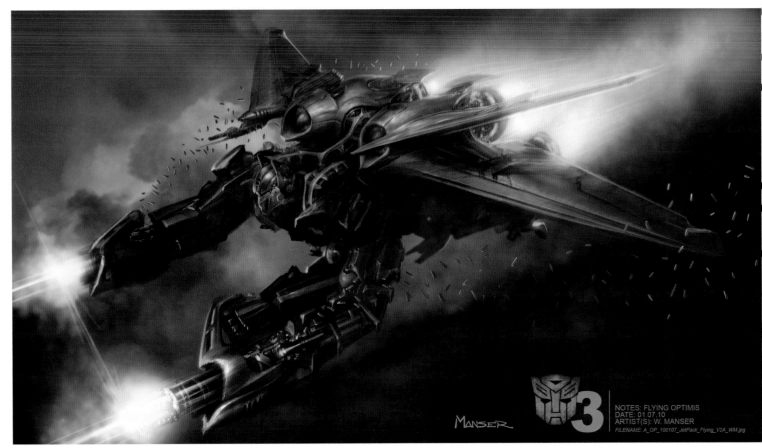

NOTES: FLYING OPTIMIS
DATE: 01.07.10
ARTIST(S): W. MANSER
FILENAME: A_OP_100107_JetPack_Flying_V2A_WM.jpg

MANSER

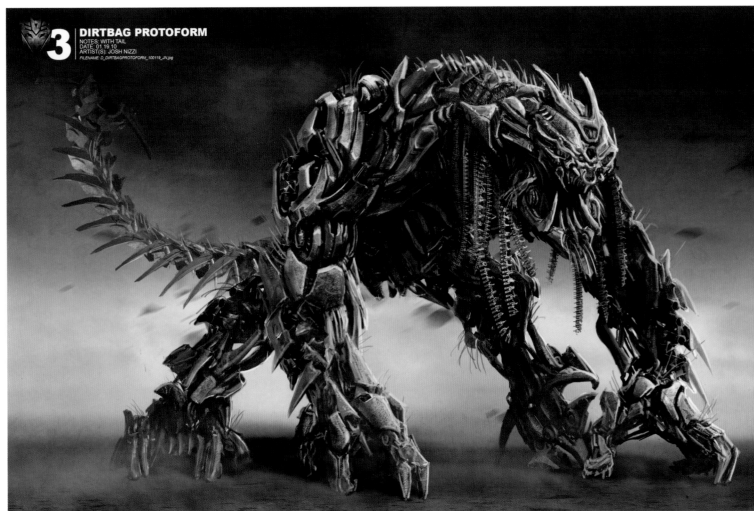

3 | DIRTBAG PROTOFORM
NOTES: WITH TAIL
DATE: 01.19.10
ARTIST(S): JOSH NIZZI
FILENAME: D_DIRTBAGPROTOFORM_100119_JN.jpg

Top: Development art, Flying Optimus Prime, *Transformers: Dark of the Moon* | Warren Manser
Above: Development art, Dirtbag Protoform, *Transformers: Dark of the Moon* | Josh Nizzi

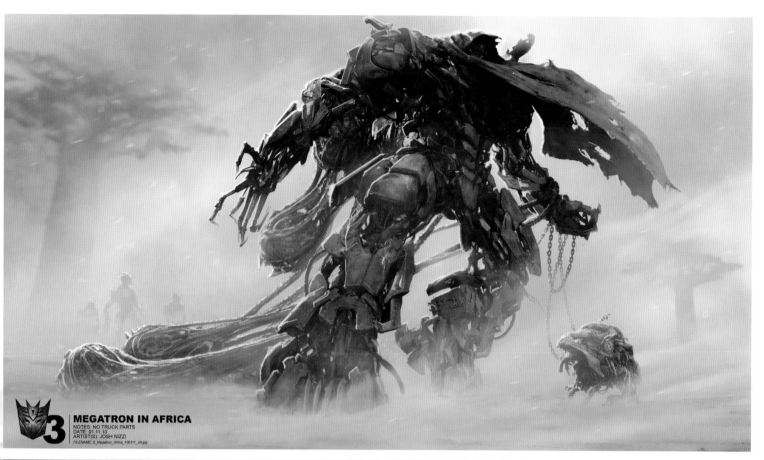

MEGATRON IN AFRICA
NOTES: NO TRUCK PARTS
DATE: 01.11.10
ARTIST(S): JOSH NIZZI
FILENAME: D_Megatron_Africa_100111_JN.jpg

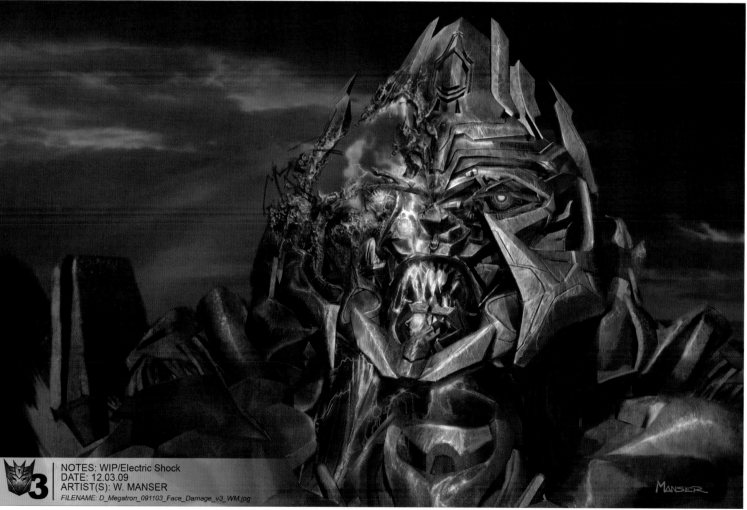

NOTES: WIP/Electric Shock
DATE: 12.03.09
ARTIST(S): W. MANSER
FILENAME: D_Megatron_091103_Face_Damage_v3_WM.jpg

MANSER

Top: Development art, Megatron, *Transformers: Dark of the Moon* | Josh Nizzi
Above: Development art, Megatron, *Transformers: Dark of the Moon* | Warren Manser

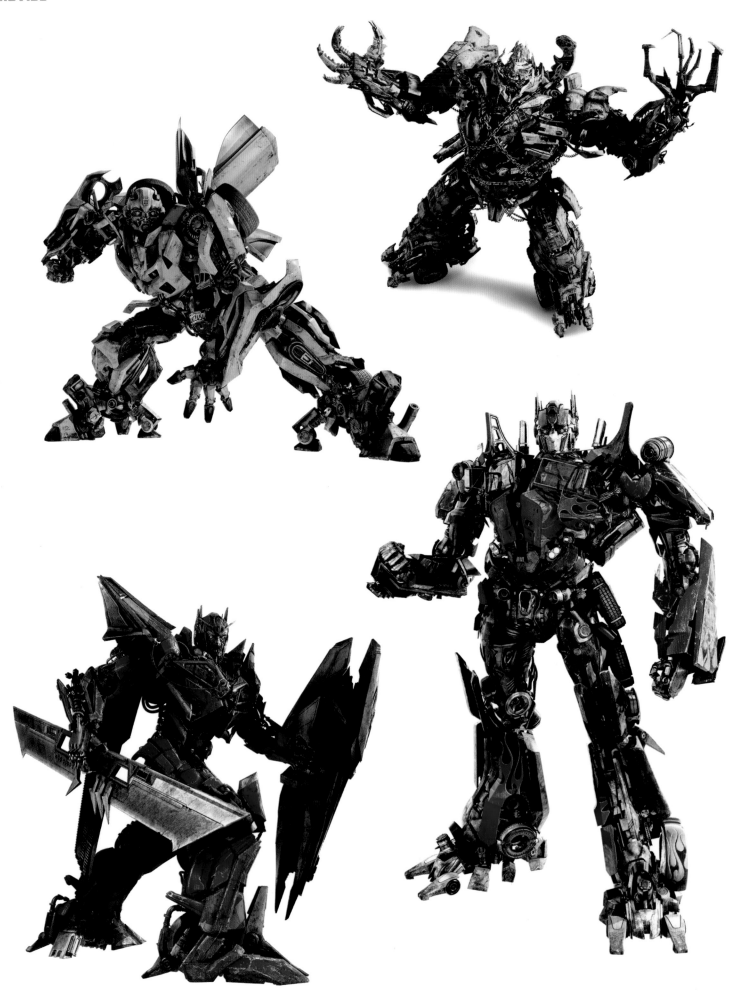

Clockwise from top left: Character renders, Bumblebee, Megatron, Optimus Prime, Sentinel Prime, *Transformers: Dark of the Moon*

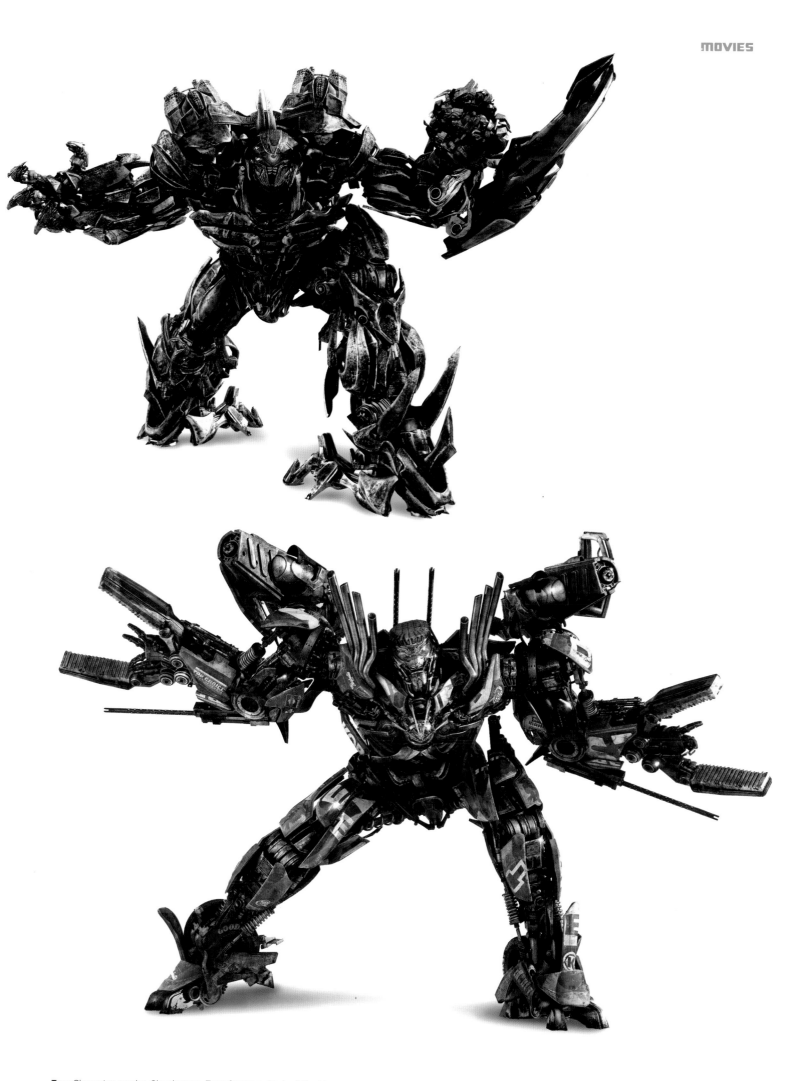

Top: Character render, Shockwave, *Transformers: Dark of the Moon*
Above: Character render, Topspin, *Transformers: Dark of the Moon*

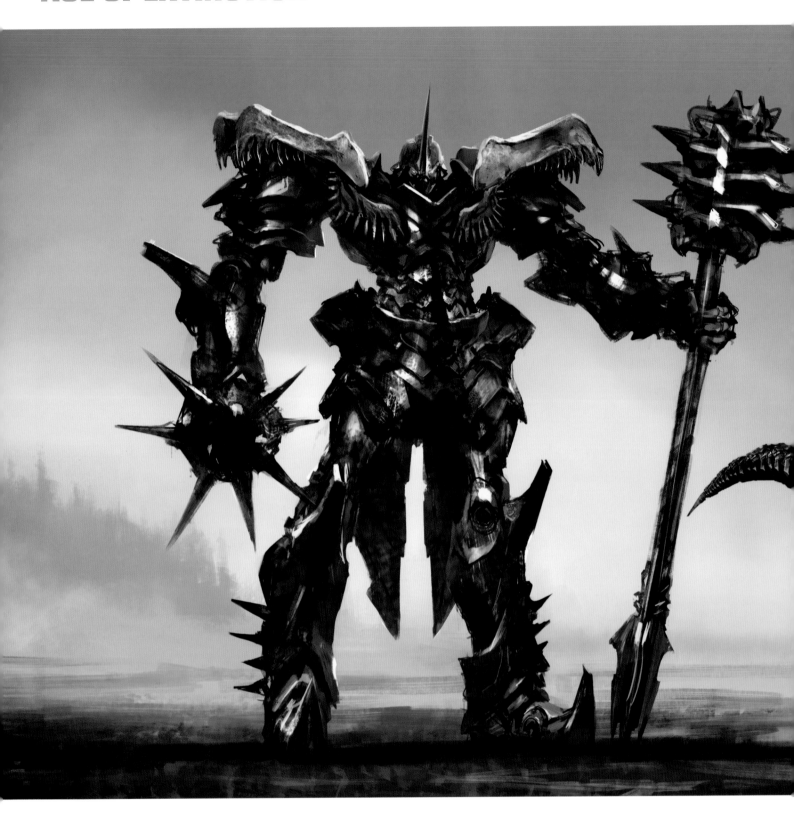

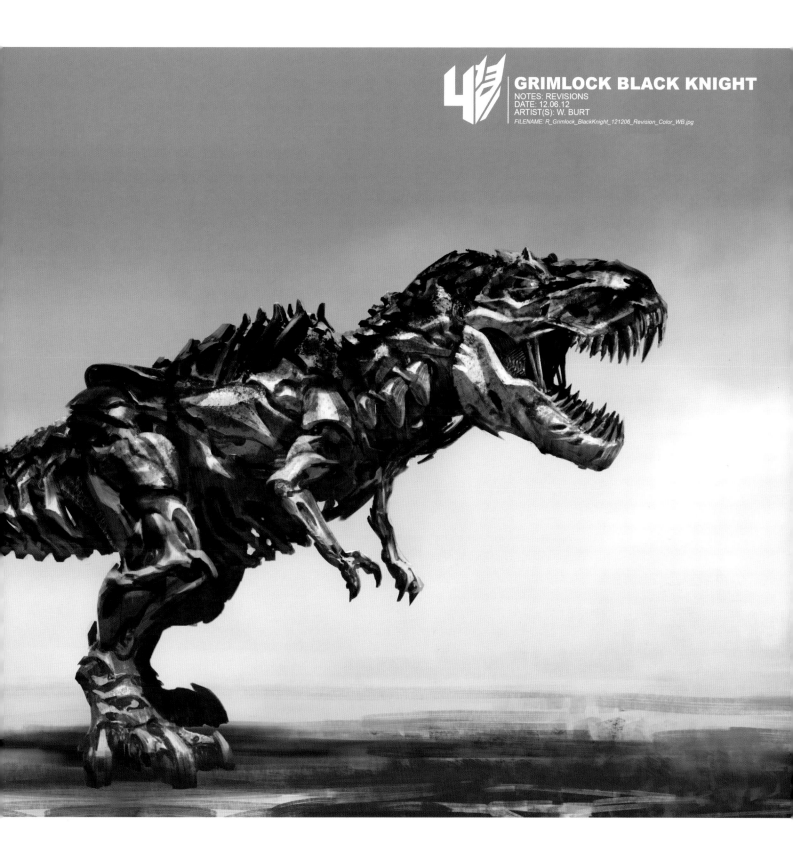

Above: Development art, Grimlock, *Transformers: Age of Extinction* | Wesley Burt & Josh Nizzi

②

④

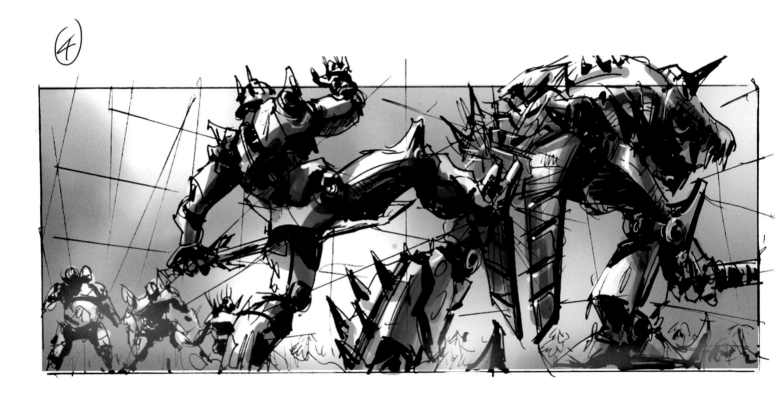

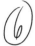

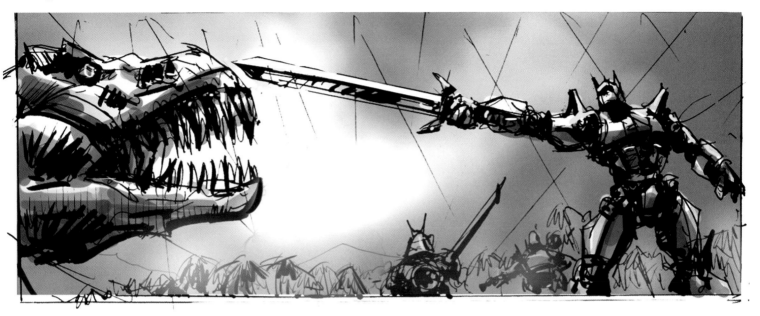

These pages: Sample storyboards, *Transformers: Age of Extinction* | Ed Natividad

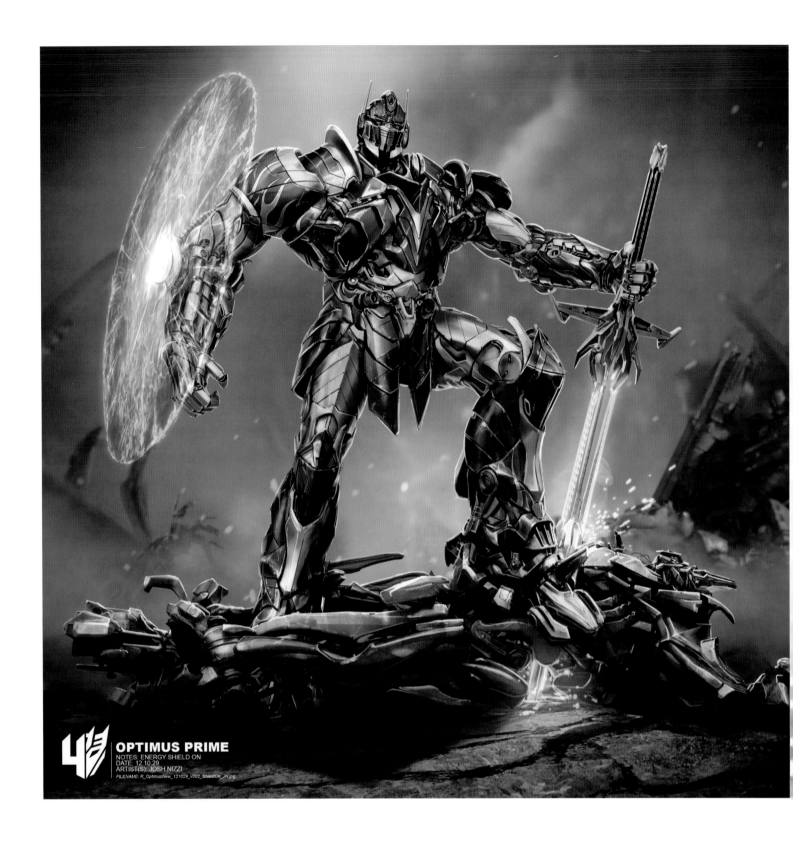

OPTIMUS PRIME
NOTES: ENERGY SHIELD ON
DATE: 12.10.29
ARTIST(S): JOSH NIZZI
FILENAME: R_OptimusNew_121029_v002_ShieldOn_JN.jpg.

Above: Development art, Optimus Prime, *Transformers: Age of Extinction* | Josh Nizzi

"For *Age of Extinction*, Optimus was going to have a new truck mode, more aerodynamic and sleek looking, so we wanted the character design to reflect that. More organic, more humanoid, fewer car parts, and a little more refined overall. This is an athletic, heroic version of Optimus, with a strong knightly influence as well." — Josh Nizzi

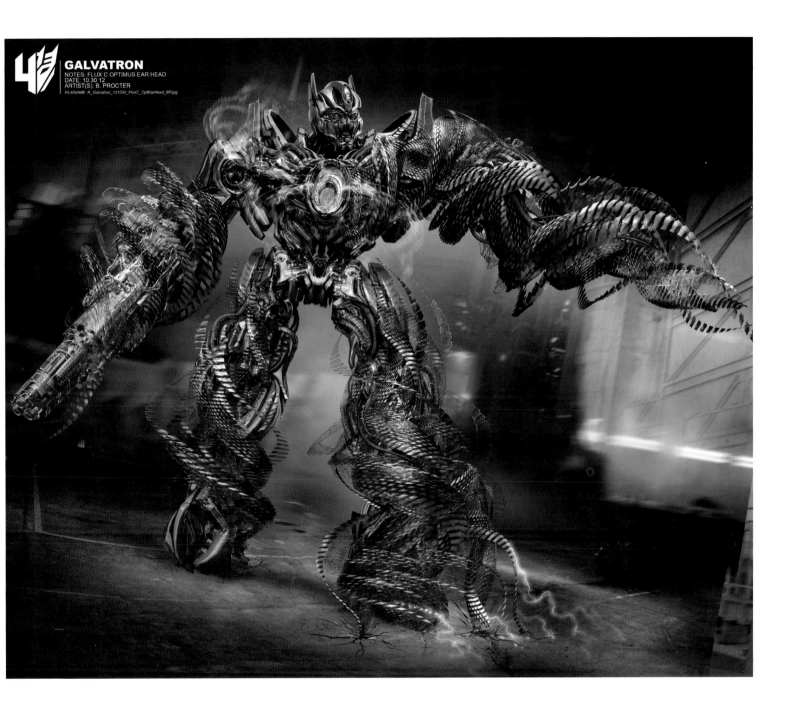

GALVATRON
NOTES: FLUX C OPTIMUS EAR HEAD
DATE: 10.30.12
ARTIST(S): B. PROCTER
FILENAME: R_Galvatron_121030_FluxC_OptEarHead_BP.jpg

Above: Development art, Galvatron, *Transformers: Age of Extinction* | Ben Procter

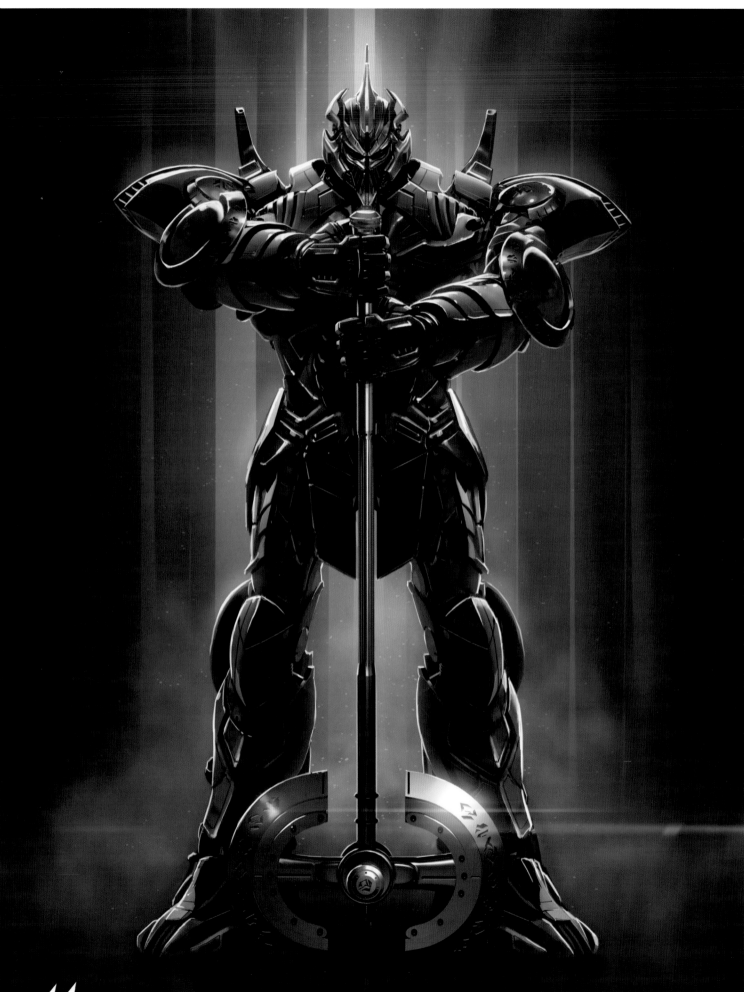

NOTES:
DATE: 12.11.08
ARTIST(S): JOSH NIZZI
FILENAME: R_BlackKnight_121108_v001_JN

BLACK KNIGHT

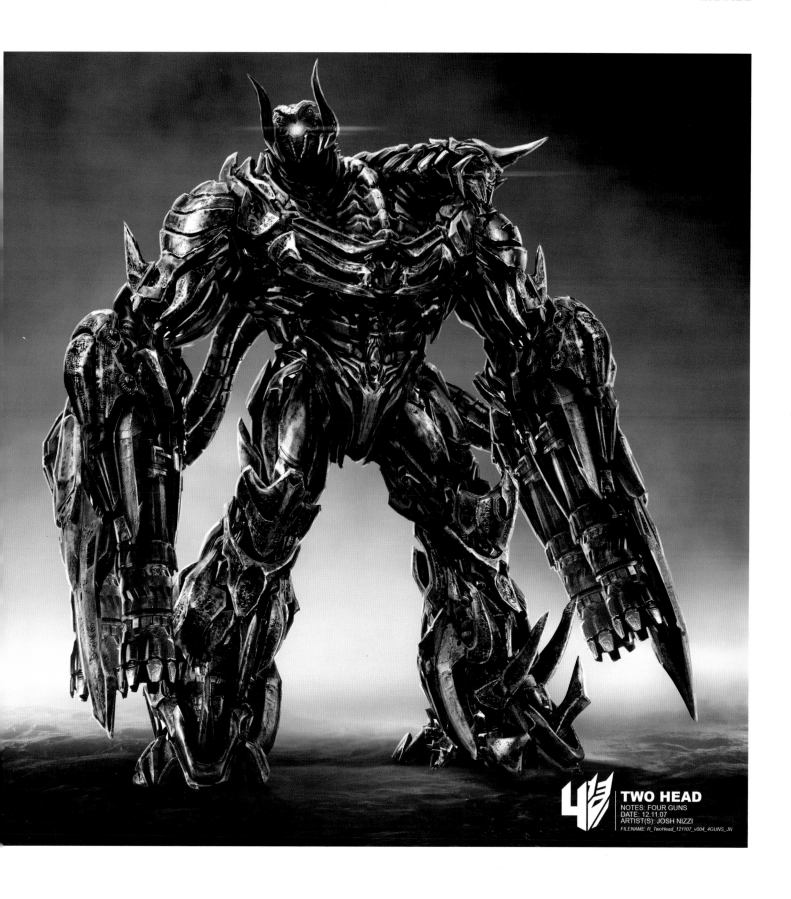

TWO HEAD
NOTES: FOUR GUNS
DATE: 12.11.07
ARTIST(S): JOSH NIZZI
FILENAME: R_TwoHead_121107_v004_4GUNS_JN

Opposite: Development art, Black Knight, *Transformers: Age of Extinction* | Josh Nizzi
Above: Development art, Two Head, *Transformers: Age of Extinction* | Josh Nizzi

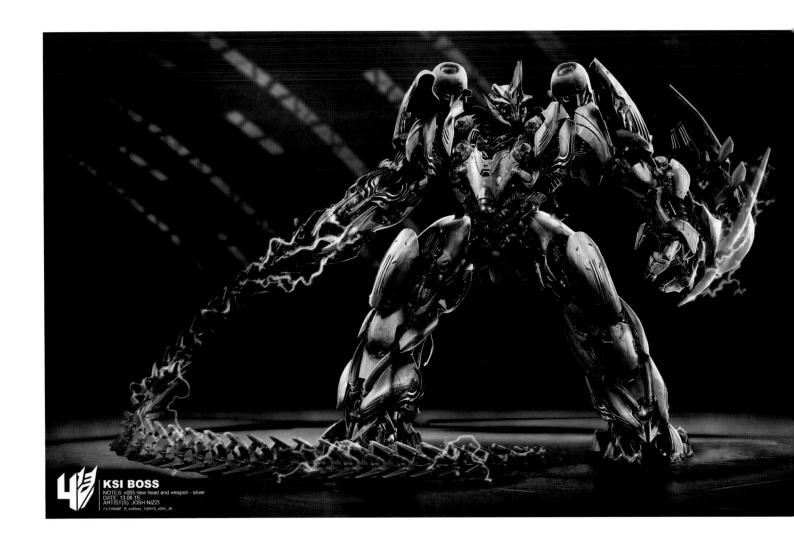

KSI BOSS
NOTES: v005 new head and weapon - silver
DATE: 13.06.15
ARTIST(S): JOSH NIZZI
FILENAME: R_ksiBoss_130615_v005_JN

Above: Development art, KSI Boss, *Transformers: Age of Extinction* | Josh Nizzi

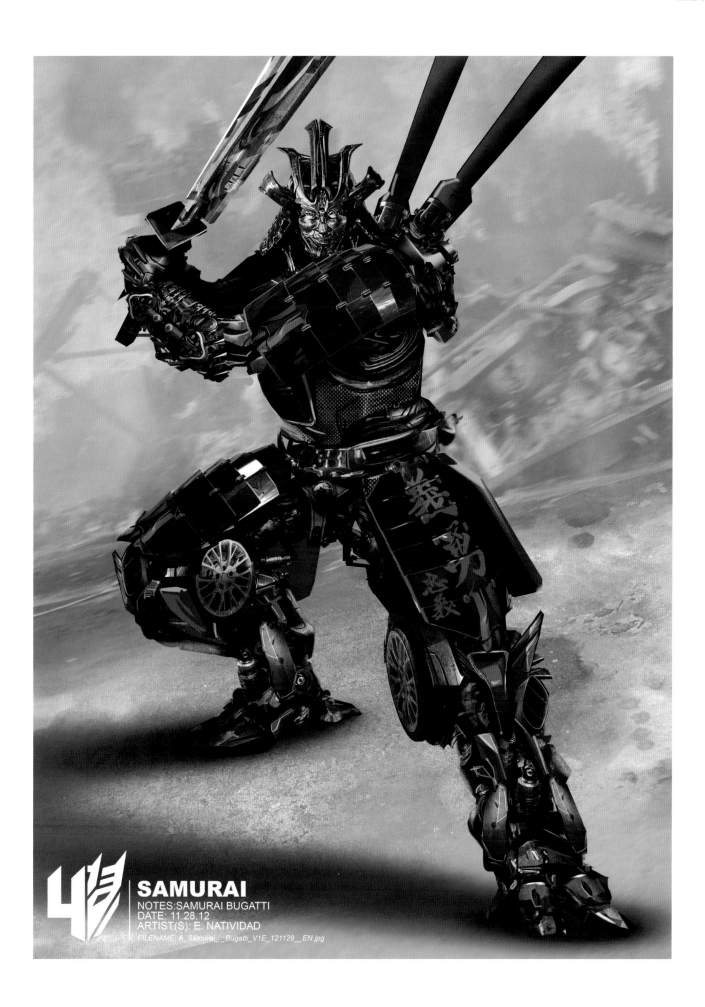

SAMURAI
NOTES:SAMURAI BUGATTI
DATE: 11.28.12
ARTIST(S): E. NATIVIDAD
FILENAME: A_Samurai__Bugatti_V1E_121128__EN.jpg

Above: Development art, Drift, *Transformers: Age of Extinction* | Ed Natividad

"We tried to work the samurai motif—like the helmet and the armor—into the robot design. You can't be too literal or it becomes not a vehicle, not a Transformer anymore. There's a fine line between literal and stylized." — Ed Natividad

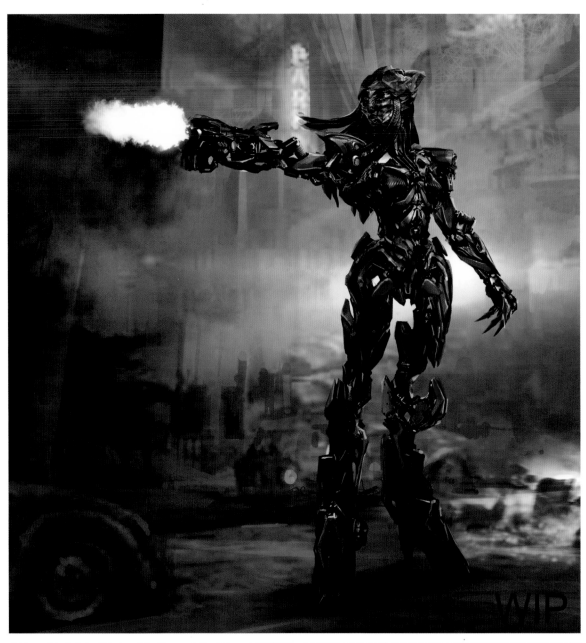

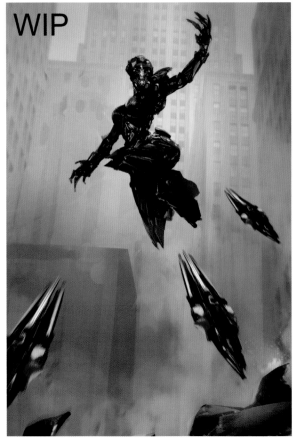

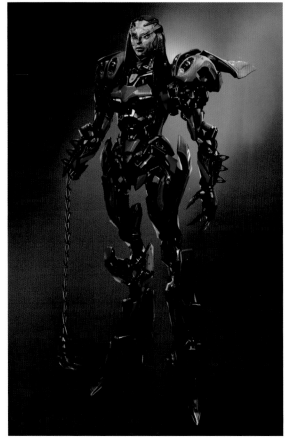

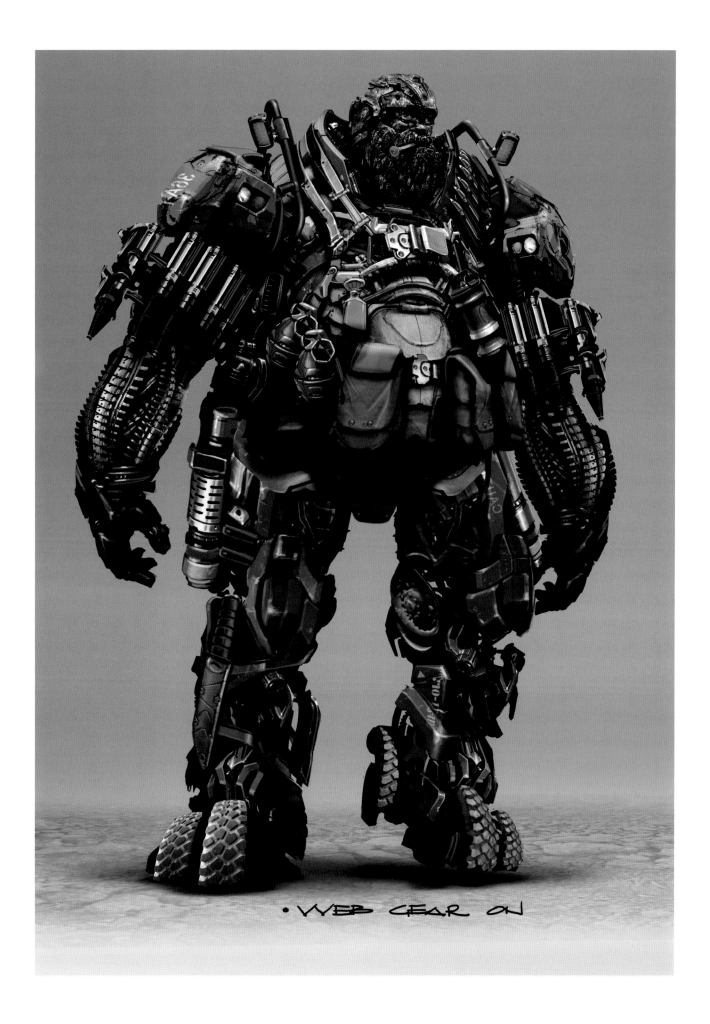

· WEB GEAR ON

Opposite: Development art, Widow Maker, *Transformers: Age of Extinction* | Steve Jung

Above: Development art, Hound, *Transformers: Age of Extinction* | Paul Ozzimo

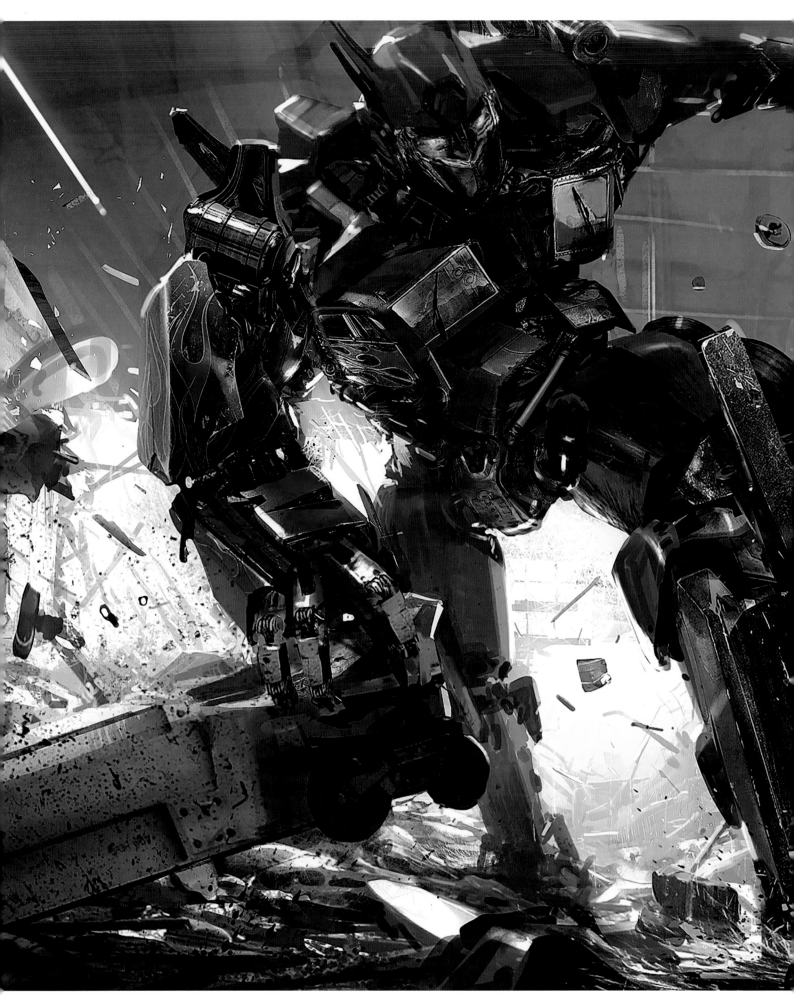

Above: Development art, Optimus Prime, *Transformers: The Last Knight* | John J. Park

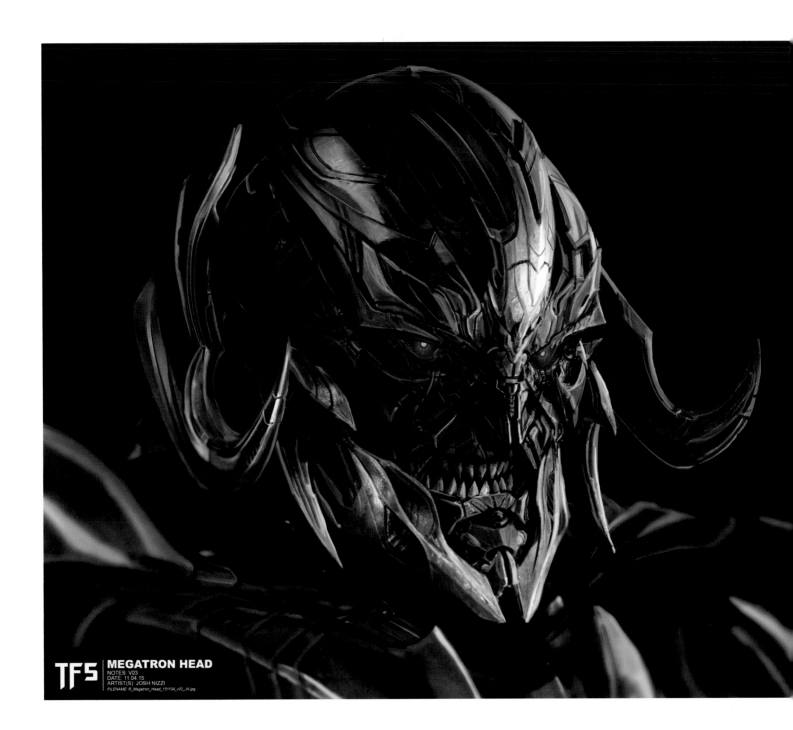

TF5 **MEGATRON HEAD**
NOTES V03
DATE 11.04.15
ARTIST(S) JOSH NIZZI
FILENAME R_Megatron_Head_151104_v02_JN.jpg

Above: Development art, Megatron, *Transformers: The Last Knight* | Josh Nizzi

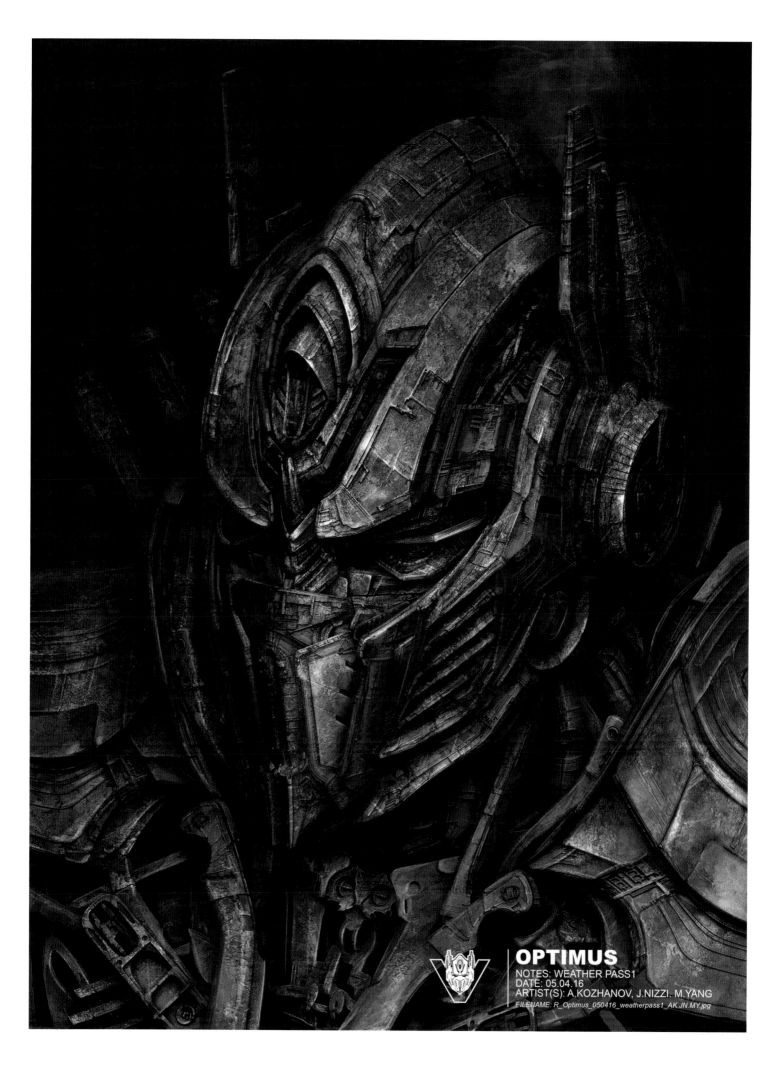

OPTIMUS
NOTES: WEATHER PASS1
DATE: 05.04.16
ARTIST(S): A.KOZHANOV, J.NIZZI. M.YANG
FILENAME: R_Optimus_050416_weatherpass1_AK.JN.MY.jpg

Above: Development art, Optimus Prime, *Transformers: The Last Knight* | Alex Kozhanov, Josh Nizzi, & Mark Yang

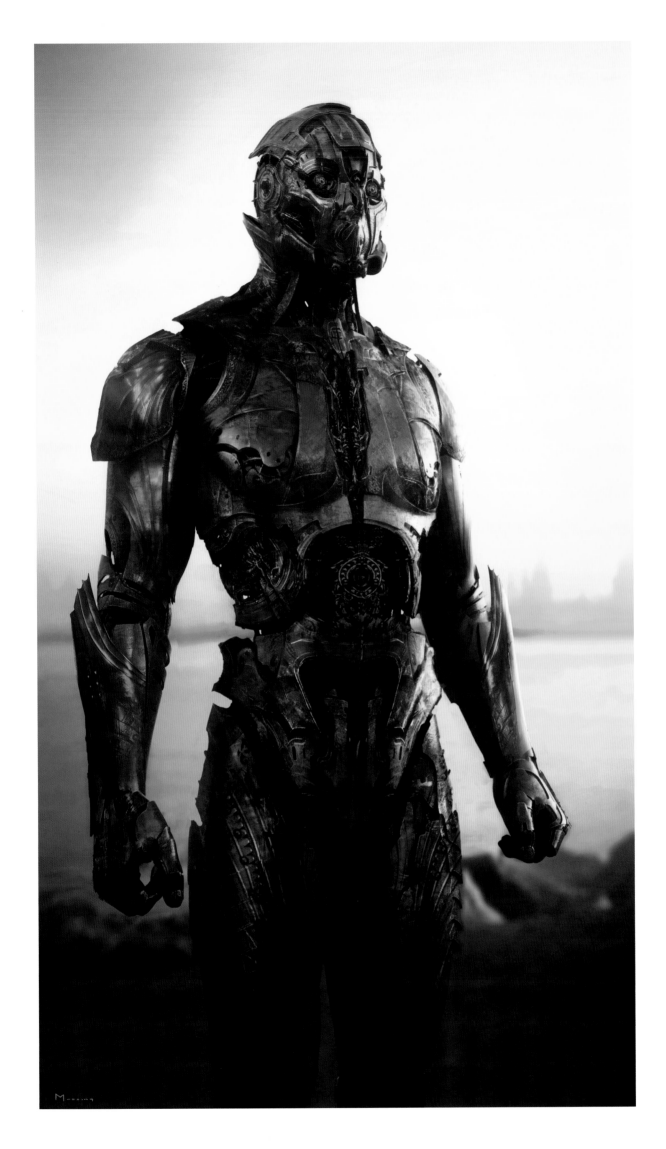

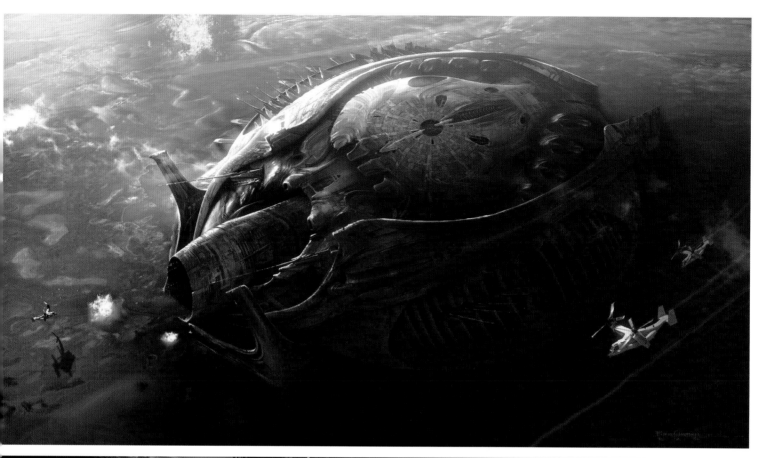

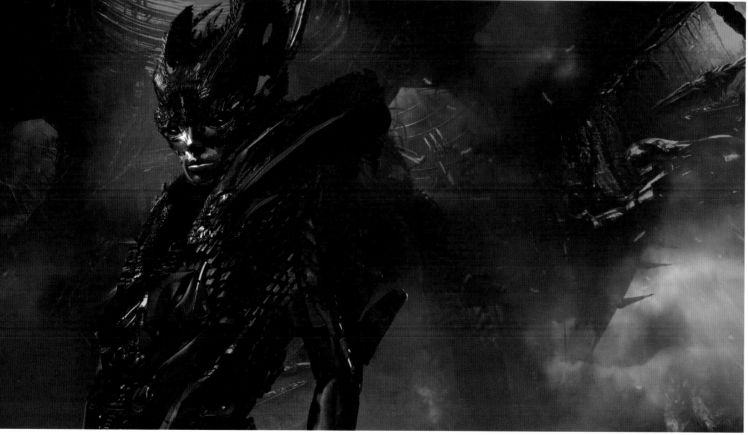

Opposite: Development art, Cogman, *Transformers: The Last Knight* | Steven Messing

Top: Development art, Ignition chamber, *Transformers: The Last Knight* | Ryan Church

Above: Development art, Quintessa, *Transformers: The Last Knight*

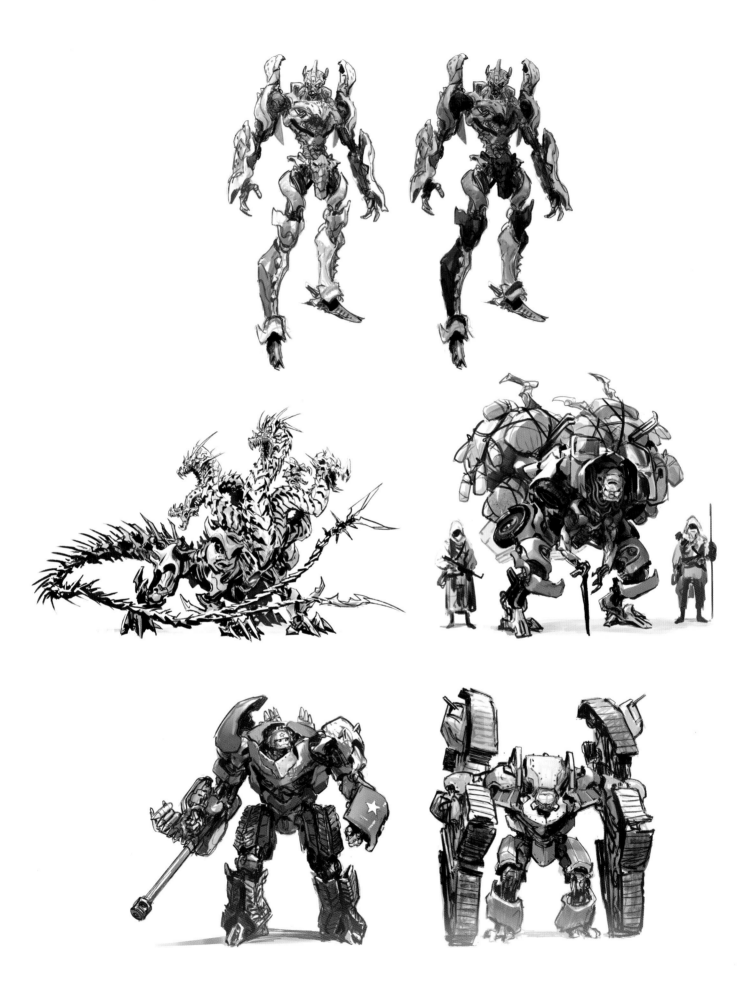

Clockwise from top left: Rough character sketches, Cheetor, Cheetor, Daytrader, Tank Bot Duo, Dragonstorm, *Transformers: The Last Knight* | Wesley Burt

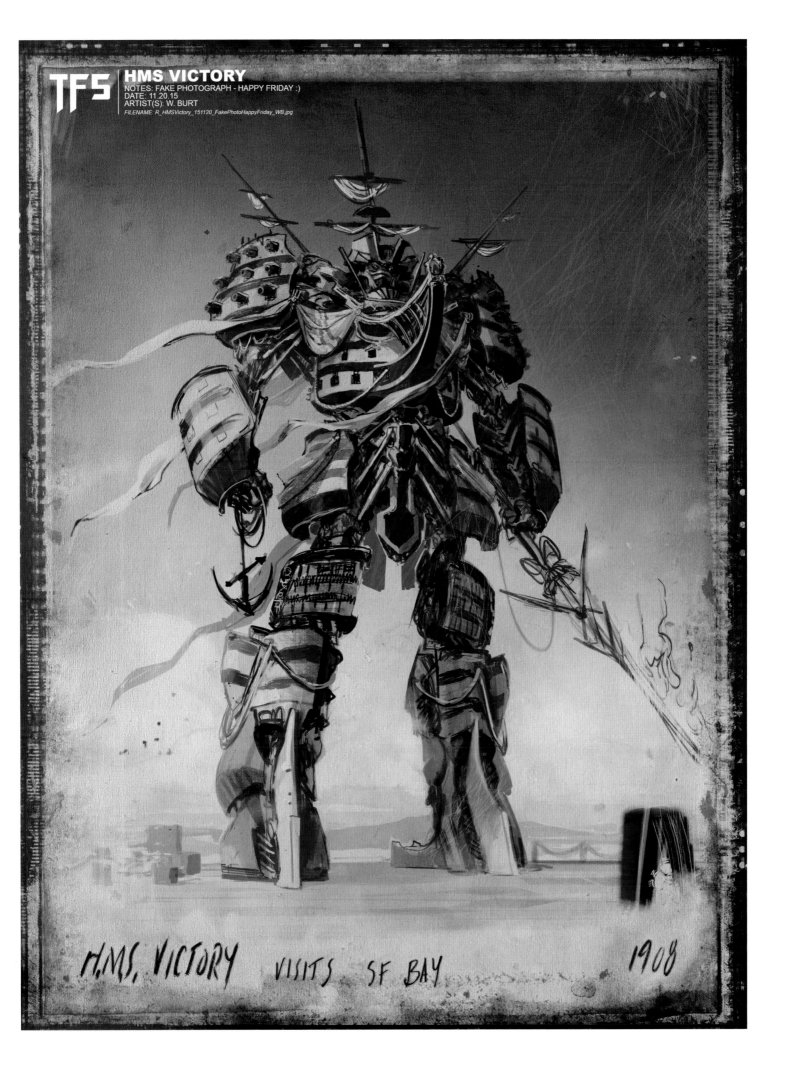

H.M.S. VICTORY VISITS SF BAY 1908

Above: Development art, *HMS Victory*, *Transformers: The Last Knight* | Wesley Burt

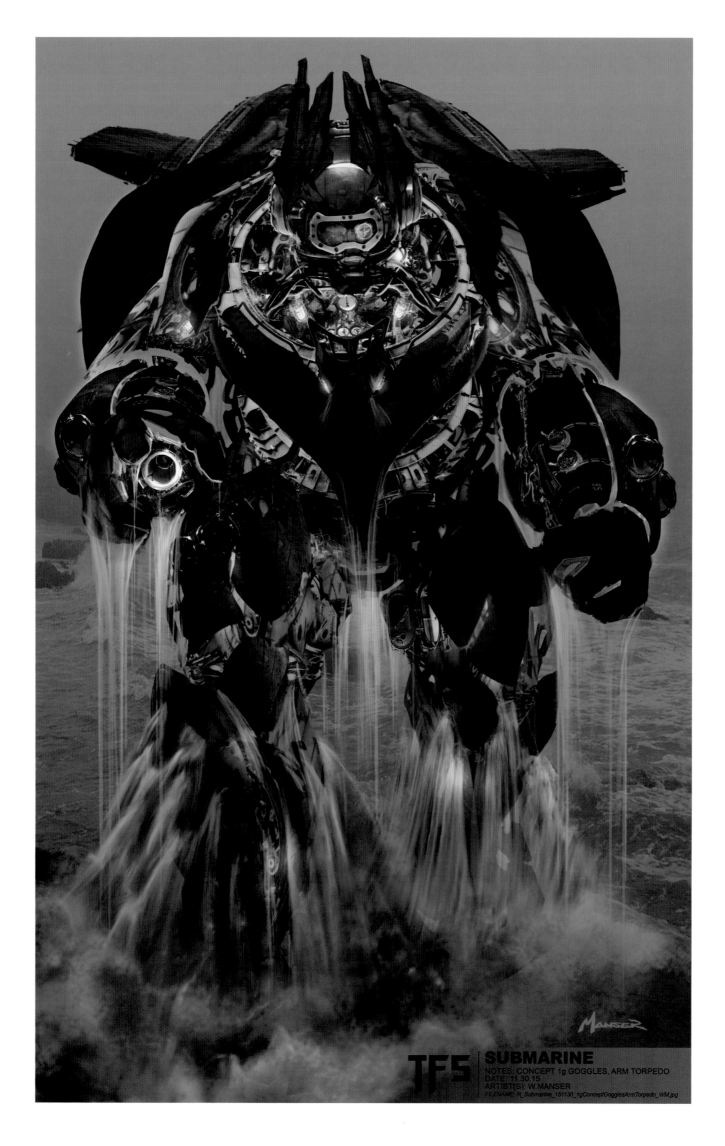

TF5 | **SUBMARINE**
NOTES: CONCEPT 1g GOGGLES, ARM TORPEDO
DATE: 11.30.15
ARTIST(S): W.MANSER
FILENAME: R_Submarine_151130_1gConceptGogglesArmTorpedo_WM.jpg

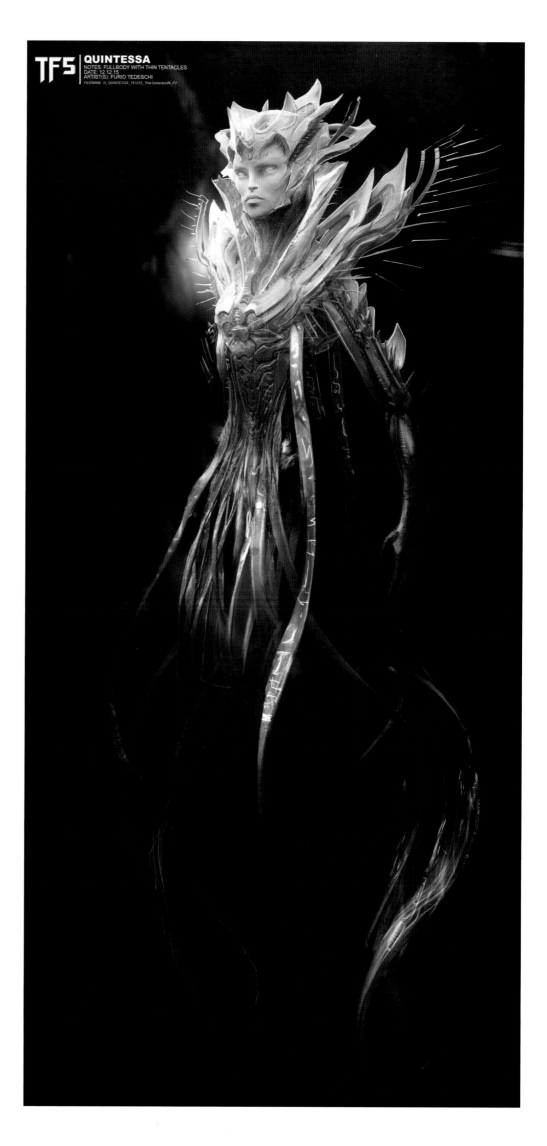

TF5 | **QUINTESSA**
NOTES: FULLBODY WITH THIN TENTACLES
DATE: 12.12.15
ARTIST(S): FURIO TEDESCHI
FILENAME: H_QUINTESSA_151212_ThinTentaclesVR_FT

Opposite: Development art, *HMS Alliance, Transformers: The Last Knight* | Warren Manser

Right: Development art, Quintessa, *Transformers: The Last Knight* | Furio Tedeschi

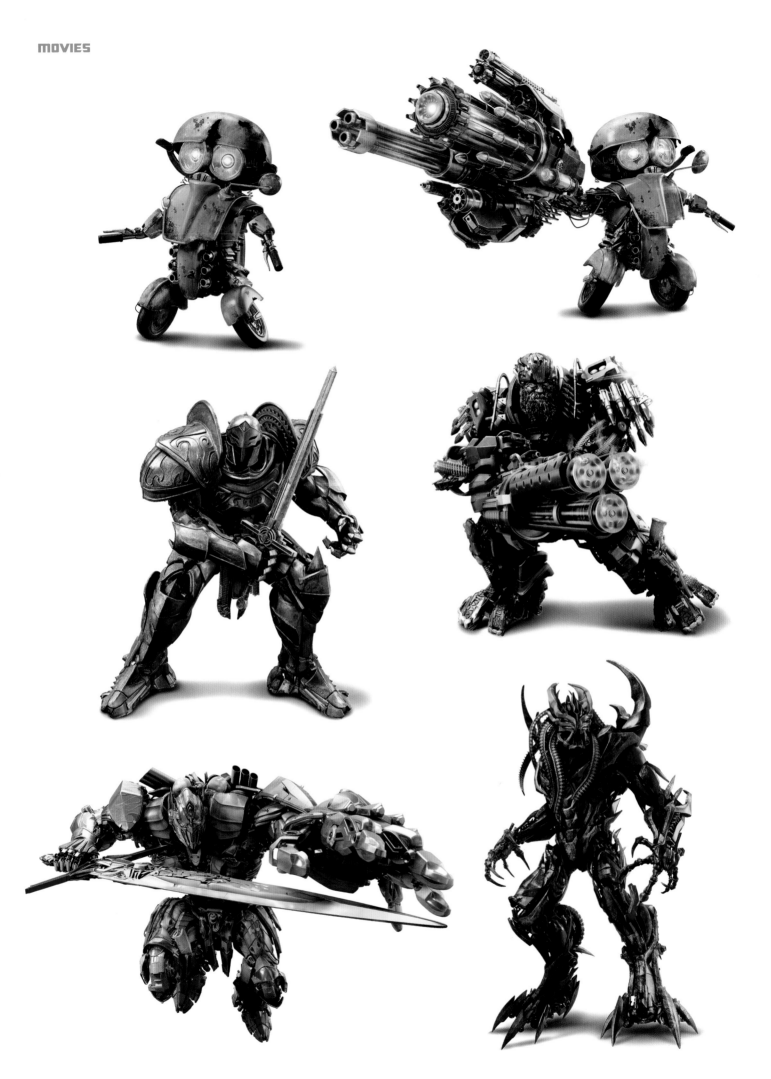

Clockwise from top left: Character renders, Sqweeks, Sqweeks, Hound, Berserker, Optimus Prime, Steelbane, *Transformers: The Last Knight*

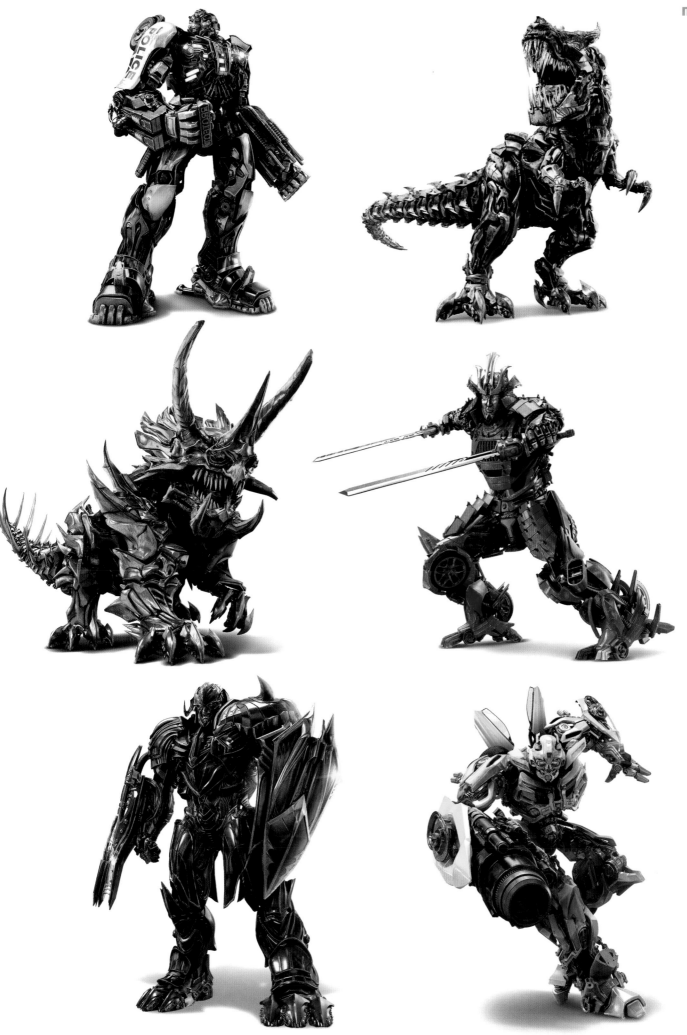

Clockwise from top left: Character renders, Barricade, Grimlock, Drift, Bumblebee, Megatron, Slug, *Transformers: The Last Knight*

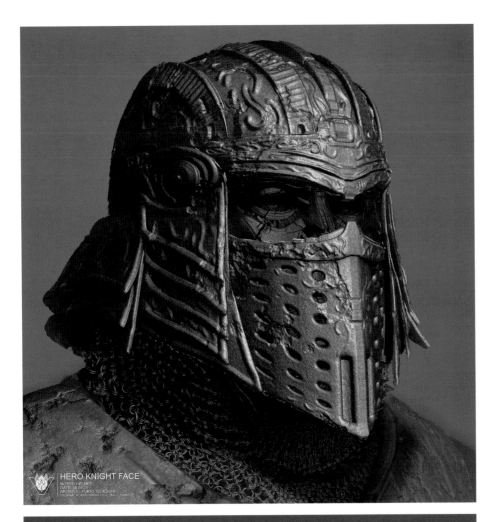

HERO KNIGHT FACE
NOTES: HELMET
DATE: 16.04.21
ARTIST(S): FURIO TEDESCHI
FILENAME: R_HEROKNIGHTFACE_16042_HKNIGHT.PT

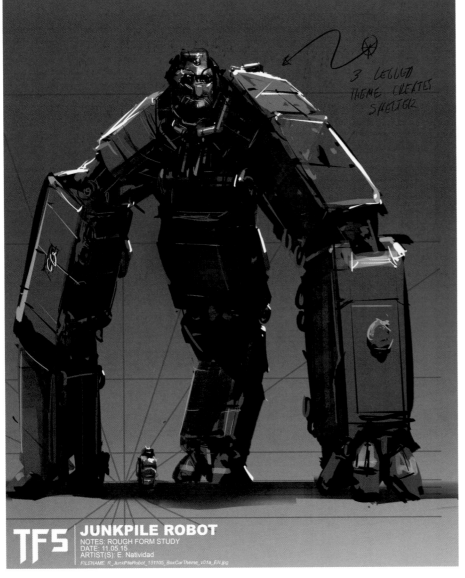

3 LEGGED
THEME CREATES
SHELTER

TF5 **JUNKPILE ROBOT**
NOTES: ROUGH FORM STUDY
DATE: 11.05.15
ARTIST(S): E. Natividad
FILENAME: R_JunkPileRobot_151105_BoxCarTheme_v01a_EN.jpg

Top left: Development art, Hero Knight,
Transformers: The Last Knight | Furio Tedeschi

Left: Rough form study, Canopy, *Transformers:
The Last Knight* | Ed Natividad

Opposite, top: Development art, Da Vinci bot in
castle, *Transformers: The Last Knight* | Wesley Burt

Opposite, below: Development art, Da Vinci bot,
Transformers: The Last Knight | Wesley Burt

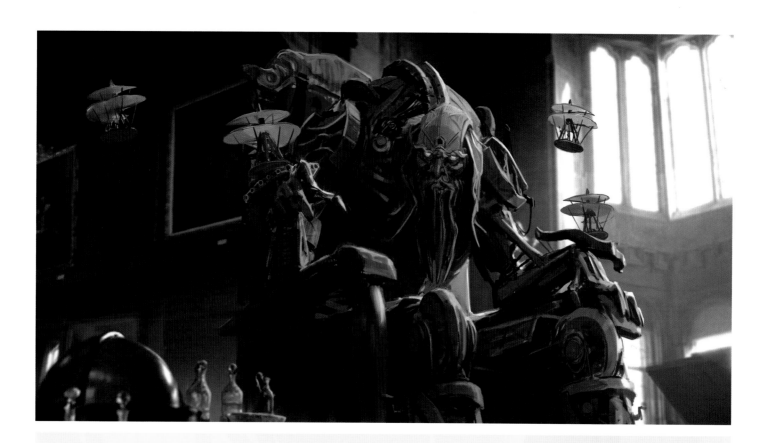
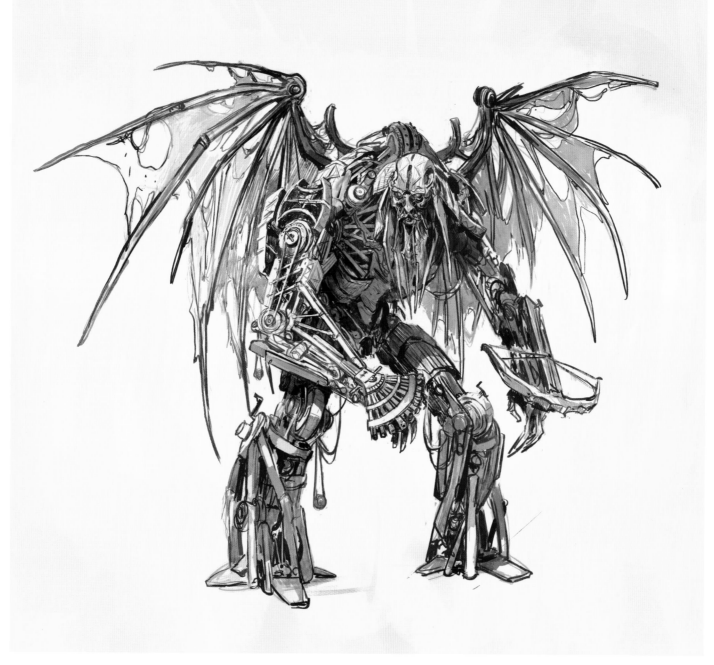

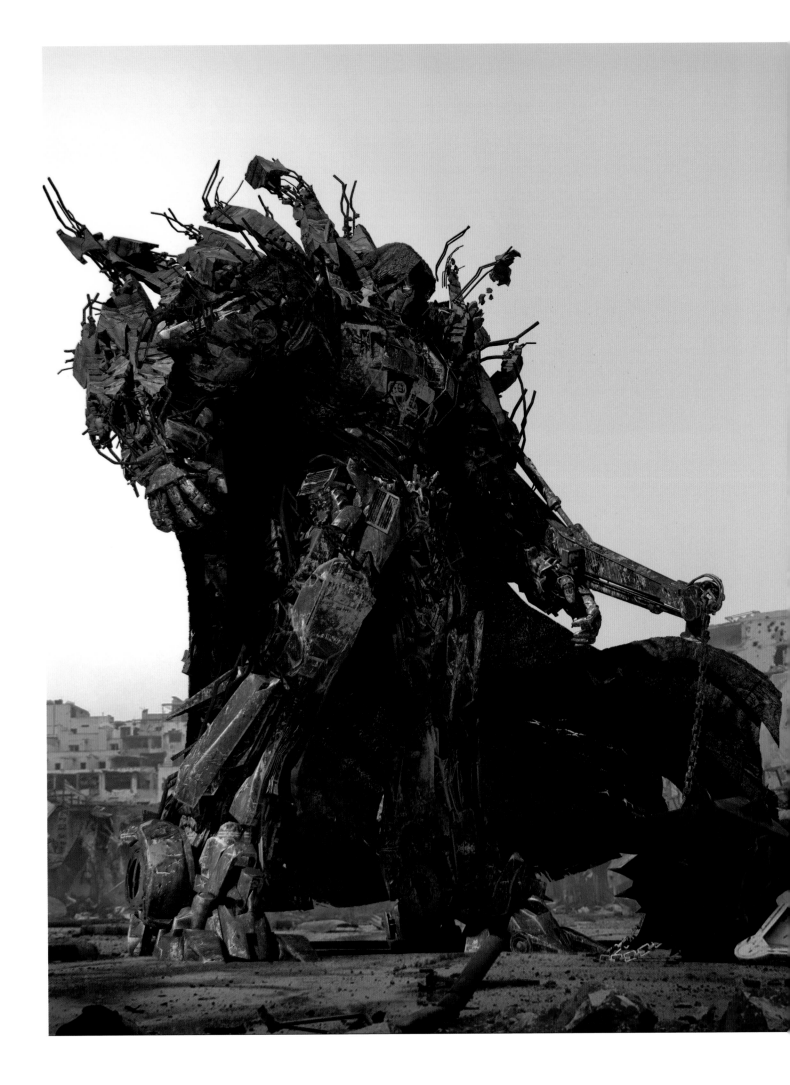

Above: Development art, Canopy, *Transformers: The Last Knight* | Luis Guggenberger

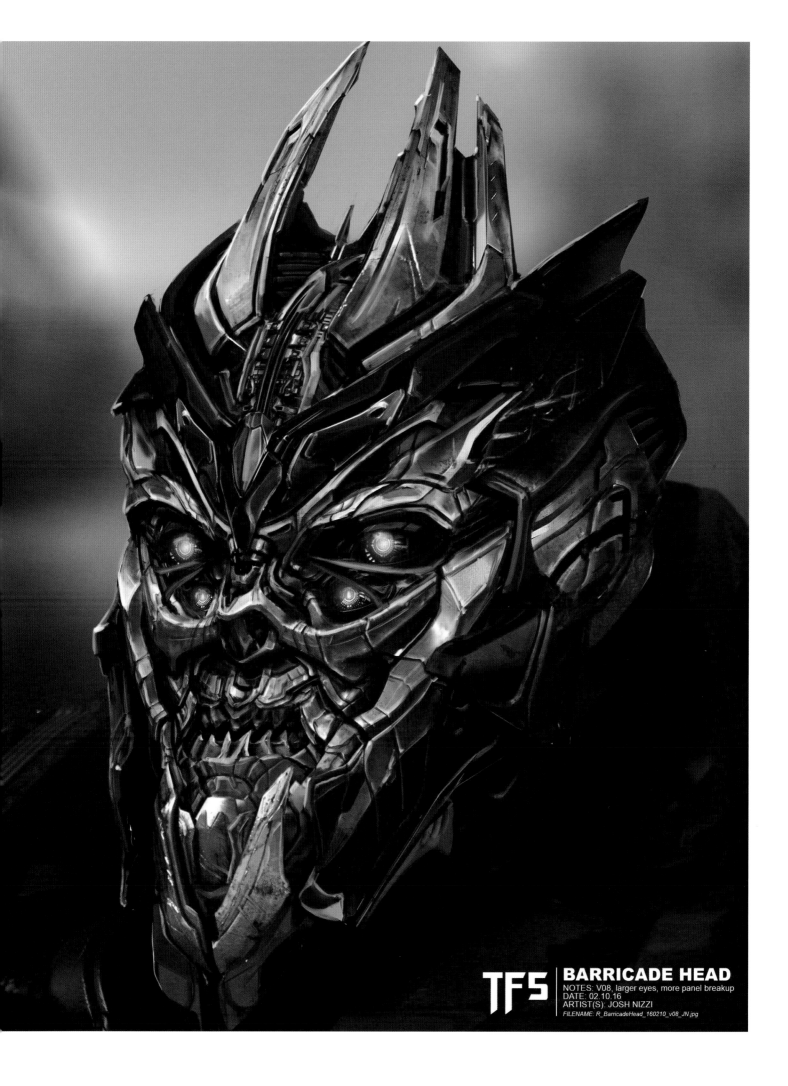

TF5 | **BARRICADE HEAD**
NOTES: V08, larger eyes, more panel breakup
DATE: 02.10.16
ARTIST(S): JOSH NIZZI
FILENAME: R_BarricadeHead_160210_v08_JN.jpg

Above: Development art, Barricade, *Transformers: The Last Knight* | Josh Nizzi

Above: Character render, boombox pose, *Bumblebee*

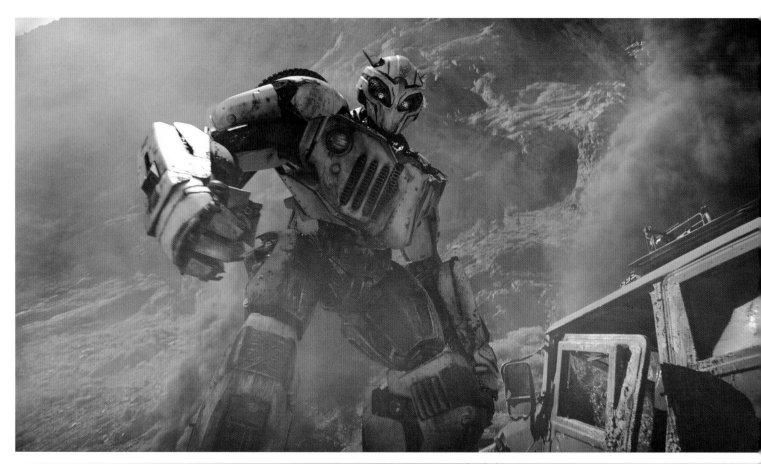

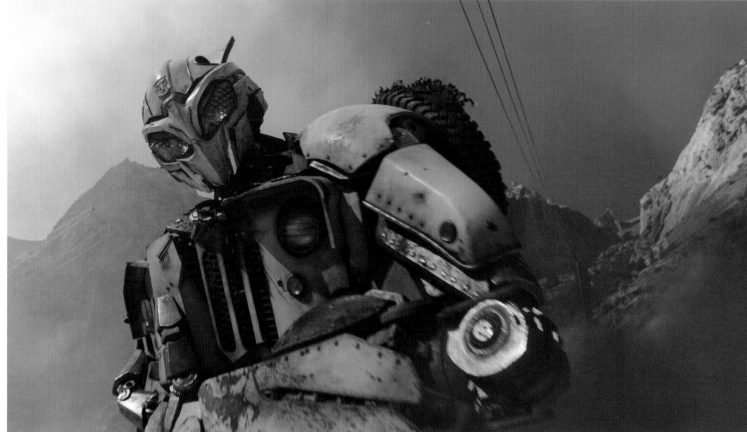

These Pages: Screenshots, *Bumblebee*

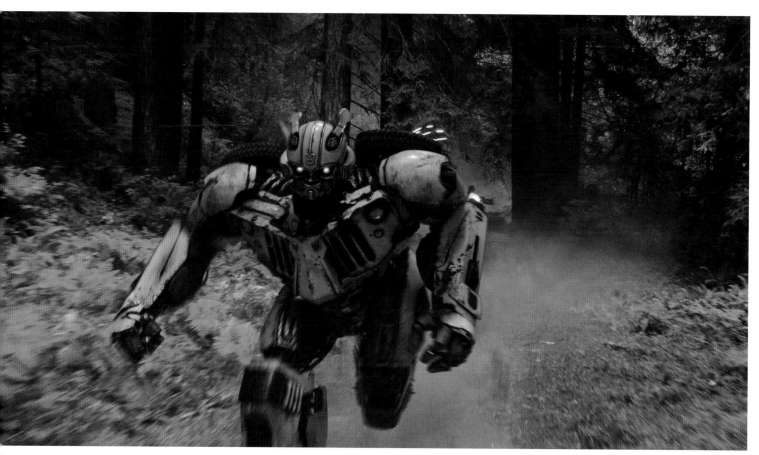

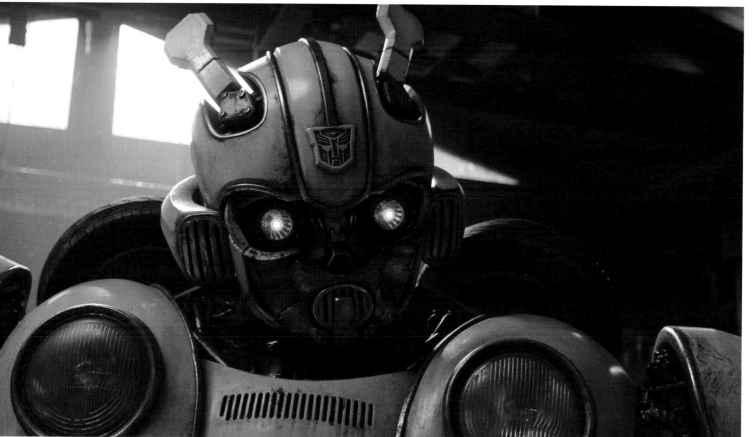

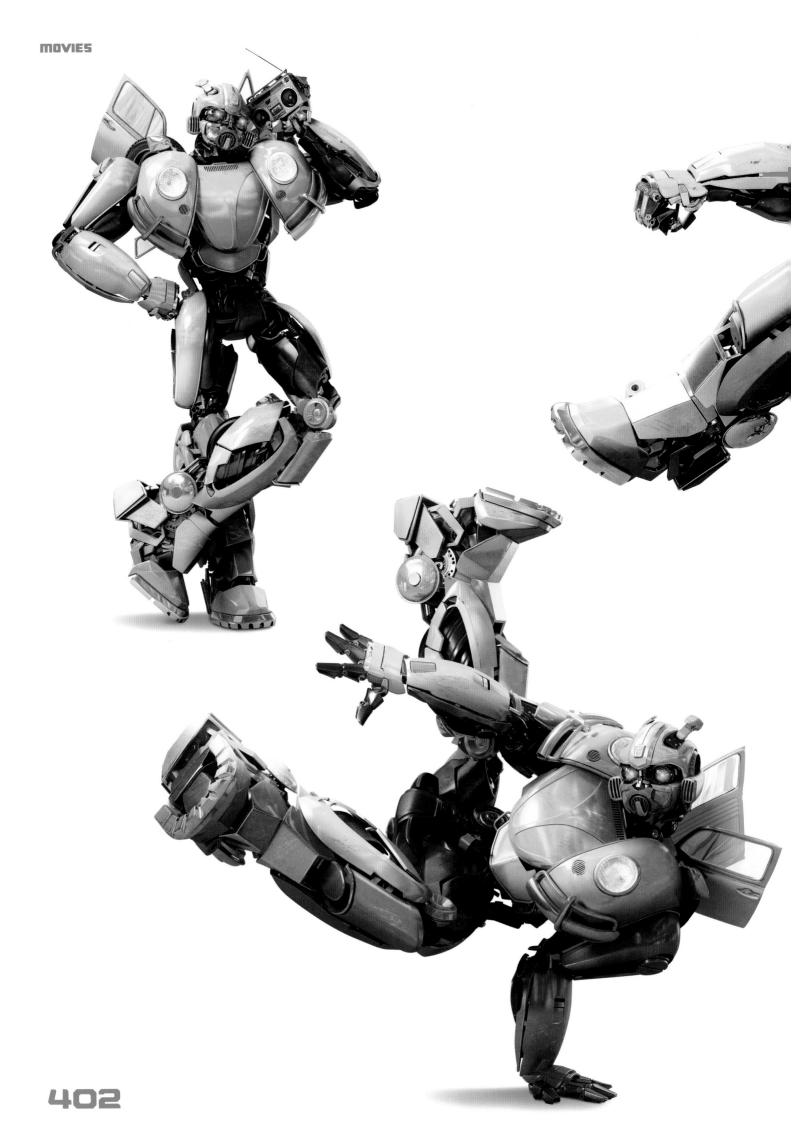

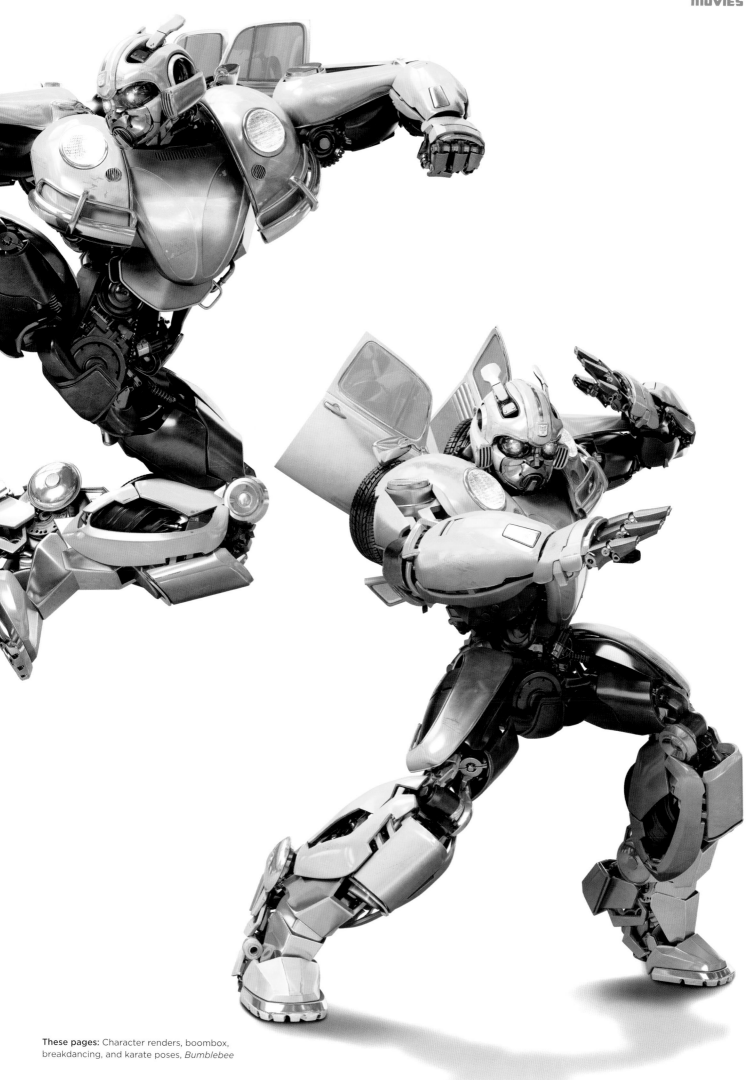

These pages: Character renders, boombox, breakdancing, and karate poses, *Bumblebee*

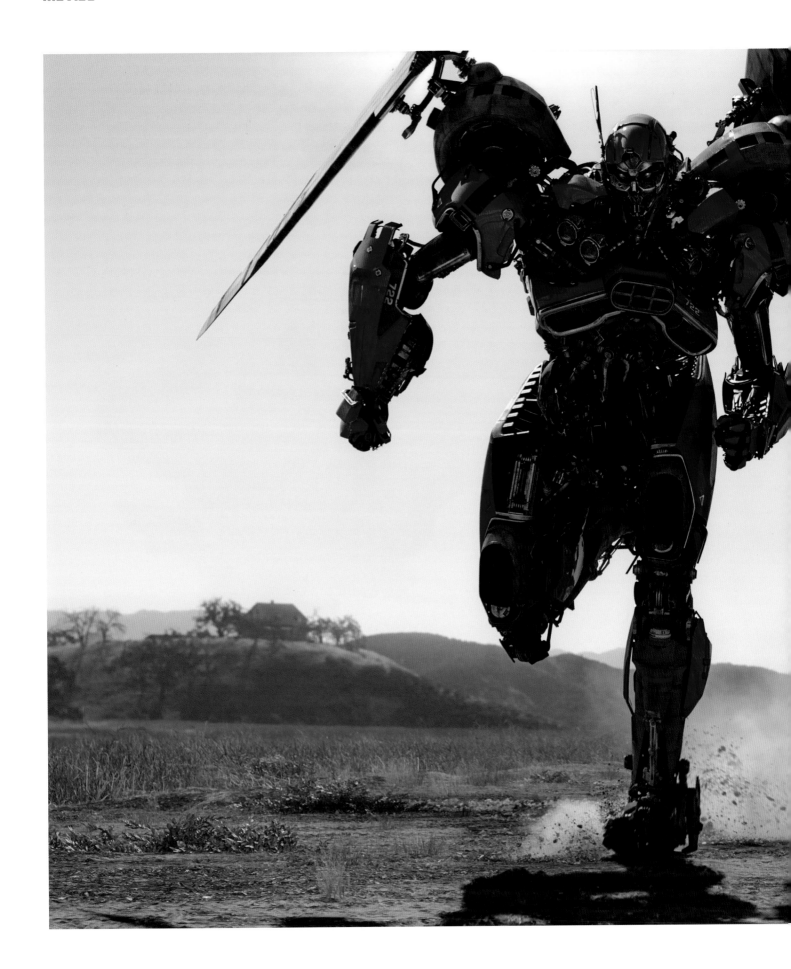

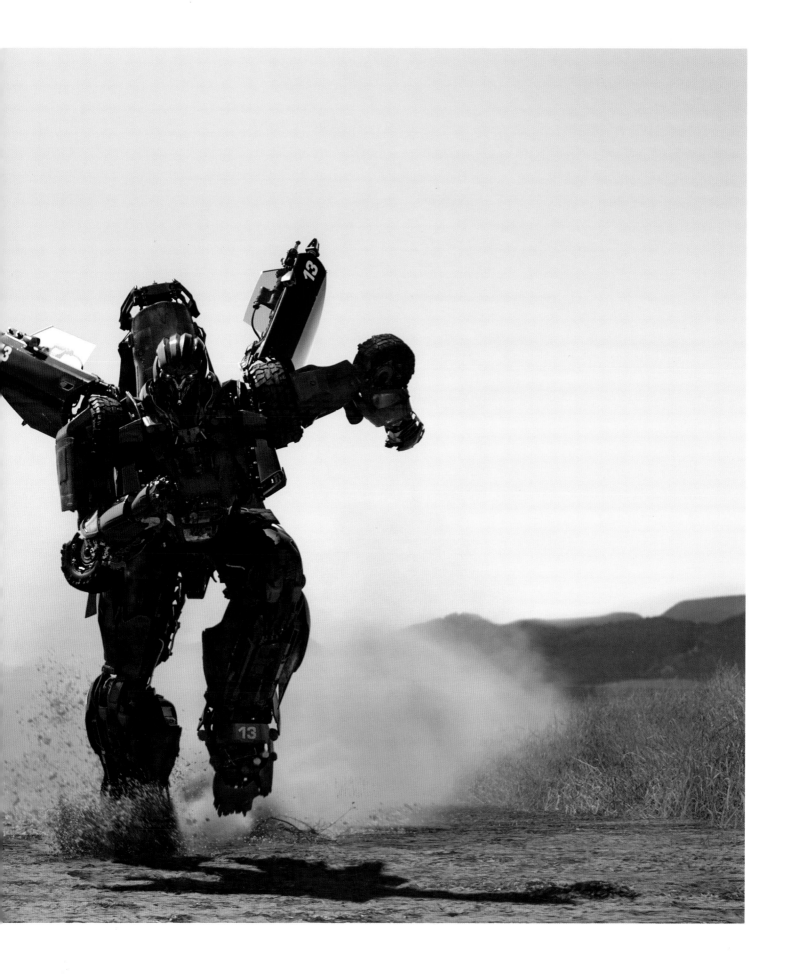

These pages: Screenshot, Dropkick and Shatter, *Bumblebee*

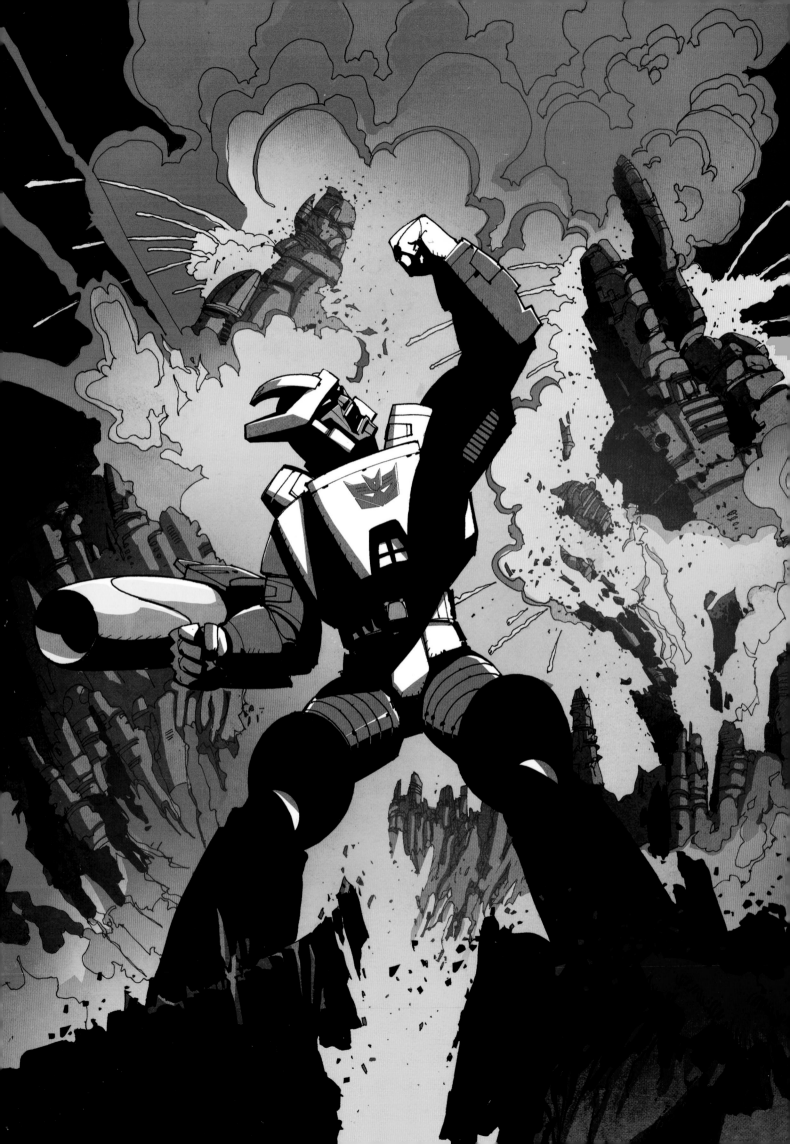

ACKNOWLEDGEMENTS

A book like *Transformers: A Visual History* is only possible thanks to the collaboration of a great many people, so it's only right that we try to thank them all. First off, the herculean efforts of Ed Lane over at Hasbro made this book possible. Other Hasbro employees who lent a hand include Sonal Majmudar, Kelly Johnson, Bryan Olender, Chris Nadeau, Nick Silvestri, Derek Kroessler, John Warden, Daizo Uehara, Mario Carreiro, Beth Artale, Richard Zambarano, Tom Marvelli, and Michael Kelly. We thank you for your patience with our seemingly endless slew of asset requests.

The packaging art section is what it is thanks to the contributions of Alex Bickmore, Allison Boiselle, Tim Finn, Rasmus Hardiker, the Hartman bros, Doug Hart, Vance McLennan, Joe Moore, Walter Mueller, Andrew Perlmutter, Heather Russell, Mark Watts, and Drew Nolosco from Wizards.

The comics section received input and assets from a great many people. David Mariotte at IDW Publishing was a lifesaver, making sure that section of the book was as robust and comprehensive as it wound up being. Chris Ryall's insight was invaluable as well. Many artists lent their expertise and went scrounging through half-forgotten hard drives, namely Robbie Armstrong, Stephen Baskerville, John-Paul Bove, Josh Burcham, Ken Christiansen, Jr., Christopher Colgin, Casey Coller, Thomas Deer, Don Figueroa, Matt Frank, Andrew Griffith, Guido Guidi, Trevor Hutchison, Dan Khanna, Shaun Knowler, Matt Kuphaldt, Marcelo Matere, Alex Milne, Robby Musso, Josh Perez, Sara Pitre-Durocher, Livio Ramondelli, Nick Roche, Emiliano Santalucia, Liam Shalloo, E.J. Su, Andrew Wildman, and Jesse Wittenrich.

The animation chapter got an extra boost from Rik Alvarez, Christopher Antoin, Aaron Archer, James Eatock, Todd Ferguson, and Paul Heal. Special thanks to Brian Ward over at Shout! Factory for some of the nicer movie pieces.

The video game pages were made possible thanks to the contributions of Daniel Arseneault, Jamie Harris, Ben Hansen, and Simon Plumb.

The movie chapter received extra material and insights from Vitaly Bulgarov, Warren Manser, Ed Natividad, Josh Nizzi, and Matt Tkocz. We want to especially thank Paul Ozzimo for his tireless help with attribution in this section.

To my sounding boards, David Bishop, Chris McFeely, and Bill Forster, I appreciate your perspective on when I'm going too far, and when I'm not going too far enough. To my wife, Ming-Li, and my son, James, thanks for sacrificing me to this project for the past nine months. To the handful of people who lent a hand who I have inevitably and unfortunately forgotten, apologies. It's a LONG list of names!

To Daniel New, thanks for making the book look so beautiful. And to Sarah Fairhall and David Brothers over at VIZ, thanks for bringing me in and cutting me loose. We surely did make something special together.

A very special thanks to you, the fans, for reading and enjoying. I love to hear from you so drop me a line at transformerstheark@yahoo.com.

And finally, a moment to thank the many, MANY talented artists, illustrators, animators, modelers, and creative people who created the hundreds of pieces that comprise this book. We couldn't have done it without you.

TRANSFORMERS
A VISUAL HISTORY

Writer: Jim Sorenson
Design & Layout: Daniel New
Editor: David Brothers

Published by VIZ Media, LLC
P.O. Box 77010
San Francisco, CA 94107

Printed in China

Library of Congress Cataloging-in-Publication Data

Names: Sorenson, Jim, author.
Title: Transformers : a visual history / by Jim Sorenson.
Description: San Francisco, CA : VIZ Media, LLC, 2019. Contents: Packaging --
Toy design -- Comics -- Homage -- Animation -- Crossover -- Video games --
Quirk -- Movies.
Identifiers: LCCN 2019013075| ISBN 9781974710584 | ISBN 9781974710577
(limited edition)
Subjects: LCSH: Transformers (Fictitious characters)--Pictorial works.
Classification: LCC NK8595.2.C45 S67 2019 | DDC 741.5/97300222--dc23
LC record available at https://lccn.loc.gov/2019013075

10 9 8 7 6 5 4 3 2 1
First printing, November 2019

Licensed by:

viz.com